MOSCOW
GRAFFITI

MOSCOW GRAFFITI:

Language and Subculture

John Bushnell

Boston
UNWIN HYMAN
London Sydney Wellington

Unwin Hyman, Inc.
8 Winchester Place, Winchester, Mass. 01890, USA

Published by the Academic Division of
Unwin Hyman Ltd
15/17 Broadwick Street, London W1V 1FP, UK

Allen & Unwin (Australia) Ltd,
8 Napier Street, North Sydney, NSW 2060, Australia

Allen & Unwin (New Zealand) Ltd in association with the
Port Nicholson Press Ltd,
Compusales Building, 75 Ghuznee Street, Wellington 1, New Zealand

First published in 1990

Library of Congress Cataloging-in-Publication Data

Bushnell, John, 1945–
 Moscow graffiti: language and subculture/John Bushnell.
 p. cm.
Includes bibliographical references.
ISBN 0-04-445168-7. — ISBN 0-04-445169-5 (pbk.)
 1. Language and culture—Russian S.F.S.R.—Moscow.
 2. Graffiti—Russian S.F.S.R.—Moscow. 3. Moscow (R.S.F.S.R.)—
 Popular culture.
I. Title
P35.5.S65B8 1990 89-24931
306.4'4'0947312—dc20 CIP

British Library Cataloguing in Publication Data

Bushnell, John
 Moscow graffiti: language and subculture.
 1. Soviet Union. Graffiti. Sociocultural aspects.
 I. Title
 302.2'244
 ISBN 0-04-445168-7

Typeset in 10 on 12 point Palatino by Fotographics (Bedford) Ltd
and printed in Great Britain by Billing and Son, London and Worcester

Contents

Preface

This book is an unexpectedly long answer to a question I began to ask in the fall of 1983: What do the graffiti on Moscow's walls mean? I put that question to Soviet friends and acquaintances, and eventually to anyone I met in any office, apartment, or courtyard. I had nothing cultural or semiotic in mind; I wanted only to know the plain meaning of the words and symbols that appeared in the graffiti. The question grew larger when it turned out that my friends were not much better at making sense of the inscriptions than I was. Why were almost all Soviet adults unable to read the writing on the walls around them? And yet another question: there had been no graffiti, at least none that caught the eye, when I lived in Moscow between 1972 and 1976. Their presence when I returned in September 1983 was one of the most visible changes that had occurred in Soviet society in the intervening years. When and why had Muscovite adolescents—for they were the culprits—taken to writing indecipherable messages on public walls?

Of course, there have always been graffiti of one sort or another in Russia. Memoirists of the nineteenth and early twentieth centuries mention dirty words on fences, and those words are there still. Prisoners have reported graffiti in Tsarist and Soviet jails, and the sometimes ferocious efforts of Soviet jailers to deter them. For decades novelists with an eye for evocative detail have placed fictional graffiti in public restrooms and elevators and on park benches, because real graffiti lurk there. Generations of students have carved graffiti on their desks. Tourists carved and painted their names on the cliffs and crags and in the caves of the Crimea and the Caucasus in the nineteenth century, and have done so ever since. Soviet soldiers covered the Reichstag and other monuments with graffiti after they broke into Berlin in 1945. During the 1970s the KGB occasionally scrawled graffiti on walls and cars to create a semblance of popular indignation

against dissidents. And a few dissidents wrote political graffiti. If one looked very closely, inscriptions of some sort could always be found. Yet, as of the middle of the 1970s, Moscow and other Soviet cities gave the appearance of being free of graffiti: the gang declarations, the bold political and social statements, the endlessly repetitive spray-painted codes of the taggers that have been in succession a prominent feature of Western cityscapes since the 1950s were missing from Soviet cities. But that changed. In the late 1970s Soviet adolescents began to write incomprehensible graffiti on public walls, and they did so just as aggressively as their Western peers. The Soviet Union had entered the graffiti age.

The less Soviet adults could tell me about these new adolescent graffiti, the more interesting they became. So I collected them, from probably 1,000 miles of walls between September 1983 and June 1984. That was not the herculean accomplishment it might seem, in fact it was a distinctly part-time occupation. Anyone who walks 10 miles in a city will see 20 miles of wall at a minimum, and most of that expanse will be blank and uninteresting. Unless you strike several particularly rich lodes, in a long day of hiking you can collect graffiti from 30–40 miles of wall; not only are most walls bare, but most graffiti are repetitious and easily inventoried. By the time I left Moscow I believed I could identify the different types, what they stood for and what they meant, and when they had begun to appear, and I intended to write an article using the graffiti to illuminate recent social and cultural changes in Soviet society. But the article turned into a book, and the book covers additional graffiti harvested from several hundred more miles of wall during three weeks in September–October 1988.

Carefully scrutinized, the graffiti disclose a great deal about the fabric of Soviet society, but some of the most fundamental insights they provide emerge in the reactions of people with whom I have discussed the subject. Americans most frequently ask why the Soviet regime permits graffiti. That question derives from a persistent misunderstanding of the character of Soviet society and government. Even at its most totalitarian, the Soviet regime never had the ability to control behavior so minute as writing on walls, and its capacity to

regulate the daily behavior of its citizens has declined steadily for better than 30 years. So has its interest in doing so. When it comes to dealing with graffiti writers, Soviet police and housing authorities are every bit as helpless as their American counterparts. The many developments in Soviet society and culture that prepared the way for the appearance of adolescent graffiti were unplanned, ungoverned, and mostly unsuspected by the regime and official Soviet institutions. Graffiti inform us of the kinds of change in Soviet society over which the regime has had no control.

My Soviet friends find nothing surprising about the graffiti, but their invariable first response is to pronounce them utterly insignificant, mere children's scribblings. That reaction betrays an interesting lack of awareness of changes under way in their own society. As late as the mid-1970s, most Soviet graffiti did consist of chalk drawings and scribbling by children, and that is what they remain in adult consciousness. There is not even an adequate Russian term for them. *Graffiti* is a learned word that refers only to the inscriptions scratched into ancient church walls; most Russians do not even know the word. Dirty words are called, generically and euphemistically, *zabornye vyrazheniia*, "fence language," whether they appear on fences or somewhere else; the reference is so specific that the phrase cannot be more generally applied. *Nadpis'*, or *nastennaia nadpis'*, meaning inscription, or sign, or announcement painted on a wall, is the closest approximation to a term for what we call graffiti, but its meaning is so broad—and there are so many official announcements painted on the walls—that Soviets do not know that you are talking about adolescent graffiti unless you add plentiful descriptive detail.

The Russian language has not yet caught up with the graffiti and the social phenomena they represent, and Soviet adults' unreconstructed mental architecture offers no niche within which they can file the new kind of graffiti. They simply disregard what their eyes see. Of course, the two things go hand in hand: without some change in the language there cannot be a new perceptual category, and vice versa. The failure of the graffiti to find a suitable place in the language is striking and also unusual. As the chapters that follow will

demonstrate, modern Russian does register an enormous number of changes in Soviet society. Moreover, this particular change is highly visible: it is a feature of the urban landscape within which Soviet adults live. The graffiti that they cannot read all around them represent a change in their society that they do not know has occurred.

The typical American question needs to be reversed. Instead of asking why the regime permits graffiti, we want to know what the fact of their appearance tells us about Soviet society. The typical Soviet reaction to the graffiti also needs to be stood on its head. If Soviet adults do not understand them, and are by and large oblivious to the emergence of nonchildish graffiti, we need to ask what quality of the graffiti makes such ignorance possible. Those two questions—what the graffiti reveal about Soviet society, and what Soviet adult society's ignorance reveals about the graffiti—frame the investigation.

I tie the various strands of the argument together in the final chapter, but the intellectual structure is straightforward and should be evident throughout. Study of the graffiti opens up the history of the Soviet youth subculture because the graffiti have developed in tandem with the subculture. The graffiti help us to see the subculture being born and evolving. The subject matter of the graffiti identify components of the subculture and developments in Soviet society that nourished them. The language of the graffiti links the various components together and defines the subculture's opposition to the normative culture. I root the argument as firmly as possible in what are ordinarily considered social history and the study of popular culture.

When the manuscript was virtually as it is now, the publisher sent it out for review. The reviewer (nameless only because he has no opportunity for a last word) praised my work extravagantly, but chiefly for what he considered its ethnographic aspect: I provide data for those who may really know what to make of the graffiti. He faulted me chiefly for "the absence in the manuscript of *any* unifying theoretical component, whether we have in mind theory of language, of communication, or of culture," for failing "to come to a rudimentary understanding of how sign systems function." I accept the justice of that criticism. History is a notoriously

atheoretical discipline, and I have not attempted to make sense of the graffiti within the framework of a theory of culture or of signs. I have proceeded as any historian would, treating the graffiti as the product of a particular society, and of particular changes in that society at a particular time. To be honest, I anticipated being criticized for making too much rather than too little of the graffiti. I am certain that practitioners of cultural criticism would come to different conclusions, some of which might be useful in a history of the graffiti. On the other hand, I would not have been able to understand the linguistic and cultural characteristics of the graffiti at all had I not learned something from the cultural disciplines.

When I began to work out what modern Soviet graffiti were about, I looked for models but found none. The ancient inscriptions on shards and in churches excepted, graffiti have attracted very little scholarly attention. An article on the graffiti at Pompeii set an obviously bad example by arguing that ancient Pompeians wrote the same kinds of messages on walls as contemporary Los Angelenos. A small cluster of studies in the 1960s and early 1970s dealt with the psychology of graffiti, especially the implications of violating taboos and walls. Other serious and popular commentaries—most famously but not only by Norman Mailer—celebrated graffiti and graffiti writers, but did not have much to say about graffiti themselves unless they had evolved into the whole-car paintings of the New York graffiti artists. A survey of graffiti through the ages was more inventory than analysis. I was particularly surprised to find no remotely adequate study of gang graffiti, even though they pose obvious linguistic (and semiotic) challenges, and most studies of gangs mention graffiti in passing. The Evanston, Illinois, police had more to tell me than did academic sociologists and anthropologists.

In short, I found no precedent for the work I was engaged in. I was much slower than I ought to have been to realize that the graffiti functioned as a language—not just as a generic sign system, but as a real language—and it took me even longer to understand the connection between modern Soviet graffiti and subculture. Those central findings seem obvious in retrospect, but the first steps were difficult. If some critical

theorist wishes to rework these raw materials into a higher and more consistent theory, I will be delighted.

This is a study chiefly of graffiti in Moscow and, unless otherwise indicated, examples come from the walls of that city. I occasionally draw on graffiti gathered in Leningrad in 1984 and 1988; for certain topics Leningrad graffiti are quite important. I also collected graffiti in Minsk in both 1984 and 1988, Kiev in 1984, and Smolensk in 1988. What I learned about graffiti outside Moscow supports a strong supposition that the social and cultural processes that have given birth to adolescent graffiti are much the same in all cities in the European part of the Soviet Union. Nevertheless, unless stated specifically to be of general application, all the conclusions I offer should be understood to refer principally to Moscow.

Many people read early chapter drafts and sketches, and I am grateful for their suggestions. They include Kristine Bushnell, who comes first alphabetically and in every way, Ben Eklof, Tom Hedden, Vladimir Padunov, Nadya Peterson, Anesa and Tim Pogacher, Don Raleigh, Alfred Senn, and Richard Stites. I am indebted to David Sloane, who let me read his article on Soviet rock music while it was still in manuscript. Adele Barker, Kelly Cronin, Robert Edelman, Nancy Friedman, Louise McReynolds, and Don Raleigh shared pictures of Soviet graffiti. Officer Ric Worshill of the Evanston Police Department explained the basic characters in Chicago gang graffiti, and I am grateful to him for taking the time to do so. I am especially indebted to Susan Costanzo, who spent the summer of 1988 in Leningrad and took hundreds of pictures and notes on graffiti for me there, and in Riga. And I thank the International Research and Exchanges Board and Northwestern University for providing grants that enabled me to collect graffiti in the Soviet Union in September-October 1988.

MOSCOW
GRAFFITI

Two Russian Traditions: Devotional and Children's Graffiti

In the chapel he wrote his name:
A strong and mighty hero passed this way
Ilya Muromets, son of Ivan.
 (from a Russian folk epic)

GRAFFITI AT THE ORIGINS OF RUSSIAN HISTORY

In the beginning was the graffito, at least in the state that centered on Kiev in the land then called Rus. Emerging toward the end of the tenth century along the river trade routes between the Baltic and Black seas, Rus was the ancestor at several removes of the later Muscovite Russian state and of the Soviet state today. It was Kievan Rus that created what would later develop into Russian and, along branching lines, Ukrainian and Belorussian cultures. Kiev nurtured the folk epics, the written language, the Orthodox church, and the graffiti that became a part of the Russian heritage after the Kievan state broke up in the thirteenth century. State, church, writing, and graffiti were all born together. The folk epic witnessed their common birth.

Civilization and graffiti are inextricably intertwined, but societies do not everywhere produce identical graffiti. In the original Italian, *graffiti* meant the "scratchings" or writing incised on objects. Such scratchings were omnipresent on the

clay vessels and dishes of the classical world. They marked ownership, authorship, or contents, or proclaimed the god to whom a particular offering was dedicated. Among the objects produced in tenth- to thirteenth-century Rus, that sort of graffiti is noteworthy chiefly by its absence. Some shards do display scratched marks, but only a handful have even fragments of true inscriptions. Remnants of no more than a dozen amphorae have been found with labels and dedications. One discovered in what appears to have been a merchant's yard as far north as Beloozero is inscribed "Oil," probably meaning olive oil shipped north from the Black Sea. Another, found at the site of medieval Riazan, announces "New wine Dobrilo sent to Prince Bogunka." And there are a few others.[1] But these attract archaeological attention chiefly because they are so rare. Evidently, the inhabitants of Rus seldom felt the need to scratch words on their clay pots and vessels. A few of the wooden objects found in excavations at Novgorod and other medieval Rus cities reveal owners' marks, and sometimes owners' names, but again the proportion with inscriptions of this or any other kind is unimpressive.[2]

The most intriguing of the inscribed objects from the Kievan age are small, doughnut-shaped slate weights that women slipped on their spindles. Thousands of these have been found, among them some with incised patterns and pictures (of animals, for instance), a few with the name of the owner ("Natasha's weight") or invocations ("Lord, aid thy slave"). One is touchingly inscribed, "Ivanko made this for you, his only daughter." These particular graffiti are of historical and ethnographic as well as linguistic interest, because they provide some evidence for female literacy, and suggest social occasions and games in which establishing personal ownership of the humble weights might be important.[3] Even counting these spinning weights, however, the total number of inscribed objects dating from the Kievan era is small.

Yet the inhabitants of Kievan cities were energetic producers of the other species of graffiti, the informal verbal or pictorial statements scratched on public walls. Admittedly, not many Kievan walls remain to yield their bounty of bons mots. Only exceptional circumstances can preserve graffiti for a millenium, and the disasters that befell the wooden cities of medieval

Rus—unlike the disaster that overtook Pompeii—were of the graffiti-destroying rather than graffiti-preserving kind. Raiding or conquering horsemen from the southern steppe put cities to the torch, and accidental fires repeatedly devastated cities that the horsemen spared. Nevertheless, the few surviving public walls show that medieval Kievans had an irrepressible urge to scratch words and pictures.

In Kiev itself, some caves whose entrances were obliterated during nomad raids preserved their ancient aspect. As Christianity infiltrated Kiev during the tenth century, and as Kiev then became the capital of a state, religious men turned natural caves in the city's vicinity into hermitages, and then expanded them into monasteries. The most famous of all Russian Orthodox monasteries is Kiev's Cave Monastery, which grew into a labyrinth of cells, chapels, public rooms, and passage ways. But early in Kiev's history there were other small cave monasteries, some not rediscovered until the nineteenth and twentieth centuries. Kievan-era graffiti—names, in one case a list of fathers superior, crosses, and invocations, carved into the walls or traced in soot on the ceilings—have been found in all of them.[4] Presumably the cave monasteries were accessible only to the religious orders that used them, and the graffiti were for the most part devotional. Still, these men produced graffiti that their own public could see; the character of the graffiti simply reflected their interests.

Most of the other walls that have survived from the Kievan era were by-products of the formation of the Kievan state, and the graffiti that accumulated on them were a heretofore unremarked consequence of state formation. The adoption of Orthodox Christianity as the state religion in 988 was a key ingredient in the creation of a state, because the Orthodox church brought to Kiev a written Slavic language that had been fashioned in the Balkans for earlier Slav converts to Orthodoxy. The church also provided clergy literate in Slavic, and made literacy possible among the laity. There could have been only the most rudimentary graffiti in pre-Christian, preliterate Kiev. But once the possibility existed, Kievans immediately set to writing on walls. We know that, because graffiti quickly appeared on the new and longer-lasting walls that the state religion provided in the form of masonry churches. Hundreds

of eleventh- to thirteenth-century graffiti have been found in the cathedrals of St. Sophia in Kiev (construction began in either 1017 or 1037) and Novgorod (begun in 1045), the oldest surviving buildings from the Kievan era. Considering that little of the original plaster is left, the number of graffiti recovered is remarkable. And the two principal cathedrals are not exceptional. Other medieval churches, or their ruins, also yield graffiti, thousands of them.[5]

There was a direct link between the adoption of Christianity and the production of graffiti, but there is no a priori reason to believe that the lay graffiti-writers of medieval Rus exhibited any particular favoritism toward church walls. A few graffiti have been found on the ruins of medieval Kiev's main city gate—the Golden Gate, so called because of the gilded cupolas on the church above the gate—and on a surviving twelfth-century portion of the Golden Gate of the city of Vladimir in North Central Russia. When in 1984 archaeologists discovered the foundations of a twelfth-century refectory in Kiev's Cave Monastery, they also discovered bits of plaster from its interior walls with traces of graffiti on them.[6] These few surviving fragments of masonry civil structures—of which there were not many in the first place—suggest that the inhabitants of medieval Rus scratched their graffiti on any accessible wall, be it civil or religious or somewhere in between. The log walls and fences of most secular buildings may not have presented so conveniently flat and smooth a surface as the plastered walls of churches, but on the other hand all medieval graffiti were literally scratched in, and wood offered a softer and in that way more inviting surface than plaster. We cannot know how frequently the inhabitants of medieval Kiev, Novgorod, Vladimir, and other cities wrote on their wooden walls. The only certain knowledge we have is that they wrote on walls other than those of churches. But for that reason alone we should reject the assumption that the abundant graffiti that have survived on churches provide a representative sample of the graffiti produced in medieval Rus.

The graffiti in the churches are in the great majority devotional, but otherwise they are extraordinarily varied. There are hundreds of invocations, memorial inscriptions, brief prayers, and crosses. But there are also maledictions: in

the ruins of a twelfth-century Smolensk church, an appeal for divine assistance against "hostile fathers superior and Klimiata," who were persecuting an unnamed monastery (or church—the "Great House" of the graffito may refer to either); some time in the thirteenth century "Ostapko a man of God" scratched into the wall of St. Clement's church in Kiev praise for the church raiment, a request for wealth, and a plea that God "invest the enemy priests with fever."[7] Some who came to church merely inscribed their names ("Ivan wrote this," a formula that changed to "Ivan was here" toward the sixteenth century). Others identified themselves as priests, sextons, pilgrims, warriors, royal officials, and merchants. A few members of the princely family wrote on the walls of Kiev's St. Sophia. Under the inscription "Lord, help thy slave Olisava, Sviatopolk's mother a Russian princess," located in the section of the choir where the women of the royal family stood, and probably written by Olisava herself in the early twelfth century, is another graffito in another hand, "And this was added by Sviatopolk's sons."[8] A graffito in the same church records that lightning struck at 9 a.m. on March 3, 1052, while in Novgorod's St. Sophia a graffito reports that on the fifth Sunday after Easter snow fell so heavily that it reached the knees.[9] One visitor to Kiev's St. Sophia lamented that "I drank away my clothes while I was here."[10] Church walls in the thoroughly commercial city of Novgorod provided space to record business deals, while drawings appeared in churches everywhere. Parishioners drew not just crosses, but also pictures of horses, birds, leopards, monks, warriors, fingers raised in blessing, and entire battle scenes.[11]

Kiev's Cathedral of St. Sophia was the principal church in the land, the place of interment for Kievan rulers, and many of its graffiti are historically significant. For instance, a graffito that can date from no earlier than the late eleventh century refers to the ruler of Kiev as "kagan," the title of the rulers of Turkic nomad federations. There are a few references in written sources to the Prince of Kiev as kagan, but none so late as this; steppe political culture evidently had a deeper and more lasting impact on the emerging Kievan state than is usually admitted. Because of the cathedral's political signifi-cance, it was apparently felt to be appropriate to use its walls to

record important events; a lengthy graffito reports a peace treaty, not mentioned in the chronicles, among feuding princes. A very long mid-twelfth-century graffito records the purchase of "Boyan's Land" by a Princess Vsevolodova. The Boyan of the eponym may be the otherwise unknown bard Boyan invoked in the Kievan epic "Lay of Igor's Host." And one graffito—"Lord, help thy slave Stavrov"—may have been written by Stavr Godinovich, who as the hero of a folk epic was immured by a Prince Vladimir until freed through the wiles of his equally heroic wife. Next to that, a second graffito in a different hand attests to the importance of the first: "Stavr Gorodiatinich wrote this."[12]

Most graffiti in the churches are devotional, but the people of medieval Rus did not hesitate to express secular concerns and images on church walls. The very few Kievan-era secular walls still standing show that the opposite was true as well: most of their graffiti seem to have been secular, but religious inscriptions appeared among them. The graffiti found on the Golden Gate of the city of Vladimir consist entirely of crosses, except for the mysterious name "Giurgich" (probably a variation or corruption of "Georgievich"), but all of these are at or adjacent to the platform on which the city's warriors stood to fight; it was certainly appropriate for them to evoke God's aid.[13] In Kiev, only a small portion of the bottom of the Golden Gate is left, and only a pathetic few fragments of plaster, dating from the eleventh and twelfth centuries, adhere to the ruins. But even those fragments afford us a positively startling glimpse of the Kievan urban world. There are a few perfectly ordinary crosses and invocations, and a few isolated names. But the Golden Gate graffiti also include a partial drawing of a bident; a picture of a centaur; a figure in profile, apparently of a monk in cowl waving a sword; a three-figure drawing of a boar hunt (trapped boar, chained dog barking, man with a spear), apparently copied from a church fresco; and a crude picture of a horse, captioned "Oskom's horse."[14]

Adult and child, eleventh- and twelfth-century Kievans must have been energetic scratchers of graffiti if the traces of plaster from the Golden Gate yield so many. The gate and other city walls must at one time have sported a dense thicket of crosses, names, animals, and mythical beasts. Even the few

that remain give us some feel for the interests and imagination of those who passed through the gate. It is at least of some cultural interest that elements of classical civilization represented by the centaur and brought to Kiev by the Christian bookmen of Constantinople had percolated out to Kiev's graffiti writers.

The graffiti at Kiev's Golden Gate can only tantalize us: they confirm that the people of medieval Rus produced much graffiti on buildings other than churches, suggest that graffiti on civil structures were overwhelmingly secular but did include some devotional items, but permit no other conclusions. The abundance of graffiti even in the churches—in many cases on plaster fragments from churches that have lain in ruins for centuries—tell us that, young and old, at least the urbanites of Kievan Rus had the graffiti-writing habit. And when they went traveling they took the habit with them. Slavic graffiti appear in the Cathedral of St. Sophia in Constantinople. No doubt Slavs from the Balkans contributed many, but others exhibit the lexical forms of Northern Russia, and one names a city important in the Kievan era: "Matfei priest of Galich."[15] Slavic graffiti predating 1238 are found as far west as the Cathedral of San Martino in Lucca, Italy. They include "A deacon from Murom wrote this."[16] Thus it is perfectly natural that Ilya Muromets—Ilya of Murom, the hero of many a folk epic—should be credited with inscribing in a chapel: "A strong and mighty hero passed this way, Ilya Muromets, son of Ivan."[17]

THE FOLK TRADITION OF DEVOTIONAL GRAFFITI

Scratching graffiti on church walls was an important facet of Kievan religious practice. Religious inscriptions must have been only one of a number of kinds of graffiti in Kievan Rus, but the great mass of graffiti that have survived in churches, and their formulaic character, leave no doubt that for many people producing devotional graffiti was an act of worship. This practice, which originated at the dawn of Christianity in

Rus, has persisted to the present day. But what was initially an exercise in devotion in which all strata of society shared became over time a folk custom, and one that the clergy actively but unavailingly combatted.

Even in the Kievan period, scratching messages on church walls was so characteristic an activity that the church undertook to regulate the practice. It did so by issuing a misleading, blanket proscription. Many redactions of the "Statute of Vladimir Sviatoslavich" (the Kievan equivalent of the Donation of Constantine), which was probably compiled during the twelfth century and which defined the prerogatives of the church, listed "carving on [church] walls" among the offenses the church punished. This provision came just after "cutting down crosses," and immediately before "bringing cattle or dogs or birds or anything similar into a church without great need."[18] From the context we may infer that Kievan sacred law held the scratching of graffiti on church walls to be an act of desecration; it defiled a holy place. However, since many priests signed their office when they inscribed graffiti in churches, that article must have been either wholly inconsistent with Kievan religious sensibilities or directed only against particular kinds of graffiti. Probably the authors of the statute meant to outlaw only some kinds of secular graffiti.

Church walls do in fact show evidence of censorship. Many graffiti in Kiev's St. Sophia were completely obliterated. In Novgorod's St. Sophia, however, some censored inscriptions are still legible, and offer a partial view of the kind of graffiti that priests found particularly offensive. One censored item is a proverb, "the young warriors sit in the boat like pancakes on a griddle." Located directly under that is another, also crossed out, which appears to be from a folk ditty: "The quail sails in the grove, set out porridge, set out pancakes, go there." Whoever defaced those graffiti left his own: "May your hands wither."[19] Perhaps the folkloric character of the graffiti elicited the hostile response. There were, after all, many other secular graffiti that might have aroused the censor's wrath, but did not. Priests in Novgorod must have understood that such items as business contracts were inscribed on church walls because the parties to them believed the sacred premises sanctified the bargain. The twelfth-century proverbs and

ditties, on the other hand, smacked of the paganism that the church was still combatting.

Church authorities apparently never objected to the devotional graffiti that Kievan-era worshipers so frequently inscribed. Most of the purely religious graffiti came in one of three forms: prayerful applications for divine assistance, memorial notices, and crosses. Invocations ranged from the simple "Oh God, aid thy slave Nestor," to more elaborate statements of sinfulness: "Oh God, aid me, a sinner, thy unworthy slave, lead me away from eternal torment, save me from [illegible] and misfortune"; "Lord, forgive me, thy sinful slave Stefan, more sinful than all men in word and deed and thought." A slight variant was "Vlas wrote this, wretched and rich in sin." Other invocations admitted sin but pleaded extenuating circumstances: "Lord, aid thy slave Andrei, rich in sin and good deeds."[20] Memorial graffiti were somewhat less common than petitions, but still frequent. They noted only the day and month of death: "Lazar slave of God died in the month of June on the 9th day." The intent, obviously, was that Lazar be covered by the memorial prayers said on June 9; the year of death was irrelevant to the effectiveness of the supplication.[21]

The most frequent of all graffiti were crosses. These came plain and simple; or "on Golgotha," a cross set on top of a small semicircle; or flowering, with elaborate and often inter-woven extensions of the arms; or monogrammed, with the initials for Jesus Christ, abbreviations of "God, aid," or the letters NIKA, Greek for victory and signifying Christ's triumph over death.[22] Many of these crosses were certainly the work of illiterates, who meant them to invoke God's aid in the same way as a written request. Characteristically, women worshipers on their side, the north, of Kiev's St. Sophia inscribed mostly crosses; men, on the south side, produced most of the actual writing.[23] Naturally, many illiterate men must also have scratched crosses into church walls as they asked their God for help.

These graffiti did more than testify to religious belief, they were acts of worship, intended to put the writer in communion with the God in whose temple they were written. Of course, we have no contemporary account of the meaning the graffiti

held for Kievan Christians. However, the Kievan practice of scratching devotional graffiti on church walls has a variety of analogues and near analogues that make their intent clear. For instance, inscribing crosses—monogrammed crosses in particular—recalls the habit of inscribing initials on offertory plates left in pre-Christian Greek temples. The meaning of the initials could easily be lost, and they could be taken as a magical sign.[24] To leap from the ancient to the nearly modern, the way in which Russian peasants in the last century, and the centuries before that, incessantly and superstitiously made the sign of the cross to ward off evil suggests how the cross as graffito could be understood as a magic charm whose mere inscription—especially in a holy place—could produce an effect.

The highly standardized formulae employed in supplicatory and memorial graffiti lend these, too, the quality of magical charms. Even in the Christian Byzantium that was contemporary to Kievan Rus, religious inscriptions were thought to have magical properties. For example, the *Geoponika*, a tenth-century Byzantine agricultural encyclopedia, advised: "Wine will not sour if you write on the vessel or jar the divine words. Taste and you will see that the Lord is good."[25] The only reason to inscribe invocations and memorial graffiti on church walls was the belief that they would have some effect, that God—not other worshipers, not priests—would heed them. Even such apparently secular graffiti as "Ivan wrote this" may have been meant to secure God's favor by attaching personal name to sacred temple.

One almost necessarily concludes from the frequency of devotional graffiti, and from the fact that churchmen as well as laity contributed, that medieval Rus worshipers believed that inscribing a graffito on a church wall would secure devine assistance. The distribution of the inscriptions supports that conclusion. Inside the churches, the surviving graffiti tend to cluster around frescoes of saints, who are themselves sometimes named in the graffiti. Here, surely, is evidence that Kievan Christians believed adding a graffito to a saint's image strengthened an appeal for the saint's intercession. Outside the church, anonymous crosses clustered around the portals, where the anticipation of the mysterious power that lay within must have been strongest, and perhaps also (the archaeo-

logical record on this point is fragmentary) on the apses of the sanctuary, the most sacred portion of the church.[26] Kievan worshipers' faith in devotional graffiti conforms to what we know about popular conceptions of religion in other medieval, and in convert, societies.[27] Kiev was both of those.

Nevertheless, Kievan devotional graffiti were not just the by-product of a primitive, still largely pagan approach to religion. In point of fact, the writing of devotional graffiti was a part of the religious tradition that Greek priests brought with them to Kiev in the tenth century. Worshipers in Byzantine churches wrote formulaic graffiti of the same type as appeared in medieval Rus, and the custom of writing devotional (and other) graffiti had developed in Bulgaria—an earlier Slav convert to Byzantine Christianity—before it reached Kiev.[28] Devotional graffiti were part of popular religious practice throughout the Byzantine cultural sphere. Whether the Greek bookmen who brought Christianity to Kiev taught that properly inscribed holy words and crosses could protect more than wine, and whether they set a practical example of graffiti writing, or whether, on the contrary, travelers from Rus learned about the practice in Bulgaria and Constantinople, the fact that devotional graffiti were a part of the religious tradition imported into Kiev explains why the practice took hold in Kievan Rus so quickly and so widely. The sensibilities of the newly Christianized Slavs provided fertile soil for the spread of devotional graffiti, but the seed was Byzantine.

Devotional graffiti must have been related to other features of popular religious practice, but an almost insurmountable obstacle stands in the way of further exploration of the subject: the only evidence of popular religious practice in the Kievan era inheres in the graffiti themselves. The surviving church statutes, sermons, and other sources tell us something about the ideas of the newly minted Kievan bookmen, and about the pagan practices that the church sought to uproot, but little about the new laity's religious observances. Nevertheless, we may posit a connection between devotional graffiti and the popular veneration of icons, also a practice common through-out the Byzantine religious sphere. By the time Christianity reached Kiev, Byzantine theologians had evolved an elaborate doctrine to cover the veneration of icons, but the popular

practice in Kievan Rus cannot have been much different from that among the common folk in Russia centuries later. In the nineteenth century, ordinary worshipers appealed to the saint who was depicted in the icon, but they also revered the icon itself and expected that the proper devotions to it would ensure God's blessing and aid. Icons, in short, were commonly understood to be magical objects that could work wonders, and Russia was full of popularly attested wonder-working icons.[29] If the same was true in Kiev (and it is hard to imagine how else the newly converted might have made sense of the icons), then the veneration of icons and the inscription of devotional graffiti were closely related and mutually supporting practices. Worshipers believed that they could put their God to work for them by venerating holy pictures and inscribing devotional formulae on holy walls.

Devotional graffiti were widespread in medieval Rus; of that we can be certain, because so many have survived even under extremely adverse circumstances. We can be almost as certain that the inscription of these graffiti was a firmly established part of popular religious practice, and that they were believed to add substantially to the force of worshipers' requests for divine succor. Finally, we can presume with a reasonable degree of probability that the writing of devotional graffiti was firmly embedded in a complex of popular religious beliefs, and was closely associated with devotions before icons. Indeed, Kievan worshipers linked the two customs when they inscribed their graffiti on or below the iconic representations of saints in church frescoes.

The very strength of the custom poses a problem of sorts: What happened to it? No one has ever suggested that writing graffiti in holy places has been part of the devotional practice of the Russian Orthodox church, but there is no evident reason the custom would have died out. There is in fact an easily documented contemporary tradition of devotional graffiti, but precious little to fill in the gap between the fourteenth and twentieth centuries. What little direct evidence there is from those centuries can—with a small infusion of speculation—sustain the supposition that the practice of writing devotional graffiti in and on churches has lasted without a break from the tenth to the twentieth century, but there is no conclusive proof that this is so.

Without question, the number of extant graffiti declines rapidly after the twelfth century. In the city of Kiev, the count is as follows: 45 graffiti from the eleventh century, 124 from the twelfth century, 91 from the thirteenth and fourteenth centuries together, and 55 from the fifteenth through the seventeenth centuries. The latter group includes an exceptional set of 24 Armenian graffiti in the Cathedral of St. Sophia. Absent those Armenian inscriptions, there are scarcely any that date from after the fourteenth century. There are Russian, Ukrainian, and Polish tourist graffiti (name and date of pilgrimage) at the Cave Monastery from the first quarter of the seventeenth century, but the caves were closed to visitors in 1625.[30] The decline in the number of dated graffiti in Novgorod's St. Sophia is even more precipitous: 192 graffiti from the eleventh and the first half of the twelfth century, 26 from the second half of the twelfth and the first half of the thirteenth century (and a group of 19 that date from some time between the eleventh and twelfth centuries), 16 from some-time in the thirteenth and fourteenth centuries. No graffiti have been found that date from the fifteenth or later centuries.[31] There are some churches, in Novgorod and elsewhere, with graffiti, in a few cases rather abundant graffiti, from the fifteenth century and later.[32] Yet the fact remains that the number of extant devotional graffiti dating from after the twelfth century declines rapidly, and shrinks practically to nothing after the fourteenth century.

Sergei Vysotskii, the leading Soviet specialist on the early graffiti in the city of Kiev, points out that the ill fortune that befell Kievan Rus in the thirteenth century—the Mongol invasion, the destruction of many cities and churches, the temporary regression of economic and social life—appears to be one explanation for the decline of recoverable graffiti. He also observes that the state of preservation of plaster has much to do with recovery: plaster at the height at which worshipers inscribed graffiti was the most likely to deteriorate and need replacement.[33] Indeed, it is noteworthy that when graffiti were discovered in Novgorod's St. Sophia in the late nine-teenth century, they were found on walls below the level of the nineteenth-century floor: the succession of floors had fortuitously conserved the graffiti. What happened next must

have happened over many centuries in many churches: the graffiti discovered in the course of renovation were covered over by new plaster, and many of them have not been found since.[34] It is, of course, an open question whether the pattern of wear and destruction, the replacement and renovation of plaster and frescoes, and the changing level of floors should favor the preservation of earlier or later graffiti. Vysotskii, in any case, concludes that the downward curve of datable graffiti that have been recovered reflects reasonably accurately a declining propensity to inscribe devotional and other graffiti in churches.[35]

Probably Vysotskii is correct, but only in a narrowly technical sense: as the scratching of words and pictures into plaster declined, writing by other means most likely increased. Here it is helpful to know something about changes in the media and implements for writing. One reason for the abundance of graffiti in medieval Rus churches was that the most common manner of writing was to scratch letters into birch bark. From the first find in 1951 to 1985, archaeologists discovered roughly 650 birch-bark letters and documents in Novgorod. Birch-bark letters have also been found, albeit in far smaller quantities, in seven other cities. The bustling commercial city of Novgorod may have had a higher literacy rate than other medieval cities—birch-bark letters were so common in Novgorod that they literally crunched underfoot as people walked the streets—but the particular soil conditions, and the luck of the dig, are the more likely reasons for the disproportionate number of documents found there. In any event, the citizens of Novgorod carried their sharp-pointed writing implements, their *stili* of iron, bronze, or bone, at their belts, sometimes in leather cases, always handy for scratching personal letters or business messages on bark. Or graffiti on church walls. The same *stili* and cases have been found in digs from all over medieval Rus, even in cities such as Kiev, where no birch-bark documents have been found. The find of a *stilus* necessarily implies the use of birch-bark letters, for those and the wax tablets used for instruction were all that they were good for—unless we are to suppose that *stili* were produced specifically for the inscription of graffiti.[36]

Paper gradually replaced birch bark for everyday use, and

ink replaced the incision of letters. For a time after it appeared in the fourteenth century, paper was too expensive to be common, but by the early sixteenth century use of birch bark was considered a token of saintly frugality. Archaeologists have found no birch-bark documents at Novgorod more recent than the fifteenth century, nor have any *stili* been found anywhere in Russia that date from after the fifteenth century. When birch bark was used after the fifteenth century, the writing was in ink. A few birch-bark manuscripts of the seventeenth-nineteenth centuries were produced by schismatics living on the outskirts of civilization, for instance.[37] As the centuries passed and quill and ink became the ordinary tools of writing, the likelihood that graffiti would be preserved and later recovered naturally declined. When by the sixteenth century worshipers no longer wore incising instruments at their belts, they could not routinely scratch crosses and prayers into church walls. Whatever else they might have had at hand to make marks on the surface would have been far more likely to produce graffiti that would fade with time, or be easily washed away.

Unusual circumstances did result in the preservation of a few graffiti—in the modern sense of writing rather than scratching—from the late seventeenth century. During the Northern War between Sweden and Russia, Peter the Great in 1701 ordered the construction of new earthen defensive works at Pskov, a city near what was then Russia's border with the German duchies in the eastern Baltic. When the ruins were excavated in 1972, graffiti were discovered, both the old scratched-in kind and words written with charcoal.[38] Had these churches not been filled in, the charcoal would long ago have disappeared. Unfortunately, the brief archaeological report provides no information on the character of the graffiti, not even whether they were devotional or secular. But at least we know that charcoal was used to write on church walls. We can confidently conclude that the chronological distribution of datable graffiti that have been preserved does *not* accurately measure the propensity to write on church walls. Whether inscriptions in charcoal and other transitory media fully compensated for the decline of scratched-in graffiti is an unanswerable question. There is certainly no reason to rule out the possibility.

There appears to be no positive confirmation that anyone inscribed a prayer or a cross in a church anywhere in Russia between the late seventeenth century and the very recent past. On the other hand, Orthodox believers now living report occasional sightings of devotional graffiti, usually on active churches that have been partially boarded up for repairs. The reason for that curious locational bias appears to be that priests police their churches, thwarting most efforts to write graffiti and quickly effacing those graffiti that do appear. Occasionally there are angry scenes when a priest catches a graffiti writer in the act. But it must be admitted that such occurrences are infrequent, and most churches today are free of graffiti.

But there is at least one important exception, the Chapel of the Blessed Ksenia in Leningrad's Smolensk Cemetery. According to legend, Ksenia was an eighteenth-century resident of St. Petersburg (as Leningrad was then known) whose life in some ways resembled that of modern street people, and who was believed to have the gift of prophecy. A woman of good birth widowed young, she gave away all of her possessions, lived on the streets, prayed all night, and was credited with prophesying the deaths of important persons and the end of domestic difficulties that troubled people whom she knew. At some point after her death (whether immediately or much later is not clear) her grave attracted pilgrims, and a chapel was built. People told tales of miracles, most of them cures and the alleviation of domestic troubles (drying out drunken husbands, preventing bad marriages), that she had wrought from beyond the grave.[39]

Popular belief in Ksenia's intercessory powers was so strong that pilgrims continued to make their way to the chapel in the decades after the 1917 revolution. In 1962, a Soviet anti-religious writer reported in disgust that pilgrims were leaving stacks of notes on her tomb: "Blessed Ksenia, help my husband so he stops drinking vodka, he's a complete drunkard. I ask you fervently, Ksenia, help"; "Dear Blessed Ksenia, help me pass geography"; and the like.[40] He urged that the chapel be closed, and it was. However, the workers assigned to the workshop into which the chapel was converted claimed to hear funeral dirges, and abandoned the premises. The chapel was boarded up and fenced around.

But pilgrims continued to visit, and they now wrote their messages on the fence: "Blessed Ksenia, please help me, a sinner, excel in work and love"; "Blessed Ksenia, please help me marry Maikov"; "Help me finish fifth grade"; and thousands more in the same spirit. Finally, the chapel was rededicated to its original purpose in 1987.[41] But visitors continued to scratch their requests on the massive iron window shutters, on the copper downspouts, and on the cement foundation. Those legible in the summer of 1988, after Ksenia had been canonized by the Orthodox church, included: "Saint Ksenia, help me return my beloved. Iulia"; "Saint Ksenia, give my daughter Tatiana health, and help Tatiana marry a good man"; "Ksenia, save me from all demonic forces"; "Blessed Ksenia, preserve our family"; "Saint Kseniushka, help Ania pass her exams. Ania, Olia." And there were many more asking Ksenia to intercede for the health of family members, or to keep families together. Worshipers also continued to stick notes in cracks, and to leave notes for Ksenia inside the chapel. In 1988 the iron shutters were periodically painted over, but there did not seem to be any serious attempt to prevent pilgrims from scratching or writing their supplications on the church.[42]

These graffiti appealing for Ksenia's intercession are in form and content twentieth-century equivalents of many of the devotional graffiti in eleventh-century Kiev and Novgorod. Whether there is a genetic connection is another question, and there is no evidence that bears directly on it. Actual graffiti at the Chapel of the Blessed Ksenia are attested to only in the years after the chapel was temporarily closed. Throughout, however, pilgrims certainly believed that leaving notes or writing their requests on the church reenforced their prayers for intercession. We can speculate, plausibly, that the custom of leaving notes at holy places was an extension of the original practice of inscribing devotional graffiti, and that the reversion to graffiti when Ksenia's tomb became inaccessible was an unconscious return to origins. But pilgrims may have been writing graffiti all along. We do not know, but it seems entirely likely.

All things considered, Russian Orthodox Christians probably wrote devotional graffiti in churches during the

eighteenth and nineteenth centuries, a period from which written records of that activity appear to be entirely lacking. It is not particularly surprising that the educated elite who report such things would either not notice or not think worth remarking the humble folk custom of inscribing prayers on church walls. There are no written reports of the writing of graffiti in churches in the centuries before that either, except for the one proscription in the Statute of Vladimir Sviatoslavich. All we have are the graffiti themselves. But unless something like that custom had continued after the thirteenth century, and into the eighteenth and nineteenth centuries, it would be difficult to explain why, given the right set of circumstances, devotional graffiti appear in Orthodox churches even today.

CHILDREN'S GRAFFITI

Children write lower on walls than adults do; their arms do not reach so high, their thoughts do not stretch to the Almighty. Devotional graffiti have deep meaning for their authors; children's scribbles are passing whims. Inscriptions in churches illuminate a mental world; children's chalk drawings reveal only childish impulses. Yet it is worth reflecting on what Russian children write, not because their graffiti contain any naive wisdom but because they are so busy at the writing.

The young have always been among the producers of graffiti. A child, probably Oskom himself, scratched the eleventh-century picture of "Oskom's horse" on Kiev's Golden Gate. Children must have drawn many of the animals in the cathedrals of St. Sophia in Kiev and Novgorod, too. On the walls of Novgorod's fourteenth-century parish churches are drawings at a height at which only children could have worked comfortably. In the Church of Theodore the Stratilate, a graffito from the late fourteenth or early fifteenth century, "I go like a beaver beside the river" (*poidu bobrom vozle reki*—a riddle? a ditty?), written over and over on the walls of the choir and the stairwell, smacks strongly of child's play.[43]

There is no reason at all to doubt that the chalk drawings of flowers, animals, people, houses, and the like that are now found in Moscow courtyards where children play are just the latest installment of pictures that children in that part of the world have been drawing on walls for a millenium and more, and the childish urge to repeat the same phrase over and over—"I go like a beaver"—has many modern examples. In Moscow in the 1980s one could find "Mama made jam" written repetitively on the side of a metal garage; or "Mama loves Lena" repeated all around the periphery of a courtyard, as though Lena had been reassuring herself and practicing her chalkmanship at the same time. The last graffito may be taken as representative of the gender origins of childish graffiti, as well: to the extent that they contain clues, the great majority of chalk graffiti point to little girls as their authors. But boys also write a lot.

Soviet children produce all of the kinds of graffiti that one would expect. Name calling (in which boys appear to be the specialists) is quite common: "Sasha's a dolt" (*Sasha durak*); "Vania's a refugee from the loony bin" (*Vania bezhenets iz psikhdoma*); "Sysoev's a loony, a dolt, and a goat" (*Sysoev psikh i durak i kozel*); someone, name obliterated, "is a fat-bellied hippo swollen with lard" (*begmot puzatyi, kotoryi zaplyl zhirom*). "Sasha ⅌" should be read "Sasha's a dirty fascist" (as Nazis are called in the Soviet Union). Almost as common are declarations of preadolescent friendship and love: "M.F. + I.D. = Friends" is the formula for friendship, "Alesha + Marina = Love" the equation for love. The warrant for attributing these graffiti to children rather than adolescents is the use of chalk, the child's writing implement. A chalk assertion of love is in fact as likely to be a tease as a confession; Alesha has not—yet—crossed out his name, but analogous graffiti are partially obliterated all over Moscow. The same graffito carved into wood or plaster, or painted, is a frank declaration by a teenager. And everywhere in Moscow and other cities are arrows and long chalk lines, by-products of the game of "cossacks and brigands," in which the brigands leave clues for the cossacks, who must chase them down. "Cowboys and Indians" may not involve a similar use of chalk, but most of the kinds of graffiti that Russian children produce are familiar from other societies.

What is somewhat surprising is the extremely young age at which Russian children begin writing on walls. Actually, they begin with sidewalks and pavement even before they can reach the walls, even before they can really walk. In Moscow, Leningrad, and other cities, mothers give their children pieces of chalk as pacifying toys to play with outside. In parks and courtyards set in the midst of apartment blocks, mothers sit on benches reading or talking while toddlers scribble on the walk. Kindergartners draw pictures on walks and walls, grade schoolers add elaborate designs and words. The urge—programmed in the genes, surely—that impels very young children to mark up walls has a sanctioned outlet in Moscow. No one much objects to the scribbling, no one even notices when the child begins to turn her hand to real graffiti. The chalk marks, after all, do not last long. But the fact remains that Soviet children, at least in the cities, are allowed—encouraged!—from the time they can clutch a piece of chalk in their fingers to enter upon a graffiti-writing career.

Soviet children are also unusual, or so appears to be the case, in the frequency with which they devote their graffiti to schoolwork, mathematical tables especially. Wandering through courtyards in fall or spring, one often comes across columns of numbers. For instance:

$$
\begin{aligned}
1 + 1 &= 2 & 1 - 1 &= 0 \\
2 + 2 &= 4 & 2 - 2 &= 0 \\
3 + 3 &= 6 & 3 - 3 &= 0 \\
4 + 4 &= 8 & 4 - 4 &= 0 \\
5 + 5 &= 10 & 5 - 5 &= 0 \\
10 + 10 &= 10 & 10 - 10 &= 0 \\
10 + 10 &= 20 &&
\end{aligned}
$$

This would appear to be an imperfectly executed school exercise, written out on the wall to demonstrate and ensure mastery. Products are less common than sums (the need to exercise on the wall must diminish with age) and are usually written as homework sets rather than as tables. One such graffito from the spring of 1984 read (in translation):

$$1 \text{ April}$$
$$\text{homework}$$

$3 \times 8 =$	$7 \times 9 = 73$
$9 \times 5 = 45$	$8 \times 3 =$

One occasionally stumbles upon foreign-language vocabulary lists, too, as for instance:

stol = table
galstuk = tie
student = student
uchenik = pupil
5 = fave
litso = fase

Doing schoolwork on the courtyard wall provides no guarantee against mistakes in either arithmetic or language.

The origins of this custom are obscure, but adults report that Soviet children have been doing schoolwork on walls and fences for a long time, at least since the years immediately after the Second World War. It may be that shortages of paper and notebooks, and of proper blackboards, in those years of ruin and poverty drove the children to it, but then they may have been writing sums on walls before the war, too; popular lore is vague on that point. Or it may be that, since they have been growing up writing on courtyard walls, children have always added to their repertoire whatever they learn at school, without particularly thinking of it as schoolwork. Scratched into the walls of churches in Novgorod, at the height at which children would work, are alphabets that fifteenth-century children must have repeated from their lessons in the same way that children in the 1980s chalk up their addition tables.[44] Not only have children been writing graffiti for centuries, in other words, they may have been working in this microgenre for just as long.

Russian children grow up writing graffiti. That is a facet, perhaps not very remarkable, of Russian urban culture. More significant culturally is that some adults, devout members of the Russian Orthodox church, write devotional graffiti requesting the intercession of favorite saints, or addressing the

Almighty directly, and thereby maintain a custom that stretches back to Kievan Rus. Together, these two distinct traditions frame a void and a question: If the writing of graffiti has been firmly embedded in Russian culture for centuries, why did Soviet cities seem to be virtually free of graffiti prior to the late 1970s? Why did not Soviet teenagers, for instance, cover the walls with the kinds and varieties of messages that their Western peers produced? Of course they chalked, carved, and painted an occasional profanity or declaration of love on the walls of their courtyards, in public toilets, in elevators, on desk tops. But the volume was minuscule and the range of offerings meager compared to the output of Western urban teens, or of Soviet children.

The apparent absence of graffiti helped in its own minor way to sustain the impression that Soviet society was either too disciplined or too repressive to permit so disorderly a practice: blank walls, orderly society. The suspicion had foundation, even though Soviet society has never been as disciplined as Westerners have imagined. In the worst of times some life did bubble beneath the surface. Since the 1950s, a quite determined effort has been required to avoid seeing through the rifts to the hurly-burly behind the facade. Yet the emergence of graffiti from church and courtyard in the late 1970s did signal a change in Soviet society: not from order to disorder, but in the kinds of unregulated, spontaneous activities that were taking place. Just as the graffiti from Kievan-era churches illuminate medieval Rus culture, the public graffiti in Moscow and other Soviet cities tell us about the groups and cultures within contemporary Soviet society. Of course, they tell us most about the adolescents who author the graffiti. But if the adolescents are behaving differently now from the way they did 15 or 20 years ago, it is because the society that shapes them has changed.

NOTES

1. The Beloozero inscription is reported in L. A. Golubeva, "Nadpis' na korchage iz Beloozera," *Sovetskaia arkheologiia*, 1960

no. 3, pp. 321–23; the Riazan inscription is in A. L. Mongait, "Raskopki v Staroi Riazani," *Ogonek*, 1950 no. 19, p. 28. For a different reading of the Riazan inscription—"Good new wine Bogunka sent to the prince"—see A. A. Medyntseva, "Epigraficheskie nakhodki iz Staroi Riazani," *Drevnosti slavian i Rusi*, Moscow, 1988, pp. 247–56. On other inscriptions: D. A. Avdusin and M. N. Tikhomirov, "Drevneishiaia russkaia nadpis'," *Vestnik AN SSSR*, 1950 no. 4, pp. 71–79; M. I. Artamonov, "Raskopki Sarkela-Beloi Vezhi v 1950 g.," *Voprosy istorii*, 1951 no. 4, pp. 146–51; B. A. Rybakov, *Remeslo drevnei Rusi*, Moscow-Leningrad, 1948, pp. 367–71; B. A. Rybakov, "Russkaia epigrafika X-XIV vv. (Sostoianie, vozmozhnosti, zadachi)," originally published in 1963, reprinted in Rybakov, *Iz istorii kul'tury Drevnei Rusi. Issledovaniia i zametki*, Moscow, 1984, pp. 42, 47–48; A. K. Korovina, "Raskopki Tamanskogo gorodishcha," *Arkheologicheskie otkrytiia 1972 goda*, Moscow, 1973, pp. 294–95; *Ocherki po arkheologii Belorussii*, v. 2, Minsk, 1972, pp. 114, 175–76; S. A. Vysotskii, *Kievskie graffiti XI-XVII vekov*, Kiev, 1985, pp. 104–9, 120.

2. B. A. Kolchin, *Novgorodskie drevnosti. Dereviannye izdeliia*, M., 1968, pp. 22–23, 33, 42, and plates 7, 11, 23, 35; A. V. Artsikhovskii, "Novgorodskaia ekspeditsiia," *Kratkie soobshcheniia Instituta istorii material'noi kul'tury*, 1949 no. 27, p. 122; A. V. Artsikhovskii, "Raskopki v Novgorode v 1948 g.," *Kratkie soobshcheniia Instituta istorii material'noi kul'tury*, 1950 no. 33, pp. 10–13; A. V. Artsikhovskii, "Novye otkrytiia v Novgorode," *Voprosy istorii*, 1951 no. 12, p. 85; A. F. Medvedev, "Raskopki v Staroi Russe," *Arkheologicheskie otkrytiia 1972 goda*, Moscow, 1973, p. 26; G. V. Shtykhov, "Okhrannye raskopki v Belorussii," *Arkheologicheskie otkrytiia 1981 goda*, Moscow, 1983, p. 366.

3. Rybakov, "Russkaia epigrafika," pp. 46–47; A. A. Medyntseva, "Gramotnost' zhenshchin na Rusi X-XIII vv. po dannym epigrafiki," in B. A. Rybakov, ed., *Slovo o polku Igoreve i ego vremia*, Moscow, 1985, pp. 218–40; V. A. Mal'm, "Shifernye priaslina i ikh ispol'zovanie," *Istoriia kul'tury Vostochnoi Evropy po arkheologicheskim dannym*, Moscow, 1971, pp. 197–206; Artsikhovskii, "Novgorodskaia ekspeditsiia," p. 122; Rybakov, *Remeslo*, pp. 197–202; L. V. Alekseev, "Tri priaslitsa s nadpisiami iz Belorussii," *Kratkie soobshcheniia Instituta istorii material'noi kul'tury*, 1955 no. 57, pp. 129–32; B. A. Rybakov, "Raskopki v Liubeche v 1957 godu," *Kratkie soobshcheniia Instituta istorii material'noi kul'tury*, 1960 no. 79, pp. 33–34; I. K. Labutina, "Raskopki v Pskove," *Arkheologicheskie otkrytiia 1974 goda*, Moscow, 1975, p. 22; *Ocherki po arkheologii Belorussii*, part 2, p. 175; B. P. Darkevich, "Issledovaniia Staroriazan-

skoi ekspeditsii," *Arkheologicheskie otkrytiia 1979 goda*, Moscow, 1980, p. 53; Vysotskii, *Kievskie graffiti*, p. 104.

4. I. Sreznevskii, "Peshchera Ivana Greshnogo i Feofila," *Izvestiia Imperatorskogo arkheologicheskogo obshchestva*, v. 2, part 1, St. Petersburg, 1861, colums 1–7; I. Kamanin, *Zverinetskie peshchery v Kieve*, Kiev, 1914, pp. 12–13, 23–26, 29–30, 51, 84–85, 88, 92, 107; P. P. Tolochko, *Drevnii Kiev*, Kiev, 1976, pp. 115–50.

5. Rybakov, "Russkaia epigrafika," p. 51.

6. V. A. Kharlamov, "Raboty Arkhitekturno-arkheologicheskogo otriada," *Arkheologicheskie otkrytiia 1985 goda*, Moscow, 1987, pp. 425–26.

7. N. N. Voronin, "Smolenskie graffiti," *Sovetskaia arkheologiia*, 1964 no. 2, pp. 171–78; B. A. Rybakov, "Smolenskaia nadpis' XIII v. o 'vragakh igumenakh'," *Sovetskaia arkheologiia*, 1964 no. 2, pp. 179–87; Vysotskii, *Kievskie graffiti*, pp. 90–93.

8. S. A. Vysotskii, *Drevnerusskie nadpisi Sofii Kievskoi*, v. 1, XI-XIV vv., Kiev, 1966, pp. 73–80.

9. Vysotskii, *Drevnerusskie*, pp. 16–18; A. A. Medyntseva, *Drevnerusskie nadpisi Novgorodskogo Sofiiskogo sobora. XI-XIV veka*, Moscow, 1978, pp. 172–73.

10. S. A. Vysotskii, *Srednevekovye nadpisi Sofii Kievskoi*, Kiev, 1976, p. 83.

11. Voronin, "Smolenskie graffiti," pp. 171–78; Medyntseva, *Drevnerusskie*, pp. 169, 195; Darkevich, "Issledovaniia," p. 53; M. K. Karger, "Razvaliny Zarubskogo monastyria i letopisnyi gorod Zarub," *Sovetskaia arkheologiia*, v. 13, 1950, p. 58; V. L. Ianin, *Ia poslal tebe berestu . . .* , 2nd edition, Moscow, 1975, p. 45; G. V. Shtykhov, "Raskopki v Vitebske i ego okrestnostiakh," *Arkheologicheskie otkrytiia 1972 goda*, Moscow, 1973, pp. 371–72. And see the plates in Medyntseva, *Drevnerusskie*; Vysotskii, *Drevnerusskie*; Vysotskii, *Srednevekovie*; and Vysotskii, *Kievskie*.

12. On the Stavr graffiti: Vysotskii, *Drevnerusskie*, pp. 56–58. For the Stavr bylina, see the eighteenth-century collection *Drevnie rossiiskie stikhotvoreniia sobrannye Kirsheiu Danilovym*, Moscow, 1977, pp. 71–72. The lengthiest discussion of the possible connection between graffito and epic hero is in B. A. Rybakov, *Drevniaia Rus'. Skazaniia. Byliny. Letopisi*, Moscow, 1963, pp. 126–30. The argument seems plausible, but must be treated cautiously because Rybakov frequently invents connections between figures in the byliny and personages from recorded history. On the other historical graffiti, see Vysotskii, *Drevnerusskie*, pp. 24–34, 49–52, 60–71.

13. N. N. Voronin, "Oboronitel'nye sooruzheniia Vladimira XII v.," *Materialy i issledovaniia po arkheologii SSSR*, 1949 no. 11, pp. 208,

210; N. N. Voronin, "Graffiti 2 fevralia 1238 g.," *Slaviane i Rus'*, Moscow, 1968, pp. 401–5.

14. Vysotskii, *Kievskie*, pp. 11–15, and plates 2 and 5.

15. Olexa Horbatsch, "Einige slavische Pilgerinschriften in der Hagia Sophia-Kathedrale in Konstantinopel," *Die Welt der Slaven*, v. 22, no. 1, 1977, pp. 86–88.

16. Giuseppe Dell'Agata, "Antiche Inscrizioni Cirilliche nel Duomo di Lucca," *Ricerche Slavistiche*, v. 20–21, 1973–1974, pp. 5–14; D. del'Agata, "Stari kirilski nadpisi v katedralata 'San Martino' v grad Lukka," *Slavianskie kul'tury i Balkany*, v. 1, Sofiia, 1978, pp. 62–64.

17. Fedor Buslaev, *Russkaia khrestomatiia. Pamiatniki drevnei russkoi literatury i narodnoi slovesnosti*, Moscow, 1904, p. 390.

18. Ia. N. Shchapov, ed., *Drevnerusskie kniazheskie ustavy XI–XV vv.*, Moscow, 1976, pp. 23, 63, 67, 71, 74. On the history of the Statute of Vladimir Sviatoslavich, see Ia. N. Shchapov, *Kniazheskie ustavy i tserkov' v Drevnei Rusi*, Moscow, 1972, pp. 115–35 and passim. The dating of the archetype of the twelfth century is Shchapov's. Daniel Kaiser, *The Growth of the Law in Medieval Russia*, Princeton, 1980, pp. 51–53, 212, 213 fn. 5, argues that the statute dates from the thirteenth or fourteenth century. In either case its attribution to Vladimir, who died in 1015, is apocryphal.

19. Medyntseva, *Drevnerusskie*, pp. 148–49; Vysotskii, *Drevnerusskie*, p. 77.

20. Vysotskii, *Kievskie*, pp. 34, 44–48; Vysotskii, *Srednevekovye*, pp. 30–31; Medyntseva, *Drevnerusskie*, p. 113.

21. Vysotskii, *Srednevekovye*, p. 63.

22. See the plates in Vysotskii, *Kievskii*; Vysotskii, *Drevnerusskie*; Vysotskii, *Srednevekovye*; Medyntseva, *Drevnerusskie*.

23. Vysotskii, *Drevnerusskie*, pp. 133–34.

24. On this, see for instance Karl Lehman, *Samothrace*, v. 2, part 2, *The Inscriptions on Ceramics and Minor Objects*, New York, 1960, pp. 19, 29–30.

25. *Geoponika. Geoponicorum sive de re rustica*, Lipsiae, 1781, p. 494. On the wide circulation of the *Geoponika*, see N. G. Wilson, *Scholars of Byzantium*, Baltimore, 1983, p. 143.

26. N. N. Voronin, *Zodchestvo Severo-Vostochnoi Rusi XII–XV vv.*, v. 1, Moscow, 1961, pp. 75–76; Vysotskii, *Kievskie*, pp. 39, 43–44, 116; Vysotskii, *Drevnerusskie*, pp. 88–92, 103; Vysotskii, *Srednevekovye*, pp. 34–36, 68–76, 101–7; Medyntseva, *Drevnerusskie*, pp. 145, 152–53; K. N. Gupalo, G. Iu. Ivakin, M. A. Sagaidak, "Issledovaniia tserkvi Uspeniia Pirogoshchi," *Arkheologicheskie otkrytiia 1977 goda*, Moscow, 1978, p. 317.

27. Keith Thomas, *Religion and the Decline of Magic*, New York, 1971, pp. 25–50.

28. Vysotskii, *Kievskie*, p. 113; Ivan Goshev, *Starob''lgarski glagolicheski i kirilski nadpisi ot IX i X v.*, Sofiia, 1961, pp. 32–34, 46–75, 77–86, 106, 109–10.

29. My account is based on reading in ethnographic sources for the nineteenth century. For a sympathetic view of the popular practice that interprets the behavior differently, see Pierre Pascal, *The Religion of the Russian People*, translated by Rowan Williams, Crestwood, N.Y., 1976, pp. 16–19. For a brief sympathetic treatment of the Byzantine doctrine on icons, see Timothy Ware, *The Orthodox Church*, 1980, pp. 38–43.

30. Vysotskii, *Kievskie*, pp. 35–39, 112; Grigor Grigorian, "Armianskie nadpisi Kievskogo sobora sviatoi Sofii," *Vestnik obshchestvennykh nauk AN Armianskoi SSR*, 1979 no. 4, pp. 85–93.

31. Medyntseva, *Drevnerusskie*, p. 180.

32. A. A. Medyntseva, "Drevnerusskie nadpisi iz tserkvi Fedora Stratilata v Novgorode," *Slaviane i Rus'*, Moscow, 1968, pp. 440–50; Vysotskii, *Kievskie*, pp. 76–79, 97–100; E. S. Sizov, "Graffiti v usypal'nitse Ivana Groznogo," *Arkheograficheskii ezhegodnik za 1968 god*, Moscow, 1970, pp. 119–26; A. N. Kirpichnikov, E. A. Riabinin, "Issledovaniia srednevekovogo Porkhova i ego okrugi," *Arkheologicheskie otkrytiia 1974 goda*, Moscow, 1975, pp. 19–20.

33. Vysotskii, *Kievskie*, pp. 112–13.

34. V. N. Shchepkin, "Novgorodskie nadpisi Graffiti," *Drevnosti*, v. 19, no. 3, 1902, pp. 26–46; Medyntseva, *Drevnerusskie*, pp. 6–12.

35. Vysotskii, *Kievskie*, p. 112.

36. Ianin, *Ia poslal tebe berestu*, pp. 23–31; V. L. Ianin et al., "Novgorodskaia ekspeditsiia," *Arkheologicheskie otkrytiia 1985 goda*, Moscow, 1987, pp. 46–48; A. F. Medvedev, "Drevnerusskie pisala X-XV vv. (po dannym arkheologicheskikh raskopok)," *Sovetskaia arkheologiia*, 1960 no. 2, pp. 63–88; Ia. N. Shchapov, "Kirik Novgorodets o berestianykh gramotakh," *Sovetskaia arkheologiia*, 1963 no. 2, pp. 251–53. Birch-bark documents have also been found in Staraia Russa, Smolensk, Vitebsk, Mstislavl, and most recently in Tver and Moscow: N. V. Zhilina, "Tverskaia berestianaia gramota No. 1," *Sovetskaia arkheologiia*, 1987 no. 1, pp. 203–16; *New York Times*, 11 Sept. 1988.

37. Ianin, *Ia poslal tebe berestu*, pp. 25–28; Medvedev, "Drevnerusskie pisala," pp. 65–72, 81; Shchapov, "Kirik Novgorodets," p. 253.

38. V. D. Beletskii, "Raboty Pskovskoi ekspeditsii," *Arkheologicheskie otkrytiia 1972 goda*, Moscow, 1973, p. 8; Iu. P. Spegal'skii,

Pskov. Khudozhestvennye pamiatniki, 2nd edition, Leningrad, 1972, pp. 113–16.

39. The church's view of Ksenia is provided in *Raba bozhiia Blazhennaia Kseniia*, Shanghai, 1948 (reprinted London, Canada, 1986, first published before 1917). A rather more jaundiced view is in N. I. Iudin, *Pravda o peterburgskikh 'sviatynikh'*, Leningrad, 1962, pp. 61–77.

40. Iudin, *Pravda*, pp. 61–77.

41. A. Silaev, "Zapiski palomnika," *Posev*, 1986 no. 1, p. 43; *New York Times*, 18 Dec. 1986; *Glasnost'*, Aug. 1987 no. 5.

42. I am indebted to Susan Costanzo for notes and photographs of the graffiti in the summer of 1988. In October of 1988 the shutters had just been painted over, but a few faint graffiti could be found elsewhere on the church.

43. Medyntseva, "Drevnerusskie nadpisi," p. 449; Ianin, *Ia poslal tebe berestu*, p. 45.

44. Ianin, *Ia poslal tebe berestu*, p. 45.

Fan Gangs and
Their Graffiti Argot

The logos of Moscow's principal soccer teams (Figures 2.1a–2.1d) first appeared on the walls in 1977 or 1978. Soon there were thousands, all over the city, many of them copiously annotated: supporters surrounded the emblems with praise, opponents covered them with scorn. These were the first Soviet graffiti to broadcast a genuinely public, social message. Devotional and children's graffiti, and what few adolescent graffiti there were to that point, expressed sentiments that were entirely individual and local. The new graffiti represented the collective interests of a new social entity, the organized gang of soccer fans. Gang members painted their emblems on the walls to announce their loyalties and to demand social recognition. Wrenching reversals in the fortunes of Spartak, long Moscow's most popular soccer team, provided the occasion for the outbreak of graffiti, but of course Spartak's role was adventitious: it merely catalyzed a process of gang formation for which all of the ingredients were already at hand. Nevertheless, the character of the gangs, and of their graffiti, owed no small debt to the circumstances of their origin.

Moscow's graffiti writers at first used spray paint, which became widely available just when they needed it. But the perennial shortages that plague the Soviet economy affected them, too. In the early 1980s many of the graffiti were laboriously applied with oil paint and brush, or were even written in chalk. By the end of the decade, colored chalk was the most common medium, aerosol spray a poor second. Writers preferred to use team colors, but made do with whatever paint or chalk they could procure. These difficulties

SPARTAK

(a)

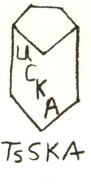

TsSKA

(b)

DINAMO

(c)

TORPEDO

(d)

Figure 2.1

with supply reduced the visual impact of the graffiti, but had no effect on the content. Nor did shortages of paint impede dissemination: by the middle of the 1980s, team logos were on the walls of cities throughout the Soviet Union.

Within a few years other groups were also using graffiti to make public declarations, but fan gang graffiti remained for a long time the most numerous, accounting for at least half of all public graffiti in Moscow until the middle of the 1980s. A perceptible decline in the number of gang graffiti after that paralleled the gradual ebb of the fan gangs, their retreat from central Moscow, and their partial displacement by other groups in the city's outskirts. However, as they yielded space

on the walls, the fan gangs left to everyone else the basic rules of the graffiti language that they had created.

FANATY: *THE FAN GANGS*

In 1976, Spartak finished at the bottom of the championship soccer league and so, for the first time in the team's history, was relegated to the second tier. Like any franchise in trouble, the club hired a new coach and new players. In 1977 Spartak finished at the top of the second tier and reentered the highest league, where it finished fifth (of 16 teams) in 1978 and first in 1979. The initial disaster produced, as is often the case, a redoubled display of partisan loyalty. A few score constant fans began to wear scarves and caps in the team's colors, red and white; they adopted rhythmic chants and claps, waved banners, and set off firecrackers. Spartak's triumphant campaign in 1977 further energized the team's supporters, and during 1977 and 1978 the numbers of the chanting, banner-waving crowd swelled into the hundreds and then thousands. Fights broke out in the stands, fans held boisterous marches from stadium to subway station, and their belligerent chants of "Spar-TAK, Cham-PION" as they poured into the trains badly frightened other passengers. And they covered walls—near the stadia, near home—with the Spartak team logo. In short, they began to look and act like British football hooligans, whose example had been spreading gradually eastward for a decade, and whom Soviet soccer fans had seen on their TV screens.[1]

The authorities' response was heavy-handed, and ultimately unavailing. The prim guardians of public decorum made no distinction between high-spirited raucousness and violence. The city government enacted a ban on chanting and on gathering in groups outside a stadium before or after a match. A recorded announcement reminded spectators of these prohibitions before the start of every match. Police searched fans wearing team colors on entrance to the stadium and confiscated whatever looked like it might be used as a

weapon, all banners, and anything else suspicious. Hundreds of police patrolled the stands to suppress organized cheers. And mounted police formed a picket after matches to channel departing spectators in the direction best suited to maintain public order and prevent fights. The police did manage to maintain order in the subdued stands, most of the time. But disorder constantly broke out on the streets, and police hauled dozens of teenagers off to the precinct stations.[2]

In the midst of the uproar, the rabid young fans turned into organized gangs of *fanaty*, as they styled themselves: fanatical backers of their teams.[3] The excitement of Spartak *fanaty* not only issued in increasingly provocative behavior at and around the stadia, it also triggered a response in kind from the partisans of Moscow's other major league soccer teams, especially TsSKA (pronounced "Tseska," the army team) and Dinamo, the other two of Moscow's big three sports associations. One TsSKA *fanat* could recall, several years later, the memorable date (September 8, 1980) when his gang of young army rooters, in alliance with Dinamo backers, exacted revenge on the Spartak fans by ambushing them as they left a match.[4] Within a few years ganging behavior spread from Moscow to the other big cities with teams in the major soccer league—Leningrad, Kiev, Minsk, Vilnius, Dnepropetrovsk, Tbilisi—and then to cities deep in soccer's minor leagues, such as Krasnodar, Barnaul, Vologda, and Kashira. There, too, *fanaty* donned team colors, waved banners, and chanted. And everywhere *fanaty* appeared, so did graffiti: team logos and slogans proclaiming the home team the champion.[5] By and large the provincial *fanaty* were not so violent as those in the capital. With only a single team around which gangs could form, the constant irritation that set rival gangs of *fanaty* against each other in Moscow was missing. On occasion, however, the locals paid back Moscow's gangs in kind. In 1987, for instance, after a match in Kiev between the local Dinamo team and Moscow's Spartak, fights broke out between Kiev fans and Spartak *fanaty* at the stadium and reached a peak of rock-throwing, window-breaking violence at the train station. Even the Spartak players were roughed up.[6]

But it was in Moscow that the *fanaty* developed into genuine gangs, of a kind the Soviet Union had never seen before. There was a time, in the devastation after the civil war and stretching through the early 1930s, when gangs of orphans plagued Soviet cities and fed into a vigorous criminal subculture. In more recent decades, Moscow and other Soviet cities have had youth gangs, but these seldom developed into anything more than amorphous bands of adolescents. The smallest, most primitive, and most widespread were neighborhood extensions of the groups of young people who hung out together in the courtyard, the Russian equivalent of the American street corner. Neighborhood gangs usually did no more than harass passers-by and fight teenagers from nearby courtyards, although some also engaged in minor recreational vandalism and occasionally traveled outside their neighborhoods for adventure. The larger gangs were based in outlying working-class districts and suburbs. They fought gangs from rival suburbs and traveled into the city to beat up Muscovite teenagers, whom suburban working-class kids think of as the effete children of the elite. The favorite date for raiding was June 20, high school graduation night, when Moscow teens dressed for graduation balls thronged the center of the city. The suburban gangs were occasionally violent, and they engaged in vandalism more frequently than the courtyard gangs, but they appear not to have had any formal structure, or to have sought explicitly to control territory, or to have engaged in prolonged gang warfare. They consisted of a nucleus of toughs who were joined by their peers whenever a fight with a neighboring suburb or a foray into central Moscow was in prospect. By American standards, the courtyard gangs were too small and transient, the suburban gangs too episodic, to be deemed gangs at all.[7]

In Moscow, the fan gangs—the *fanaty*—represented a quantum jump in both organization and violence. The Spartak *fanaty* early on found a charismatic leader in Rashid Seifullin. Seifullin, a student in a teachers' college, rose to eminence because he was known to be a first-class amateur goalkeeper, because he actually knew some of the players on the Spartak team personally, and because he could play the accordion and set newly minted ditties and chants to music. By 1978 or 1979

younger Spartak *fanaty* were seeking his autograph, and Spartak's massed legions rose and cheered whenever he entered a stadium. Seifullin as city leader had subordinates, known as group leaders, who like their chief emerged spontaneously from the informal gatherings of fans before matches. That much was reported in the Soviet press in the middle of the 1980s, when it appeared that the fan gangs had gone for good.[8]

The Soviet press reported on the activity of the fan gangs infrequently and gingerly, but not inaccurately. Reporters denounced the fights, drunkenness, and firecrackers at the stadia. They hinted at a primitive initiation ritual, the stealing of a hat worn by a rival *fanat*, dangerous because the *fanaty* traveled in packs. They observed that one of the gangs' activities was the writing of graffiti. They mentioned regular meetings in beer halls, attacks on rival fans on streetcars, and the trips *fanaty* made to distant cities; Spartak *fanaty* who traveled to Tbilisi not only caused public disturbances during and after the match, they also tried to take a train by storm when they could not buy tickets home. Reporters suggested that the gangs financed these trips through petty theft and black market enterprise.[9]

Unofficial and unpublished sources from the early 1980s merely filled in some details. Below the group leaders was a tangle of small groups, many of them simply the old courtyard gangs converted into branches of the citywide Spartak gang, which was really a gang federation. All three gangs—Spartak, TsSKA, Dinamo—had communications networks and designated assembly points at which gang members gathered on signal. Around 1980 there was something like gang warfare, with major clashes in which (so persistent rumor affirms) a few people died. Fights broke out in the subways, and on buses and trolleys. Bicycle chains, clubs, and black-jacks were the favored weapons; police found or confiscated them near the stadia, and displayed them at parents' meetings at high schools.

Violence at the bottom was strangely paired with organizational sophistication at the top. Yuri Shchekochikhin, the leading Soviet youth journalist, reports that all the original leaders of fan gangs, not just Seifullin, were college students.

A dissident source claims that the *fanaty* had organizational, financial, and provisioning departments, and that they manufactured banners, T-shirts, and other paraphernalia that were unobtainable in the stores. Indeed, not even the red-and-white Spartak caps could be bought on the legal market.[10] And it is true that one of the enterprises the *fanaty* carried out with the money they raised was arranging trips with their teams to other cities. They thereby spread the example of violent disorder throughout the Soviet Union.

More or less important details aside, the only critical feature of the gangs that the press neglected to mention was that the *fanaty* in fact constituted organized gangs rather than packs of delinquent fans, even though Rashid Seifullin was identified by name as "the leader of the Spartak camp" in 1982.[11] But the police certainly knew what they were dealing with, and, as is true everywhere, they were not averse to the occasional modus vivendi with the gangs. There are quite credible stories, for instance, that in 1982 the police told the leader of the Spartak gang in the working-class suburb of Liubertsy that if he wanted to avoid trouble he should mobilize his followers to beat up the fascists who were going to demonstrate at Pushkin Square on Hitler's birthday, April 20. And the *fanaty* did just that.[12]

Soviet commentators occasionally sought to distinguish between good and bad *fanaty*. Seifullin himself, after he had graduated from college and begun a more respectable career as a teacher, tried rather disingenuously to separate the true fans who merely wanted to express their enthusiasm from hooligans who attached themselves to the movement and whom he had been powerless to influence. It was the hooligans, he said, who were responsible for such acts of vandalism as overturning buses. But in 1982, while still the leader of the Spartak *fanaty*, Seifullin admitted to taking British football hooligans as his model.[13]

There must, of course, have been differences in the degree to which those who wore the paraphernalia that identified them as *fanaty* engaged in gang behavior. Just as was the case with British soccer hooligans, anyone who looked and acted the part could become a *fanat*. True, there is the occasional report of initiation ritual or membership test—cap snatching,

for instance. And one local group of the Spartak gang for a time tested those who wanted to join by sending members who were unknown to the candidates to pose as Dinamo *fanaty*; if when threatened they still pledged allegiance to Spartak, they were admitted.[14] But that seems to have been more a product of juvenile fantasizing than a widespread rite of passage.

Studies of British soccer hooligans provide both analogies and important contrasts that help us to appreciate what being a Moscow *fanat* involved. In both cases older adolescents and young adults assumed leadership (it was not only in Moscow that leaders of the *fanaty* were identified as college age). The various roles among groups of soccer hooligans and *fanaty* were filled by general consensus, as candidates emerged spontaneously. Adolescents joined in preexisting groups of school or neighborhood gangs that coalesced in the stands. They talked more violently than they acted, but they did fight with backers of rival teams at and around stadia. In the British case, anyone accepted as sufficiently tough by the rest could attach himself to the group, but a large number of adolescents who did not quite fit in hung around the fringes.[15] Those characteristics to this day describe fully the *fanaty* outside Moscow: they attract attention by their boisterous behavior, regalia, graffiti and periodic disorderly outbursts, but they have no organized existence outside the stadium.

The Moscow fan gangs of the early 1980s departed from that model in a number of important respects: their size, their clearly defined leadership hierarchy, and their life—sometimes violent—on the streets and in the courtyards. These differences must have been due in part to the competition among fans in the capital, which has numerous major and minor league soccer teams. Rivalries born in the stands carried over into every arena where groups of adolescents came into contact, and the constant conflict produced permanent and ramified organization. In that situation, there could be little difference between the good fan and the nasty hooligan: anyone wearing team (gang) colors had to be prepared to be identified as a member of a gang, and to deal with rival *fanaty*. Unless a fan was willing to take the risks of gang membership—prepared to be in a real gang, with all of its consequences—he would not wear gang colors. That made the Moscow fan gangs comparable,

albeit at a much reduced level of violence, to the inner-city gangs in Los Angeles or Chicago, where wearing the wrong color can cost you your life.

The Komsomol, the official youth organization that is supposed to provide a forum for all youth activities, did make one halfhearted attempt to take the Moscow *fanaty* in hand, but it could not overcome gang members' unwillingness to accommodate themselves to the needs of the Komsomol, or the resistance of official society to anything that seemed as indisciplined as the *fanaty*. In 1981 the Moscow city Komsomol committee dispatched a single organizer to set up a Spartak fan club. He approached Seifullin and some of the other Spartak gang leaders, who apparently were willing to try their hand at cooperation. Through the good offices of the Komsomol and the youth tourist organization Sputnik, the *fanaty* accompanied their team to Kiev, where they not only got to see the match, but were also taken to patriotic tourist sites. But when the Komsomol representative tried to impose statutes on the *fanaty*, they resisted. And when another trip was organized, to watch Spartak play Zenit of Leningrad, the Leningrad authorities turned Spartak's rowdy followers away from the stadium. The organizer complained that his efforts were undermined as well by the fact that he had to work alone, and by constant police harassment of anyone who even looked like a *fanat*.[16] As a matter of fact, it is hard to imagine how the Komsomol might have managed to assimilate the activities of the Moscow *fanaty*, since so much of what the *fanaty* did had little to do with rooting. The fact that the Komsomol rapidly backed away from the attempt suggests that Komsomol officials found the task inconceivable as well.

One problem the Komsomol would have had, certainly, was the sheer number of fan gang members. Of course, the relative informality of membership—join when you feel like it, drop out when you want—makes membership estimates more than usually hazardous, but everyone agrees that in the early 1980s the number was in the thousands, with the Spartak gang considerably the largest, the TsSKA and Dinamo gangs following, in that order, and none other worthy of mention. A graffito (Figure 2.2a) found near Luzhniki stadium in 1983 suggests that 10,000 might be taken as a rough order of

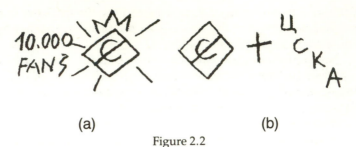

(a) (b)

Figure 2.2

magnitude for membership in the Spartak gang, even though that number is suspiciously large and round. An estimate said to come from the police in 1983 put total Spartak membership at an even larger 30,000. A journalist writing in 1986 claimed that in the early 1980s there had been 100,000 *fanaty* in Moscow.[17] That was surely an exaggeration. Nevertheless, a few tens of thousands might be taken as a reasonable guess for membership in all the fan gangs combined. Moscow is, after all, a very large city, and the gangs, although they had a central leadership nucleus, also had just the sort of federative character that permitted groups scattered in courtyards the city over to claim to be part of the same organization, and occasionally to act in concert.

The size and activity of the gangs peaked around 1982 or 1983, and appeared to decline precipitously after that. Satisfied commentators suggested that, like Seifullin, the *fanaty* had grown up, graduated from college, gone to work, or been drafted into the army. Those still spared the responsibilities of adulthood had, it was suggested, switched their rooting allegiences to other of the newly emerging youth groups, and journalists could find examples to make the case. Many of the original *fanaty* must indeed have graduated into the workaday adult world, and as they grew older they were—like aging British football hooligans—much less inclined to fight.

But the gangs' demise was pronounced overhastily. In the late 1980s gang graffiti had not completely disappeared even from the center of Moscow, and were still plentiful in the outer working-class districts. The old leadership had departed, but some of the old linkages among constituent groups remained, and the surviving *fanaty* exhibited the same proclivity for

fighting with rival gangs as at the beginning. By 1987 the fan gangs were once again in noisy evidence, and were arranging their gang fights for the city center. In June 1988, for example, gangs from the northern districts and southern suburbs met on the Arbat pedestrian mall and set upon each other with iron rods, to the dismay of the hundreds of pedestrians caught in the middle. The pusillanimous police intervened only when the crowd on the street pushed them into the middle of the fight; when the police arrested a few of the participants, the gangs united to besiege the police station. This was reminiscent of the situation in the late 1970s, although the rank order of the gangs had in the meantime changed somewhat: the Dinamo gang had shrunk, and a new Torpedo fan gang threatened to pass it by. The Torpedo soccer club had moved from the middle ranks to challenge for the championship, and Torpedo *fanaty* who had barely been in evidence in 1983 emerged as a fighting fan gang in their own right.[18] The TsSKA soccer club, on the other hand, fell on hard times and was relegated to the second tier after the 1987 season, but that had no very noticeable impact on the TsSKA fan gang.

GANG GRAFFITI AND SOCIAL GEOGRAPHY

Because they used the logos of their favorite soccer teams as gang emblems, the *fanaty* created a superficially ambiguous genre of graffiti: any individual graffito could be taken as a statement of support for a team or as a gang marker. Of course it was both, just as the *fanaty* themselves were both fans and gang members. And no matter what the private intentions of their authors, the graffiti were a product of the gangs. After all, there had been no graffiti in support of soccer teams before there were gangs. In the aggregate, the graffiti reflected many of the gangs' social characteristics: as products of a specific social milieu, the graffiti necessarily betrayed their origins. They confirmed much that was evident in any case, and they also revealed facets of gang behavior otherwise hidden from view.

The appearance of stylized graffiti built around team logos in 1978, or possibly as early as 1977, marked an important step in the crystallization of the gangs. This was the point at which they acquired a sense of identity, at least a rudimentary structure, and a purpose transcending the rooting interests that lay at their origins. The graffiti exemplified the novel character of the fan gangs: producing graffiti and thereby giving public notice of their existence was one of the gangs' essential attributes. Self-advertisement was a variety of behavior unknown to earlier gangs, while fan gangs came into being in no small part in order to make their existence known—however paradoxical that may seem. Take away their graffiti, and the *fanaty* were merely exceptionally ebullient fans. But as soon as they began to think of themselves as a collective social entity, they had messages to communicate: they announced their existence, and they made a claim to social space. Or, as gang members themselves might have put it, they painted their emblems on the walls in order to let everyone know that they were going to organize, congregate, and otherwise act as they saw fit. Producing graffiti was in itself an assertive social act, a challenge to anyone—the authorities, rival gangs—who threatened the group.

Because so many Westerners conceive of Soviet society in a single political dimension, the observation that fan gangs publicly asserted their organizational independence may appear to suggest that the gangs presented at least a quasi-political challenge to the Soviet regime, which until recently has not condoned any independent organizations. Certainly the gangs' declaration of existence—far more than their existence itself—was a direct affront to official social and political norms. For that very reason, in Moscow and a few other cities those charged with controlling Soviet youth made halting efforts to bridle the *fanaty*. Nevertheless, the gangs were not politically self-conscious. Gang members understood that they were defying explicit and official social norms and that the regime considered their actions antisocial, but they did not equate social deviance with political dissent. Moscow's fan gangs were no more political entities than are American street gangs, or British football hooligans, similarly engaged in establishing an identity and realm of activity for themselves.

Nor were they any less political. But to read politics into gang behavior in Chicago or Liverpool or Moscow is to define politics in a way that gang members themselves would find incomprehensible.

Gang graffiti are contagious as well as aggressive, and they helped spread gang behavior by example. Not all gang graffiti are produced by organized *fanaty*, and a free-standing team logo does not ordinarily reveal the identity of its author. The difficulty of distinguishing between gang-produced and individually authored graffiti imposes caution in reading graffiti as evidence of gang presence in any specific instance. But individual fans who replicate gang graffiti use a medium and symbols that the fan gangs created. Not only were there no individual fan graffiti prior to the emergence of gangs, but individuals who have since taken to declaring their loyalties on the walls betray no aspiration toward individualized expression of support for a team. Indeed, since an individual graffito is likely to be mistaken for a gang emblem anyway, it may represent the idea of a gang—a "gang wanted" advertisement, a wish to be identified with a fan gang—where no gang yet exists. One graffito reported in the Soviet press, "I want to be a *fanat*" (*khochu fanatet'*), bears out that possibility.[19] Precisely because they could be copied by anyone, graffiti were essential to gang growth: they spread a message, and they elicited imitative behavior.

Even allowing for the intrusion of individual statements, the distribution of the graffiti reveals the territorial and social dynamics of the *fanaty*. At no time have fan gang graffiti in Moscow been so strongly localized as gang graffiti in the United States, where the posting of a gang name or emblem, especially around a perimeter, constitutes a claim to control territory both against rival gangs and in many cases against the inhabitants of the neighborhood. The structure of Moscow's fan gangs alone rules out precise territorial delimitation; the principal fan gangs have affiliates throughout the city and suburbs, and so they must overlap. In only a very few areas has there been strong evidence that a particular gang has staked out and been able to enforce territorial control. Even where the Spartak (or TsSKA, or Dinamo) gang obviously predominates, its graffiti are defaced, and the stray (and

quickly defaced) graffiti of rival gangs penetrate. Since the public identity of the gangs is defined by loyalty to particular teams, and since emotional attachments to a team have little to do with place of residence (at least in Moscow, which has a number of top-flight clubs), there are perpetual challenges to the unifying principle of territorial organization.

Nevertheless, fan gang graffiti are not distributed evenly through the city. Apart from concentrations around stadia, they have at all times been found most frequently in residential complexes: in courtyards, or in territory bounded by apartment blocks that are either physically connected or are so arranged as to produce a large square. The only other graffiti found so predominantly in residential complexes are those produced by children. That is as it should be: both children and adolescents who write gang graffiti hang out near home. When there is a concentration of fan graffiti in a courtyard, it is usually the work of a single gang, which labels the archways leading from the street into the courtyard with large emblems obviously meant to be territorial markers. While mostly found in the archways and courtyards where adolescents congregate, gang graffiti sometimes emerge to take over nearby streets. That was true in particular of the narrower streets in Moscow's older, central residential areas in the early 1980s.

The territoriality of fan gang graffiti also emerges from a comparison with other kinds. The names of rock bands constitute a major Soviet graffiti genre, and collections of these graffiti occasionally challenge the primacy of gang graffiti in residential complexes. However, clusters of rock and roll graffiti are almost as often located near adolescent gathering spots away from home. The graffiti produced by counterculture groups (hippies, pacifists, punks), when they are found in significant numbers, have special locations near public squares, cafes, and other favorite counterculture hangouts. There is no reason at all to suppose that the writers of gang graffiti are any less mobile than other graffiti writers. They paint their emblems mostly near home because that is where they aspire to establish control. The gangs' behavior is, in a word, territorial, though less strongly and aggressively so

than in American cities. And Moscow's fan gangs do not seek to terrorize the neighborhood, only rival gangs.

Since the gangs' territorial boundaries are not so distinct as in the United States, and since there is in Moscow considerable intermingling of small gang territories, gang graffiti overlap. In the early 1980s, as many as three relatively well-defined territories might abut in central Moscow. At the junctions, sometimes along borders several blocks long, large agglomerations of graffiti advertised the presence of all the gangs and gave full play to the graffiti vocabulary of invective. One finds occasionally, too, declarations of gang alliance. Figure 2.2b, for example, is a message that local Spartak and TsSKA gangs, usually fierce rivals, have joined forces, either to act against the local Dinamo gang, or because neither Spartak nor TsSKA can achieve superiority and the two have declared a truce, or because residence-based friendship transcends gang affiliation.

The distribution of the graffiti reveals not only the territorial behavior of the gangs, but also, because the territory is after all inhabited, the social origins of gang members. Soviet commentators routinely claim that the *fanaty* are trade school students (*PTUshniki*, from *Professional'nye tekhnicheskie uchilishcha*), or in other words offspring of the working and lower service classes being funneled into working-class jobs. The graffiti of the early 1980s, when this assertion was current, revealed something quite different: fan gangs flourished in districts inhabited by the middle elite (the sociopolitical upper middle class) as well as in working-class districts. It is conceivable that working-class areas were the seedbeds of the fan gangs (but there is no evidence that directly confirms this) because they had a primitive gang culture to begin with, while middle-class neighborhoods did not. However, middle-class adolescents readily adopted gang practices. It is reasonable to presume, again, that fan gangs from working-class districts were then as later the more violence prone. Nevertheless, the distribution of gang graffiti demonstrated unambiguously that there was no significant difference in the ganging propensities of working-class and middle-class districts. The journalists' and academics' perception that the *fanaty* were mostly trade school students was rooted in assumptions about social class

and social behavior that overrode the evidence to the contrary. Both public and private reports on gang behavior in the early 1980s made clear that gang affiliation transcended antagonisms rooted in differences in social class. As Rashid Seifullin put it when contrasting the fan gangs to other extralegal youth groups, "the *fanaty* were the most democratic youth gang."[20]

That had changed dramatically by the late 1980s. The gangs retreated to the outlying working-class districts because the adolescents of central Moscow found other interests, which working-class teens by and large did not share. The counter-cultural and other youth organizations that predominated in the central districts after about 1985, which will be the subject of subsequent chapters, drew their members dis-proportionately from the upper half of Soviet society, as Seifullin suggested. And the fan gangs' recent hostility to the countercultural groups includes a strong dose of social antagonism. Indeed, the *fanaty* in the suburbs have blended in with the elite-bashing, West-denouncing suburban toughs known collectively as *Liubery*, after the working-class suburb of Liubertsy, from which they first emerged en masse to smash hippies and the devotees of heavy metal rock music. These will be discussed later. For the moment, it is enough to observe that the changing distribution of graffiti registered rather well the changes in the fan gangs' social composition and the class-based differences in the interests of Muscovite teenagers.

THE VOCABULARY AND GRAMMAR OF GANG GRAFFITI

Fan gang graffiti communicate through combinations of words and symbols; they therefore constitute a kind of language. In the modern way of thinking, *language* has become an unusually capacious concept that can encompass almost any social or cultural activity, or social structure as a whole, or human history. I mean here language in the old narrow sense, the kind whose vocabulary and grammar are studied in language classes. The gangs use their graffiti as

though they constitute a natural language—they would not call them that—to make perfectly straightforward statements. Our first task is therefore to understand what the *fanaty* say, and how they say it.

Moscow's *fanaty* achieve their greatest verbal and symbolic expressiveness, and display the bulk of their graffiti vocabulary, in the graffiti skirmishes that mimic real gang fights. Members of one gang deface the graffiti produced by another by turning an emblem with a positive connotation into a defamation, and by superimposing their own emblem on that of their rivals. Spartak's rivals most frequently convert the Spartak logo into the word "meat" (*miaso*), as in Figure 2.3a. In ordinary discourse, "meat" is not obviously derogatory, but in the slang of Soviet sports fans it is a nasty slur on Spartak's origins. The Spartak sports club was originally sponsored by Moscow's retail trade organizations, and for a long time the dominant slang term for Spartak players was "stall keepers" (*lavochniki*). Because of the increased violence and aggression that the fan gangs have brought to Soviet sports, "stall keepers" has been displaced by "meat," a more emotive word that singles out butchers as Spartak's progenitors. The reference

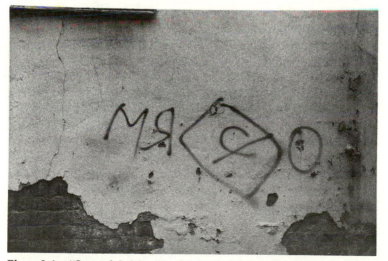

Photo 2.1 "Spartak Is Meat"—the Spartak logo transformed into the standard anti-Spartak taunt. (Moscow, 1988)

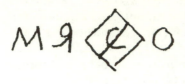

(a)

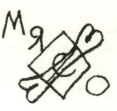

(b)

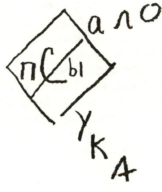

(c)

(d)

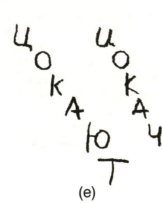

(e)

(f)

Figure 2.3

to butchers is occasionally made even more explicit by the superimposition of bones over the Spartak logo (Figure 2.3b). Opponents also at times turn the *S* in the Spartak logo into the derogatory *pSy* ("dogs") or *Suka* ("bitch"). Occasionally, they transform the *S* into *Salo* ("lard"), which, like "meat," denigrates Spartak's putative origins (Figure 2.3c).

Rival gangs invariably label TsSKA logos "horses" (*koni*) (Figure 2.3d). This odd expletive derives from the location of the club's stadium, near where the army stables once stood. In the older and now superseded sports slang, army players were known as "stable hands" (*koniushnie*). Most Russians, however, do not know the derivation of the slang meaning of "horses," and the current popular etymology derives the insult from the fact that TsSKA, as the sports club sponsored by the Soviet army, can draft any young player it wants; the "horses" in this sense are the players who, no better than dumb beasts, are run in and out of the stable as the team has need of them. Interestingly, in fan gang usage *koni* has an emotive force precisely the opposite of that in standard Russian, where *kon'* is a noble steed and *loshad'* a common nag; yet because *koni* is meant to be defamatory, it is taken that way. Occasionally, the lettering in the TsSKA logo is turned into *tsokaiut*, the clip-clop sound made by a horse, or *tsokach*, the one who makes such a noise (Figure 2.3e).

The Dinamo logo attracts the greatest variety of insulting defacements. There are good Russian expletives that begin with *D*, such as *Der'mo* ("crap") and *Drian'* (nonfecal crap, stinking matter). Occasionally, the Dinamo *D* is converted into *paDlo*, a dialectism for "carrion." Much the most frequent insult appended to the Dinamo logo, "garbage" (*musor*), is on the face of it far milder, but is standard slang for cops; like "meat" for Spartak and "horses" for TsSKA, it is an aspersion of Dinamo's origins as the sports club of the Ministry of Interior (Figure 2.3f). Other slang terms for police less frequently added to the Dinamo logo include *duby* ("oaks," meaning that police are blockheads) and *menty* (as nasty as "pigs"). The earlier and far milder slang reference to Dinamo —*gorodoviki*, a word for police in prerevolutionary Russia— has given way entirely to the stronger expressions.

The negative epithets in the graffiti are highly specialized.

"Meat" and "horses" are defamatory only in association with the Spartak and TsSKA emblems. "Garbage," instantly recognized in all contexts as a defamatory characterization of the police, makes sense only as an appendage to the Dinamo logo. These words are nasty insults, but only when attached to the proper emblems. In fact, they lack meaning if misapplied: "Spartak—Horses" and "Dinamo—Meat" would be incomprehensible and so are never written on the walls. The only term of opprobrium suited to deface all three gang emblems is a pictograph rather than a word, as in Figure 2.4a, where the Spartak logo has been turned into a swine snout. Swine have the same negative connotation in Russian as in any other language. But that defacement is uncommon. The general rule of invective in gang graffiti is that each emblem has its own individual set of defamatory modifiers. The most frequently employed cast aspersions on the team's origins—these are the mother oaths of gang graffiti, the nastiest things that can be said in the graffiti language. In noteworthy contrast, the mother oaths of ordinary Russian are never used in gang graffiti. Of course, there are occasional deviations from the strict specialization of negative epithets. "Bitch" or "bitches" is occasionally added to TsSKA or Dinamo as well as to Spartak logos, for instance, probably by novice writers. The few exceptions underscore by their irregularity the rule that defamatory modifiers are bound strongly to specific emblems.

Unlike graffiti curses, praise is generic: the same words and symbols are added to all the emblems. Three of the most common positive modifiers are pictorial: a crown (see Figure 2.2a), stars, and a hand signaling "V for Victory" with two fingers (Figure 2.4b). The crown and stars, which assert that the team and its *fanaty* are dominant, are part of an international sports vocabulary but have verbal equivalents in Russian; a top player is either a "star" or, if truly outstanding, a "king." The fingers forming a *V* are equally international, but have no equivalent in Russian. Even as a pictograph the meaning of the *V* is obscure to most Russians, since their language has no letter that looks like *V*. Few know the symbol's etymology, and that knowledge is virtually a prerequisite of grasping the meaning. When the *V* pictograph was first used in the late 1970s or early 1980s, very few outside the

(a) (b)

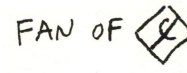
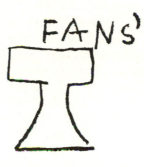

(c)

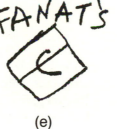

(d) (e)

Figure 2.4

adolescent gang community had any idea at all what it meant.[21] Most still do not.

The most frequent of all additions to the gang emblems is a caption, the English FAN or FANS, most commonly with an apostrophe—FAN'S or FANS'—as in Figure 2.4c. Figure 2.4d presents the ideal graffito from which the grammatically incorrect variants derive. There actually was such a graffito in

Moscow in 1983, but it may have been the only one of its kind. The errant apostrophe betrays genuine confusion over the marking of the possessive in English, but FAN'S and FANS' should probably not be considered mistakes so much as elements in a linguistic hybrid with its own grammatical rules. In Russian as in English, Spartak rather than FAN would be in the possessive, but a logo does not decline, and the apostrophe emphasizes the connection between the FANS' and their gang.

The problematic marking of the possessive is far less intriguing than the use of FAN in the first place. The most obvious explanation is that it is a direct borrowing from English, but the history of the graffiti suggests a more likely alternative. Gang graffiti at first employed FANAT'S rather than FAN'S (Figure 2.4e). Most of the early graffiti were covered over during the campaign to beautify Moscow in preparation for the 1980 Olympics, so only a few logos with the FANAT label could still be found in the early 1980s; by the end of the decade, none were left. FANAT'S was simply a transliteration of the Russian neologism *fanaty*, and gang members wrote it either because they believed it to be an English word

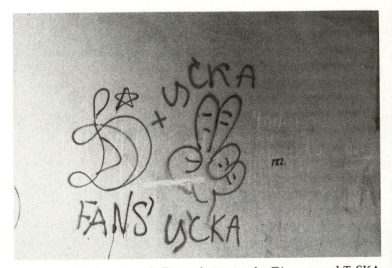

Photo 2.2 Declaration of alliance between the Dinamo and TsSKA gangs. (Moscow, 1988)

or because they wished to mimic English. Most likely, FANAT was then reduced to FAN under the influence of standard English and of a misperception of the meaning of "fan." Rashid Seifullin, then the leader of the Spartak gang, was quoted in the Soviet press in 1982 as claiming that *fanat* itself derived from the English "fan," and that the latter meant football hooligan.[22] In fact, *fanat* is one of a class of words derived from the earlier Russian borrowing *fanatik* (fanatic). It is of course possible that the *fanaty* borrowed FAN directly due to a misunderstanding of the word's English meaning. However, the graffiti record and the gangs' oral tradition linking English "fan" with *fanat* suggest that the FAN of Moscow graffiti originated as a linguistic reduction of FANAT. In either case, on Russian walls FAN means *fanat*, not "fan."

Whatever its origin, FAN is more esoteric than FANAT. FANAT, at least, makes sense to any Russian who can puzzle out the pronunciation. When FAN first appeared on the walls, it had no meaning when pronounced in Russian. Or rather, it might have come out as *fen*, meaning hair dryer and making the graffito most perplexing. Yet thereafter FAN was so widely employed in graffiti that it became in some sense a part of the language Russians (or at least one group of them) used. Its status was for a time ambiguous, since it existed only in a visual medium; lacking semantic value in spoken Russian, it was almost as abstract a representation as the logo with which it was always joined. Eventually "fan" transliterated both as *fen* and *fan* did enter standard written Russian, not in its gang meaning but in its standard English meaning, and as a slang expression that sometimes needed parenthetical elucidation for uninitiated readers.[23] That the meaning of FAN was never much more than mildly puzzling to an Anglophone observer is irrelevant; most observers were Russophone, and unless they were familiar with the gang milieu its meaning was opaque. And even as "fan" is being assimilated into the lexicon of Russian slang, it does not mean quite what it does when written in English as part of a graffito.

FAN is linguistically specialized, but its use in graffiti is related to the fashion among Russian teenagers and young adults of sprinkling their speech with English words.[24] Other borrowings used as captions for logos, such as CHAMPION

and SUPERCLUB (or SUPERKLUB) are part of the same vogue, though they accentuate the uniqueness of FAN. Both have entered directly into spoken and written Russian with only slight modifications due to phonetic transliteration (*chempion, superklub*), and the English and Russian spellings are employed interchangeably in the graffiti, while "fan" is never spelled in Russian characters. SUPERKLUB (in Latin characters) might conceivably be a direct borrowing from German, but it is far more likely a misspelling of the English or (almost the same thing) a reverse transliteration from the Russian into what *fanaty* think is English.

Gang graffiti in Moscow are extremely repetitive, because they employ the same few stock symbols and words over and over in a limited number of combinations. There are exceptions, of course. "TsSKA *dura*" ("TsSKA is a ninny") draws most of its sting from the use of the female form of "ninny" to question TsSKA's masculinity. "TsSKA *navoz*" ("TsSKA is dung") is a mildly amusing derivative of the standard anti-TsSKA expletive. "Spartak *mudak*" and "Spartak *super-mudak*" ("Spartak's an ass" and "Spartak's a superass") may be fragments of what were initially anti-Spartak chants. "TsSKA HORSES" translates, uniquely, the fearsome epithet *koni* into English. SCREW SPARTAK is another highly unusual all-English denunciatory graffito. These items stand out not because they are clever, but because they deviate from the language and symbols that almost all other gang graffiti employ. That may mean, in fact, that they were authored by unattached, would-be *fanaty* who had not yet mastered the gang idiom.

The poverty of the gangs' graffiti lexicon is related to the character of the *fanaty* themselves. Because of their origins in the stadia, their vocabulary is closely associated with sports: much of the native slang and most of the international symbols refer to the character or achievements of sports teams and their followers. Because the graffiti are the work of gangs, they draw on only a small portion of available sports terms and symbols. They never employ slang expressions characterizing play, nor do they deal with the actual play of the game in any other way. And they never celebrate team stars. The graffiti use only those terms that impugn the character, or best of all

the origins, of a rival team and gang, or those that assert the championship quality of their own team and gang. These assertions only occasionally and accidentally coincide with the position that a team actually occupies in the standings. In any case, the available sports slang and symbols have been pared down to those that most directly express conflict and rivalry. Gang graffiti draw on other sources—native derogatory slang, international symbols that are not necessarily associated with sports—but only according to the same principle of selection. The result is that the total of words and symbols in the graffiti is quite small.

Fanaty deploy their impoverished vocabulary according to the rules of a highly restrictive grammar. The rules are simple:

- Every statement must include the emblem of a soccer team.
- The emblem may be modified only by positive and negative epithets.
- Positive modifiers must be words and symbols of international, preferably English-language, origin.
- Positive modifiers may be applied to any emblem.
- Negative modifiers must be Russian slang expressions.
- Negative modifiers are specific to each emblem.

Writers of graffiti do occasionally violate these rules, as do the writers of any language. But the regularities are so pronounced that there can be no doubt that these are, in fact, the rules of an underlying grammar. Members of even the most dull-witted gang would introduce, if only randomly, more variety than can be found in Moscow's gang graffiti did they not unwittingly submit to rigid grammatical conventions.

We can appreciate these rules for what they are when we consider not only the words and symbols that are a part of the graffiti vocabulary, but also those that might be used but never are. Both FAN and the drawing of the hand waving two fingers in a *V* come directly from English, and cannot be understood without some knowledge of the English language. *Chempion* and *superklub* are Russian words, but the fact that they are just as frequently presented in the graffiti in English suggests that graffiti writers use them precisely because of

their English-language origin. The crown and stars symbols might be derived from Russian, but in fact they appeared in Western graffiti and Western emblems before they showed up in Soviet graffiti. And while all of these positive modifiers are borrowed from English, not one positive statement is ever made with intrinsically Russian symbols, or even in words with Russian roots—not one. The writers of the graffiti feel instinctively that Russian words of praise do not adequately glorify the team and gang. By contrast, the vocabulary of invective is exclusively Russian, and Russian slang at that. English has many strong swear words, and the graffiti writers know some of them, but they do not use English to defame an enemy.

Once these rules have been identified for what they are, the grammar is not hard to explain. Part of the explanation must, of course, be social: different language strata express different social values, in graffiti as in any other language. English words and symbols enjoy prestige and automatically— irrespective of their precise meaning—do the emblem honor. Native slang has shock value and conveys hostility. In the language of the graffiti, the principal grammatical operation consists of selecting the social lexicon that best reinforces the message the writer wishes to convey.

The second operation is to choose the proper word from the appropriate lexicon. Because the emblem of a soccer team is always a part of the graffiti message, and because the *fanaty* originated as genuine fans of soccer teams, the vocabulary is heavily biased toward words and symbols associated with sports. The authors of the graffiti have hundreds of defamatory slang expressions to choose from, but (the rare swine picto-graph excepted) they always choose sports slang. And because sports slang has been evolving for decades, a special set of negative expressions is available for each emblem. Positive expressions are also invariably taken from the sports lexicon, but they are generic: the same superlatives are added to all emblems. One reason for this is that the international sports vocabulary offers no special terms for individual Soviet teams. Another reason may be that the *fanaty* have at best a superficial command of English, so they cannot fashion specialized positive epithets. Then again, hostility is a stronger

emotion than affection, and the vocabulary of invective has always been richer and more specialized than the vocabulary of praise.

GANG GRAFFITI AS ARGOT

Almost every one of the observed characteristics of the vocabulary and grammar of fan gang graffiti points to the conclusion that graffiti function like an argot, that is, a variety of language used by a socially marginal community. Linguists who have written about argot invariably define it in terms of the community that uses it rather than by specifying the properties of the speech itself. Of course there is a connection: argot is to the local standard language as the argot-speaking group is to society at large, antagonistic and derisive.

Argot, all agree, is the special language of criminal sub-cultures, but beyond that there is no consensus on the character of groups that speak an argot. One source of the difficulty is that linguists have not consistently distinguished among "argot," "jargon," and "slang," and sometimes use the terms more or less interchangeably. As a matter of fact, jargon and slang may also be products of distinctive social or professional groups.[25] Yet if defining an argot is difficult, recognizing one is not. Everyone agrees that groups such as itinerant peddlers and professional criminals in prerevolutionary Russia spoke an argot that was virtually incomprehensible to anyone not part of their community. Thieves and beggars in France in the nineteenth century and earlier spoke an argot. So did British criminals ("thieves' cant") and American confidence men. So do criminals and neighboring social groups in many countries today.

A distinction that the Soviet scholar Viktor Zhirmunskii made between jargon and argot in 1936 probably provides the best guidance on the interrelated characteristics of argot and argot-using groups. Jargon and argot differ, he noted, in their degree of specialization: a professional jargon is highly specialized, an argot is not. That difference is in turn rooted in

the character of the groups using argot or jargon: argot-speaking groups are on the fringes of society, and their special vocabulary covers the many different situations that ensue from that fact. Jargon is rooted in a job, argot in a life-style.[26]

Leaving social characteristics aside for the moment, what linguists agree to be the attributes of argot as language bring us back to Moscow's gang graffiti.[27] The graffiti of the *fanaty* do deviate from argot in some ways. For instance, a true argot is an incomplete language, a lexicon only, built on and subordinate to the grammar of the native colloquial language; Moscow's gang graffiti have their own grammar, in part because they constitute a semipictorial language. Furthermore, a true argot has a much larger lexicon than do gang graffiti. Yet the points of resemblance are numerous. The vocabulary of argot is emotionally charged and metaphorical; every item in the gang graffiti has the heightened emotionalism associated with maledictions or with especially prestigious words and symbols. As in an argot, words and symbols in the graffiti cannot be accurately translated into the base language because the emotional charge that constitutes their essential meaning is lost in the translation. Translating "horses" (*koni*) into "members of the TsSKA gang are stupid beasts" is impossibly long-winded; "stupid beasts" alone will not do, because the epithet necessarily involves TsSKA. The V-for-victory hand wag does mean "we will win" or "we are best," but words do not capture the insolence, challenge, and swagger that the gesture communicates. Just as in an argot, items in the graffiti lexicon are often employed only in specific syntactical structures; "garbage" (*musor*) is part of the graffiti argot only as a negative modifier for a Dinamo logo, "horses" (*koni*) modifies only TsSKA logos, and so on. Most significant of all, like every true argot the graffiti draw on contiguous languages (native slang, internationally understood symbols, the English that circulates among Russian youths; every argot makes use of foreign words), and in doing so give new meaning to the borrowed terms and create a composite vocabulary that is unique.

It is not so much the individual characteristics that make fan gang graffiti an argot as the way in which all of them together render the graffiti virtually incomprehensible to those outside

the gang milieu. The gangs do not seek intentionally to be secretive, yet the symbols they have chosen and the meanings they have attached to their graffiti vocabulary do not make sense to ordinary Russians. The graffiti are easy enough to decode if they are studied carefully, but the same is true of any apparently unintelligible argot. And what seems readily intelligible may not be so—even familiar slang expressions like "garbage" (*musor*) and "horses" (*koni*) have new meanings in gang argot. To understand what gang members mean when they say (as they do), "Let's find some horses to beat up," one must know that "horses" refers to members of a gang, and not just players on a team; the meaning is not obscure, but it is at one remove from the common slang. When gang members talk of their "team" (*komanda*), they mean their gang, not the team for which they ostensibly root.[28] And what can be understood in a verbal context is not necessarily comprehensible when expressed in a visual code. It may be, in fact, that the employment of sports slang and symbols masks the meaning of gang graffiti more effectively than the use of foreign words. A Russian who sees FAN on a wall at least knows that this is a message that needs deciphering. A Russian who has translated the graffiti in Figure 2.5 into sports slang—"Dinamo players are blockheaded cops," and "Spartak is king"—has not yet reached the intended meaning, because the graffiti are really about the presence and standing of gangs.

It may be objected that if Moscow's gang graffiti are to be considered an argot, then so must gang graffiti everywhere, because they employ symbols that have special, unfamiliar meanings, and are highly charged emotionally. To a certain extent, that is true. The pitchforks and daggers in Chicago gang graffiti are not immediately meaningful to Chicagoans

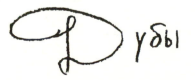 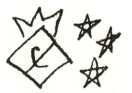

Figure 2.5

who do not live in gang neighborhoods. Most do not know that, for instance, the inverted five-pointed crown with crossed pitchforks pointed upward is a warning from the Disciples to the Latin Kings gang to keep away, or that crossed inverted pitchforks and D-KILLER constitute a similar threat to the Disciples.[29] But (Hispanic gangs obviously excepted) Chicago gang graffiti employ only words and symbols with colloquial English meanings, not a mix of languages and foreign symbols. And there is usually not much doubt about whether a graffito is gang related. Only if Chicago gangs called themselves the Bears, Cubs, and White Sox, and produced graffiti that apparently celebrated athletic exploits ("BEARS—WORLD CHAMPS"), might there be the kind of ambiguity that arises in Moscow. Moscow gang graffiti is, therefore, very different linguistically from gang graffiti in the United States. Since most Americans cannot read the graffiti that is rooted in their own language and that they know to be produced by gangs, we should not underestimate the difficulties that ordinary Muscovites have in deciphering the graffiti that confront them.

The fact that Moscow's gang graffiti constitute a kind of argot tells us a great deal about those who produce them. David Maurer, the American specialist in criminal argots, considers use of an argot to be prima facie evidence of the presence of a criminal subculture.[30] Making due allowance for the fact that the socially marginal groups that have historically used an argot—not just thieves and con artists, but also beggars, tramps, and peddlers—have all sought to deceive the public, Maurer's observation seems valid. Zhirmunskii makes the same point differently: those argot-speaking groups were all déclassé and engaged in an anarchic struggle against the social order.[31] It was their special position outside of and in conflict with the legitimate social order, and under pressure from legitimate authority, that impelled them to fashion their own sets of values, symbols, and patterns of behavior. The same must be true of Moscow's fan gangs: denounced by socially legitimate organizations, harassed by the police, they cannot exist unless they create their own social world and their own legitimating values. If they accept the values of society around them, they must desist from their gang activity. Their

command of a graffiti argot is a measure of their own cultural cohesiveness and their distance from their uncomprehending surroundings. On the evidence of the graffiti, Moscow's gangs constitute an antagonistic subculture within Soviet society. The *fanaty* may be less violent than American urban gangs, but they deviate from the normative culture more than most American gangs do.

Argot does more than signal that a subculture is present, it plays a crucial organizational and legitimating role in the subculture itself. As Maurer again points out, "Subcultures and specialized linguistic phenomena seem to arise spontaneously and simultaneously; language seems to lie at the heart of their cultural genesis."[32] The reason, as the British sociolinguist Michael Halliday notes, is that language structures society and antilanguage (Halliday's term for argot), creates and maintains the antisociety that is under constant pressure; it does so by providing a strongly affective identification for its speakers.[33] That was evidently the case with Moscow's fan gangs and graffiti: gangs and graffiti appeared simultaneously, and the graffiti argot helped to organize and demark the gang subculture. It drew in those who understood the language of the graffiti well enough to engage in successful mimicry, and it provided a code the knowledge of which served as a clear test of membership in gang subculture. Fan gang graffiti also provided a language that linked neighborhood gangs into citywide federations; the subculture as a whole embodies many different groups.

Most important, the graffiti argot (like all argots) expresses and sustains the gangs' deep-seated antagonism to surrounding society. Simply by proclaiming the existence of a network of extralegal, officially illegitimate organizations, the graffiti advertise a subculture that sanctions otherwise deviant behavior. Giving derisive expression to vicious rivalry, the graffiti implicitly sanction gang fights; they encode violence in their representation of the gangs. Using symbols of presumptively English and Western origin as honorifics, gang graffiti impute value to the culture from which those words come. Using Russian only as the language of derogation, the graffiti stand the official hierarchy of values on its head. The very grammar of the graffiti argot expresses the *fanaty*'s disdain for

the world their fathers and grandfathers made. The *fanaty* do not necessarily understand the cultural implications of their graffiti, any more than the peddlers of nineteenth-century Russia understood the social and cultural antagonism their own argot expressed. Yet every time a *fanat* produces a graffito comparing the relative merits of his own and rival gangs, hostility to legitimate society is embedded in the vocabulary and grammar he uses.

The appearance of fan gang graffiti in Moscow in the late 1970s signaled the formation of a distinctive subculture in Soviet society. Gang graffiti of any kind would have marked the onset of a novel social phenomenon, because there had theretofore been no gangs of the size and complexity of the *fanaty*. Irrespective of their linguistic characteristics, the graffiti revealed gang coherence, self-consciousness, and defiance of constituted authority; all of those qualities inhered in the public manipulation of a stylized set of words and symbols. That the words and symbols constituted an argot largely incomprehensible to ordinary Muscovites and expressing antagonism toward official verities signaled that the emergence of the fan gangs was a cultural as well as a social process.

Just how such a subculture came into existence is a question whose answer must reflect on Soviet society as a whole; we will turn to it after taking up other varieties of graffiti and examining their relationship to the graffiti argot of the *fanaty*. It should be self-evident that the Spartak soccer team's seesawing fortunes had nothing much to do with generating the subculture. Spartak's relegation gave the club's followers a jolt, but the path their reaction took was set by social and cultural changes that had been going on for decades.

NOTES

1. Aleksei Samoilov, "Sportivnoe zrelishche i sportivnyi zritel'," *Sovetskaia Rossiia*, 17 May 1981; Iu. Bychkov and N. Dogopolov, "Kak bolel'shchiku 'bolet' '?" *Komsomol'skaia pravda*, 9 June 1981;

G. Shvets, "Pomogi futbolu, bolel'shchik," *Komsomol'skaia pravda,*
30 June 1981; "Eshche raz o krikunakh na tribunakh," *Sovetskaia
Rossiia,* 12 July 1981; Sergei Abramov, "Liubliu 'Spartak,' no ne
liubliu, kogda vokrug komandu razgoraiutsia nezdorovye strasti,"
Sovetskii sport, 17 Jan. 1982; Sergei Mikulin, letter, *Smena,* 1984 no.
18, p. 32; "Futbol'nyi klub 'Nadezhda.' Vypusk 5-i," *Smena,* 1985 no.
4; V. Kulikov, "Besprizornye 'fanaty,' " *Komsomol'skaia pravda,* 5
Oct. 1986; Iurii Shchekochikhin, "Na perekrestke," *Literaturnaia
gazeta,* 22 Oct. 1986; Iu P. Shchekochikhin, "Po kom zvonit kolokol'-
chik?" *Sotsiologicheskie issledovaniia,* 1987 no. 1, pp. 85–86; "Con-
fession of football 'fanatic,' " *Moscow News,* 1–8 Nov. 1987. I have
also drawn on personal observation and communications.

The only published source to misstate the chronology is I. Iu.
Sundiev, "Neformal'nye molodezhnye ob"edineniia: opyt ekspozitsii,"
Sotsiologicheskie issledovaniia, 1987 no. 5, p. 58. Sundiev is a police
major, but he draws most of his information from the press, in this in-
stance Kulikov, "Besprizornye 'fanaty,' " which he has misunderstood.

2. Many of the sources in note 1 refer to measures taken against the
fanaty. On the ordinance announced at stadia, see Shchekochikhin,
"Po kom zvonit kolokol'chik?" p. 95.

3. Shchekochikhin, "Po kom zvonit kolokol'chik?" p. 95. I have
also drawn on personal observation and communications.

4. Shchekochikhin, "Po kom zvonit kolokol'chik?" pp. 86–87.

5. "Diagnoz—fanat," *Smena,* 1984 no. 21, pp. 22–23; "Futbol'nyi
klub 'Nadezhda,' " pp. 32–33; Sergei Mikulik, "Fanaty? Ne tol'ko . . . ,"
Smena, 1985 no. 17, pp. 14–15; Kulikov, "Besprizornye 'fanaty' "; A.
Ignatov, "Shagat' navstrechu," *Komsomol'skaia pravda,* 10 Oct. 1986.

6. *Los Angeles Times,* 14 November 1988, based on a report in
Komsomol'skaia pravda. See also *Izvestiia,* 21 Oct. 1987.

7. I base the description of traditional gang activities in and around
Moscow on personal observation and discussion with knowledgeable
Muscovites. I have found no good discussion of this in the literature
on juvenile delinquency, although one article by A. I. Dolgova,
"Problemy profilaktiki kriminogennykh grupp," *Voprosy bor'by s
prestupnostiu,* 1980 no. 32, pp. 16–30, comes close to describing the
delinquent subculture. Other sources that provide information
conforming to the situation as I have outlined it include Ilya Zeldes,
"Juvenile Delinquency in the USSR: A Criminological Survey,"
International Journal of Comparative and Applied Criminal Justice, v.
4, no. 1, Spring 1980, pp. 22–23; V. S. Prokhorov, "O gruppovoi
prestupnosti nesovershennoletnikh," *Vestnik Leningradskogo
universiteta* (Seriia ekonomika-filosofiia-pravo), v. 2, 1967 no. 11, pp.
117–24; L. A. Andreeva, "O nekotorykh obstoiatel'stvakh, sposob-

stvuiushchikh polovym prestupleniiam nesovershenoletnykh, i merakh ikh preduprezhdeniia," *Voprosy bor'by s prestupnostiu*, 1969 no. 10, pp. 108–10; S. S. Ostroumov, "Nekotorye voprosy izucheniia pravonarushenii sredi nesovershennoletnikh," *Izuchenie i preduprezhdenie pravonarushenii sredi nesovershennoletnykh*, Moscow, 1970, pp. 33–38, 44–45; K. I. Igoshev, *Pravonarusheniia i otvetsvennost' nesovershennoletnego*, Sverdlovsk, 1973, pp. 35–41, 56–58; I. S. Polonskii, "Nekotorye sotsial'no-psikhologicheskie faktory organizatorskoi deiatel'nosti v stikhiinykh gruppakh podrostkov," *Uchenye zapiski Kurskogo pedagogicheskogo instituta*, v. 70, no. 1, 1970, pp. 48–62. The most notorious suburban gang, the *Liubery*, will be discussed in Chapter 4.

8. Seifullin was referred to by name as "the leader of the Spartak camp" by S. Leskov, "Fal'shivye strasti. Bolenie, kak iavlenie," *Komsomol'skaia pravda*, 11 June 1982. More about him and the early stages of the Spartak fan gang emerged in the course of published interviews with him, under pseudonyms, in Shchekochikin, "Na perekrestke"; and Kulikov, "Besprizornye 'fanaty.' "

9. Bychkov and Dogopolov, "Kak bolel'shchiku 'bolet' '?"; "Krikuny na stadione," *Sovetskaia Rossiia*, 2 July 1981; Abramov, "Liubliu 'Spartak' "; A. Leont'ev and N. Simonin, "Zachem krushit' taburetki?" *Sovetskii sport*, 7 Mar. 1982; Leskov, "Fal'shivye strasti"; Valerii Vinokurov, "Osleplennye. Stadion dlia vsekh! No ne dlia p'ianits," *Smena*, 1984 no. 2, p. 5; V. Mezentsev, "Pri chem zdes' futbol? O lzhebolel'shchikakh i istinnykh liubiteliakh sporta," *Trud*, 25 Apr. 1984; Iurii Shchekochikhin, "Predislovie k razgovoru," *Literaturnaia gazeta*, 6 June 1984. See also the poem by Evgenii Evtushenko, "Fanaty," and the response by a *fanat*, in *Literaturnaia gazeta*, 4 July 1984.

10. Interview with Iurii Shchekochikhin, September 1988, and other personal communications. See also "Fashizm v SSSR. Spontanyi protest ili inspirirovannoe dvizhenie?" *Strana i mir* (Munich), 1984 no. 1–2, p. 52. Officials of the Spartak sports association told Professor Alfred Senn of the University of Wisconsin that they could not provide information on where the *fanaty* obtained their identifying paraphernalia; letter to the author, 17 Jan. 1985.

11. Leskov, "Fal'shivye strasty."

12. Personal communications, supported by reports in the *New York Times*, 29 Apr. 1982; and *Vesti iz SSSR*, 15 June 1982. The demonstration will be treated in detail in Chapter 4.

13. Leskov, "Fal'shivye strasti"; Shchekochikhin, "Na perekrestke"; Kulikov, "Besprizornye 'fanaty.' "

14. Shchekochikhin, "Po kom zvonit kolokol'chik?" p. 83.

15. See the studies by Peter Marsh, "Life and Careers on the Soccer Terraces," in Roger Ingham, ed., *Football Hooliganism: The Wider Context*, London, 1978, pp. 61–81; and by Peter Marsh, Elizabeth Rosser, and Rom Harre, *The Rules of Disorder*, London, 1978, pp. 58–134. They present findings of a multiyear study of football hooligans who follow Oxford United. Since this is neither one of the larger nor one of the more violent groups, it is possible that the social order they describe is not wholly representative. Indeed, their work has been criticized for minimizing violence, and for ignoring the lower-working-class social roots of ganging behavior inherent in soccer hooliganism; see, for instance, Eric Dunning, Patrick Murphy, and John Williams, "Spectator Violence at Football Matches: Toward a Sociological Exploration," *British Journal of Sociology*, v. 57, no. 2, 1986, pp. 221–244. See also Stephen Wagg, *The Football World: A Contemporary Social History*, Brighton, 1984, pp. 194–219; and for a prickly Marxist account that relates football hooliganism to social change, Ian Taylor, "On the Sports Violence Question: Soccer Hooliganism Revisited," in Jennifer Hargreaves, ed., *Sport, Culture and Ideology*, London-Boston, 1982, pp. 152–96.

16. Kulikov, "Besprizornye 'fanaty' "; Shchekochikhin, "Na perekrestke."

17. Kulikov, "Besprizornye 'fanaty.' "

18. Shchekochikhin, "Po kom zvonit kolokol'chik?" pp. 84–85, 95–96; Sundiev, "Neformal'nye molodezhnye ob"edineniia," p. 58; Kulikov, "Besprizornye 'fanaty' "; "Confession of football 'fanatic,' " *Moscow News*, Nov. 1–8, 1987; *Glasnost'*, no. 2–4, July 1987, and no. 5, Aug. 1987. An innocent casualty of the June 1988 gang fight on the Arbat provided the details of that incident, and there is an abbreviated account in Iurii Shchekochikhin, "Ekstremal'naia model'," *Literaturnaia gazeta*, 12 Oct. 1988. Robert Edelman, "Stalinism or Good Clean Fun? Political Ideology and Popular Culture in Soviet Spectator Sport" (unpublished manuscript), also provides information on *fanaty* in the late 1980s.

19. Iurii Shchekochikhin, "Predislovie k razgovoru," *Literaturnaia gazeta*, 6 June 1984.

20. Shchekochikhin, "Na perekrestke." In this interview, Seifullin goes by the name "Rifat." He refers to the fan gang as a *komanda*, which in this context means gang, but not necessarily a criminal or violent gang.

21. Barbara Monohan, *A Dictionary of Russian Gesture*, Ann Arbor, Mich., 1983, pp. 156–57, describes the V hand wag, and ascribes to it two meanings: a traditional pan-European assertion of an intention to make a sexual conquest, and the modern "victory"

meaning. She agrees that the gesture was then used only by adolescents. However, according to Desmond Morris et al., *Gestures: Their Origins and Distribution*, New York, 1979, pp. 227–40, the sexual and victory signs differ in the direction in which the hand is held: palm inward for the sexual gesture, palm outward to signal victory. Furthermore, they found that the sexual gesture (meaning roughly "fuck you") was confined almost entirely to Great Britain. They did not conduct survey research in Eastern Europe, but I do not believe that the sexual gesture was known to Russian adolescents. Gang graffiti always display the V sign palm outward.

22. Leskov, "Fal'shivye strasti." And when Sim Rokotov used *fan* in the sense of rock fan, he explained in a footnote that the word was derived from *fanat*: Sim Rokotov, "Govori!" *Iunost'*, 1987 no. 6, p. 83.

23. For instance, in Anatolii Doronin and Arkadii Lisenkov, "Chto proku ot 'roka,' " *Molodaia gvardiia*, 1985 no. 10, p. 226; and Rokotov, "Govori!"

24. This is very well known. For a succinct treatment that emphasizes the social significance and danger of the massive intrusion of Anglicisms into Russian youth slang, see E. G. Borisova, "Sovremennyi molodezhnyi zhargon," *Russkaia rech'*, 1980 no. 5, pp. 51–54.

25. What might be taken as the standard Soviet linguistic definitions of *argo* and *zhargon* are offered by L. I. Skvortsov in *Russkii iazyk. Entsiklopediia*, M., 1979, pp. 22–23, 82–83. Skvortsov gave a somewhat different definition of *argo* in *Bol'shaia sovetskaia entsiklopediia*, v. 2, 3rd edition, Moscow, 1970, p. 171.

One of the earliest to consider the language analytically was J. I. Baudoin de Courtenay, in an introduction to a dictionary of Russian thieves' argot published in 1908. See his *Izbrannye trudy*, v. 2, Moscow, 1963, pp. 161–62. For a review of the various definitions and conceptions that Soviet linguists have offered, see Wilhelm von Timroth, *Russian and Soviet Taboo Varieties of the Russian Language*, revised and enlarged edition, translated by Nortrud Gupta, Munich, 1986, pp. 66–71 and passim. Much of von Timroth's study is devoted to the history of the study of argot and related linguistic phenomena in Russia.

For French linguists, the problem of linguistic and social distinctions is compounded by the fact that a single word, *argot*, is used for the language of criminals, for professional jargon, and for student slang. See the observations in Albert Dauzat, *Les argots*, Paris, 1929, pp. 5–21 and passim; and Pierre Guiraud, *L'argot*, 2nd edition, Paris, 1958, pp. 5–7, 97–107. On English cant, see Eric Partridge, *Here, There and Everywhere: Essays upon Language*, London, 1950, pp. 97–115.

26. V. Zhirmunskii, *Natsional'nyi iazyk i sotsial'nye dialekty*, Leningrad, 1936, pp. 118–19. The distinction between job and life-style is mine, but it emerges directly from Zhirmunskii's observation. Zhirmunskii confuses matters by calling argot a professional jargon of déclassé groups.

27. My understanding of the principal linguistic characteristics of argot is based on Zhirmunskii, *Natsional'nyi iazyk*, pp. 118–63; B. A. Larin, "O lingvisticheskom izuchenii goroda," *Russkaia rech'*, 1928 no. 3, pp. 61–75, reprinted in B. A. Larin, *Istoriia russkogo iazyka i obshee iazykoznanie*, Moscow, 1972, pp. 175–89; V. V. Straten, "Argo i argotizmy," *Izvestiia komissii po russkomu iazyku*, v. 1, Moscow-Leningrad, 1931, pp. 111–47; D. S. Likhachev, "Cherty pervobytnogo primitivizma vorovskoi rechi," *Iazyk i myshlenie*, v. 3–4, 1935, pp. 48–100; D. S. Likhachev, "Argoticheskie slova pro-fessional'noi rechi," in *Razvitie grammatiki i leksiki sovremennogo russkogo iazyka*, Moscow, 1969, pp. 311–59 (written in 1938); Dauzat, *Les argots*; Guirand, *L'argot*; David W. Maurer, *Language of the Underworld*, collected and edited by Allan W. Futrell and Charles B. Wordell, Lexington, Ky., 1981, pp. 260–65, 355, 370, 387, and passim; M. A. K. Halliday, *Language as Social Semiotic: The Social Inter-pretation of Language and Meaning*, Baltimore, 1978, pp. 164–82; and Roger Fowler, *Literature as Social Discourse: The Practice of Linguistic Criticism*, Bloomington, Ind., 1981, pp. 142–58.

28. Shchekochikhin, "Predislovie k razgovoru." Examples of the use of *komanda* in this meaning can be found in Shchekochikhin, "Na perekrestke."

29. On Chicago black gangs, see R. Lincoln Keiser, *The Vice Lords: Warriors of the Streets*, New York, 1969, and (less satisfactory) Useni Eugene Perkins, *Explosion of Chicago's Black Street Gangs*, Chicago, 1987. On Chicano gangs in Chicago, see Ruth Horowitz, *Honor and the American Dream: Culture and Identity in a Chicano Community*, New Brunswick, N.J., 1983, pp. 77–113, 177–97. None of these studies has anything useful to say about gang graffiti, however. I am grateful to Officer Ric Worshill of the Evanston Gang Crime Unit, who has studied Chicago gang graffiti for years, for discussion of the symbols and the ways in which they are used.

30. Maurer, *Language of the Underworld*, pp. 259–62.

31. Zhirmunskii, *Natsional'nyi iazyk*, p. 119.

32. Maurer, *Language of the Underworld*, p. 264.

33. Halliday, *Language as Social Semiotic*, pp. 170–72, 180.

Rock and Roll Graffiti

Westerners who venture away from Moscow's main avenues and stroll down side streets and through courtyards or peer into stairwells will eventually discover, amidst the indecipherable fan gang graffiti, familiar names in an alphabet they can read: BEATLES, LED ZEPPELIN, AC/DC, KISS, QUEEN, and other internationally renowned rock and roll bands. They will find many other names that are not so renowned; the variety of groups named demonstrates, if nothing else, Soviet teenagers' extraordinarily detailed knowledge of Western rock music. There are names of bands better known in Europe than in America, such as URIAH HEEP, KROKUS, ACCEPT, NAZARETH, and MODERN TALKING. There are names not all of which even the most dedicated followers of rock music would be able to identify, and whose commemoration in Moscow is rather startling. In the early 1980s, there were graffiti dedicated to MEAT LOAF, a very fat and briefly popular American singer; OTTOWAN, a black American group based in West Germany and entirely unknown to Americans; BLACKJACK, a very bad and very obscure American heavy metal band of the late-1970s; SMOKIE, an equally obscure British mellow-rock band of the mid-1970s; and SCORPIONS, a mediocre German heavy metal band. At the end of the decade, those had been replaced by HELLOWEEN, MANOWAR, VENOM, and other obscure new bands unknown to anyone but heavy metal fans. In 1983, Soft Cell, a minor British new wave group, figured not under its own name but in the guise of an album title, NON-STOP EROTIC CABARET. Then and later, graffiti named other album titles as well, the Beatles' ABBEY ROAD, Kiss's LOVE GUN, and Supertramp's BREAKFAST IN AMERICA, to name just three.

In 1983 and 1984 these graffiti as a rule stood alone or in twos and threes in courtyards and along side streets. But there were places where young people congregated and collections of band names accumulated. In an underpass outside Gorky Park in late 1983, for example, AC/DC and QUEEN were represented several times each. OZZY OZBORNE (that should have been "Osbourne"), BLACK SABBATH, DEEP PURPLE, RAINBOW, and SLADE, written in several different hands, were grouped in close proximity. In the fall of 1988, the same underpass—recently repainted—held several graffiti each of ACCEPT, KISS, DEPECHE MODE, and HEAVY METAL (a style, not a band), as well as OZZY, SCORPIONS, MANOWAR, DIO, THE BEATLES FOREVER! and WHITE SNAKE. There were also a few individually authored lists of rock bands in 1983 and 1984. One basement shutter boasted: DEEP PURPLE, ROCKET'S, KISS, SMOKIE, PINK FLOYD, AC/DC. By the end of the decade the long list of names was typical of this kind of graffiti. A representative example from a stairwell mentioned DURAN DURAN, KISS, W.A.S.P., BLACK SABBATH, DEEP PURPLE, NAZARETH, SLADE, JUDAS PRIEST, AC/DC, STATUS QUO, MOTORHEAD, SAXON, WHITE SNAKE, MANOWAR, DEF LEPPARD, METALLICA, OZZY OZBOURNE, RAINBOW, LED ZEPPELIN, and DIO.

Graffiti naming rock bands appeared in Moscow shortly after the *fanaty* pioneered public graffiti. As of 1983–1984, they accounted for roughly 20–25 percent of the total, as against the roughly 50 percent authored by fan gangs. In 1988, the proportions were exactly reversed; rock graffiti had become the leading genre. No catalytic, datable event comparable to the fall and rise of the Spartak soccer team accounted for the appearance of rock graffiti, and neither published sources nor private recollections fix the date. Probably, adolescents were inscribing the names of rock bands on Moscow's walls by 1979. Fan gang graffiti must have provided the immediate impetus; there has been more than a casual association between gang and rock graffiti. But of course we cannot begin to make sense of the graffiti devoted to rock music until we understand the music's place in Soviet society.

A BRIEF HISTORY OF
SOVIET ROCK MUSIC

The story of rock music's establishment in the Soviet Union is in outline simple.[1] It is also instructive: it provides a model of the way in which Western popular culture infiltrated Soviet society. Indeed, the music pulled considerable additional popular culture in its wake. The authorities proved unable to suppress the music, and as they gradually abandoned the cultural ramparts, popular culture became increasingly autonomous. Rock music also turned into an important item of commerce. Popular culture is commercialized in all societies, but in the Soviet Union much of the business has been transacted in the underground economy—what economists call the "second economy." The growth of an autonomous popular culture, with rock music as a central component, helped to drive the second economy boom.

When rock music arrived in the Soviet Union in the mid-1950s, both the interested public and official detractors at first conflated it with jazz, which was both very popular and ideologically suspect. They soon learned the difference. Soviet Olympic athletes were introduced to rock music in Melbourne in 1956, brought records back, and showed the dances they had learned. The first mass exposure came during the 1957 Moscow International Youth Festival, when the thousands of Western participants played their records, sang their songs, and became the models for Soviet youths to emulate. Twenty years later, Muscovites who had been teenagers at the time could still recall the excitement that this brief glimpse of the West in their midst had brought. And in 1957, Bill Haley and Elvis Presley recordings, on recycled X-ray plates, could already be bought on the black market.[2]

By the second half of the 1950s, the basic channels through which rock music and other artifacts of Western popular culture were assimilated had been established. A few records arrived and achieved instant notoriety and value, as much for their Western provenance as for their intrinsic appeal. But the rhythm and energy of rock music did provide a welcome alternative to staid Soviet pop fare. Private

workshops, already producing some jazz plates, added rock to their inventory and achieved commercial success. Tape recorders later made acquisition and then mass reproduction much easier, but workshops continued to cut bootleg discs into the 1980s. The lag between the rise of a band to the top of the charts in the West and its popularity among Soviet young people was never long, and eventually disappeared altogether. Diffusion into the provinces was slower, but word of the latest Moscow and Leningrad fashions did percolate out.

Fierce, utterly unavailing resistance by Soviet cultural authorities provided a comically solemn antiphone to the steady advance of rock music. Down to the middle of the 1960s, the official line was that rock was a clever device to divert youthful anger against the capitalist system into harmless channels or, alternatively, that music capitalists had invented rock to foment a sensation and so part the young from their money. One presumes, of course, that official hostility stemmed as much from conservative sensibilities as from ideological scruples. It was not just the music that offended, but the associated dances as well. The twist, for instance, was judged repellent because of its "sexuality, its deliberate intimacy, its isolation from everyone and everything and its demonstrative contempt for social principles."[3] Police, Komsomol activists, teachers, and chaperons broke up jam sessions and dances they considered indecent, and posted signs at public dance floors banning dances "in the style" (that is, in the Western style); other notices ordered "Twisters Out into the Cold." And all in vain. Soviet teens preferred to twist and chance expulsion than appear to be old-fashioned. They soon felt an equal obligation to dance the shake, the monkey, and the jerk. Dance bands, to hold their customers, had no choice but to sneak as much fast, danceable music into their programs as they could.[4] Even before the advent of the Beatles, in other words, young people throughout the Soviet Union had been exposed on a considerable scale to Western rock and roll music. With the ground well prepared, the Beatles and the other groups that were a part of the first British wave swept triumphantly through the Soviet Union, and *bitlz* entered the Russian language as a generic term for local longhairs who imitated the Liverpool four.[5]

By the middle of the 1960s, those who monitored the behavior of Soviet teens understood that they had lost the first encounter with rock, and they began to make tactical accommodations. In February 1965 the *Moscow Evening News* (*Vecherniaia Moskva*, the capital's most popular newspaper) announced that the twist was not objectionable "if danced beautifully." The "Twisters Out into the Cold" signs came down in the capital, though harassment continued in the provinces until the end of the decade. The poet Leonid Martynov, in "Tvist v Krymu" ("The Twist in the Crimea"), even likened the twist to the eminently acceptable folk dance *kazachok*. At the same time, cultural authorities cast about for suitable alternatives. The Ministry of Culture attempted to popularize the bunny hop (under the name "khoppel-poppel") and encouraged the invention of native Soviet dances in the rock idiom. The problem with the new Soviet dances was epitomized by the *infiz*, so called because it was devised in the Institute of Physical Culture; even Soviet commentators had to admit that the *infiz* and the other dances were too contrived, too complicated, and too athletic.[6]

In the meantime, amateur musicians had formed rock bands and had not incidentally stimulated the black market production of instruments and amplifiers. The Soviet bands of the 1960s were almost entirely imitative, trying as best they could to reproduce the music coming in from the West, English lyrics included. In practice, many vocalists mouthed incomprehensible sounds that seemed English to the Russian ear, "fish style" (*ryba*), as the technique was called. Bands that wrote their own lyrics did so mostly in English, that language being considered part of the rock aesthetic. But Soviet bands in this respect behaved no differently from rock musicians all over Europe; for the first few decades, English was the language of rock music just as Italian had at one time been the language of opera. By the middle of the 1960s these amateur bands had gained a haven—and practice facilities, and in some cases access to expensive instruments and amplifiers—in schools and in clubs attached to factories and other institutions. The clubs had a commercial stake in attracting paying customers, and rock bands provided the drawing power. The better bands performed regularly for pay in cafes and restaurants and at

academic institutions. They were in especially great demand and commanded high prices—on the order of 1,000 rubles, at that time half of an average annual salary—at high school graduation proms. By the end of the decade, promotion of engagements by rock bands had become a profitable enterprise, and one especially successful underground entrepreneur even organized annual rock festivals in Erevan, Armenia, from 1969 to 1972; at which point he was arrested, apparently for not passing a sufficiently generous share of the profits on to local authorities.[7] An underground rock music economy had been born, and the underground was for the time being where it had to remain.

In the late 1960s the authorities sought to provide an attractive legal alternative to these underground bands by awarding official concert status to a few of the more polished and cooperative groups that were then trying to write their own music. *Pesniary* (the Songsters), for instance, was a Belorussian band that for the sake of official status and record contracts stopped attempting to imitate the Beatles and instead mixed soft rock and pop with Belorussian folk music. *Veselye Rebiata* (the Happy Lads) played a bit of real rock along with electric pop. These and some of the other official groups that emerged later were at first quite popular, played to thousands in sold-out concert halls, and released records that sold well. The price of their success was denatured music. As David Sloane points out, the Soviet press even embargoed the word "rock" as applied to these Soviet groups, referring to them instead as "vocal-instrumental ensembles" (or VIAs); until the late 1970s, no officially approved Soviet band could call itself a rock band, or be referred to as such. The VIAs successfully carved out a niche for themselves in the world of Soviet popular music, but their performances were so closely monitored and they had to play so many clean-cut Soviet pop tunes that they displaced neither the semiprofessional groups that played rock with the beat left in nor the Western records that continued to command prices of 100 rubles or more on the street. Over the long term, only a single product of this sterile milieu achieved lasting success. Alla Pugacheva, who originally sang for *Veselye Rebiata* and launched a solo career in the 1970s, became a genuine superstar because of her ability to

incorporate a wide range of Western styles (including Motown and reggae) in her repertoire, and to tweak social, moral, and political conventions during concerts.[8] The lesson there was clear enough.

If the 1960s ended with grudging official acceptance of a denatured Soviet version of rock, in the 1970s even Western rock groups received official Soviet blessing. The turn from hostility to hospitality was abrupt. In the early 1970s the Soviets refused to allow entry to the Fifth Dimension, a sugary-sweet group that the American government proposed for the cultural exchange. In 1974 the Soviets did admit, perhaps inadvertently, an American rock band that performed with the Joffrey Ballet's "Trinity," but it took three years of negotiations to win approval for a month-long tour by the Nitty Gritty Dirt Band in 1977; the band's use of folk music and instruments allowed cultural officials to pass it off as essentially a folk group. Then in quick succession the Soviets staged performances by Boney M (a Jamaican reggae group based in West Germany and best known for its hit "Rah Rah Rasputin, Russia's Greatest Love Machine") in 1978, and by British rocker Elton John and the American king of rhythm and blues, B. B. King, in 1979. Access to these concerts was tightly controlled, but in 1978 a Leningrad newspaper announced that on July 4 there would be an open-air concert by Santana, the Beach Boys, and Joan Baez in front of the Winter Palace. By the time fans poured into the city, the authorities had thought again and had canceled the concert, and there was a protest demonstration down the city's main drag. But if that break-through was thwarted, records by Western groups were in the meantime being released by the Soviet record industry, first (as happened to Credence Clearwater Revival in the mid-1970s) covered by a Soviet group that imitated the original, then under contract: ABBA, Paul McCartney and Wings, John Lennon, Boney M. A movie of an ABBA concert was also shown widely in Soviet theaters.[9] This sudden opening to Western rock groups had all the earmarks of a coup by younger members of the cultural establishment. By the late 1970s, a new generation that had grown up with Western rock music was rising in the hierarchy, and the old ideological defensiveness was crumbling.

The same generational transition was evident in other arenas of more immediate importance to Soviet young people. The Komsomol's mass circulation monthly, *Rovesnik*, which in the 1960s had joined in the general denunciation of Western music, began in the second half of the 1970s to carry tidbits of Western rock gossip out to the provinces.[10] During the 1970s the Komsomol Theater in Moscow integrated a rock group into its productions, and by the end of the decade the theater attracted a youth audience as much because of the hard rock that blasted from the loudspeakers as because of the plays.[11] After 1975, the Komsomol also began sponsoring discos; by the end of the decade there were hundreds in Moscow and other cities, and then thousands. The novelty here was that Soviet teenagers could dance to the Western music they liked best, and that they still traded on the black market, with the requisite amplification and with flashing lights, all under the aegis of the Komsomol. The Ministry of Culture charged the Komsomol with providing culturally edifying programs as accompaniment, but few discos actually performed to the ministry's satisfaction. And if the local public disco did satisfy the authorities, teenagers could for a price enjoy private discos with better music and the opportunity to purchase drinks.[12]

While commercialized top-40 Western rock was gaining official acceptance, Soviet rock musicians were finally developing their own styles, and in the late 1970s and early 1980s they also gained at least tacit official recognition. Among the first major groups to stop imitating Western groups, compose their own songs entirely in Russian, and work their way out of the rock underground were *Arsenal* (Arsenal) and *Mashina vremeni* (Time Machine). Arsenal, founded by the jazz musician Aleksei Kozlov, played in the idiom of Chicago and Blood, Sweat, and Tears, and had an enormous influence on other Soviet rock musicians. Time Machine had a stronger hold on the rock audience. Its music was basic, but its songs of adolescent angst and unfocused yearnings, and of the hypocrisy of the adult world, earned it the status of an underground supergroup, the first in the history of Soviet rock music. Time Machine acquired official concert status in 1979, and over the next few years released a few singles, appeared in a movie, and continued to sing the songs that had made it

popular. In consequence, it earned nasty adult comments on its questionable ideology and excessive pessimism. These negative reviews did not prevent the legalization of a few other formerly underground rock bands over the next few years.[13]

Because Arsenal, Time Machine, and groups like them wrote their own music, they developed public identities that earlier semiprofessional bands had lacked. They also released a few records officially, but much more of their music circulated on tapes, which they began to produce for the black market in the late 1970s. Through tape sales (at 10 rubles a cassette, the same price charged for rerecordings of Western groups), even the groups that did not have official performance licenses could become nationally known. Lack of a permit did not in fact prevent them from going on tour; clubs, even concert halls, that needed revenue to meet their annual profit plans signed up bands whether they were officially approved or not, just as they always had. There was more money to be made from these underground tours and the black-marketing of tapes than could be made on the official circuit. And restaurants still counted on local bands to attract customers, and so continued to provide a place for groups to break in.[14]

As of 1980 or so, a number of groups had national followings and had played all over the country, and their music had circulated even more widely on tape. The rock underground had acquired a density and structure that were qualitatively new, but by then "underground" was something of a misnomer. Although cultural officials and the police continued to harass rock groups, in 1980 the city of Tbilisi hosted a major rock festival, and top prizes went to genuine rock groups like Time Machine and Magnetic Band (from Tallinn). In 1981 an official rock club opened in Leningrad and provided a haven and unpaid bookings for unofficial bands, this in a city in which for several years running police had broken up attempts to hold rock festivals. In the early 1980s a few intellectual journals began to carry sympathetic commentaries on some of the better bands, while youth newspapers introduced rock columns and charted the popularity of both the official and the supposedly amateur bands.[15]

Yet semi-outlaw status remained an important component of the image of both rock music and rock groups. The image

was increasingly in conflict with reality, but it had a life of its own. When Time Machine appeared on TV in the early 1980s, it acquired a reputation for having sold out, and its popularity declined precipitously, despite the fact that its repertoire was not much different from before, and despite its continued bad notices in the official press. The new supergroup was *Akvarium* (Aquarium), which thrived within the Leningrad rock clubs, performed successfully on the unofficial circuit, and was not tarnished with official concert status.

Officially or not, in the early 1980s rock became a public commodity as it had never been before, and much of the public, and officialdom, was shocked.[16] Russian groups mixed heavy doses of ironic social commentary into their music. *Primus* (Primus), one of the major Moscow bands, sang of Russian teens' primal desire for blue jeans, and offered a devastating and funny talking-rock composition based on the conversation among men lined up in anticipation of the 11 a.m. opening of the liquor stores. Other groups flaunted their heterodoxy in their names, such as the Leningrad bands *Razgnevannye klitory* (Enraged Clitorises) and *Menstrual'nye poviazki* (Menstrual Pads). Groups in the Baltic mixed nationalism into their songs, while a Baptist group in Leningrad sang religious rock and tried unsuccessfully to cross into Finland to find a recording studio.[17] The most popular bands drew on a native tradition of bardic social verse to guitar accompaniment, and achieved a genuinely poetic effect with their lyrics. Many groups did produce music and lyrics that were as banal as those in typical Western rock music, yet content analyses show that, on the whole, Soviet rock was at the time socially engaged to an unusual degree.[18]

Officials found the social commentary, no matter how poetically phrased, outrageous and the musicians' attire (often punk, glitz, or American insignia) and special effects (sound distortion, smoke, lasers) no better. They and cultural conservatives alike identified rock as the leading edge of an imperialist effort to corrupt Soviet youth, and they took action. In June 1983, Konstantin Chernenko, then in charge of ideology, wheezed to a meeting of the Communist Party Central Committee that "musical groups of dubious quality" were causing "ideological and aesthetic harm," and countless

acolytes took up the chant. Immediately thereafter, the Ministry of Culture ordered a review of all groups that had permission to perform, suppressed a few of them outright (some on the grounds of making speculative profits from their concerts), and imposed a performance moratorium on others. The Russian and other republic ministries of culture imposed tighter control over the lyrics of songs the official groups sang, and forbade them to devote more than 20 percent of their programs to their own compositions. Performances were to be toned down, and symbols alien to Soviet society were banned. Amateur groups were also required to register with some official body, and to have their lyrics vetted. And in October 1984, the USSR Ministry of Culture issued a directive forbidding the playing of the recordings (at discoes, for instance) of 68 foreign groups (mostly Anglo-American and West German hard rock and heavy metal bands, bands that used "Russian" or "KGB" in their names, and for some reason Julio Iglesias as well), and 29 Soviet groups, including Primus, Aquarium, and many other of the most popular Soviet bands.[19]

And yet for all the official ferocity, nothing much changed. The disbanded groups reformed under new names, concert and club managers still provided venues and closed their eyes and ears to the performances, black marketeers still did a lively business in the tapes of the banned Soviet and Western groups, and thousands of amateur groups refused to register with any official body. Rock music, both domestic and imported, was by now an ineradicable part of Soviet society. The number of rock bands alone rendered all efforts at control meaningless. The émigré Soviet musicologist Solomon Volkov asserted in 1982 that millions of Soviet young people were engaged not merely in listening to rock, but also in the performance and writing of the music. Official Soviet figures indicate Volkov's estimate was not wildly exaggerated. In 1984 the USSR Ministry of Culture counted 29,352 amateur bands with 230,000 members, while information given as official in 1985 had it that there were no fewer than 160,000 registered amateur "electric guitar groups."[20]

The new officials who took charge of cultural affairs soon after Gorbachev came to power in 1985 recognized that reality,

and effected an abrupt reversal of course. They have implemented a policy that combines laissez faire with what seems at times to be promotion of rock music. In 1985, *Avtograf* (Autograph), previously condemned in *Pravda* for aping the mannerisms of Western rock bands, was designated to take part in the international Live Aid concert. In 1986, Soviet rock groups, including some banned in 1984, took part in a benefit concert for the victims of the Chernobyl nuclear disaster. Rock videos, among them a Michael Jackson number, appeared on Soviet TV. Billy Joel, Carlos Santana, and the Doobie Brothers from the United States, Uriah Heep and UB-40 of England, and Modern Talking of West Germany played to Soviet crowds of 20,000 and more. Break dancing broke out, won praise in the press, and was rewarded with officially sponsored competitions. Heavy metal, long demonized by opponents of rock, received air play, and heavy metal concerts became commonplace. The Soviet Union even became an exporter of rock: *India Today*, reporting on the Soviet cultural exposition in India in 1987, suggested that backwoods cities would perhaps "get their first taste of rock culture" from the Soviets, and singled out Alla Pugacheva and Arsenal for special praise.[21]

By 1987 rock in almost all of its guises had become the mainstay of official Soviet popular music. That does not please the many older Soviet citizens who cannot abide rock music, and it enrages the conservative nationalists who denounce rock as satanism, a narcotic, cultural terrorism, or the moral equivalent of AIDS (a figure they use), an incurable delirium destroying Russian and Soviet national culture.[22] If the Gorbachev regime were to attempt to suppress rock, it would have considerable public support. But whatever they may think about the music, cultural officials now understand that they cannot control it: were they to try, they would merely revive the dynamic underground rock economy that had grown spontaneously for decades. All that the new policy has done is to make more visible what had been present all along.

The more serious Soviet commentators now discuss not whether rock music degrades art, or induces moral stupor, or subverts Soviet values, but whether it is at the center of a youth subculture, and whether the many years of official persecution

contributed to the formation of that subculture.[23] Of course rock is as much a social as a musical (or economic) phenomenon. In the Soviet Union as in the West, rock music exerts a major influence on fashion and language, and it provides the framework for adolescent self-definition and self-assertion. It was just this extramusical freight that led Solomon Volkov to suggest in 1982 that Soviet rock music was at the center of a subculture threatening to turn into a counterculture.[24] And, as in the West, rock music has outgrown the adolescent ghetto. It retains a hold on men and women in their 20s and 30s, and some older than that, for whom popular music means rock.

HEAVY METAL GRAFFITI

Rock music has a long history in the Soviet Union and had thoroughly saturated Soviet society by the 1970s. That is an important fact. We can see in the example of rock music how Soviet popular culture grew around and over official barriers, how the uncontrolled likes and dislikes of Soviet young people spawned social and economic institutions beyond the control of the regime, and how unofficial popular culture ultimately found sponsors within the regime itself. That is, Soviet popular culture not only became more autonomous— genuinely popular—with every passing decade, it eventually put pressure on official cultural and political institutions. And all of that years before Mikhail Gorbachev came to power. The way in which popular culture, or at least commercial youth culture, grew away from statutory institutions makes it a useful model of the social changes that have occurred since the 1950s. Yet the history of Soviet rock music does not explain the production of graffiti about rock music, or why graffiti writers concentrate on certain kinds of rock bands. When we appreciate how little the emergence of a dynamic community of rock consumers and producers contributed to the graffiti, we will be better able to understand what the graffiti are really about.

No doubt the prolonged exposure of Soviet society to rock music was a prerequisite of the graffiti, but no law of graffiti

requires that the names of rock groups be inscribed on public walls. In the West, graffiti hailing rock music are rare. They have never appeared in any quantity remotely approaching the tens of thousands that adorn Moscow and other Soviet cities. Whatever the urges are that find an outlet in graffiti—to violate taboos, fashion group or individual identity, vent aggressive impulses, address the world at large—they do not in the West spring from adolescent enthusiasm for rock music. In the Soviet Union, the name of a rock group on a wall does constitute a public violation of a taboo, or a message, or both, but after even a brief review of the history of rock music it is not self-evident why this is so. The music had ceased to be taboo long before the graffiti appeared in 1979. Western rock bands had large Soviet followings years before Soviet teenagers found a reason to inscribe public testimonials to them.

Since the music did not inspire the graffiti, the mostly likely stimulus was the graffiti that the *fanaty* began producing in the late 1970s. In a way, this is a trivial proposition: the second variety of public graffiti followed after the first. But chronological and causal sequence yields an interesting implication: the message contained in rock graffiti inhered as much in the medium, in the writing on walls, as in the music that was written about. The fan gangs employed graffiti to establish their identities, and in doing so communicated ideas of aggressiveness, defiance, and violence. Those who first wrote the names of rock groups on the walls used graffiti to broadcast the very same attitudes.

Graffiti naming rock bands reflect only a very small part of the Soviet experience with rock music. The very familiarity of the bands the graffiti celebrate is misleading, at least for Westerners. We may be surprised to see BEATLES and KISS and the names of other Western bands written in large Latin letters in Moscow, but because they represent the world of rock music as we know it, we are likely to assume that if such graffiti be, then these are the appropriate names. But of course the Western bands, as popular as they are, do not account for all the music to which Soviet rock fans listen. Rock music is well rooted in Soviet society, and Soviet rock fans could write more and different names than they do. Those missing names provide the key to deciphering what we do see.

By the time rock graffiti appeared at the end of the 1970s, the rock underground was in full flower, yet prior to 1985 the names of the leading Soviet bands were scarcely ever on display. One had to look long and hard to find an occasional *MASHINA VREMENI* (Time Machine, the best-known group of the period) or *ROK-GRUPPA "VOSKRESENIE"* ("Rock Group 'Resurrection,' " one of the bands repressed in 1983); or a pair devoted to Primus, *PRIMUS* FANS balanced by *PRIMUS GOVNO* ("Primus is shit"); or a quotation from a song by Aquarium, *TY SMOTRISH V OKNO A GLIADISH' NA SVOE OTRAZHENIE* ("You look in the window and see your own reflection"). The very infrequency of graffiti referring to Soviet bands served as a reminder that, if the graffiti had been an index of popularity, Soviet groups should have been named often. The names of Soviet bands were also missing from Leningrad, which in the early 1980s was home to a particularly vital rock community. One would have expected that the semi-outlaw and cult status of many of the underground bands might have made them ideal subjects for graffiti, because they exemplified the fashionable heterodoxy so often encountered in adolescent graffiti elsewhere. Later in the decade a small but noticeable proportion of Soviet graffiti did begin to mention Soviet bands, but their absence prior to 1985 leaves no doubt: the Soviet rock underground had nothing to do with the initial outbreak of graffiti devoted to rock music.

The enormous number of Western groups named in the graffiti give a misleading impression of complete coverage. Just as the Soviet underground bands were missing, so were major segments of Western rock music. It is a curious fact, for instance, that graffiti writers by and large ignored the Western groups and musicians who toured the Soviet Union in the late 1970s, or whose records were released around that time by the Soviet music industry. ABBA has been a consistent but infrequent exception to that rule. The Western groups invited under Gorbachev have fared just slightly better; at least one graffito, *D. Dzhoul'* (that should have been *B.*), in Leningrad takes note of Billy Joel, and there are some MODERN TALKING and URIAH HEEP graffiti, too—but they predate those groups' Soviet debuts. A very few MICHAEL JACKSON

graffiti no doubt derive from his appearance on Soviet TV. But at no time in the 1980s have more than a minuscule portion of the graffiti been related to Western bands' performances or release of records in the Soviet Union. In the early 1980s the graffiti mentioned no American country-rock bands, no rhythm and blues artists, no Motown or disco groups, and no reggae musicians. In 1983–1984, there was not a single graffito dedicated to Jackson Browne, Bruce Springsteen, Boy George, or Sting and Police, all extremely popular at the time. Every one of those styles, groups, and musicians was known to Soviet adolescents, and not just in Moscow: an early 1980s advertisement for a disco-in-the-park in the remote Central Asian city of Fergana promised that the program would include hard rock, "eccentric rock," "black humor rock," punk rock, and country rock.[25] POLICE did, finally, merit a graffito in Leningrad in 1988. The truth is that the writers of rock graffiti have never produced a representative sample of American, or British, or continental Top 40 music. They could easily do so if they wished.

Soviet adolescents know all the Western bands and styles, but those who write graffiti have consistently concentrated on two very narrow segments of rock music. One of these consists of the Beatles, and John Lennon as an individual. Beatles graffiti convey unambiguous antimilitaristic messages and frequently accompany pacifist symbols. They constitute an important and distinct subgenre and we will have occasion to consider them again, but they account for only a small percentage of the graffiti about rock music. Throughout the 1980s, the most frequently named bands by far have been AC/DC and Kiss, from the heavy metal ("thud rock") school that emphasizes basic rhythms and overpowering, often distorted, electric guitars; one heavy metal number, "Feel the Noize," gets the impact of the music just right. In 1983 and 1984 Queen and Deep Purple, also heavy metal bands, trailed somewhat behind Kiss and AC/DC. The Deep Purple graffiti subset included separate mentions of the group's one-time lead guitarist, Ritchie Blackmore, and Rainbow, his next band. With the exception of the Beatles, the graffiti in those years named no other groups with any regularity, but the great majority of names that appeared more than once—Krokus, Def Leppard,

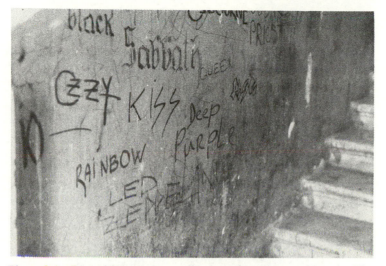

Photo 3.1 Part of a typical *metallist* list of heavy metal bands. The list, with many repetitions, extends up two flights of stairs. (Moscow, 1988)

Iron Maiden, Nazareth, Black Sabbath, Saxon, Uriah Heep, Ozzy Osbourne—were also part of the heavy metal genre.

That pattern continued in 1988. Accept (West German heavy metal) followed slightly behind Kiss and AC/DC, with Metallica, Manowar, Ozzy Osbourne (he had advanced a notch or two in the standings), Black Sabbath, Deep Purple, and W.A.S.P., all heavy metal bands, also regularly inscribed. And most of the many other bands mentioned—Slayer, Sodom, Helloween, Metal Church, Anthrax, and Venom, to name just a few of the bands new to the graffiti since 1983–84— played heavy metal, too. HEAVY METAL was an occasional graffito in the beginning of the decade, very frequent at the end, as was just plain METAL. By then fans of heavy metal had fashioned their own HMR ligature (Figure 3.1a), reducing HEAVY METAL ROCK to an easily inscribed logo. Graffiti in 1988 even named highly specialized varieties of heavy metal music: ONLY SPEED METAL and THRASH METAL TOP (or ONLY THRASH).

The heavy metal style involves far more than musical violence. The bands employ shock effect in their stage

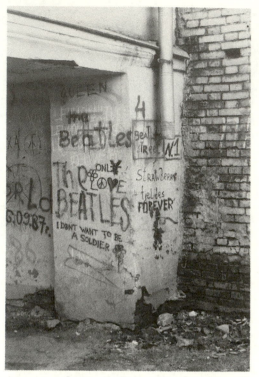

Photo 3.2 A courtyard ("Beatle Street No. 1") where Beatles fans congregate. Similar graffiti cover the entire courtyard. (Moscow, 1988)

presentations and, in one combination or another, the trappings of devil worship, misogyny, sadomasochism, and Nazism. Metal and leather are an almost necessary part of the costume. These are the bands that God-fearing Americans suspect of secretly recording satanic chants backward, and that prompt maladroit efforts to censor rock lyrics. AC/DC lyrics (and those of heavy metal groups in general) emphasize sex, drinking, and damnation, and the band regularly moons audiences. Kiss for many years appeared on stage in elaborate, ghoulish costumes and makeup and killed chickens—blood spurting across the stage—as part of its act; early Kiss albums bore such titles as *Hotter than Hell, Dressed to Kill,* and *Destroyer.* Ozzy Osbourne (*Diary of a Madman, Speak of the*

(a)

(b)

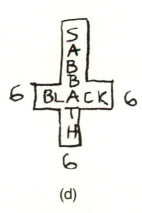

(c)

(d)

Figure 3.1

Devil), one-time lead singer for Black Sabbath, bit off the heads of doves and bats in concert—or at least that was the legend. Soviet rock fans have all along been aware of these heavy metal traits, if only because Soviet ideological moralists took pleasure in revealing the revolting details when they condemned heavy metal bands by name and in general.[26]

The graffiti reveal that Soviet heavy metal enthusiasts are attracted to just these elements in the heavy metal style. AC/DC and Kiss may be particularly popular with graffiti writers because their trademarks (as in the graffiti in Figure 3.1b)—the Nazi SS twin lightning bolts in KISS, the gothic lettering and lightning bolt of AC/DC—convey visually the heavy metal ethos. Not all the Kiss and AC/DC graffiti are as carefully lettered as those, but almost all capture the lightning bolt in some way. Most other heavy metal groups also employ Gothic—or at least pseudo-Gothic, or at least angular and suggestive—lettering in their album designs, and Soviet graffiti writers copy the designs faithfully (as in Figure 3.1c). Black Sabbath graffiti frequently involve inverted crosses, with 666—the number of the beast—at the bottom three points (Figure 3.1d).

Out of the full range of rock music familiar in the Soviet Union, the writers of graffiti are attracted disproportionately to heavy metal bands. Within that narrow frame they focus particularly upon AC/DC and Kiss, whose sinister images can be communicated in the very lettering of the names. Even in 1984, those two bands were musically passé both in the West and among Soviet heavy metal fans; only the ethos that their graffiti project has sustained them as the symbols of heavy metal. The frequency with which the heavy metal bands appear in graffiti does not reflect their relative popularity among Soviet rock fans at large, any more than the absence of the names of Soviet bands in the early 1980s meant that the rock underground was unimportant. Graffiti measure the popularity of bands only among graffiti writers, and it is the complex of attitudes associated with heavy metal music and style that attracts them.

The characteristics of graffiti as a medium of communication in the Soviet Union prompted the match between graffiti and heavy metal. The heavy metal bands hyperbolically defy

musical, social, and moral conventions, and that corresponds perfectly to the violation of taboos inherent in writing graffiti on public walls. Defiance and aggression were associated with graffiti as pioneered by the *fanaty*, and so it was the example of fan gang graffiti that both elicited and defined the contours of, graffiti devoted to rock music. The medium was appropriate for an aggressive message; it attracted heavy metal writers at the same time it screened out the names of most Western rock bands and the entire Soviet underground rock movement. Of the non-heavy metal bands, only the Beatles found a substantial niche in Soviet graffiti, and they did so not just as rock musicians, but as exemplars of counterculture pacifism.

METALLISTY

No one paid any attention to them, but the heavy metal graffiti proved to be predictive. As of 1984, heavy metal sentiments were widely advertised on the walls, but not otherwise apparent. Within two years, the fans of heavy metal had coalesced into groups of *metallisty* who had their own loose organizations, hangouts, and distinctive dress. They imitated the costumes of their favorite Western heavy metal groups: metal-studded leather vests, arm bracelets, spiked hair, and chains were generic, but those who favored the group Manowar donned military garb, followers of speed metal bands like Metallica emblazoned "Satan" on their T-shirts, Black Sabbath fans wore inverted crosses. Groups formed all over Moscow, to listen to and play metal music, and to attend the newly tolerated heavy metal concerts: the heavy metal sound and style suddenly became very prominent among both the officially registered rock groups and the semiunderground and nonprofessional bands. In some respects the *metallisty* were just dedicated fan clubs, and in the new and more tolerant atmosphere of Gorbachev's Moscow a few groups of heavy metal fans (but not the "black metal" devotees of satanism) managed to register as clubs with official organizations such as the Komsomol. Registered or

not, the local clubs formed a loose citywide network; *metallisty* from all over met at designated cafes, and roamed the streets and parks in packs. They looked very threatening in their leather and metal outfits, especially to Muscovites unused to public displays of defiantly nonconformist dress. Most groups did not actually indulge in violence, but enough did to sustain the image.[27]

Accounts of the genesis of the *metallisty* consistently identify *fanaty* as the immediate forebears. Some individual *metallisty* admit to having first been in fan gangs, while Soviet commentators note that during the lull in fan gang activity in the mid-1980s heavy metal music replaced soccer teams as the object of fanatical rooting.[28] Of course, the connection can have involved at most shared attitudes and a common milieu rather than an organizational transformation. Everyone agrees that the *metallisty* are on the whole young, around 14 to 17 years old. Only a very small number of the heavy metal activists of 1986 and later could have been in the fan gangs in the early 1980s.

Yet graffiti do substantiate the connection. In the early 1980s gang and heavy metal graffiti often shared wall space; that was not surprising, since they also shared intimations of violence. AC/DC and TsSKA or Kiss and Spartak emblems were written next to each other, often in the same hand. Occasionally the link was closer than mere physical proximity. The graffito *TsSKA* SUPERCLUB*KISS ARMY* spelled it out. "Kiss army" was what Kiss fans in the West styled themselves, and it may be that the author of this graffito was aware of the pun involved in joining KISS ARMY to the initials of the army soccer team. Whatever his level of linguistic sophistication, he explicitly associated Kiss with ganglike behavior. KISS ARMY standing by itself had gang overtones, and in the early 1980s KISS ARMY graffiti dominated the occasional Moscow court-yard in the same way that fan gang graffiti dominated others. One small courtyard staked out by the CENTRAL KISS ARMY also proclaimed LOVE GUN and DESTROYER (Kiss albums); in a large graffito listing the army's phone numbers, two of the soldiers assigned themselves the names of band members; Misha was Gene (Simmons), Sergei was Paul (Stanley), while another Sergei had no pseudonym.

More common than the interweaving of heavy metal and gang statements was the incorporation of the gangs' argot in rock graffiti. In a way, even inscribing the bands' names in English—they can be transcribed into Russian, and the scene is still Moscow, after all—involved use of the argot, because it rendered even the simplest heavy metal inscription incomprehensible to most passers-by. Probably the heavy metal writers wrote their graffiti in English for the same reasons that the *fanaty* put all their honorifics in English, rather than actually borrowing the practice from the fan gangs. But they did borrow. Declarations such as KISS FAN and AC/DC FAN CLUB were not uncommon in the early 1980s. To Western eyes, those graffiti appeared deceptively commonplace; in the idiom of the *fanaty*, however, FAN connoted gang membership. The graffito in Figure 3.2a may be a visual pun, with the crown as part of a queen's regalia, but gang graffiti first established that symbol. The graffito in Figure 3.2b employs gang vocabulary even more explicitly and fully: the FAN, crown, and V-for-victory symbol were all taken from gang graffiti. *Pakhan*, at one time criminal argot for "gang leader" but now mere slang, was transliterated into English to accord with the rest of the graffito, and was identified as FILL (probably Phil misspelled, a reference to Phillip Rudd of AC/DC).

Heavy metal graffiti not only borrowed from the vocabulary of gang graffiti, they also used the fundamentals of the gang grammar, at least in a rudimentary way. When a metal graffito involved more than the name of a band, English was invariably the language of exhaltation. Queen was THE BEST and AC/DC and Kiss had many FANS. (Other graffiti devoted to rock music followed the same rule: BEATLES TOP POLL and SONGS OF THE BEATLES WILL LIVE FOREVER.) If they had wanted to, the authors could have written their encomia to Queen and the Beatles in Russian. Either they deliberately chose English or they simply assumed that English was the appropriate language for praising their favorite bands. No graffiti criticized Western bands in the early 1980s, but the very few graffiti that named Russian bands followed the rule that English was used to praise, Russian to denigrate: *PRIMUS* FANS was positive, *PRIMUS GOVNO* ("Primus is shit") negative.

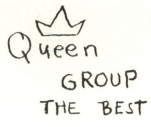

Queen
GROUP
THE BEST

(a)

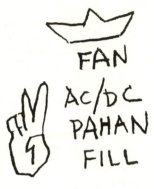

FAN
Ac/DC
PAHAN
FILL

(b)

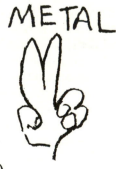

HMR METAL

(c)

Figure 3.2

The relationship between gang and early rock graffiti was, then, quite close. Gang and heavy metal statements frequently inhabited the same space. When rock graffiti writers went beyond a simple declarative AC/DC, KISS, or QUEEN, they either employed the vocabulary and grammar of gang graffiti or joined gang and band in a single composite graffito. Both gang and rock graffiti used a language the knowledge of which was confined to distinct subcultures, probably a single sub- culture that included both *fanaty* and heavy metal writers. Shared attitudes underpinned the linkages.

No one seems to have noticed exactly what transformed the widespread heavy metal sentiments of the early 1980s into identifiable and cohesive groups of *metallisty*. There was some connection to the decline of the fan gangs at mid-decade, but whether the decline of the gangs came first or whether the pool of *fanaty* dried up when adolescents began to fashion them- selves into *metallisty* is unclear. In either case, the *metallisty* emerged on the streets almost as dramatically as the *fanaty* had in the late 1970s. A reasonable guess is that the heavy metal concerts that began under Gorbachev were the catalyst, because they gave heavy metal fans an opportunity to flaunt their attitudes publicly in the fist-waving, body-jerking hysteria that metal fans the world over display. These concerts did not create *metallisty* out of thin air, any more than Spartak's fall from the championship league created fan gangs. But in both cases, public performances served as precipitants in the social chemistry of group formation. Heavy metal fans needed a social occasion in order to become a social group.

Soviet commentators see in the *metallisty* a social pathology, working-class hostility to the socially privileged. That is an easy error to make, given the metal fans' public posturing. Aleksei Kozlov, long-time leader of the jazz-rock group Arsenal, asserted in early 1987 that metal fans were kids from broken homes in Moscow's working-class suburbs, trapped in dead-end schools and dead-end jobs, antagonistic to the affluent youth of central Moscow with their cars, tape decks, and Western fashions. For that very reason, Kozlov supported heavy metal concerts: "They just like to wave their hands and then calm down. If we forbid this music, they will display their

aggressiveness in other forms."[29] A police specialist on youth groups proffered the same diagnosis, but in crude psychologizing terms: the *metallisty*, he asserted, occupy a sociocultural ghetto, and they are neurotic, as demonstrated by their ecstatic behavior at concerts and discos.[30] Such pronouncements aside, there is no good evidence that the *metallisty* are overwhelmingly anomic, socially distressed offspring of the working class.

The distribution of the graffiti suggest, in fact, that the *metallisty* may be slightly skewed toward the upper half of the social spectrum. The names of heavy metal groups can be found all over Moscow, but they are most numerous in the more prestigious central districts, where they have in large part supplanted the fan gang graffiti that predominated earlier in the decade. In the working-class suburbs, on the other hand, fan gang graffiti are more numerous than heavy metal inscriptions. The social maps are imprecise, but they imply that the more privileged teens of the center have switched loyalties from fan gangs to metal gangs; or, to be more precise, the younger brothers of the upper-middle-class *fanaty* of the early 1980s were upper-middle-class *metallisty* at the end of the decade. Nor is it difficult to find real live *metallisty* who go to academic high schools rather than trade schools, and who come from the families of the intelligentsia rather than from worker families.[31] Comparison with the United States is suggestive: American heavy metal fans are overwhelmingly male and in their mid-teens, and live disproportionately in suburbia.

The transformation of amorphous heavy metal enthusiasm into *metallisty* has had some effect on the graffiti. For one thing, the detail has increased: the graffiti name more groups, more individual musicians, and more album titles. THE SONG REMAINS THE SAME/L.Z. (Led Zeppelin), METAL HEART (Accept), and KILLEMALL (Metallica) are just three of many titles the *metallisty* now inscribe. One result of the more intense association among heavy metal fans is an increased circulation of knowledge about the subject; the leaders of the groups are those who know most about Western heavy metal music. Accumulation and recitation of names is one of the metal fans' major activities, and it can serve as a test for

membership. In Leningrad in 1986, beginning *metallisty*—youngsters just starting to wear some heavy metal para-phernalia—were challenged by self-appointed guardians of true metallism to name 15 to 20 heavy metal bands and their leaders; if they could not do so, they were beaten up as imposters who did not have the right to wear metal regalia.[32]

The stereotyped graffito list of heavy metal band names was one by-product of the increased organization of metal fans. Another was the HMR graffito in double ligature, as shown in Figure 3.1a. By 1988 this reduction of HEAVY METAL ROCK had become one of the most common heavy metal graffiti, not only in Moscow but in Leningrad, Minsk, and Smolensk; it also appeared in Riga, Vladimir, and no doubt in many other cities as well. The generic declarations METAL and HEAVY METAL had also become far more common than they had been earlier, but HMR was the more significant because encoded: it had become the trademark of *metallisty* through-out the Soviet Union, it was a product of group self-conscious-ness, and it could only be an indecipherable puzzle to most Soviet citizens. In fact, Westerners would not recognize its meaning, either, because the *metallisty* had reduced English words to an abbreviation unfamiliar in the English-speaking world. Even if no other sources were available, the changes that had occurred in the graffiti would tell us that the scattered heavy metal enthusiasts had become organized *metallisty*.

As graffiti like ONLY SPEED METAL and THRASH METAL TOP from the second half of the 1980s show, metal writers continued to follow the rules laid down earlier. In Moscow in 1988, all statements hailing rock music in general or individual bands and styles were in English: LONG LIVE MANOWAR, ONLY SCORPIONS, ONLY HEAVY METAL, FREEDOM TO ROCK IN USSR, LONG LIFE HMR. And there were many others, including a good number by metal writers in need of further tuition: HAVE METALL!!, HEVI METALL, HEW METAL. In Moscow a single *KHEVI METAL* pointed up the fact that producing English-language graffiti is a two-step process: first the words must be learned (*khevi metal*), then they must be written in Latin characters (HEVI METAL and all other correct and incorrect variants). Of all of the heavy metal graffiti, a single offering in Leningrad, *NADO SLUSHAT'*

TOL'KO METALL ("Listen only to metal"), might have made sense to ordinary passers-by—if, that is, they knew what "metal" meant. Not only did they observe the rule dictating use of English, heavy metal writers invented a previously unknown English abbreviation, HMR, when they needed it. That is, they used English creatively, as their own language for expressing their own ideas. On those very few occasions when they vented hostility, they also observed the rule that Russian is the language of denigration: ACCEPT *ZHOPA* ("Accept is an ass"), and somewhat oddly, DEEP PURPLE *KONI* ("Deep Purple are horses," i.e., stupid beasts like TsSKA).

Metallisty also continued to use the symbols from the fan gang graffiti argot: crown, stars, and V-for-victory hand wag. Indeed, those symbols accompanied heavy metal graffiti more frequently in 1988 than they had at the beginning of the decade, when metal fans were more closely associated with the fan gangs. The graffiti in Figure 3.2c are representative of those accompanied by symbols—and they are generic heavy metal statements. Graffiti naming individual heavy metal groups also use these symbols (as do the graffiti from 1983–1984 in Figures 3.2a and 3.2b), but far less frequently. The difference, of course, is that METAL and especially HMR are affirmations of group identity, and thus are more likely to occasion symbolic assertions of superiority. In any case, the wholesale appropriation of the graffiti language of the *fanaty* by groups that had broken away from and in some areas superseded the gangs was a noteworthy development. The graffiti argot had become detached from its original milieu, but it continued to provide links between disparate social groups.

THE ASSIMILATION OF SOVIET BANDS, AND THE EXCEPTIONAL ST. BOB

Because *metallisty* have taken it upon themselves to multiply heavy metal graffiti, that variety now predominates over other graffiti devoted to rock music even more strikingly than was the case early in the decade. But heavy metal writers

do not have the walls to themselves. The Beatles remain a frequently named group, as before chiefly in association with pacifist statements. The graffiti name other Western bands, too, but proportionately less often than before. On the other hand, tributes to BREAK DANCING (or just plain BREAK, and very infrequently Russian *BREIK*) are a minor new variety of graffiti, a consequence of the brief flowering of unofficial break dance associations for a few years after 1985. Devotees of break dancing formed clubs in abandoned basement rooms and practiced their moves for hours on end, training for display at discos and organized competitions. They replicated on a smaller scale the organization and single-minded dedication of the *metallisty*, and their graffiti confirm that they had, at least for a while, a group identity.

By far the most significant new species of graffiti devoted to rock music in the second half of the 1980s were those naming Russian groups. *BRAVO* (Bravo), *BRIGADA-S* (S-Brigade), *Kruiz* (Cruise), *NAUTILUS* (Nautilus), *AVGUST* (August), *SEKRET* (Secret), *NEP* (NEP, the acronym for the New Economic Policy of the 1920s), *DDT* (DDT), and the names of many other Soviet rock bands—of all styles—are now inscribed on the walls of the major cities. Even Alla Pugacheva, more a pop singer than a rock star, is honored in both Leningrad and Moscow with a graffito or so, always in the style shown in Figure 3.3a, which proclaims "Bravo Alla" (*Bravo* being one of her albums).

If we consider graffiti about Soviet bands separately, the frequency with which bands are named is a general measure of their popularity. Fame is often local. August and NEP, for instance, are Leningrad bands that have earned graffiti only in Leningrad; Nautilus and S-Brigade are Moscow favorites. In Minsk, graffiti name two local heavy metal bands, METAL BOYS and METAL WOLF. Far and away the most frequently mentioned Soviet bands everywhere are *Alisa* (Alice), *Akvarium* (Aquarium), and *Kino* (Cinema), and the graffiti often name their charismatic lead singers as well: Kostia Kinchev (Alice), Boris Grebenshchikov (Aquarium), and Viktor Tsoi (Cinema). Grebenshchikov frequently appears simply as BOB, in either English or Russian spelling (see Figures 3.3b and 3.3c).

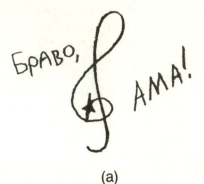

(a)

(b)

АКВАРИУМ

BOB

(c)

₅₅ АВГУСТ ₅₅

(d)

Figure 3.3

The appearance of these graffiti was significant, if only because it was so long delayed. Soviet rock bands had national followings years before they began to show up regularly in the graffiti. The breakthrough occurred just when the Gorbachev regime began to promote rock, and when Soviet bands began to perform frequently, at large venues, on TV, and sometimes in movies, and it may be that all of the new exposure was decisive. Yet most of the bands the graffiti name had been well known before that, at the very least through the circulation of tapes. Probably the way they were treated was more important than the publicity per se: they became public personalities with images cultivated just like those of big name Western bands. Whatever brought it about, the presence of Soviet bands amidst the graffiti suggests that Soviet rock fans are beginning to put these bands in the same class as the Western bands long acclaimed on the walls. But with the exception of Alice and Aquarium they are named no more frequently than most of the non-heavy metal Western bands; their presence on the walls is noticeable, but not large.

If it is significant that the names of Soviet bands appeared in the graffiti in the late 1980s, it is even more significant that the graffiti presented them in the familiar manner: they were easily assimilated into the existing graffiti conventions. English, for instance, is the language with which to honor Soviet bands even when their names are given in Russian; FAN crops up from time to time, for instance. A few graffiti about Soviet bands are written entirely in English, such as TIME MACHINE FOR EVER. And the name of the rock group Alice is written almost as often ALICE as in Russian, *ALISA*. The accepted stylized lettering of *Alisa* and *Avgust* (Figures 3.3b and 3.3d) has been borrowed from the conventional stylization of heavy metal band names. And a star occasionally shows up as a symbol accompanying a Soviet band name. A curious example of the power of these conventions is provided by the design of the album cover for *Shestvie ryb* (*A Procession of Fish*) by the group *Televizor* (Television). The name of the group and album are given in Russian, but against the background of a brick wall with graffiti: a star, a peace symbol, and the English words LOVE and ROCK.

There is one interesting departure from the existing rules of graffiti writing: the hammer and sickle symbol sometimes shows up as a prideful declaration that this is a Soviet heavy metal band, as for instance in Figure 3.4a, a graffito honoring S-Brigade. The hammer, often with the sickle that in some arrangements can be read as a Russian S for "Soviet," has become the symbol for Soviet heavy metal. The context in which the national emblem appears would no doubt appall the guardians of Soviet patriotism were they aware of it, but this is the first indication that Soviet symbols can have positive connotations for Soviet adolescents. Perhaps this is the first fruit of the Gorbachev administration's promotion of Soviet rock music. And yet even when using Soviet symbols, the heavy metal writers are likely to revert to English—as in Figure 3.4b—as the only language appropriate for the expression of enthusiasm. So far, the use of the hammer and sickle is a very minor deviation from the established rules of graffiti writing.

A much more significant exception is provided by a large collection of graffiti honoring Boris Grebenshchikov, leader of the rock group Aquarium. The stairwell of the building where he lives in Leningrad, at Sofia Perovskaia Street No. 5, has become an object of pilgrimage for fans from all over the Soviet Union. A graffito on the street sign proclaims this Boris Grebenshchikov Street, another on the building next to his announces *MUZEI* ("museum") BOB ART GALLERY. The gallery consists of the wall along the six flights of stairs that spiral up to Grebenshchikov's top-floor apartment.[33] Authors of the hundreds of large and small graffiti have identified themselves as visitors from Moscow, Sevastopol, Sverdlovsk, Artemovsk, Tiumen, Sochi, Voronezh, Tallin (in the Russian spelling, with only one *n*), Petrozavodsk, even distant Chukotia, opposite Alaska. Others are *metallisty* (they inscribe their HMR logo and the names of heavy metal bands; another graffito calls for the expulsion of the *metallisty*), punks (large graffito, crossed out), pacifists (the stairwell is chock-full of peace emblems), hippies, Krishnaists, Jews (stars of David), fans of the Leningrad soccer team Zenit, members of the rock band Alice (a series of graffiti), veterans of the Afghan war, and members of the Mitki (a nationalist counterculture group in Leningrad). They inscribe lengthy tributes, short notes of

„БРИГАДА ☭ "

(a)

METAL

(b)

(c)

FOREVER

(d)

БОБ

(e)

Figure 3.4

thanks for his music, declarations of undying love, and quotations from Aquarium songs. They draw pictures: a guitar, heads of Grebenshchikov and of the band's cellist and flautist, a railroad track with a water tap that refers to a song. Most frequently they liken Grebenshchikov to a saint. SAINT BOB is how one graffito puts it. *BORIA—TY SVIATOI* says the same in Russian.

It is not easy to explain precisely why Grebenshchikov and Aquarium have been singled out for such idolatry, or why they appeal to so many different audiences, but a part of the answer lies in the quality of the music and the lyrics. Grebenshchikov founded Aquarium as long ago as 1972, so the musicianship is by now extremely proficient in many different styles. There is a notable modern jazz inflection to some of this work, not surprising given that Grebenshchikov and his former occasional keyboardist Sergei Kurekin are accomplished jazz musicians. The music is sufficiently interesting to attract attention, but the poetic and slightly obscure lyrics hold it. "My efficiency increases every day/ I love my walls I call them home/ Signals reach me from all directions/ I dream of ashes," or "We danced

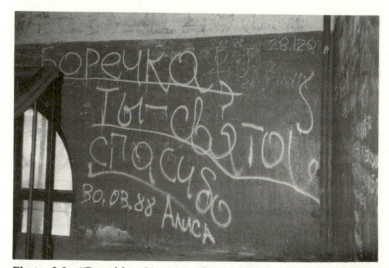

Photo 3.3 "Borechka, You're a Saint. Thanks. 30 March 1988. Alisa." Tribute to Boris Grebenshchikov from the rock group Alisa in the Grebenshchikov stairwell, Leningrad. (Credit: Susan Costanzo)

on the beach/ made love in the sand/ flew higher than a bird/ held stones in our hand," or "We stood on a plane/ with alternating angle of reflection/ observing the law/ that sets scenes in motion/ Repeating words with no meaning/ but with no power/ with no power"—verses like these have an intense appeal for adolescents, and for many adults, who are trying to define themselves personally and within their society. Since many lack specific referents, the lyrics can be understood as both personal and social statements. The texts of many of Grebenshchikov's songs circulate as underground poetry, and are typed and retyped just like the most treasured of samizdat manuscripts. Grebenshchikov's longstanding reputation for asceticism, for never compromising with the authorities, and for not trying to make more than a bare living from his performances and tapes adds considerably to the oracular quality of his verse.[34]

Thus Grebenshchikov is esteemed a saint, as the graffiti testify, or even a God, which has naturally provoked a reaction. *BORIA—TY BOG* ("Boria, you're God) and *BORIA—TY MOI BOG* ("Boria, you're my God") carry the hero worship about as far as it can go. *OBRASHCHAT' VODU V VINO!* ("Turn water into wine!") is presumably an ironic comment on such excess. Other visitors to the stairwell are more direct. One bold graffito proclaims *KUL'T LICHNOSTI B.G.* ("The B.G. Cult of the Individual"), which in the Soviet context has a very sharp edge. Other graffiti proclaim *ON NE BOG, ON CHELOVEK!* ("He's not a God, he's a man!") and (from the Mitki) *BORIA KAKOI NECHELOVECHESKIII UZHAS—MY POBOIALIS' K TEBE ZAITI* ("Boria, what a godawful horror —we didn't have the nerve to drop in"). And a few are downright nasty, calling Grebenshchikov a liar, a shit, or a fucker. The variation in attitudes toward Grebenshchikov and Aquarium has given rise, according to the popular lore, to the competing symbols in Figure 3.4c. The *A* with the halo attached affirms saintliness, while the *A* with the halo detached suggests that perhaps Grebenshchikov and Aquarium are not so special after all; the *A* with the peace logo is a visual pun of sorts, combining pacifist sentiments (widely ascribed to Grebenshchikov himself) with canonization. However, the *A* and detached halo also appear on an

Aquarium album cover, which suggests either that the popular etymology is wrong or that Grebenshchikov agrees, as some of his songs indicate, that the reverence has gone too far. In any event, all three symbols are quite numerous in the stairwell and in the rest of Leningrad.

Graffiti had begun to accumulate in the stairwell by at least 1985, the year of the first dated graffito visible as of 1988. Whether that was year one of the collection is another matter. The stairwell was reported to be "covered" with graffiti during the winter of 1986–87.[35] However, the walls appear not to have been painted at any time to October 1988, so they must have held many more graffiti then than earlier; "covered" for winter 1986–87 should not be taken literally. Not many of the graffiti are dated, but the preponderance of those that are date from 1987 and 1988. If in late 1986 only half as many graffiti were present as in late 1988, a first-time visitor would still have been struck by their number. If there were roughly twice as many graffiti in late 1988 as in late 1986, then 1984 or 1985 would be the likely starting point. Collections like that at Grebenshchikov's can grow very quickly. One of the very few comparable sets of graffiti, in the Bulgakov stairwell in Moscow, grew so rapidly that the walls were more densely covered within a year after the first inscriptions appeared in mid-1983 than was the Grebenshchikov stairwell even in October 1988.

Popular memory is not to be trusted here, because it attributes an honorable antiquity to any cult site. By 1986, for instance, devotees of Bulgakov believed that admirers had been writing praise in the stairwell for decades, not for a mere three years. Grebenshchikov's youth precludes an imagined tradition of that length, but by 1988 Leningraders firmly believed that there had been graffiti in his stairwell for many years. The likelihood is that Grebenshchikov graffiti began to accumulate at about the same time as, or at most a year before, other Soviet rock bands were so honored. While the collection testifies to Grebenshchikov's enormous popularity, and to the seriousness with which many Soviet adolescents and young adults take rock music, the probable date of origin fits comfortably within the familiar historical development of Soviet graffiti about rock and roll music.

In their variety and density the Grebenshchikov graffiti are of course quite exceptional, but what is most unusual about them as Soviet graffiti is the language: they are written mostly in Russian. In gang graffiti the use of English is mandated by the rules of the grammar. English is fundamental to the very numerous graffiti about Western rock groups, and English is used routinely in the not-very-frequent graffiti honoring Soviet bands that include anything more than a band name and song title. The Grebenshchikov stairwell itself provides an example: *MARAZM* FAN'S ("Decay Fans"). Among the hundreds of tributes to Grebenshchikov there are, of course, a few instances of English, such as the above-mentioned SAINT BOB. Others are GOOD MOOD TO YOU *BOB*, where the invariable nickname "Bob" is kept in Russian, and the Russian slang expression *byt' v mazhore* is translated awkwardly into English; *BOB* FANS!; and the sanctified Aquarium symbol in Figure 3.4d. These and the few other graffiti in English show yet again that among younger Russians English is the language of honor, but they are out of place. That point is driven home in a pair of graffiti: LET'S YOU WRITE THE SONGS OF YOURSELF, under which appears *ZAMKNITES'! VAM CHTO, HE KHVATAET RUSSKOGO?* ("Shut up! Isn't Russian good enough for you?").

The Grebenshchikov graffiti remind us that it is, after all, possible to write public graffiti in Russian. Or perhaps that it is necessary to do so, if the inscriptions are to be as elaborate as many of those in the stairwell. But the existence of this collection, and the even more thoroughly Russian-language collection of Bulgakov graffiti in Moscow, establishes something else: there is a cultural boundary within Soviet graffiti. On one side English is a necessary component of the graffiti; on the other side the use of English provokes an angry rebuke. Of course, English is here in part a placeholder for the argot of gang graffiti: whatever graffiti draw on that argot must incorporate English, while graffiti that do not use English cannot be associated with the gang milieu. The gang language that might be used to praise Grebenshchikov is indeed notably lacking in his stairwell: aside from *BOB* FANS and *MARAZM* FANS the few English-language graffiti do not use gang vocabulary, and the only other item

taken from the gang lexicon is a crown, used only once (Figure 3.4e).

We have in these contrasting languages of Soviet graffiti evidence of a sharp demarcation between different spheres of Soviet popular culture. We will explore the differences and their significance after we have examined the other Russian-language collection in the Bulgakov stairwell. First, however, we need to return to the much more numerous graffiti that incorporate large amounts of English and draw on the argot of the *fanaty*. And lest we forget, that includes the vast majority of the Soviet graffiti dealing with rock and roll.

NOTES

1. The history of Soviet rock music, unlike the history of Moscow's gangs, can be reasonably well documented from published sources; my reconstruction relies as well on discussions with Soviet informants, and on personal observations. For different accounts, with different foci, see S. Frederick Starr, *Red and Hot: The Fate of Jazz in the Soviet Union 1917–1980*, New York, 1983, pp. 292–315 (or more briefly, S. Frederick Starr, "The Rock Inundation," *Wilson Quarterly*, v. 7, no. 4, Autumn 1983, pp. 58–67); Artemy Troitsky, *Back in the USSR: The True Story of Rock in Russia*, Boston and London, 1987; Terry Bright, "The Soviet Crusade Against Pop," *Popular Music*, v. 5, 1985, pp. 123–48; Pedro Ramet and Sergei Zamascikov, "The Soviet Rock Scene," Kennan Institution for Advanced Russian Studies, Occasional Paper no. 223, 1987; and David Sloane, "Grandfathers and Children: The Rock Music Phenomenon in the Soviet Union," *Semiotext(e)*, forthcoming. Starr's account is somewhat skewed by the fact that his principal sources were rock musicians who emigrated in the mid-1970s, but he provides excellent coverage of the late 1960s and early 1970s. Bright and Ramet and Zamascikov concentrate almost exclusively on the period since the late 1970s. Troitsky, a Soviet rock journalist, provides the most comprehensive single account, but his judgments on the years before the late 1960s are founded on hearsay and are inexact. Sim Rokotov, "Govori! Illiustrirovannaia istoriia otechestvennogo roka," *Iunost'*, 1987 no. 6, pp. 83–85, offers a good analysis of the early period.

2. "Eshche raz o dzhaze," *Sovetskaia kul'tura*, 1 Oct. 1957; *New York Times*, 13 Nov. 1956, 3 Feb. 1957, and 3 Oct. 1957; *Newsweek*, 12 Aug. 1957; Starr, *Red and Hot*, pp. 241, 249–50; David Allchurch, "Diversions and Distractions: Beyond the Leisure Principle," *Soviet Survey*, no. 26, Oct.-Dec. 1958, p. 55; Aleksandr Dimov, "Blues, Jeans, and All That Jazz," *National Review*, 31 Aug. 1979, pp. 1106–7; Aleksandr Zhitinskii, "Zapiski rok-diletanta," *Avrora*, 1982 no. 2, p. 130; Rokotov, "Govori!" p. 185; Troitsky, *Back in the USSR*, pp. 18–20.

3. Igor Moiseev, "Tantsevat' 'stilem' zapreshchaetsia," *Izvestiia*, 29 Apr. 1962. See also the *New York Times*, 1 Apr. 1957; "Global Report on Rock 'n' Roll," *New York Times Magazine*, 20 Apr. 1958, p. 56; Anatolii Makarov, "Idoly i idealy," *Rovesnik*, 1963 no. 7; D. Poshunina and V. Zviagin, "O buntariakh i sinei ptitse," *Rovesnik*, 1965 no. 10; O. Orestov, "Krugi pered glazami," *Pravda*, 31 Oct. 1966; Leonid Shkol'nikov, "Vsegda li tanets sluzhit krasote?" *Molodoi kommunist*, 1968 no. 11, pp. 117–21.

4. *New York Times*, 3 Oct. 1957; G. Sviridov, "Iskorenit' poshlost' v muzyke," *Pravda*, 17 Sept. 1958; Lev Kassil, "Priglashenie k tantsu," *Komsomol'skaia pravda*, 6 Apr. 1962; Moiseev, "Tantsevat' 'stilem' zapreshchaetsia"; "Aldemaro iz Saltykovki," *Sovetskaia kul'tura*, 1 Sept. 1964; D. Zotov, "Povrezhdennyi tantsgigant," *Sovetskaia kul'tura*, 20 Feb. 1965; L. Shkol'nikov, " 'Rasreshite priglasit' . . .' O tviste, shliagerakh i problemakh sovetskogo bytovogo tantsa," *Trud*, 8 Sept. 1965; Shkol'nikov, "Vsegda li tanets sliuzhit krasote?"; V. Orlov, "Dva prikhlopa, tri pritopa," *Komsomol'skaia pravda*, 16 Feb. 1967; V. Ksenofontov and A. Chemonin, "Zametki o kul'turnoi rabote. V vechernii chas," *Izvestiia*, 19 Mar. 1968; Maurice Hindus, *The Kremlin's Human Dilemma*, Garden City, N.Y., 1967, pp. 88–89; Hedrick Smith, *The Russians*, New York, 1976, p. 234; Leonid Likhodeev, "Weekend Adventists," *Current Digest of the Soviet Press*, 13 Feb. 1965 (translation from *Komsomol'skaia pravda*, 13 Dec. 1965); Valentin Iumashev, "Zarisovka v stile breik," *Iunost'*, 1986 no. 12, p. 102. Troitsky, *Back in the USSR*, pp. 25–26, understates the resistance to rock and the twist during the early 1960s.

5. *Novye slova i znacheniia. Slovar'-spravochnik po materialam pressy i literatury 60-kh godov*, Moscow, 1973, p. 79; Troitsky, *Back in the USSR*, pp. 22–24.

6. Hindus, *The Kremlin's Human Dilemma*, pp. 88–89; Leonid Martynov, ["Stikhi"], *Iunost'*, 1966 no. 1, p. 49; Leonid Shkol'nikov, "Tantseval'naia kanitel'," *Izvestiia*, 23 May 1962; Igor Moiseev, "Ot menueta do tvista," *Semia i shkola*, 1968 no. 1, pp. 36–38; Shkol'nikov,

"Vsegda li tanets sluzhit krasote?"; Orlov, "Dva prikhlopa, tri pritopa"; Viktor Kriger, "Nasha anketa," *Sovetskaia kul'tura*, 1 Sept. 1964 (and other articles in the same issue); L. Shkol'nikov, "Tantsuem ter-ri-kon," *Nedelia*, 14–20 Mar. 1965; Leonid Shkol'nikov, *Rasskazy o tantsakh*, Moscow, 1966, pp. 105–23.

7. I am greatly indebted for information here to the manager of a Soviet semiprofessional band of the late 1960s and early 1970s; I draw on personal observations as well. Starr, *Red and Hot*, pp. 294–302; Rokotov, "Govori!"; Troitsky, *Back in the USSR*, pp. 21–25, 29–30, 32–36, 38–39 are particularly good on this period. See also Smith, *The Russians*, pp. 232–33; William Carlson, "Russian Rock Scales the Iron Curtain," *Rolling Stone*, 9 Sept. 1976; V. Terskaia, "Vinovata li moda? Zametki o muzykal'nykh ansambliakh," *Pravda*, 13 Dec. 1975; V. Iarustovskii, "Muzyka i sovremennost'," *Sovetskaia kul'tura*, 2 June 1976; Gunnar Graps, "Muzyka dlia obshcheniia," *Avrora*, 1984 no. 3, p. 139; Vladimir Kozlovskii, "Vozvrashchenie v Moskvu," *Novoe russkoe slovo* (N.Y.), 24 Dec. 1987.

8. In addition to personal observation: N. Alekseeva, "Pesniary," *Ogonek*, no. 42, Oct. 1972, pp. 32–33; Smith, *The Russians*, p. 234; Carlson, "Russian Rock Scales the Iron Curtain"; Starr, *Red and Hot*, pp. 302–3; V. Kozlovskii, "Konets 'Veselykh Rebiat,'" *Novoe russkoe slovo* (N.Y.), 23 Aug. 1983; B. Serebrennikova, "Eshche o 'Veselykh Rebiat'," *Novoe russkoe slovo*, 2 Sept. 1983; Terskaia, "Vinovata li moda?"; Vadim Yurchenko, "Festival Shows Strength of Russian Rock," *Billboard*, 22 Jan. 1972; Sloane, "Grandfathers and Children"; Ramet and Zamascikov, "The Soviet Rock Scene," pp. 5–6; "Udacha ili bezvkusitsa?" *Smena*, 1986 no. 5; Natal'ia Kozlova, "Ni s kem nesravnimaia Alla," *Novoe russkoe slovo*, 31 Aug. 1988; Pavel Leonidov, *Vladimir Vysotskii i drugie*, New York, 1983, p. 146.

9. Smith, *The Russians*, p. 236; Logan Robinson, *An American in Leningrad*, pp. 232–49; Ed Harrison, "Dirt Band 'Teaches' Russians the Art of Rock 'n' Roll," *Billboard*, 2 July 1977, pp. 1, 18; Thomas Gambino, *NYET: An American Rock Musician Encounters the Soviet Union*, Englewood Cliffs, N.J., 1976; Barney Cohen, "R and R in the USSR," *Saturday Review*, 23 June 1980, p. 29; *New York Times*, 23 and 29 May 1979; *Time*, 25 Dec. 1978; Iaroslav Khabanov, "Pravda i lozh' o kul'turnykh obmenakh," *Sovetskaia kul'tura*, 29 May 1979; *A Chronicle of Current Events. Number 51*, London, 1979, p. 189; *Rovesnik*, 1977 no. 1; Richard Tempest, "Youth Soviet Style," *Problems of Communism*, May-June 1984, p. 63.

10. See the reports in *Rovesnik*, 1977 nos. 4 and 5, about Ringo Starr, George Harrison, the Bay City Rollers, and Bob Marley. In *Rovesnik*, 1982, nos. 1–4, 6–11, see the reports on Yoko Ono, George

Harrison, Elton John, Bob Marley and reggae, the Rolling Stones, Styx, the Clash, Police, Ringo Starr, Simon and Garfunkel, Rod Stewart, UB-40, new wave, the Knack, Alice Cooper, Kiss, Uriah Heep, Roxey Music, Deep Purple, Rainbow, Led Zeppelin, AC/DC, Queen, Pat Benetar, Stevie Nix, Joan Jett, the Go-Go's, Talking Heads, Blondie, Pete Best, and Jerry Lee Lewis. Some of these rated entire articles, others only paragraphs and pictures.

11. Kris Kel'mi, "Raznye roli 'Rok-atel'e,' " *Smena*, 1985 no. 21, p. 20; and personal information and observation.

12. A. Petrov, "Chto takoe diskoteka: muzykal'nyi klub? Tantseval'nyi zal?" *Komsomol'skaia pravda*, 31 Aug. 1978; E. Taranov, "Pod parusami diskoteki," *Pravda*, 5 Mar. 1980; R. Rassol'nikov, "Tekh zhe shchei, da pozhizhe," *Novoe russkoe slovo* (N.Y.), 6 Aug. 1981; *Newsweek*, 7 July 1980; *New York Times*, 2 June 1980 and 3 July 1980; *Chicago Tribune*, 1 Nov. 1981; "Muzykal'naia lovushka," *Komsomol'skaia pravda*, 11 Oct. 1984; Jim Gallagher, "Russia's Young Rebels," *Chicago Tribune Magazine*, 21 May 1982; Viktor Ivanov, " 'Anatomiia' diskoteki," *Smena*, 1984 no. 23, pp. 22–23; Bright, "Soviet Crusade," pp. 140–41; "Spravka k AS no. 5519," *Materialy samizdata*.

13. Smith, *The Russians*, pp. 11, 228–30, 233; Starr, *Red and Hot*, pp. 312–15; Andrei Okulov, "Nastroeniia molodezhnoi oppozitsii," *Posev*, 1981 no. 1, p. 12; L. Pereverzev, " 'Arsenal' Alekseia Kozlova," *Iunost'*, 1976 no. 6, pp. 102–3; "Rok-razgovor," *Iunost'*, 1983 no. 5, pp. 86–92; "Ragu iz sinei ptitsy," *Komsomol'skaia pravda*, 11 Apr. 1982; "Vser'ez o legkom zhanre," *Komsomol'skaia pravda*, 11 July 1982; Stanislav Kuniaev, "Chto tebe poiut? Polemicheskie zametki o modnom v kul'ture," *Nash sovremennik*, 1984 no. 7, pp. 176–77; "Mashina Vremeni. Novyi Povorot," *Smena*, 1986 no. 13; Sloane, "Grandfathers and Children"; Bright, "Soviet Crusade," pp. 128–29; Mikhail Lemkhin, "Kto zhe oni, kumiry?" *Vremia i my* (N.Y.), 1987 no. 95, pp. 137–38; Troitsky, *Back in the USSR*, pp. 33–36, 40–42, 60–61.

14. Based by and large on personal knowledge. But see also Vassily Aksyonov, *The Island of Crimea*, translated by Michael Heim, New York, 1983, pp. 181–87, for a fictionalized account of an underground band on tour; and Troitsky, *Back in the USSR*, pp. 90–93 and passim. For allusions in the Soviet press: Anatolii Doronin and Arkadii Lisenkov, "Chto proku ot 'roka,' " *Molodaia gvardiia*, 1986 no. 5, p. 223; Pavel Ermishev, " 'Bolevye tochki' molodezhnoi estrady," *Smena*, 1985 no. 4, pp. 6–7; Aleksandr Morozov, "Okhota na popugaia v sumerkakh," *Ogonek*, no. 8, Feb. 1988.

15. Okulov, "Nastroenie molodezhnoi oppozitsii," pp. 11–13;

Ramet and Zamascikov, "The Soviet Rock Scene," pp. 6–10, 14; "Rokrazgovor," *Iunost'*, 1983 no. 5, pp. 86–92; David Tukhmanov, "Eti spornye ritmy . . . ," *Litueraturnaia gazeta*, 6 Apr. 1983; Kuniaev, "Chto tebe poiut?" pp. 173–74; Iv. Geiko, "O vkusakh sporiat!," *Komsomol'skaia pravda*, 23 Sept. 1984; N. Bogoslovskii, "Bez lishnikh usilii," *Pravda*, 1 Oct. 1984; Troitsky, *Back in the USSR*, pp. 53–67, 71–74. See also the extensive coverage given to Western rock groups in *Rovesnik* in the early 1980s.

16. For more detailed descriptions of the rock groups, lyrics, performances, and public impact in the early 1980s, see Aleksandr Zhitinskii, "Zapiski rok-diletanta," *Avrora*, 1982 no. 9, pp. 130–34; 1983 no. 3, pp. 126–28, 134–36; 1985 no. 10, pp. 130–36; Doronin and Lisenkov, "Chto proku ot 'roka,' " pp. 222–26; Bright, "Soviet Crusade," pp. 125–35; Sloane, "Grandfathers and Children"; Ramet and Zamascikov, "The Soviet Rock Scene," pp. 19–20; Vladimir Mishin, "Zvukovye kollazhi 'Avtografa,' " *Smena*, 1984 no. 24, pp. 26–27; Boris Kagarlitsky, "The Intelligentsia and the Changes," *New Left Review*, no. 164, July-Aug. 1987, pp. 16–19; G. B. Zulman et al., "Formirovanie muzykal'noi kul'tury molodezhi," *Sotsiologicheskie issledovaniia*, 1983 no. 4, pp. 120–23; "Rok: Muzyka? Subkul'tura? Stil' zhizni? (Obsuzhdenie za 'kruglym stolom' redaktsii)," *Sotsiologicheskie issledovaniia*, 1987 no. 1, pp. 32–33, 40, 46–48; N. P. Meinert, "Po vole roka," *Sotsiologicheskie issledovaniia*, 1987 no. 4, pp. 88–93; Troitsky, *Back in the USSR*, pp. 77–95.

17. On the Baltic groups: *New York Times*, 16 and 18 Oct. 1980; *USSR News Briefs*, no. 13, 31 Oct. 1980; *Christian Science Monitor*, 28 Aug. 1984. On the Baptist rock group, *Trubnyi zvon*, the basic sources are the indictment, verdict, and lengthy commentary by the group leader, published in *Materialy samizdata*, nos. 5493, 5494, 5496. See also *Vesti iz SSSR*, no. 4, 28 Feb. 1983; no. 19–20, 31 Oct. 1983; no. 8, 30 Apr. 1984; no. 22, 30 Nov. 1984.

18. S. L. Kataev, "Muzykal'nye vkusy molodezhi," *Sotsiologicheskie issledovaniia*, 1986 no. 1, pp. 105–8; S. L. Kataev, "Soderzhanie i intonatsiia molodezhnoi pesni," *Sotsiologicheskie issledovaniia*, 1987 no. 1, pp. 77–80.

19. Bright, "Soviet Crusade," pp. 123, 138–44, treats this episode extensively. For Chernenko, see *Pravda*, 15 June 1983. For the Ministry of Culture rules, "Estrada: bez skidki na legkost' zhanra," *Sovetskaia kul'tura*, 26 July 1983. The October 1984 directive is available in *Materialy samizdata*, AS no. 5519. A lengthy "Spravka" to this document lists the various measures that were taken against rock music. The annotations by the publisher provide a great deal of information about the commentary on Soviet and Western groups in

the Soviet press during the early 1980s. See also Troitsky, *Back in the USSR*, pp. 95–99; S. Tsvigun, "O proiskakh imperialisticheskikh razvedok," *Kommunist*, 1981 no. 14, p. 99; Valdislav Chachin, "V plenu u muzykal'noi mody," *Izvestiia*, 17 Sept. 1980; Vladislav Shoshin, "Bez fal'shivykh not," *Izvestiia*, 18 Oct. 1981; V. Tverskaia, "Iskat' svoe litso," *Pravda*, 3 May 1982; V. Lisovskii, "Kto tvoi kumir?" *Izvestiia*, 17 Jan. 1982; A. Andrusenko, "I pel iamshchik padam-dudam," *Sovetskaia kul'tura*, 12 July 1983; Nikolai Mashovets, "Sobstvennaia gordost'. Zametki publitsista," *Pravda*, 31 Oct. 1983; "Estrada, bez skidki na legkost' zhanra," *Komsomol'skaia pravda*, 26 July 1983; N. Saprykina, "Kogda gadkii utenok prevratitsia v lebedia?" *Sovetskaia kul'tura*, 24 Mar. 1984; Iu. Filinov, "Barbarossa rok-n-rolla," *Komsomol'skaia pravda*, 16 Sept. 1984; A. Mokhon'ko, "Uchit' i uchit'sia," and A. Iakushin, "Lozhnye tsennosti," *Sovetskaia kul'tura*, 18 Dec. 1984; G. Chumakova and V. Maricheva, " 'Ali-Baba' i sorok ansamblei," *Sovetskaia kul'tura*, 30 May 1985; T. Abakumovskaia, "Prekrasnye ritmy pesen novykh," *Sovetskaia kul'tura*, 22 Oct. 1985; B. Alibasov, "Khudozhestvennyi rukovoditel' ne predusmotren . . . ," *Sovetskaia kul'tura*, 7 Dec. 1985; *Vesti iz SSSR*, no. 22, 30 Nov. 1983; "Pis'ma iz Rossii," *Posev*, 1985 no. 9, p. 12.

20. Solomon Volkov, "Rok-muzyka v Sovetskom Soiuze. Sem tezisov k probleme," *SSSR. Vnutrennie protivorechiia*, v. 5, New York, 1982, pp. 44–50; N. Bogoslovskii, "Bez lishnikh usilii," *Pravda*, 1 Oct. 1984; Pavel Ermishev, " 'Bolevye tochki' molodezhnoi estrady," *Smena*, 1985 no. 4, pp. 6–7.

21. *India Today*, 15 Dec. 1987; Sloane, "Grandfathers and Children"; *New York Times*, 5 May 1986, 31 Oct. 1986, 9 Jan. 1987, 6 Apr. 1987, and 28 July 1987; Iumashev, "Zarisovka v stile breik," pp. 101–4; Michael Benson, "Rock in Russia Today," *Rolling Stone*, 26 Mar. 1987; *Chicago Tribune*, 5 July 1987; Kozlovskii, "Vozvra- shchenie v Moskvu"; Toomas Ilves, "Youth Trends: Breakdancing In, Heavy Metal in Trouble," *Radio Free Europe Research*, Baltic Area, 29 Aug. 1986, pp. 5–7; "Das andere Moskau," *Spiegel*, no. 15, 6 Apr. 1987; Oleg Smolenskii, "Poveriaia algebroi garmoniiu," *Ogonek*, 1988 no. 3, pp. 16, 27; Aleksandr Morozov, "Okhota na popugaia v sumerkakh," *Ogonek*, no. 8, Feb. 1988, pp. 14–16; Irina Vedeneeva, " 'Assa' sostoialas'!" *Ogonek*, no. 16, Mar. 1988, p. 31; *Washington Post*, 16 May 1988; Troitsky, *Back in the USSR*, pp. 112–38. The criticism of "Autograph" is in V. Tverskaia, "Iskat' svoe litso," *Pravda*, 3 May 1982.

22. Doronin and Lisenkov, "Chto proku ot 'roka,' " p. 215 and passim; An. Doronin, 'O roke—bez prikras," *Molodaia gvardiia*, 1987

no. 12, pp. 213–28; Iurii Bondarev, "Istina mnogolika . . . ," *Sovetskaia kul'tura*, 18 July 1987. See the statements by Iurii Sergeev and Sergei Mikhalkov at a meeting of the governing board of the Writers' Union, *Literaturnaia gazeta*, no. 19, 6 May 1987.

23. "Rok: Muzyka? Subkul'tura?," pp. 33–35, 38–39, 44, 46–47.

24. Volkov, "Rok-muzyka," pp. 44–50.

25. See the picture in *Cambridge Encyclopedia of Russia and the Soviet Union*, New York, 1982, p. 234.

26. For example, A. Karmen, "Otravlennyi 'Potselui,' " *Komsomol'skaia pravda*, 30 Sept. 1983; Iu. Filinov, "Barbarossa rok-n-rolla," *Komsomol'skaia pravda*, 16 Sept. 1984; N. Korzun, "Dvumia akkordami po nervam?" *Sovetskaia kul'tura*, 10 June 1986.

27. I draw heavily on personal observation and information from Soviet informants, but there are good published sources: Ilves, "Youth Trends"; V. Kulikov, "Besprizornye 'fanaty,' " *Komsomol'skaia pravda*, 5 Oct. 1986; *New York Times*, 9 Jan. 1987; Bill Keller, "Russia's Restless Youth," *New York Times Magazine*, 26 July 1987; Boris Kagarlitsky, "The Intelligentsia and the Changes," *New Left Review*, no. 164, July-Aug. 1987, pp. 17–18; N. D. Sarkitov, "Ot 'khard-roka' k 'khevi-metallu': effekt oglupleniia," *Sotsiologicheskie issledovaniia*, 1987 no. 4, pp. 93–94; I. Iu. Sundiev, "Neformal'nye molodezhnye ob''edineniia: opyt ekspozitsii," *Sotsiologicheskie issledovaniia*, 1987 no. 5, p. 59; A. P. Fain, "Spetsifika neformal'nykh podrostkovykh ob''edinenii v krupnykh gorodakh," *Psikhologicheskie problemy izucheniia neformal'nykh molodezhnykh ob''edinenii*, Moscow, 1988, pp. 32–36; L. Beletskaia, "Pustynia, okazyvaetsiia, byvaet v dushe cheloveka," *Komsomol'skoe znamia* (Kiev), 6 Dec. 1986.

28. Kulikov, "Besprizornye 'fanaty' "; Iurii Shchekochikhin, *Allo, my vas slyshim. Iz khroniki nashego vremeni*, Moscow, 1987, pp. 244–45.

29. *New York Times*, 9 Jan. 1987.

30. Sundiev, "Neformal'nye molodezhnye ob''edineniia."

31. Fain, "Spetsifika neformal'nykh podrostkovykh ob''edinenii," p. 36, and personal observation.

32. Fain, "Spetsifika neformal'nykh podrostkovykh ob''edinenii," p. 35.

33. I am particularly indebted in the following discussion to Susan Costanzo, who copied down every legible graffito in the stairwell in July 1988. Little had changed by the time I examined the graffiti in October 1988, but an effort to wash or scrape some of the graffiti off the walls had left many more of them illegible.

34. The first excerpt is from the album *Red Wave: 4 Underground Bands from the USSR*, 1986, produced by Joanna Stingray, who recorded them in Leningrad; the second is from the album *Radio Afrika*, recorded in 1983 for distribution by tape, released by the official record company Melodiia in 1987; the third example comes from the album *ASSA*, released in the Soviet Union in 1987. In 1989 Grebenshchikov sans Aquarium released an album (*Radio Silence*), and went on tour in the United States. On Grebenshchikov and Kurekin (transliterated Kuryokin) as jazz musicians, see Leo Feigin, ed., *Russian Jazz: New Identity*, London, 1985, pp. 54–55, 79–81, and passim. Other information on Grebenshchikov and Aquarium can be found in *People*, 6 Apr. 1987; *New York Times*, 9 Apr. 1987; Mikhail Lemkhin, "Kto zhe oni, kumiry?" pp. 138, 141, 148–49; Sloane, "Grandfathers and Children"; Benson, "Rock in Russia"; Zhitnitskii, "Zapiski," *Avrora*, 1985 no. 10, pp. 136–37; I. Aleksandrov, "Priblizitel'nyi voin s moim podsoznaniem v ruke," *Russkaia mysl'* (Paris), 20 Dec. 1985; Troitsky, *Back in the USSR*, pp. 51–52, 57–59, 75–77; Naomi Marcus, "Glasnost's First Gold Record," *Mother Jones*, Oct. 1988.

35. *People*, 6 Apr. 1987, p. 51.

Counterculture Graffiti

Politics found a place on Moscow's walls soon after the fan gangs made graffiti a medium of public expression, but political dissidents were not the culprits. Dissidents did occasionally paint graffiti during the 1970s, but these were so unusual that they set off KGB investigations, and sometimes political trials.[1] When political graffiti appeared in quantity in the early 1980s, they were the work of pacifists and punks, both associated with the Soviet counterculture. Hitler's small band of Soviet admirers began to contribute graffiti at about the same time. A few new counterculture groups made their marks at mid-decade, and the *Liubery*, self-proclaimed enemies of hippies, punks, *metallisty*, fascists, and other such groups befouling Soviet society, invaded Moscow's streets and walls in 1986. These graffiti-writing groups, from within and without the counterculture, engaged in a politics that revolved in considerable degree around cultural styles. Politics they were, nonetheless.

Pacifist graffiti have from the outset been found all over Moscow and are numerous enough to catch even the inattentive eye. Other countercultural graffiti generally cluster at counterculture hangouts. Taken all together, the political and countercultural graffiti have not at any time equaled the number devoted to heavy metal bands. Like their peers elsewhere, Soviet adolescents are more attuned to aggressive, faintly deviant music than to deviant politics. Nevertheless, and keeping always in mind that they represent minority sentiments, the countercultural political graffiti afford a glimpse of the political ferment that stirred beneath the surface stagnation of Soviet society prior to 1985, and that erupted after Gorbachev's advent to power. Like the heavy metal graffiti, the political graffiti of the early 1980s proved to be good predictors.

Pacifists, punks, hippies, fascists, and latterly the *Liubery* reveal more in their graffiti than their politics: they unwittingly betray their kinship to the fan gangs and *metallisty*. Most would vehemently reject any suggestion of filiation, especially with the *fanaty*. The explicit messages of (just for example) pacifist and gang graffiti are of course quite different. Yet all of the Soviet countercultural political groups draw on the example and vocabulary of gang graffiti. There is no inherent reason the counterculture should adopt gang symbols, or write their graffiti preponderantly in English, but they do. Counterculture graffiti writers adapt the gangs' graffiti argot to their own purposes because they respond to the same social and cultural cues as the gangs, and because they have a similarly antagonistic attitude toward the rest of Soviet society. If the two groups did not have a great deal in common, they could not use the same graffiti argot.

THE COUNTERCULTURE "SYSTEM"

Soviet hippies, pacifists, and punks take their lead from the West, but they are not just pale imitations of the originals. By the late 1970s Western fads and fashions, Western rock music, the artifacts of Western youth culture in general, had been flowing into the Soviet Union for two decades. An alluvium had built up that could provide native sustenance for whatever seeds the Westerly winds might blow in. During the 1970s Soviet society began to strike out on its own, in the matter of nonconformist groups as in rock music: a self-sustaining counterculture came into being. The West continued to provide the models that Soviet youngsters emulated, of course; the names they gave themselves demonstrated their cultural dependence. Yet in their actual behavior they could increasingly build on familiar precedents from their own environment. As even a Soviet police specialist on non-conformist youth groups has observed, despite all of their borrowings from the West, their dominant features are native to Soviet society.[2]

The immediate domestic precursors of the graffiti-producing pacifists and punks were hippies (*khippi*), who came to flower in Soviet society around 1970.[3] In 1987 Soviet hippies issued manifestos celebrating the twentieth anniversary of their movement, but the choice of 1967 as birth date was arbitrary. Perhaps a few Soviet youngsters, ever alert to the latest Western trend, had begun to copy the hippies by then; other sources also place the beginning of the hippie movement in the late 1960s. Rock music carried the counterculture style into the Soviet Union and helped to generate a counterculture, just as it had advertised and popularized the counterculture in the West. The connection between rock music and the counterculture was doubly strong in the Soviet Union, however. In the West, the counterculture interacted with the legitimate economy, while in Moscow commerce in rock and its trappings was at best semilegitimate.[4]

The counterculture as fashion attracted tens of thousands, but when and how a genuine hippie community crystallized is unclear. The earliest action that hippies undertook that registered in the public consciousness was an attempt, on International Children's Day (June 1) 1971, to march from the downtown campus of Moscow University to the American Embassy to protest the Vietnam War. No sooner did they unfurl their banner ("Make Love Not War," in English) and march out to the street than police hustled all 150 of them into buses and hauled them off to police stations.[5] By 1973 there were enough hippies in Moscow so that Vladimir Kozlovskii, who was then collecting Soviet gay slang, could collect hippie slang as well.[6] They were sufficiently numerous as of that date, in other words, to generate and sustain their own distinctive language.

From the very fragmentary available information on the early hippies, it appears that they were mostly in their late teens, and mostly the children of well-to-do and intellectual families; in Moscow, hippies still come disproportionately from the elite central districts. They claimed to have deliberately dropped out of mainstream Soviet society. As the Soviet scholar Mark Rozin aptly observes, however, they deliberately drew attention to themselves and provoked outrage by their behavior and appearance, so interaction (or as Rozin puts it,

drawing on Bakhtinian literary theory, dialogue) with society was an intrinsic if unconscious element in their life-style.[7] But during the 1970s, the dialogue transpired on the symbolic plane only. The attempted 1971 demonstration was untypical of the hippies of that decade, because they conscientiously abstained from all social and political activity (thus offending against their duty to participate in regime-directed activities). Unlike many of their American counterparts, Soviet hippies of the 1970s did not claim to aspire to transform society. Many adopted deliberately passive, even immobile, behavior; the legends that they still tell celebrate the hippie who did not emerge from his apartment for months, or the hippie who abstained from washing for weeks. Otherwise they looked and acted very much like the Americans whom they wanted desperately to imitate, which of course set them apart from everyone else. Their dress code—ragged but colorful clothing, long and tangled hair—gave them instant visibility, and also an alternative name, *volosatye*, "the hairy ones." When settled, their lives revolved around some combination of rock music, sex, alcohol (by the end of the 1970s, drugs), and self-conscious gentleness. Some hippies professed mystical religious notions, others a vague commitment to Tolstoyanism or alternative quietist philosophies.

Their English-language emblems and embroidered slogans —"Make Hair Everywhere," "Long Live Butterflies," "Love," "Rock Explosion"—expressed both their ideas and their identification with their Western precursors. Their slang, also heavily influenced by Anglicisms, better demonstrated the transformation of these foreign elements in the Russian environment. English words like *grin* ("green," meaning dollar), *ask* (here, "begging"), and *gyorl* ("girl") acquired Russian prefixes and suffixes and declined and conjugated as Russian words. Thus a Russian family sprang from English "ask": *askat'*, "to beg"; *obaskat'*, "to beg from everyone"; *zhit' na aske*, "to live by begging." Or from "crazy": *kreiza*, "insane asylum"; *kreizanut'sia*, "to go crazy"; and so forth.[8] Any English word could be employed occasionally as slang, but no English speaker would have known what it meant, or even recognized it as English, in its hippie use. Russian speakers knew that they were hearing Russian, even if they did not

understand the words. In other words, the hippie community developed its own distinctive argot.

In their organizational life, too, Soviet hippies followed practices that looked Western but were adapted to the conditions of their own society. By the early 1970s they were circulating through a network of hangouts (chiefly cafes and coffee shops) and crash pads (or *flety*, "flats"). This network and the people who lived within it became known as the "system" (*sistema*). The hangouts were known as *tusovki*, which in the popular etymology derives from *tasovat'*, "to shuffle." As they moved from crash pad to *tusovka*, the hippies were continually reshuffled, tagging along with whatever new group struck their fancy. Usually they formed into bands of a dozen or so who camped out in a single *flet*. The bands, if semipermanent, were also known as *tusovki*. Hippies lived on odd jobs, handouts, the hospitality of friends, or, in the worst case, on the sufferance of their despised parents. If they had settled jobs (and some of the older hippies did), they worked as watchmen, or boiler operators, or in some other situation where they had much free time and little supervision. Not knowing what else to do with youths whose behavior was so obviously abnormal, the authorities dispatched many hippies to short terms in the *kreiza*. Despite that harassment, the "system" managed to thrive within the nooks and crannies of Soviet society. It could not establish itself independently: some hippies did try to set up permanent communes, but the authorities apparently forestalled all such efforts.

Hitchhiking from city to city was an important part of hippie life, especially during the summer. Some bands followed a seasonal route: Moscow and the Baltic in the summer, Central Asia or the Black Sea littoral in the winter. Occasionally the scattered bands set their course to a common objective, such as Tolstoy's Yasnaia Poliana estate on the 150th anniversary of the master's birth in 1978; perhaps as many as 200 hippies, denied entrance to the estate, camped in the woods for two days. Beginning in 1978, hippies set up an annual summer encampment on the Gauja River, near Riga, and in the early 1980s came to Tallinn to celebrate May Day. These encampments and meets continued into the 1980s, despite occasional

arrests, roadblocks, and roundups. Hippies frequently converged, too, on rock festivals, such as the abortive American Fourth of July rock show in Leningrad in 1978, and mass concerts in the Baltic republics in later years.[9]

In the late 1970s and early 1980s, drug use devastated the Soviet counterculture, and in reaction to that and to their own advancing age many participants began to explore other ways in which they could express themselves. Some moved from nebulous spirituality to organized religion, usually the Orthodox church. Others expanded the principle of non-violence into political dissent, mostly of the antimilitarist variety. Of course, it was possible to combine Orthodox Christianity and antimilitarism, and some did. While the *sistema* proper shrank, many of its religious and antimilitarist graduates remained in touch with it, and still thought of themselves as part of the counterculture.[10]

The Western European antinuclear and Green movements provided a new model for those many hippies who began to style themselves pacifists (*patsifisty*). Under their impact, the transition to pacifism had been accomplished in Leningrad by 1980—the first attested pacifist graffiti appeared there in 1979 or 1980—and probably in Moscow by the same time.[11] Many of the new pacifists continued to call themselves hippies, and the two movements never did become disentangled. Mikhail Bombin of Riga turned the hippie encampments that he had organized on the Gauja into "peace encampments," and in Moscow both the Free Initiative (*Svobodnaia initsiativa*) and Goodwill (*Dobraia volia*) groups that became active in the early 1980s styled themselves "hippie pacifists." Other pacifists who had nothing much in common with hippies began to organize at about the same time, and made contact with the counterculture. The Moscow Trust Group, a dissident peace organization that some Moscow intellectuals set up in 1982, was certainly not a by-product of the hippie movement. Yet Sergei Batovrin, one of the founders of the Trust Group, had in the 1970s drifted with the hippies, Mikhail Bombin signed the Trust Group's programmatic declarations, and the Trust Group had contacts with Free Initiative and Goodwill. And when Western counterculture peace activists began to visit members of the Moscow Trust Group, Soviet hippies

came to view the Trust Group as a bridge to Western hippies.[12] Pacifism thus offered hippies a way out of their restrictive countercultural ghetto, and provided establishment dissidents with an entrée into the youth culture that had grown up in the 1970s.

The youth pacifist movement also drew in many students who had no interest in pursuing the hippie way of life. Indeed, it is reasonable to presume that one of the attractions of pacifism—both to those disengaging themselves from the hippie milieu and to those firmly ensconced in academic institutions—was that it required the rejection only of the regime's military and foreign policies, not the complete repudiation of settled life and creature comforts. The pacifist ethos also provided considerable scope for what were little more than student high jinks. One pacifist favorite of the early 1980s, for instance, was on May Day—the official Soviet peace holiday—to begin mass chanting of officially approved preteen slogans ("Sunny World, Yes, Yes, Yes. Nuclear Explosion, No, No, No") in circumstances that lent them an oppositional flavor. The same slogans suddenly chanted during the May 9 Victory-in-Europe celebration, a military holiday, had an even more ambiguous ring. Of course, to say that pacifists are high-spirited and prefer not to make a fetish of material deprivation is not to belittle them.

Unlike the early hippies, pacifists articulated a clear political program. They opposed Soviet intervention in Afghanistan, the arms race, and high levels of military spending, which they blamed for the low Soviet standard of living. They asserted that the Soviet Union and the United States were equally responsible for provoking local conflicts. To these general Soviet pacifist positions the counterculture pacifists added their own opposition to military service; an appeal for solidarity among Soviet, American, and other youth; the assertion that conflicts should be settled through mutual love; refusal to cooperate with forces and institutions that do harm to the world; and the principle that people should live in harmony with nature.[13]

One consequence of the pacifist movement's genesis within the hippie community is that its initial activities are difficult to track. The various constituent groups had no leaders with

names familiar to established dissident figures, and they did not have their own connections with the foreign press. They were thus largely anonymous. Nevertheless, some information is available, on the public record and off. The earliest of the actions consistently associated with the hippie-pacifist amalgam were memorial meetings on the anniversary of John Lennon's death, held on the Lenin Hills overlooking Moscow. The very first of these memorials was in fact held immediately after Lennon was gunned down, in December 1980. Roughly 200 gathered, at the time a sizable demonstration, before the surprised police intervened to disperse them. In 1981 the police knew what to expect and arrested all suspicious-looking young people as they exited from the subway nearby. Taken to a police station, the would-be demonstrators covered the walls with graffiti slogans such as "Lennon lived, Lennon lives, Lennon will live" (in Russian), a pun on the familiar Soviet inspirational slogan "Lenin lived, Lenin lives, Lenin will live!" In subsequent years, small numbers of demonstrators managed to gather, but were quickly dispersed by the police. Free Initiative and the Moscow Trust Group took part, and occasionally distributed leaflets, but the event attracted participants from all branches of the Soviet counterculture.[14]

Although the counterculture pacifist movement remained almost entirely unknown to the outside world, it had become a sufficient nuisance to the Soviet authorities that in 1982 they detained a number of peace activists to prevent them from making contact with the Nordic Women's Peace March when that group was in Moscow. And over the next few years, the pacifists could mobilize demonstrators in what were for the time impressive numbers. In 1983 the Goodwill group held a meeting in a suburban Moscow park on the night of May 31-June 1, to coincide with International Children's Day on June 1; police dispersed the gathering, and arrested up to 200 people over the next few days. On June 1, 1984, Free Initiative and Goodwill combined to hold three separate demonstrations in Moscow, with over 100 persons detained. Unable to speak out in public, Free Initiative in 1985 and 1986 systematically spread its antiwar messages with spray paint: END THE SHAMEFUL WAR IN AFGHANISTAN; OUT OF AFGHANISTAN; GORBACHEV—MURDERER OF AFGHAN

CHILDREN; RUSSIAN CHILDREN'S SKIN IS JUST AS SENSITIVE TO NAPALM AS AFGHAN SKIN (all of these in Russian). In 1986, Sergei Troianskii, one of the leaders of Free Initiative, was arrested on suspicion of writing these and other graffiti.[15]

A recounting of meetings and other group activities inevitably leaves the impression that the countercultural pacifist movement was well organized, when in fact it deliberately eschewed formal organization. Free Initiative, for instance, consisted of a more or less permanent but small core of activists, a dozen or two at most, who spread the word when they planned an initiative and then waited to see who would show up. It did not have members, but what its leaders called *supportery*, "supporters," anyone willing to identify with any of its actions at any time. Most of the pacifists came from the hippie counterculture, many continued to wander through the "system's" national network of crash pads, and they continued the hippie tradition of journeying in groups to hang out together. They also held conclaves, some of which pretended to the stature of national pacifist congresses. Two particularly large intercity meetings are said to have been held in the Urals city of Ufa ("a city of pacifists," according to a Soviet observer); by the same account, during one of them the pacifists marched down the main street, but only after midnight, when it was deserted. The facts that when Mikhail Bombin was arrested in Riga in late 1984 the police carried out interrogations in Riga, Lvov, Leningrad, Ufa, and perhaps in Moscow and other cities, and that a Soviet press report on the case noted Bombin's frequent trips confirm the existence of a pacifist counterculture network, and suggest that there may be some truth in the stories about the Ufa meetings.[16]

Pacifists by and large emerged from within the counterculture system; punks were an addition to it. The Soviet punk movement came into existence in the late 1970s under the direct impact of British punk, and so was in a way just one more automatic response to the latest spasm in the Western rock and counterculture world. Nevertheless, punks soon became a small and ambivalent but apparently permanent fixture within the Soviet counterculture. On the one hand, the punks directed their aggressive nihilism against many hippie

and pacifist verities. On the other hand, they engaged in an identical form of social discourse, using style as their principal means of establishing an identity and expressing themselves. Moreover, the "system" gave punks an audience and a haven. Punks established their own hangouts and crash pads, but they used the existing network as well.

The components of Western punk were somewhat rearranged in the Soviet environment. Punk music, for instance, was very slow to catch on. None of the British punk bands—the Clash, Sex Pistols, Germs, Buzzcocks—had much of a following in the Soviet Union; they never appeared in the graffiti of the early 1980s, and the Ministry of Culture did not even think it necessary to include them on its 1984 list of proscribed Western bands.[17] By 1982 or so a few Soviet punk bands had formed, but they were not particularly popular, either, and by that time punk as a rock style was dying out in the West.[18] Furthermore, and quite in contrast to the British situation, Soviet punks came overwhelmingly from the top half of the social hierarchy.

Something of the bitterly and deliberately inarticulate anti-establishment attitude of the original British punks did take hold, but for many participants punk revolved largely around the manner of dress.[19] Soviet punk fashion adopted the gaudiness and eroticism, and sometimes the implied sado-masochism, of Western punk. Safety pins became a punk trademark in the Soviet Union, too, but affixed to clothing rather than worn through the cheek. Around the middle of the 1980s chains and leather entered the punk repertoire, since punk attitudes blend into heavy metal attitudes. Throughout the 1980s, hairstyles most clearly distinguished punks from all other groups. In the early 1980s a few punks dyed their hair green or orange; that practice has become somewhat more common in the Gorbachev era. Spiked hair, too, was more common in 1988 than in 1984, as were the mohawk, a strip of hair down the middle of the shaved scalp, and the crest, the same strip grown long, dyed, and lacquered into standing position. In the early 1980s, punks suggested the mohawk by shaving their temples, a style often on display in high schools and universities. But there, of course, punk as social statement shaded off into mere adolescent fashion.

From the start, the punks' principal reason for donning their garb has been to offend the public, which they do in an organized manner, and with due regard for the possible consequences of their activity. Offense is the effect punks prize the most. The legends they treasure are of the punk who defecated in a packed subway car, or the punk rock singer who urinated on stage. The pseudonyms they give themselves are (almost always in Russian, to preserve the bite) Swine, Rat, Pus, Flaw, Freak, and the like. Such provocative comportment naturally brings trouble, so in the early 1980s punks usually traveled to their gathering spots in conventional dress; safely at their rendezvous, they changed into uniform. For the same reason, punk hangouts moved frequently. In the years 1983–1984, the citywide punk gathering spot (they had scattered district *tusovki* as well) shifted from Pushkin Square (one of the principal haunts for youths of all persuasions), to Nogin Square (a stone's throw from the headquarters of the Communist Party Central Committee), to Nezhdanov Street (a neighborhood inhabited by the musical elite). After they had sheltered on Nezhdanov Street for a few months, the police began to make nightly raids and hauled many in for questioning. The punks' response to police harassment bespoke some courage: they asked why they were being picked up, asserted that they were not bothering anyone, and after being held by the police for a few hours, returned to their assembly point.

Of course, some punks mean to make a political statement by parading in provocative fashion. Most of these ideologically inclined punks share the basic views of the pacifists, but antimilitarism is for them simply a matter of course. Punks have more thoroughgoing antiestablishment views, and in flaunting their shocking dress they give the finger to the authorities. Over the years anarchism has joined nihilism as a central tenet of punk thinking; one of their favorite slogans in the late 1980s was "anarchy is the mother of order" (*anarkhiia mat' poriadka*). No doubt the presence of a rudimentary ideology is the reason—despite assertions even by those who speak with some knowledge that punk will not last, or is only a passing fad—punks have now been offending the Soviet public for a decade, and are still going strong.

In fact, the punks have become bolder and more numerous since 1985, as have all of the groups that make up the Soviet counterculture. Punk leaders from Moscow began traveling about trying to establish their own intercity network to rival that of the hippies. The Gorbachev government's greater tolerance for unregulated, nonconformist activities stimulated a hippie revival and some further ideological differentiation within the counterculture as well. There are now, for instance, groups calling themselves *bitniki* or, collectively, the "beat army" (pronounced as English) with a broken Red Army star as their emblem (thus producing a complex pun, since one meaning of *bit* in Russian is "broken"); the beatniks scorn the hippies' passivity. Other groups, too, have become affiliated with the "system," however loosely. In Moscow and Leningrad (and other cities) *metallisti* have their own gathering spots, but they also rub shoulders with punks and hippies at many local *tusovki*. So do the members of motorcycle gangs, known as *rokery* (from the British, probably by way of the German), who have been around since at least the 1960s but have become much bolder in the second half of the 1980s. Enthusiasts of skateboarding, break dancing, and other fads hung out with the more substantial groups until their time had passed. Not all members of these smaller groupings belonged to the *sistema* proper, of course—not if they spent the night at their parents' homes rather than in one of the system's *flety*. But they certainly stood on the fringes of the counterculture, and could enter if they wished. Adolescents moved from one group to another as their interests changed, from the local mixed *tusovka* to the central *tusovki* dominated by individual counterculture factions, and then from city to city through the counterculture network.[20]

As their numbers increased, the counterculture began to venture out of its *tusovki*. In August 1985, hippie pacifists in Moscow set up an open-air "Children and Peace" exhibit of art and homemade children's toys. Police broke that up, and temporarily detained about 40 persons, but street displays of pacifist and other unofficial art became common in 1986 and 1987. There were occasional relapses: a hippie art display was broken up by force in May 1987; in July 1987 about 50 hippies improvised a rock concert in a park, and police, in response to

neighbors' complaints, beat up some of the participants and arrested others. But in both cases the press roundly condemned the police for overreacting and for brutality. And in May 1988 a memorial demonstration commemorating the disrupted May 1987 art exhibit passed without incident. Pacifists, hippies, and punks, too, produced samizdat publications without hindrance: journals, collections of poems, memoirs, manifestos. While older and more conservatively inclined Soviet citizens found it difficult to adjust to the increased visibility of so ragged and bemaned a breed, occasional Soviet commentators praised the hippies' new engagement with issues of social reform as a commendable display of responsibility. One reason for the increase in the size of the counterculture must have been that as it edged toward tolerated semirespectability the risks involved in participation fell sharply. Some hippies complained, however, that on one hand their movement was being swamped by fair-weather converts, and those chiefly interested in experimenting with drugs, while on the other the hallowed veterans who had been hippies since the early days kept their distance from those who had been involved for only a few years.[21]

COUNTERCULTURE GRAFFITI

The hippies wandering about in the 1970s produced no graffiti of which there is any record. No hippie messages were visible on Moscow's walls during the middle years of that decade. If the hippies even noticed what the *fanaty* were up to in the late 1970s, they displayed no interest in following their example. In the early 1980s, when the original counterculture system was changing shape, few graffiti could be linked to the apolitical hippie traditionalists. A solitary POWER OF FLOWER (in English) was virtually the only graffito in sight in 1983 that could reasonably be construed as a hippie contribution.

By contrast, counterculture pacifists were from the beginning prolific graffiti writers. The pacifist message lent itself to clear statement more readily than did the diffuse ideas of the

hippies, and the pacifists had at their disposal a ready-made logo that suited their purpose exactly: the old ban-the-bomb symbol devised for Bertrand Russell's Campaign for Nuclear Disarmament in 1958, but known to Soviet adolescents only two decades later when it resurfaced in Western European demonstrations that were widely reported in the Soviet media. The emblem with CND label in Figure 4.1a, dating from 1988, made the connection to the British movement explicit, but that was unusual. Whether or not they knew much about the history of the symbol, the first Soviet pacifists found the ideal pacifist graffito already at hand. Yet ease of symbolic expression does not explain the pacifists' urge to make their presence and message known. Hippies, intellectually committed to disengagement from the world around them, did not seek to spread their views. Pacifists, by contrast, were determined to address Soviet society, and so produced an abundance of graffiti.

All pacifists employ the standard peace symbol, but many introduce modifications to distinguish their brand of pacifism from others. For instance, there are almost as many Christian peace symbols, with cross on top, as plain and simple logos.

Photo 4.1 Pacifist graffito. The flower emphasizes the pacifist link to the counterculture. (Moscow, 1988)

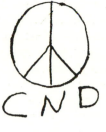

(a)

(b)

(c)

(d)

(e)

Figure 4.1

There is a distinction between pacifists who are religiously motivated and those who are strictly secular, but both groups have their roots in the counterculture. Judging from the NEW PACIFIC graffito (a single example was found in Moscow in 1983) shown in Figure 4.1b, the secular pacifists may have been first on the walls. By 1988, the cross was sometimes inscribed within the circle. The graffito in Figure 4.1c, rare but found in Moscow in both 1983–1984 and 1988, is the symbol of feminist pacifists.[22] The variant in Figure 4.1d is the symbol of Free Initiative, but is hardly ever to be seen.

Some logos have identifying initials, but these do not always have an obvious reading. The SCVO (a single example, Moscow 1984) in Figure 4.1e baffles efforts at decoding; perhaps like CND the initials were copied from a Western European model. But the use of Latin characters is by no means a certain indication of foreign origin. As the graffiti in Figures 4.1b and 4.2a show, pacifists occasionally label their emblem PACIFIC, and sometimes incorporate "pacific" in the names of their organizations. A member of the LENINGRAD PACIFIC CLUB left the group's mark in a Moscow underpass in 1983. In Leningrad itself at that time, the initials LP alone sufficed for identification; in 1988, no pacifist graffiti initialed in that way were to be found in Leningrad or anywhere else. A similar organizational code, RP, found in Moscow in different variants in 1984 and 1988 (Figure 4.2b)—and only in one example each year—may mean "Russian Pacific," or "Rozhdestvenskii Pacific" (both were found in the general area of Rozhdestvenskii Boulevard), or some other "pacific" entirely. However they are deciphered, those graffiti exemplify the persistent tendency to add identifying Latin initials, standing for English words, to the generic pacifist emblem.

Pacifists also add slogans and statements to their logos, almost always in English. Many of the slogans point to the hippie origins of a sizable segment of the pacifist movement, as for instance FLOWER'S POWER and LOWE in Figure 4.2c, found in Moscow in 1988. Favorites over the entire decade, in Moscow and other cities, have been MAKE LOVE NOT WAR and each of its two constituent injunctions (Figure 4.3a). ALL YOU NEED IS LOVE, a quotation from a Beatles song, is

PACIFIC

LENINGRAD
PACIFIC
CLUB

(a)

(b)

FLOWER'S
POWER

(c)

Figure 4.2

another recurring label. MAKE SEX NO "MX" is an updated version from 1988. The graffiti in Figure 4.3b were all in one stairwell in 1988; the Russian phrase reads "Let the machine guns rust." In 1984 and 1988 the archway leading into the housing complex off Metro Aeroport where the literary elite live sported the declaration PACIFIC ARCH, shown in Figure 4.4a; one section of the courtyard was labeled PACIFIC YARD. WE MUST LIVE IN PEACE and *MY ZA MIR* ("We are for peace") both date from 1984. A single PAIX, sans logo, was in that year a unique French graffito. PEACE standing alone was not uncommon in 1988.

The longer the pacifist statement, the greater the likelihood that the writer will resort to Russian out of sheer linguistic necessity. On the short side, *DAITE POEST'* ("Feed us") with peace emblem in 1988 linked the common dissatisfaction over food shortages to the pacifist opposition to military spending. *SVOBODU TOLIKU GRODNENSKOMU* ("Free Tolia Grodnenskii") with peace emblem was a 1988 plea for the release of a counterculture pacifist who had been arrested after several years of dodging the draft. A group of graffiti that appeared on the asphalt around a statue of Gogol in the spring of 1984 included *LUCHSHE DOZHDEM CHEM BOMBEZH-KOI* (loosely, "Better rain than a hail of bombs") and *LUCHSHE SEGODNIA BYT' AKTIVNYM CHEM ZAVTRA RADIOAKTIVNYM* ("Better active today than radioactive tomorrow"). And probably it was a pacifist who in 1988 scribbled on a wall:

> *USKORENIE—VAZHNYI FAKTOR*
> *NO NE VYDERZHAL REAKTOR*
> *I TEPER' NASH MIRNYI ATOM*
> *VSIA EVROPA KROET MATOM*
> ("Acceleration's an important factor,
> But it overloaded the reactor,
> And right now our peaceful atom
> Is by all of Europe spat on.")

Many pacifist graffiti refer to the Beatles, or consist of lines from Beatles songs, as for example "All you need is love." Among the graffiti around the Gogol statue in the spring of

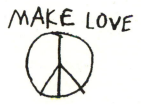

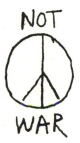

(a)

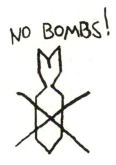

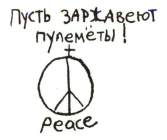

(b)

Figure 4.3

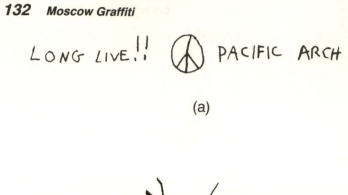

(a)

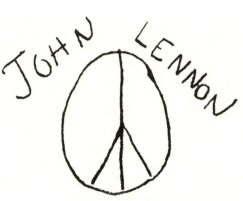

(b)

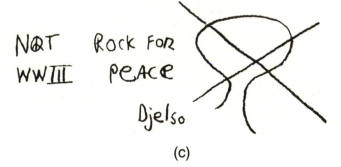

(c)

Figure 4.4

1984 was PEACE/LOVE/LIBERTY/THE BEATLES. Another graffito elsewhere the same year was a lengthy quotation:

MAKE LOVE NOT WAR
IF YOU WANT BLOOD YOU'VE GOT IT GIVE PEACE A CHANCE
(JOHN LENNON)

Other graffiti have paired the pacifist logo with what is obviously meant to be a likeness of Lennon, or have used his name as a caption (Figure 4.4b, from 1984). Lennon has become the patron saint of Soviet pacifists, as the annual memorial observances of his death would indicate. (In 1983, pacifists in Riga asked to be officially registered as the John Lennon Peace Committee.)[23] There is a certain piquancy to the pacifists' adoption of Lennon and the Beatles, since in the late 1960s and early 1970s the Beatles received good notice in the Soviet press because of their peace songs, opposition to the Vietnam War, and presumed criticism of bourgeois values. The lyrics of their "Back in the USSR" were even published in Russian translation in a youth journal whose editor must have been insensitive even to the heaviest irony.[24]

Pacifists listen to other rock bands, of course, but like the *metallisty* they single out a particular group for inscription because of the associations the name evokes; it is almost certainly due to the pacifists that the Beatles graffiti not explicitly joined to peace symbols rival in number those dedicated to the most popular heavy metal bands. The countercultural proclivities of the graffiti-writing Beatles fans are evident in the interconnected courtyards in central Moscow that they turned into a *tusovka*—a hangout dedicated to Beatles worship—and covered with quotations from the music, declarations of admiration, and pacifist logos, most in English but with a few interesting Russian declarations like *NA UBIISTVO D. LENNONA OTVETIM UBIISTVOM I. KOBZON* ("We'll answer J. Lennon's murder by murdering I. Kobzon," an establishment pop singer). Of course, there are occasional deviations from the association between pacifist and Beatles graffiti. In 1984, for instance, one Moscow graffito linked the peace logo somewhat incongruously to DEEP PURPLE, then a favorite of the heavy metal writers. More

appropriately, a pacifist laid claim to the long tradition of antiwar rock music—and perhaps more specifically to the British antinuclear rock groups of the early 1980s—in a four-feet-tall, bright red graffito that appeared on a side street on the eve of May Day 1984 (Figure 4.4c).

Ranging as they do from political symbols to slogans, couplets, quotations, and invocations of selected rock musicians, pacifist graffiti are far more varied and articulate than those produced by any other group. Pacifists most often reproduce the peace logo, but they are not limited to a highly stylized, repetitive vocabulary. Unlike the *fanaty*, they appear to think about what they write. They state their message explicitly, unlike the *metallisty*, who employ the threatening names of heavy metal rock groups to evoke a chain of associations. The diversity of the graffiti corresponds to the relatively unstructured character of counterculture pacifism, while the scatter of inscriptions that incorporate group initials or trademarks reveals the seeds of organization within the pacifist flux.

But if the differences between pacifist and the other graffiti are evident, so are the similarities, of which one is the most striking: the use of English and of alphabetic and symbolic encoding render most pacifist graffiti incomprehensible to most Russians. Even the standard peace emblem was not so widely understood in the early 1980s as one might suppose; it appeared in TV and magazine accounts of Western antinuclear demonstrations, but it was not explained. And it has never been part of the inventory of officially approved symbols. Indeed, the ban-the-bomb logo was banned from official Soviet peace marches, though it occasionally surfaced on placards bootlegged into the columns by conscripted student demonstrators. As of 1986 or so, endless repetition had taught most Muscovites and Leningraders, at least, what the symbol meant. But they still had no idea what the occasional variations represented.

Soviet punks, unlike the pacifists, had no logo handed to them at birth, and it took the better part of a decade before they arrived at a uniform and generally recognized emblem. The three symbols Moscow punks most frequently employed in the early 1980s were a slightly altered pacifist logo, a cross

inscribed in a triangle (both in Figure 4.5a), and what looked like a musical natural sign (Figure 4.5b). The modified pacifist symbol was in use by at least 1982.[25] It was invariably captioned, and derived from the connection between pacifists and punks; occasionally a standard pacifist logo was labeled PUNK. The cross in a triangle was not meant to imply any religious sentiments, even though the symbol may have come originally from a traditional Russian grave marker, a cross under a pitched roof.[26] It should be read as "in honor of," or some such secular declaration. The symbol in Figure 4.5c, found in Nogin Square in spring 1984, was probably a punk inscription dating from the time when punks met there. But not all crosses in triangles had captions, and they were used as markers by other groups, too. The "ushki" insignia, written in either Latin or Cyrillic characters, was the most (but still not very) common of the three early punk emblems, and the only one still in evidence as of 1988; its meaning is unclear, and the punks of the late 1980s either could not or would not explain it. Also in the early 1980s, punks in at least two different Moscow districts devised the district logos in Figure 4.5d. The *L* in the first stands for the Lenin city district. The second, unusual because it was written entirely in Russian, used a Cyrillic *P* for *punki*, and spelled out the city district, Krasnaia Presnia. Both groups borrowed the affirmative crown from gang graffiti.

None of these emblems was much used in 1983 and 1984, and they had no currency outside the city of Moscow. Leningrad punk emblems of the time were quite different. The safety pin graffito in Figure 4.6a may not have been meant as an insignia, but the PAPONKIE graffito (Figure 4.6b) found repeatedly in one downtown Leningrad neighborhood in 1984 was certainly a group emblem. It linked pacifists with punks, PAcific PUNKS; "ponkie" was a reasonable English transcription of the Russian pronunciation of *punki*, Russian plural for punks. That symbol was apparently no longer in use by the late 1980s. Punks in Smolensk toward the middle of the decade devised the emblem in Figure 4.6c; the variant with the Russian *Ia* ("I") in the center was meant to be read "I am a punk."

The variety of short-lived emblems revealed two things about the punks of the early 1980s: they were a heterogeneous

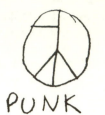

(a)

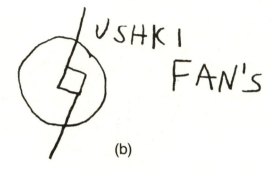

(b)

(c)

(d)

Красная Пресня

Figure 4.5

(a)

(b)

(c)

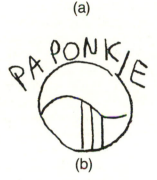

(d)

Figure 4.6

and disaggregated group, but they had a very strong urge to assert an organizational identity. By the end of the decade, they had adopted the anarchist A in a circle, the *A* always written in about the same manner as in Figure 4.6d. A few punks produced anarchist emblems early on, and as the anarchist component of punk thinking became more pronounced, the emblem became almost as central to punk graffiti as the antinuclear logo was to pacifist graffiti. In the late 1980s it appeared in all of the combinations in Figure 4.7, and in others as well. "N.A.A." probably stood for "New Anarchist Army" or something like that, and some of the other variations may also have been the organizational trademarks of individual punk groups. But the almost universal use of the encircled A—in Leningrad, Smolensk (often in combination with the emblem in Figure 4.6c), and Minsk as well as in Moscow—was the significant development. Like the HMR symbol of the *metallisty*, it provided evidence of at least a loose community of views as well as of extensive contacts. On the evidence of the graffiti, punks at the end of the decade had achieved the kind of consensual community that the pacifists had enjoyed at the beginning.

Like pacifists, punks produce graffiti without logos, for example (from different years during the 1980s): PUNK, PUNC, PUNK IS THE TOP, I LOVE PUNKS, and PUNK ROCK GREATEST STREAM IN ROCK MUSIC. A graffito proclaiming ANGARSK PUNK CITY (Angarsk is a small city on the shores of distant Lake Baikal) appeared in a Moscow underpass in 1984; the initials of the army soccer team were used to obliterate that graffito, an act expressing symbolically the fan gangs' hostility toward punks. The Russian *PUNKI* was painted on the entrance to the headquarters of a Komsomol voluntary patrol in Moscow in 1983. Presumably, Russian was used to ensure that the despised Komsomol got the point. A pacifist logo had been painted on the same entrance earlier, and had been whitewashed; the punk graffito was part of a continuing war of symbols. *ANARKHIA MAT' PORIADKA* ("Anarchy is the mother of order") appeared on more than one wall in 1988. NON STOP EROTIC CABARET, written large in an archway off Nezhdanov Street in the spring of 1984, was almost certainly a punk graffito from the time

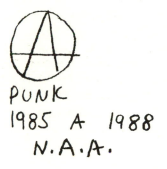

PUNK
1985 A 1988
N.A.A.

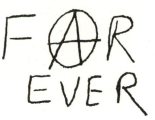

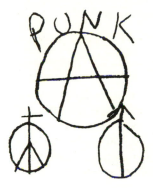

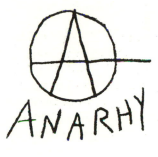

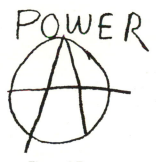

Figure 4.7

when punks hung out in that area. The phrase was the title of an album by Soft Cell, an early 1980s new wave band of the type whose fashions punks copied, and it expressed the eroticism that appealed to punks. *NOVAIA EROTIKA* ("New erotica"), in an archway off the Arbat where the counter-culture gathered in 1988, was probably another punk inscription. Near that was another punk graffito, part of an exchange of graffiti opinion:

MY KHOTIM KHLEBA I ZRELISHCHA
("We want bread and circuses")

NAM NUZHNY TOL'KO PIVO, ANARKHIIA I GRIAZ'
("All we need is beer, anarchy, and dirt")

A NAM ETO NE NUZHNO!
("But that's not what *we* need!")

Two other 1988 punk graffiti, written very large, expressed roughly the same sentiment: ALL THE WORLD IS MADE OF SHIT (this occupied 30 feet of wall), and CRAZY PEOPLE.

Unlike the pacifists, who broadcast their message as widely as possible, punks write most of their graffiti at or near punk, or at least counterculture, hangouts. In Moscow in 1983 and 1984, the greatest concentration was around Pushkin Square, which punks had frequented the longest. In Moscow and Leningrad in 1988, punks covered the walls outside and inside their *flety* with graffiti. VELVET UNDERGROUND, an American rock group that was in some ways a distant antecedent of the punks, appeared in the stairwell leading to an apartment used by Leningrad punks. The door to the apartment featured a crude life-size painting of a man obviously meant to be a punk, and a number of slogans in both English—PUNK ROCK and FUCK OFF—and Russian. The Russian set included "Mimicry," "Citizens, catch the crocodiles," "No one knows what a high is," and "No exit! And no entrance, either." There was also a symbol that looked very much like a swastika with one of its short feet missing. The effort to be simultaneously clever and crudely offensive nicely exemplified the punk manner.

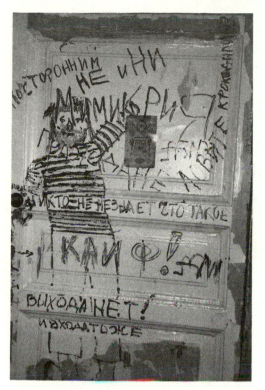

Photo 4.2 Door to a punk *flet*. (Leningrad, 1988. Credit: Susan Costanzo)

The counterculture *tusovki* accumulate a wide variety of graffiti, by all of the main graffiti-producing groups—pacifists, punks, *metallisty*, sometimes even *fanaty*—as well as by groups that produce little graffiti, and by individuals who inscribe their personal marks. In 1988 a wooden shelter behind the Moscow cafe-*tusovka* known to the counterculture as the *Pentagon* had amidst its many graffiti the insignia of the "Beat Army," the *rokery* motorcycle gangs, the Association of Soviet Socialist Anarchists (by then defunct, but interesting in its use of Soviet symbols), a group of absurdist artists who call themselves the *kontrkul'tura*, and probably other obscure groups as well (see Figures 4.8a–4.8d). Some graffiti communicated standardized messages, such as "The USSR equals

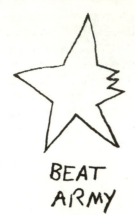

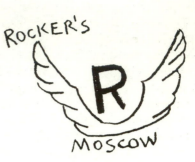

BEAT
ARMY

(a)

(b)

(c)

(d) (e)

Figure 4.8

fascism" (Figure 4.8e). And there was the usual assortment of English and Russian statements, for example I'VE GOT A GIRLFRIEND ITS BETTER THAN YOU ALL! and *MAMA ANARKHIA, PAPA STAKAN PORTVEINA* ("My mother is anarchy, my father's a glass of cheap wine," a line from a song by the popular rock group *Kino*). The graffiti shown in Figure 4.9 appeared around the door of the cafe itself; the first five were personal insignia, and could be found at other *tusovki* in Moscow and Leningrad. The *Pentagon* was not one of the central counterculture hangouts; there were larger assemblages of counterculture graffiti elsewhere, especially in Leningrad. Still, the graffiti at the *Pentagon* can be taken as modestly representative. Counterculture graffiti are individually interesting, but in very large doses they become wearisome.

The graffiti of the counterculture *sistema*, whether the work of pacifists and punks, the Beat Army, or even the individuals who make only personal marks, present an ideology of opposition to official society. They do so through verbal and symbolic statements, by using antiofficial symbols as identifying emblems, or simply by mapping the network of *tusovki* and *flety* that the counterculture has carved out of official society and occupied for itself. That is a tautological assertion—if the counterculture graffiti did not negate established values and verities they would not be the graffiti of a counterculture—but a reminder that there are unifying threads within the diversity is not amiss. And it is certainly worth pausing to note that the counterculture graffiti stand apart as a graffiti genre in their own right. They say things that neither fan gang nor *metallist* graffiti say, in a symbolic style that the other genres do not use, and often in places where few other graffiti appear.

And yet for all their distinctiveness, counterculture graffiti are a part of the mainstream of Soviet graffiti. The use of English—by pacifists, by punks, by unattached individuals—is one powerful bond. No matter how unconventional hippies and punks may be in other respects, they adhere to the most important of all the conventions of Soviet graffiti. By observing that convention, the authors of counterculture graffiti severely limit the audience for their messages, in part unintentionally.

MAⓍIM GORky CO

 M A ▽ A Ⓐ

 GLOT

 ONLY!

GREEN PEACE

 ONLY
WHITE

Figure 4.9

But as one member of the *sistema* asserted in 1988, hippie slogans do not look right in Russian. Their non-Russianness is part of their message.

Conventions other than the use of English also structure the graffiti-writing and -reading universe, and the counterculture writers observe them, too. Like the *metallisty*, for instance, pacifists communicate by posting the name of a favored rock band. Heavy metal and pacifist writers are both immersed in the Soviet rock culture and both contribute to the uniquely Soviet variety of graffiti that name rock and roll bands. The attitudes associated with the Beatles and Metallica may be quite different, but heavy metal fans and pacifists inhabit a distinctive world in which it makes sense to communicate through the invocation of the names of Western rock groups; they are neighbors saying different things in a common language. *Metallisty* do hang out on the fringes of the counterculture, and it was not unusual in 1988 to find a counterculture statement or two among the bands named in heavy metal graffiti lists. Even the punks, strangely reluctant to name specific bands, identify themselves by exalting the punk musical style.

The *metallisty* provide a bridge between the fan gangs and the counterculture: in the early 1980s heavy metal fans and heavy metal graffiti had links to the fan gangs and gang graffiti, while at the end of the decade *metallisty* and their graffiti had counterculture associations. And over the course of the entire decade, some counterculture graffiti have used vocabulary from fan gang argot, and with gang connotations. FANS occasionally accompanies both pacifist and punk emblems (Figures 4.5b and 4.10a), and the gang crown sometimes crops up, too, as in Figure 4.10b. There are even a few graffiti that explicitly link pacifists with fan gangs. The graffito in Figure 4.10c, from Moscow in 1984, joins pacifists to the Dinamo gang (or at least to support for the Dinamo soccer team, in 1984 an almost certain sign of affiliation with the *fanaty*), and includes a small KISS as well. That graffito, referring to gangs, pacifists, and heavy metal, combines the three major constituents of Moscow graffiti in a single composition and—by implication—the writers into a single, albeit heterogeneous, population set

FANS

(a)

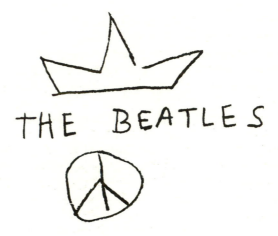

THE BEATLES

(b)

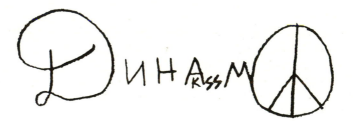

(c)

Figure 4.10

apart from all of those who can neither contribute to nor understand this or most other public graffiti.

THE ENEMIES OF THE COUNTERCULTURE

Counterculture attitudes, style, and behavior shock older Soviet citizens and deeply offend many young people as well. The counterculture encompasses only a very small minority of Soviet youth, several tens of thousands at most. Even allowing for all those who circle in fascination around the fringe, and the very many who adopt elements of the counterculture style so as to be fashionable, probably most Soviet young people consider counterculture values alien. Innumerable Soviet citizens of all ages interpret the counterculture as a sign of social disorder and decay, and favor harsh remedies. During the 1970s, folk Stalinism—a yearning for a firm hand, for suppression of all manifestations of social and cultural hetero-geneity ("sleaze and indecency" is how folk Stalinists would put it), for disciplining corrupt and indifferent officials—increased in proportion to the Brezhnev regime's decrepitude and incapacity to direct Soviet society. The more visible the counterculture, the greater the popular authoritarian revulsion it provoked.

By the early 1980s, groups of teens and young adults who wanted to take action against social blemishes had begun to form. Demobilized veterans of the Afghan war swelled in number. The Afghan veterans—*Afgantsy*—reacted strongly against the indifference of their fellow citizens to what they had experienced in Afghanistan, as well as to the regime's incompetence in dealing with the needs of the vets. Many of the *Afgantsy* adopted at least the posture of social puritanism, and set their goal as wreaking vengeance against black marketeers, crooks, and corrupt officials who somehow slipped through the clutches of the law. But the vets were not doing anything that other bands of vigilantes had not already begun. Veterans of combat or not, they practiced military drill, trained in karate and other combat skills, and searched for an

outlet for their indignation. Judging from unofficial sources, and from the few reports on these groups in the Soviet press, they mostly have a working-class membership. Social frustration plays a part in their hostility to the indiscipline and indifference to proclaimed Soviet values that they see all around them.[27]

Most of the vigilante groups have no special animus against the counterculture, but two of them—not coincidentally, the two known to produce graffiti—are so attentive to the counterculture system that they are practically a part of it. The fascists—*fashisty*, in fact neo-Nazis—are not really a vigilante group, but they were the first to espouse authoritarian puritanism as a critique of the condition of Soviet society. Other vigilante groups consider the *fashisty* part of the problem, but intellectually they have a great deal in common. The *Liubery*, working-class vigilantes from the Moscow suburb of Liubertsy, are the prototype for the newly emerging youth gangs that engage in clearly criminal activity and at the same time claim to be about cleaning out the scum who import Western values into Soviet society.

Moscow's fascists brought themselves to public attention dramatically on April 20, 1982, when they attempted to hold a demonstration at Pushkin Square on the occasion of Hitler's birthday. There are as many different accounts of that event as there were eyewitnesses, but at least a rough outline can be reconstructed.[28] Anywhere from just more than a dozen to a hundred or so young men, and a few young women, dressed in black and wearing small swastika medallions, or swastika arm bands, emerged from a cafe off Pushkin Square that served at the time as the fascist watering hole, formed an orderly column, and set off—perhaps bearing a portrait of Hitler—for the Pushkin monument. Members of the Spartak fan gang immediately fell upon them, but the fascists had armed themselves with bicycle chains and clubs and they fought back. Police, present in more than the usual numbers, prevented passers-by from intervening, in effect providing a ring for the battle. The police did eventually move in to arrest fascists and gang members alike, but by at least some accounts they did so only when they saw that the *fanaty* were getting the worst of the fighting.

Some of the combatants sustained serious injuries and had to be taken to the hospital by ambulance. One well-positioned witness watching from the *Izvestiia* building overlooking Pushkin Square reports that it took more than an hour to evacuate all the wounded. A more cautious source reports that approximately 10 seriously injured participants were taken to nearby Hospital No. 24.[29] That figure suggests that more than a couple of dozen fascists were involved.

The extensive advance publicity the demonstration received points to the same conclusion. Extra police, gang members, and numerous informed witnesses attended the demonstration because the fascists' intentions were known well ahead of time. High school students all over Moscow knew about it, and a few of their parents went to Pushkin Square on April 20 to see what would happen. Teachers, following police instructions, warned students away, but the students treated the affair with levity and in the weeks preceding the demonstration greeted each other with the Nazi salute and salutations of "Heil Hitler!" The police prepared by calling in the leader of the Spartak *fanaty* from the working-class suburb of Liubertsy and ordering him to mobilize his followers to vent popular indignation against the fascists.

Even if the demonstration had not been advertised in advance, it would have been widely observed. Pushkin Square was the scene of many brief dissident demonstrations in the 1960s and 1970s because of Pushkin's status as Russia's national poet, and because the square is a traffic hub. It is near the city center on Moscow's main street, and it was then at the intersection of two (now three) subway lines, so there is always a great deal of pedestrian traffic moving through and adding to the large numbers of young people who traditionally hang out at the monument. And because gardens slope away from the square on two sides, there are long, unobstructed views of whatever happens. The fascists, who chose deliberately to put themselves on display, picked the site that afforded maximum exposure. And, either to increase the audience or to make escape easier, they timed the demonstration to coincide with the end of a show at the large movie theater on the square.

According to the accounts of those reasonably well placed to

know what they are talking about, the arrested fascists were quickly released because they were the offspring of the political elite; one rumor had it that the grandson of Andrei Kirilenko, then a member of the Politburo, took part, and that he bore Hitler's portrait. Indeed, everyone who claimed any knowledge of the fascists in the early 1980s described them as the sons and daughters of the elite, enrolled in schools attended exclusively by the children of the elite. It was widely believed at the time, too, that there were fascists high in the Komsomol hierarchy, and that some even sat on the Komsomol Central Committee. That the demonstrators of 1982 were well connected would explain the peculiar way in which the police handled the demonstration. Rather than meeting them in force and bundling them off to police stations within seconds —the well-practiced routine for dealing with dissident demonstrations at the time—the police chose to allow the fascists to suffer a sound thrashing. The authorities may have hoped that this would knock some sense into the fascists and spare the police, and the fascists' powerful fathers and grandfathers, the embarrassment of having to book them. According to one very creditable report, in fact, the police records on the fascists were immediately removed from the files, while a witness who had saved a young lady fascist from a savage beating was none too politely told to get lost. The young lady herself was whisked home in a limousine.

The fascists certainly meant the 1982 demonstration to be their public debut—they must have spread word of it themselves in order to attract an audience—but they had already existed, in the fastness of their elite institutions and unknown to almost everyone in mainstream Soviet society, for several years. The best guess is that in Moscow a more or less organized fascist movement dates from the late 1970s. But there were ambient fascist inclinations before that. The earliest reported pro-Nazi demonstration occurred in Tallinn, where in September 1980 a small group of Estonian youngsters at a rock concert on the anniversary of the Soviet liberation of Estonia from the Germans shouted "Heil Hitler" (the reports claim this incident was organized by young fascists, but mere anti-Soviet nationalists might have done the same thing). A larger pro-Nazi demonstration involving more than 100 high

school-age demonstrators wearing swastika arm bands and shouting "Fascism will save Russia!" is reported from Kurgan in Western Siberia in November 1981. And there is fragmentary information about fascist demonstrations in 1982 or before in Iuzhno-Uralsk, Sverdlovsk, Leningrad, and elsewhere.[30]

Whatever motivated the Moscow fascists to seek the spotlight in 1982, they quickly retreated into the shadows. But they did not fade away entirely. The police were awaiting them in force on Pushkin Square on April 20, 1983, but there was no demonstration; instead, individual *fashisty*, identifiable by the swastikas they had shaved into their hair, passed quietly through the square without incident. In 1984, they celebrated Hitler's birthday not at Pushkin Square, but at a banquet in the restaurant of the Hotel Berlin; the restaurant's management expelled them when they stood and raised a toast to Hitler. Not only did the fascists in Moscow continue to make themselves known in small ways, they adopted a dress code: wide leather belts, black jackets, narrow black ties (all black clothing, in fact), sunglasses, and sometimes buttons with portraits of Hitler.[31] Since black leather jackets and sunglasses were a fashion among many young people who were not fascists, the fascist uniform did not stand out boldly.

Fascists were more visible in other cities. In 1983 they celebrated Hitler's birth with demonstrations in Sverdlovsk, Kuibyshev, Omsk, Rostov, Saratov, and the Ukraine.[32] The Moscow rumor mill had it in 1984 that provincial fascists had planted a Nazi banner on a church cupola, and that they had attempted to stir up an anti-Jewish pogrom in a Ukrainian town. The fascists were particularly numerous and active in Leningrad; in the early 1980s there were far more fascist graffiti there than in Moscow, and well-dressed young men and women were spotted in Leningrad chanting "We are the fascists." By 1987 the Soviet press had begun to report on the Leningrad fascists, who hoisted Nazi banners, sewed Nazi uniforms, painted Nazi graffiti down the main street of the naval-base city of Kronstadt on Hitler's birthday, forced isolated pedestrians to chant Nazi slogans or suffer a beating, issued themselves attestations of their right to bear arms, and kept neat files in folders covered in red leatherette.[33] In 1987

Soviet TV broadcast a documentary on *fashisty* in Irkutsk, and in 1988 three young Moscow fascists expounded their views on live TV.[34] By then the Soviet Nazis were an admitted ugly reality in Soviet society; although probably not very numerous, they were nevertheless a persistent presence. And at least outside Moscow, no one any longer characterized them as exclusively offspring of the elite.

Despite their name, and despite their veneration of Hitler, the Soviet fascists are extreme Russian nationalists. The fascist label does accord with their desire to root out the Western influences that they believe are corrupting Soviet society. They are anti-Semitic, but anti-Semitism is only one of their core attitudes. They are opposed to all interethnic marriages, and have a particular animus against the rapidly expanding Muslim population, which they would like to confine to Central Asia. The three *fashisty* who appeared on TV in 1988 spoke of the threat of overpopulation, resource exhaustion, and (although they do not seem to have used the word) mongrelization: women who are not sufficiently strong and pure, they said, give birth to children with defects and thereby weaken the Russian nation.[35]

Except for the celebration of Hitler's birthday, the fascists' views are not, within the Soviet context, entirely aberrant. One official of the Moscow city Komsomol organization in 1965 circulated among his colleagues—and sent to Komsomol offices in other cities—a moral code that spoke of the "voice of the blood" and called for "a cult of the ancestors," branding and sterilization of women who had sexual relations with foreigners, caste stratification, and corporal punishment for young people, since "a blow to the body hardens the soul."[36] It is not at all inconceivable that similar notions should have become a part of the intellectual baggage of succeeding generations of Komsomol leaders. In any case, since the 1960s almost all of the fascists' views have been expressed either in official print or in samizdat by Russian nationalists of one sort or another. And an anti-Semitic Russian nationalist organization, *Pamiat'* ("Memory"), has become a mass organization since 1986.[37]

It is the deliberate choice of the name "fascist," and the veneration of Hitler, that set the fascists apart. They esteem

Hitler not so much for his specific beliefs—certainly not for his ideas about Slavs—but for his concept of racial purity and his example of dynamic, authoritarian rule. Yet, as *Pamiat'* has shown, symbols less offensive to Russian sensibilities could have been found to represent roughly the same ideas. The fascists have chosen deliberately to offend: their purpose is as much rebellion against political verities as it is promotion of a set of political views. They resemble in that way the counter-culture they claim to despise.

The graffiti, as usual, help us to pin down both the social and cultural characteristics of the *fashisty*. In the early 1980s, fascist graffiti were found most frequently in and around Pushkin Square, where the fascists had their cafe haunts, and in a few other streets and courtyards in central Moscow. The few isolated graffiti elsewhere were at or near identifiably elite apartment buildings, a distribution supporting the prevailing supposition that the fascists in Moscow were at that time the offspring of the elite. The original fascist emblem was the swastika, but not all swastikas were produced by fascists. Children in the Soviet Union, as in the United States, find the swastika a challenging doodle, and they occasionally use the swastika as a negative epithet: "Tolya's a fascist." A swastika set off with a circle, or accompanied by the twin lightning bolts of the SS (Figure 4.11a), were then and later calculatedly fascist inscriptions.

Fascists in 1984 and later also occasionally employed the emblem in Figure 4.11b, sometimes with the superior N, sometimes without. The derivation can only be guessed at. The *N* probably referred to Nazis. The jagged line within the circle may perhaps have been taken from the mathematical radical sign, which can be interpreted in this context as an allusion to racial rather than mathematical roots. That is only a hypothesis. Scarcely anyone other than the fascists them-selves knew what the emblem stood for, but in at least one instance accompanying commentary made the meaning plain. The original author added to the logo the exclamation *DA ZDRAVSTVUIUT RUSSKIE* ("Long live Russians"). Someone else then added inside the circle *ETO NE VERNO* ("This is not true"). Finally, either the first writer or someone else effaced the negative particle, leaving the entire composition a

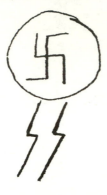

(a)

(b)

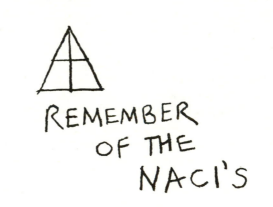

REMEMBER
OF THE
NACI'S

(c)

(d)

Figure 4.11

tautological assertion of the fascists' racist nationalism. At least one fascist in 1984 used the cross in a triangle as a fascist emblem, as in Figure 4.11c. The caption is a bad English rendering of the Russian *pomni o natsistakh*. And by 1988 fascists used the encryption "88," as in Figure 4.11d, as a symbol; *8* stood for *h*, the eighth letter in the German alphabet, and the double *8* translated into "Heil Hitler." The fascists' adoption of increasingly arcane symbols—swastika, radical-with-N, and 88 almost certainly appeared on the walls in that chronological sequence—paralleled their gradual retreat from the public eye after the 1982 demonstration.

Some fascist graffiti do state their meaning directly. HEIL HITLER, or the same in Russian transliteration, *KHAIL GITLER*, and GOT + MIT + UNS accompanied by a swastika, are the most frequent, but there are others. In November 1982 a set of German-language fascist graffiti, including *HEIL HITLER JUGEND!*, appeared on the walls of the State Film Institute in Moscow.[38] A swastika and the phrase EDEM RUSS EIN SCHUS ("One shot for every Russian," a German slogan from World War I), which appeared on the walls of the Komsomol Theater off Pushkin Square in 1983, was almost unbelievably another fascist statement. No German could have written the slogan in that way, nor would any Balt, nor any Western Slav—if only because they all use *j* in the same way Germans do. The character of the spelling errors makes it overwhelmingly likely that the author's native language was Russian. While it may seem preposterous that a Russian authoritarian nationalist should have written such a slogan, it is not much more so than the same nationalist celebrating Hitler's birthday.

Far more than the graffiti of pacifists and punks, fascist graffiti provoke hostile responses. A swastika may be challenged by a bold *NET* ("no") in a different paint and hand. In one instance in 1984, a swastika was obliterated by a superimposed hammer and sickle, one of only two graffiti employing the officially patriotic symbol seen in a year of looking (and at that the swastika was left unanswered for six months). In 1983 and 1984, swastikas were often answered with the peace symbol drawn alongside or—in underpasses and archways—on the opposite wall. For a while after the

fascists' emergence in 1982 there was a running graffiti war between pacifists and fascists, and an exchange of real blows on the few occasions when fascists and pacifists spotted each other sporting identifying badges. But a swastika or fascist slogan on the walls is so offensive that it can galvanize even someone who has nothing to do with the graffiti-producing groups into responding in kind. By 1988 there were fewer antifascist graffiti, but then the number of fascist graffiti—never large—had also declined.

Fascists and their graffiti have a problematic but nevertheless close relationship to the counterculture. Fascists and pacifists not only address their graffiti to each other, the fascists employ the symbols, and sometimes the language, of their counterculture opponents. They use German more often than English, but that is in keeping with the particular symbols to which Moscow's young fascists cleave. It is of course contradictory for so militantly nationalist a group as the fascists—who are explicitly hostile to the encroachment of Westernisms into Soviet society—to incorporate so much English and German in their graffiti, but that is the least of their contradictions. Fascist symbols—not just swastikas, but also all of the others—do occasionally show up at counterculture *tusovki*, and the members of the counterculture may be the only people other than the fascists who know how to decode the encryptions.

Other anti-Semitic groups that are at least ideologically very close to the fascists—they may actually be fascists—also observe the graffiti conventions. The graffito in Figure 4.12a, from Moscow in 1988, reads "Beat the Jews"; the abbreviation inside the circle is for the *chernaia sotnia*, the anti-Semitic "black hundreds" who organized pogroms in late Imperial Russia. That is an unusual graffito in its exclusive use of Russian. But in the city of Pskov an anti-Semitic group has covered walls with the same organizational message in English, and for good measure has added on the crown from gang graffiti (Figure 4.12b).[39] And if some anti-Semites are fully capable of employing the graffiti argot, more than a few signs of racism show up in the graffiti of the counterculture: ONLY WHITE, as on the wall of the *tuskovka* known as the *Pentagon* (Figure 4.9), or WHITES ONLY (the "blacks" are

the peoples of Central Asia and the Caucasus), or KKK. The graffiti, in other words, offer evidence of at least some interpenetration of the counterculture and the neo-Nazis. The neo-Nazis are not part of the counterculture, but they are close if hostile neighbors.

While Moscow's *fashisty* have been quite furtive since 1982, the other graffiti-writing opponents of the counterculture, the *Liubery*, have become increasingly brazen. The *Liubery* are the latest variation on the suburban working-class gangs that have for decades beaten up Moscow teenagers. The city of Liubertsy, a short train ride southeast of Moscow, lent its name to the phenomenon, and the Liubertsy toughs were the first to turn their ganging into an ideological cause and to single out counterculture groups as targets. However, by the late 1980s working-class groups from all the suburbs—even from Moscow itself—called themselves generically *Liubery*.

Working-class youngsters in Liubertsy took to bodybuilding in the same way that many others in the late 1970s took up karate. Physical training of either sort went hand in hand with moral and social puritanism; bodybuilders, for instance, did not smoke or drink, and despised corruption of the body social as well. Like every other display of private social initiative, physical training provoked official displeasure. Karate was first regarded with suspicion, then briefly given the status of an official sport subject to regulation and licensing from Moscow, then outlawed. The authorities feared both the capacity of devotees to inflict harm and their militaristic posturing; the karate masters to whom the trainees owed obedience were not part of the official hierarchy. Bodybuilding did not arouse so much suspicion, but neither did the authorities encourage it. While outlaw karate clubs formed all over the Soviet Union, teenagers in Liubertsy turned dingy basements into private gyms, outfitted them with weights, and began working on their musculature. Liubertsy police counted around 50 of these private weight-lifting clubs as of early 1987, and claimed they had 500 members.[40] But a larger number of Liubertsy teens than that would have counted themselves among the *Liubery*.

The *Liubery* were first talked about on Moscow streets in the early 1980s.[41] Their aggressiveness and physiques set them

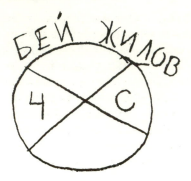

(a)

(b)

(c)

Figure 4.12

apart from the run of suburban toughs, as did their uniform, the central items in which were exhibitionist muscle shirts and baggy checked slacks. But they became a major element of Moscow street life only in the middle of the decade. When the counterculture surfaced in all of its variety under Gorbachev, the *Liubery* responded by descending on Moscow en masse and hunting for hippies, punks, *metallisty*, even skateboard riders to beat up. They explained, when asked, that they were beating up the scum for patriotic reasons. As one 16-year-old *Liuber* wrote to a newspaper:

> We don't beat up everyone we meet, like many think, only the ones we don't like. Do you really like those who go around in chains, all in rivets or dyed hair, who shame our country? Every so-called punk or *metallist* you ask will say the way they look and act is an expression of protest. Against whom? All of us![42]

And he went on to threaten that the *Liubery* would run down those counterculture groups at movie theaters, cafes, and discotheques, and on the streets. A group of *Liubery* on benches outside a subway station told a Soviet reporter that they were waiting for hippies who were known to gather nearby: "They disgrace the Soviet way of living. We want to clear them out of the capital."[43] And there were many similar reports.

The invasion of the *Liubery* created something of a moral panic, the first media-fed hysteria about youth violence in modern Soviet history. Rumors of impending raids swept through the counterculture youth groups in late 1986 and early 1987, hundreds—in some tellings, thousands—of Moscow youths gathered several times in city parks and gardens waiting for battle, trade school students circulated notices that they had formed an interschool alliance to do battle with the *Liubery*, and *metallisty* distributed their own declaration of intent to take on the enemy. The fact that suburban gangs, from Liubertsy and elsewhere, really did beat up individual hippies, punks, and *metallisty*, and that they fought pitched battles with some of the fan gangs, convinced Muscovites that there was substance to all the rumors. The panic was sustained by the suspicion that the *Liubery* enjoyed the protection of the

KGB, or more generally of opponents of Gorbachev's reforms; the *Liubery*'s claim to be struggling to purify Soviet society lent itself to such speculation.[44]

One of the many signals that the *Liubery* had acquired more organization, identity, and sense of purpose than the mere lads from Liubertsy who had always beaten up Muscovites was their use of an emblem, the graffito in Figure 4.12c. This is the only graffito the *Liubery* produce, which is also to say that they all use it. The weights are sometimes more fully drawn, in the odd case the *L* is enclosed in a circle rather than a triangle, and the crown in Figure 4.12c is actually a rare addition to the basic emblem. The Liubertsy *L* is always written as a Latin rather than a Cyrillic character—a superficially paradoxical feature, since the *Liubery* claim to be defending the honor of their country. But of course the reason for their ideological deviation is that the conventions of public graffiti, well established by the time they began to write, mandated the use of English. The *L* is the only writing involved, which means that the graffiti of the *Liubery* without exception abide by the rule that English is the language of exhaltation. The exceptional crown goes back to fan gang graffiti. The *Liubery*, in other words, use the graffiti language of the *fanaty, metallisty*, and counterculture, the very groups they claim to be fighting against.

The distribution of the graffiti confirms the *Liubery*'s intense involvement with the counterculture. In Liubertsy itself there are many emblems, as well as a scattering of heavy metal and fan gang graffiti. In Moscow, the *Liubery* leave their graffiti chiefly in areas where the counterculture groups hang out, all along the Arbat pedestrian mall, for instance. Punks, pacifists, and *metallisty* all have *tusovki* on the Arbat, and the L-and-barbells logo is near every one, sometimes superimposed over counterculture emblems. And occasionally pacifists and punks respond in kind, crossing out the *Liubery*'s emblem.

That does not make the *Liubery* a part of the counterculture, but it does establish a bond. Even without the counterculture there might be *Liubery*; they had set their distinctive course toward bodybuilding and social purification before they had more than occasional contact with hippies and punks. However, confrontation with the rapidly expanding counterculture

from 1985 on was what provided the final impetus and gave them the identity that they now have. The *Liubery* write their graffiti where hippies and punks hang out because it is through conflict with those groups that they define themselves. They write their graffiti in the same way that the counterculture writes because they learned the language from the counterculture—or conceivably from the gangs that were the first teachers of all—and are engaged in cultural contention with the counterculture. Those statements are not figures of speech, they are a literal description of what is happening on the streets of Moscow. The exchange is not unidirectional, either; the counterculture groups are themselves galvanized by the conflict with the *Liubery*, through which they reaffirm their own identity.

A GRAFFITI MAP OF THE COUNTERCULTURE AND ITS NEIGHBORS

The groups that make up the Soviet counterculture produce so much graffiti, and graffiti seem so appropriate a means of counterculture expression, that upon reflection it may appear odd that the counterculture did not originate the practice. Yet the counterculture existed for a decade or so without producing any graffiti. Or, to be somewhat more cautious, if there were countercultural graffiti in the 1970s, there could not have been many, because they did not register with the public or leave any trace in the collective memory of the counterculture itself. Whatever it takes to invent public graffiti, the fan gangs had it and the early counterculture did not. Perhaps that is not so surprising after all: gangs used graffiti in other societies long before there was a counterculture. Once the fan gangs had invented this means of public expression, counterculture groups took it up. The timing may have been related to the coincidental transformation of the countercultural "system," the decline of the original hippies and the emergence of pacifists and punks who had a strong urge to address the public.

Since about 1980, counterculture graffiti collections have provided a rough guide to the structure of the counterculture. Hippie pacifists are the premier counterculture graffiti writers, but most pacifist graffiti are located away from the *tusovki*. The pacifist graffiti at *tusovki* reflect general hippie sentiment more than the presence of the politicized pacifists. Punks are not as energetic writers as the pacifists, but they contribute enough graffiti at their own and systemwide *tusovki* to confirm what is obvious anyway: they may have intruded on the system from without, but they are clearly a part of it. Other groups, too, interact with the counterculture. The emblems of *rokery* occasionally crop up at *tusovki*, but it is as though the bikers were just checking in to see what was happening. The *rokery* are friendly onlookers, but they have had their own network for decades; their motorcycles inhibit circulation from counterculture *tusovka* to *flet* back to *tusovka*, and preclude the counterculture practice of hitchhiking from city to city. For a while, it appears, the break dancers—*breikery*—were closer to the counterculture than the bikers; they hung out with hippies and punks, and left written evidence in the collections of graffiti that accumulate at *tusovki*. The *metallisty* are a special case: they are in many ways part of the system, since they drop in on counterculture *tusovki*, contribute graffiti, and adopt a special provocative style. But they have their own independent history and their own hangouts, and they are so numerous that they really constitute a separate system.

The graffiti allow us to construct a rough map not only of the counterculture and of those groups—like the bikers—who are contiguous but independent of the "system," but also of opponents like the *Liubery* who define themselves through hostility to counterculture values. Of course, the lines dividing the groups are permeable. Adolescents very often assume a number of countercultural or near-countercultural identities in quick succession. The map is really of a world of possible roles, every one of which is defined in part by its relationship to every other role.

The map of counterculture and related groups is coherent only because all of the groups—pacifists, punks, *metallisty*, *Liubery*, *fashisty* and other anti-Semites, and of course the fan gangs—share a common graffiti language. They all use English

as the language of honor, they tend to use Russian as the language of dishonor, and from time to time they employ the symbols pioneered in gang graffiti. We have now proceeded far enough in our examination of graffiti-producing groups to see just how unusual this is. Socially, these groups have very little in common. The fascists, at least in Moscow, sprang from the midst of the elite. Pacifists, punks, and *metallisty* come disproportionately from the Soviet equivalent of the middle and upper middle classes, or (to group them in a slightly different way) from among the college or college-bound population. Since the middle of the 1980s, members of the fan gangs have come predominantly from the working class. The *Liubery* have never been anything other than working-class toughs. Yet all of them write graffiti that are mutually comprehensible to one another while being largely incomprehensible to those who do not write graffiti.

The contrast between the linguistic unity of the graffiti in Moscow and the linguistic disunity of American graffiti is enormous and therefore instructive. In Chicago (New York, Los Angeles), lower-class gang graffiti are utterly unlike the graffiti produced by college students and the counterculture. American student graffiti never include the crowns, canes, tridents, and daggers that make up the gangs' symbolic idiom, and students cannot read graffiti written with those symbols. Nor do students use or understand the alphanumeric code employed by taggers, the individual ghetto writers who fan out along subway and bus lines. In Moscow, fascists, pacifists, and punks all use gang idioms. American gang writers would, in turn, find much of the student and counterculture graffiti incomprehensible, while in the Soviet Union the entirely working-class *Liubery* know just what pacifists and punks are up to. That there is such a common language, that it transcends otherwise formidable social and intellectual divisions, and that it is quite opaque to those who do not write graffiti suggests that the graffiti-writing groups are bound together by more than language alone.

The writers of the graffiti constitute a sharply demarked linguistic community. This community consists of two socially distinct parts, the fan gangs and the counterculture. The *metallisty* provide a bridge between the two, and in a different

way so do the *Liubery*. All of these groups interact, which is of course the reason they all write the same graffiti argot. That is not the only reason, in fact it is a bare precondition, for the establishment of the linguistic community. They all use the argot because it serves an identical expressive need for all of them: it proclaims their antipathy to the conventions of Soviet society. The linguistic community is an anticommunity united by its opposition to the normative community.

The components of the oppositional linguistic community have quite different origins, but rock music—like the *metallisty*—has helped to weave them together. That at least seems a plausible hypothesis. Rock music was certainly midwife to the Soviet counterculture in the late 1960s. By the time the *fanaty* emerged in the late 1970s, rock music and associated Western popular culture so thoroughly saturated Soviet society that the gangs found it perfectly natural to use English as the language of prestige and to express their antagonism to Soviet conventions. The *metallisty* and their forerunners of course sprang directly from Soviet involvement with rock music. When counterculture groups like the pacifists and punks finally took to writing graffiti, they found the existing argot—use of English, naming of rock bands—perfectly suited to their needs, and adopted the gang symbols that were part of the argot. Rock music is not the only thing binding the graffiti-producing groups, but the peculiar cultural freight the music carries in Soviet society did help to turn these groups into a community sharing a language of cultural opposition.

NOTES

1. For reports on such graffiti, and of a 1976 political trial in Leningrad involving graffiti, see *A Chronicle of Current Events. Numbers 40, 41, 42*, London, 1979, pp. 164–67, 182; *A Chronicle of Current Events. Numbers 43, 44, 45*, London, 1979, pp. 24–28, 161–62, 221, 295–97.

2. I. Iu. Sundiev, "Neformal'nye molodezhnye ob"edineniia: opyt ekspozitsii," *Sotsiologicheskie issledovaniia*, 1987 no. 5, p. 58.

3. There are good, if brief, descriptions of Soviet hippies of the 1970s in *Newsweek*, 8 Dec. 1975; Andrea Lee, *Russian Journal*, New York, 1981, pp. 90–100; Artemy Troitsky, *Back in the USSR: The True Story of Rock in Russia*, Boston and London, 1987, pp. 30–32; A. M. Presman, "Eshche raz o khippi," *Sotsiologicheskie issledovaniia*, 1988 no. 4, pp. 113–14; and A. P. Fain, "Liudi 'sistemi' (miroo-shchushchenie sovetskikh khippi)," *Sotsiologicheskie issledovaniia*, 1989 no. 1, p. 88. M. V. Rozin, "Psikhologiia moskovskikh khippi," *Psikhologicheskie problemy izucheniia neformal'nykh molodezh-nykh ob"edinenii*, Moscow, 1988, pp. 44–69, is by far the best source on Soviet hippies, and a model of careful scholarship. Rozin analyzes Moscow's hippies in the 1980s, but most of what he says applies to the 1970s as well. In addition I have drawn heavily here and in what follows on my own observations from the 1970s and later, and from the observations of Soviet informants, including several involved in the counterculture in the late 1970s and early 1980s.

4. For a hippie anniversary statement, see Initsiativnaia gruppa khippi Moskvy, Kieva, L'vova, drugikh gorodov SSSR, "Ideologiia sovetskikh khippi (1967–1987)," *Den' za den'*, no. 7, July 1987. (*Den' za den'* is a samizdat publication of the Moscow Trust Group, a grass-roots antinuclear group. The entire issue is available in *Materialy samizdata*, AS no. 6114. The manifesto was published as well in *Novoe russkoe slovo* [N.Y.], 22 Dec. 1987.) Also: Troitsky, *Back in the USSR*, pp. 30–31, and V. A. Danchenko, "Kontrkul'tura: karat' ili milovat'?" *Sotsiologicheskie issledovaniia*, 1988 no. 2, pp. 140–42. For a nonanalytical account of the role of popular music in the development of the American counterculture, see Todd Gitlin, *The Sixties: Years of Hope, Days of Rage*, New York, 1987, pp. 195–221.

5. *A Chronicle of Current Events. Issues no. 19 and 20*, London, 1971; no. 20, 2 July 1971, pp. 252–53. A somewhat distorted recollection of this event is in Sylvia Rothchild, *A Special Legacy: An Oral History of Soviet Jewish Emigres in the United States*, New York, 1985, p. 312. *Newsweek*, 8 Dec. 1975, reports what was by that date a highly exaggerated recollection, which had thousands participating, and in 1970.

6. V. Kozlovskii, *Argo russkoi gomoseksual'noi subkul'tury. Materialy k izucheniiu*, Benson, V., 1986, p. 37. Unfortunately, Kozlovskii provides no examples.

7. Rozin, "Psikhologiia moskovskikh khippi," pp. 60–61, 65. On the hippies' social origin, see also A. I. Mazurova, "Slovar' slenga, rasprostranennogo v srede neformal'nykh molodezhnykh ob"edinenii," *Psikhologicheskie problemy izucheniia neformal'nykh*

molodezhnykh ob"edinenii, Moscow, 1988, pp. 149, 157 (under the definition of *tsentroviki*).

8. See Mazurova, "Slovar' slenga," pp. 148–57. Hippies in Moscow provided other examples for me in October 1988.

9. Lee, *Russian Journal*, pp. 92, 98; *Chronicle of Current Events. Issue No. 20*, p. 253; Rothchild, *Special Legacy*, p. 312; Troitsky, *Back in the USSR*, pp. 31, 45; *Vesti iz SSSR*, no. 17, 15 Sept. 1983; *Ekspress-informatsiia "V"*, no. 105, 1983, in *Materialy samizdata*, AS no. 5072; *Latvian Information Bulletin*, July 1984; Ludmilla Alexeyeva, *Soviet Dissent: Contemporary Movements for National, Religious, and Human Rights*, Middletown, Conn., 1985, p. 391; Sundiev, "Neformal'nye molodezhnye ob"edineniia," p. 60; *Ekspress Khronika*, no. 22, 29 May 1988. I am especially indebted here to Sergei Klubov of Minsk, a participant in the summer encampments on the Gauja in the 1980s.

10. For information about the situation around 1980, I am particularly indebted to Nikolai Khramov, Aleksandr Rubshchenko, and Sergei Klubov, interviewed in September-October 1988. See also Nikolai Khramov, "Is It Easy to Be Truthful? Reflections in a Movie Theater," *Across Frontiers*, v. 4, no. 1, Winter 1988, and Presman, "Eshche raz o khipi," pp. 113–14.

11. Andrei Okulov, "Nastroenie molodezhnoi oppozitsii," *Posev*, 1981 no. 1, p. 11, mentions the Leningrad graffiti.

12. On Mikhail Bombin, see *Vesti iz SSSR*, no. 5–6, 31 Mar. 1986; no. 7–8, 30 Apr. 1986; no. 15, 15 Aug. 1986; no. 18, 30 Sept. 1986; no. 19, 15 Oct. 1986; "Obvinitel'noe zakliuchenie po ugolovnomu delu No. 5200285 po obvineniiu Bombina Mikhaila Mikhailovicha," *Materialy samizdata*, AS no. 5798; "Soobshchenie o dele Mikhaila Bombina, pravoslavnogo," *Materialy samizdata*, AS no. 5797; V. Silin'sh, "V chuzhom oblich'e," *Sovetskaia Latviia*, 11 Nov. 1986 (attached to *Materialy samizdata*, AS no. 5801). On the encampments on the Gauja: *Vesti iz SSSR*, no. 4, 29 Feb. 1984; *Ekspress Khronika*, No. 22, 29 May 1988. On Free Initiative and Goodwill: *Vesti iz SSSR*, no. 17, 15 Sept. 1983; no. 22–23, 15 Dec. 1986; no. 7–8, 30 Apr. 1988; "Nazad puti net," *Den' za den'*, no. 9, 10 Sept. 1987, in *Materialy samizdata*, AS no. 6122. On the Moscow Trust Group and Sergei Batovrin: Joshua Rubenstein, *Soviet Dissidents: Their Struggle for Human Rights*, revised edition, Boston, 1985, pp. 275–88; Alexeyeva, *Soviet Dissent*, pp. 386–88; Olga Medvedkova, "The Moscow Trust Group: An Uncontrolled Grass-Roots Movement in the Soviet Union," Mershon Center, *Quarterly Report*, v. 12, no. 4, Spring 1988. And Nikolai Khramov, interviews, September 1988.

13. The outline of the pacifist program is based largely on information from Soviet pacifists, including Nikolai Khramov and Aleksandr Rubshchenko. A police official does summarize it more or less accurately: Sundiev, "Neformal'nye molodezhnye ob"edineniia," p. 60. There are also fragmentary reports in *USSR News Briefs*, no. 21, 15 Nov. 1983; *Vesti iz SSSR*, no. 22–23, 15 Dec. 1986; and Alexeyeva, *Soviet Dissent*, p. 392. For the hippie elements in the program, see the manifesto for Free Initiative, "Nazad puti net," in *Den' za den'*, no. 9, 10 Sept. 1987, in *Materialy samizdata*, AS no. 6122.

14. SMOT, *Informatsionnyi biulleten'*, no. 25, Dec. 1981, in *Materialy samizdata*, AS no. 4711 (an editorial note provides the AP report on the December 1980 demonstration); *Vesti iz SSSR*, no. 5, 15 Mar. 1983; no. 23–24, 31 Dec. 1985; *USSR News Briefs*, no. 23–24, 31 Dec. 1983; Alexeyeva, *Soviet Dissent*, p. 392; Nikolai Khramov, a participant in some of these demonstrations, September 1988 interview.

15. *Vesti iz SSSR*, no. 7, 15 Apr. 1983; no. 17, 15 Sept. 1983; no. 11, 15 June 1984; no. 22–23, 15 Dec. 1986; *Latvian Information Bulletin*, July 1984; interview with Nikolai Khramov, September 1988.

16. On Free Initiative, I am particularly indebted to information provided by Nikolai Khramov and Aleksandr Rubshchenko. Khramov had not heard of the Ufa meetings, but they would have occurred before he became involved in the pacifist movement, and he did confirm that at one time Ufa had a substantial counterculture network. The Ufa meetings were reported to me in 1984. On Bombin: *Vesti iz SSSR*, no. 5–6, 31 Mar. 1986; V. Silin'sh, "V chuzhom oblich'e," *Sovetskaia Latviia*, 11 Oct. 1986 (attached to *Materialy samizdata*, AS no. 5801).

17. See *Materialy samizdata*, AS no. 5519. The list did include the Ramones and Blondie, two American groups that were at one time classified as punk, but which never came close to the raw violence and deliberately primitive style of British punk. One SEX PISTOLS graffito in Moscow in 1988 does not compensate for the surprising absence of similar graffiti in the early 1980s.

18. David Sloane, "Grandfathers and Children: The Rock Music Phenomenon in the Soviet Union," *Semiotext(e)*, forthcoming, citing an interview with the leading Soviet rock critic, Artemii Troitskii. For a description of the behavior of a Soviet punk band, see Terry Bright, "The Soviet Crusade Against Pop," *Popular Music*, v. 5, 1985, pp. 132–33.

19. Most of my discussion on punks is based on personal observation and information from Soviet informants. The Soviet press has mentioned punks frequently, but almost always with outraged

incomprehension. Such articles do at least register the punks' presence and what unsympathetic observers see as their principal characteristics. See, for example, V. Lisovskii, "Politmitrofanushki. Zametki sotsiologa o prichinakh infantil'nosti v molodezhnoi srede," *Sovetskaia Rossiia*, 15 Aug. 1986; "Davai rabotat' vmeste!" *Komsomol'skaia pravda*, 7 Sept. 1986 (the transcript of a phone-in conducted by the leader of the Komsomol); A. Ignatov, "Shagat' navstrechu," *Komsomol'skaia pravda*, 10 Oct. 1986; Iu. P. Shchekochikhin, "Po komu zvonit kolokol'chik?" pp. 86, 92; Presman, "Eshche raz o khippi," p. 114. Western correspondents have also mentioned the punks in passing: Jim Gallagher, "Russia's Young Rebels," *Chicago Tribune Magazine*, 21 May 1982; Bill Keller, "Russia's Restless Youth," *New York Times Magazine*, 26 July 1987; Ruth La Feria, "Soviet Chic," *New York Times Magazine*, 31 July 1988. On punks in Estonia, where the situation seems different from the Russian metropolises: Toomas Ilves, "Punks, Drugs, and Violence," *Radio Free Europe Research*, Baltic Area, SR1, 27 Jan. 1986. See also Troitsky, *Back in the USSR*, pp. 68–70. The best, if very brief, treatment is in A. P. Fain, "Spetsifika neformal'nykh podrostkovykh ob'edinenii v krupnykh gorodakh," *Psikhologicheskie problemy izucheniia neformal'nykh molodezhnykh ob'edinenii*, Moscow, 1988, pp. 26–27.

20. I owe much of this to conversation with participants in the "system" at their *tusovki* in September and October 1988, but there is also information on the development of the Gorbachev-era counterculture in Fain, "Spetsifika neformal'nykh podrostkovykh ob'edinenii," pp. 25–27, 30–32; Fain, "Liudi 'sistemy,' " pp. 85–92; Rozin, "Psikhologiia moskovskikh khippi," pp. 44–69; "Rok: Muzyka? Subkul'tura? Stil' zhizni? (Obsuzhdenie za 'kruglym stolom' redaktsii)," *Sotsiologicheskie issledovaniia*, 1987 no. 1, p. 48; Iurii Shchekochikhin, "Na perekrestke," *Literaturnaia gazeta*, no. 43, 22 Oct. 1986; L. Beletskaia, "Pustynia, okazyvaetsia, byvaet v dushe cheloveka," *Komsomol'skoe znamia* (Kiev), 6 Dec. 1986; Keller, "Russia's Restless Youth"; Linda Feldman, "Laid-Back in the U.S.S.R.," *Philadelphia Inquirer*, 24 Dec. 1987; *On Gogol Boulevard: Networking Bulletin for Activists East and West*, v. 1, no. 1, Fall 1987; v. 1, no. 2, Winter 1987/88; v. 1, no. 3/4, Spring 1988; v. 2, no. 1/2, Fall 1988.

21. Much of this can be followed in published sources: *Vesti iz SSSR*, no. 18, 30 Sept. 1985; no. 9, 15 May 1987; no. 13, 15 July 1987; no. 17–18, 30 Sept. 1987; no. 19–20, 31 Oct. 1987; no. 7–8, 30 Apr. 1988; no. 9, 15 May 1988; *Ekspress-Khronika*, no. 19, 8 May 1988; no. 20, 15 May 1988; "Nazad puti net," *Den' za den'*, no. 9, 10 Sept. 1987, in

Materialy samizdat, AS no. 6122; Initsiativnaia gruppa khippi, "Ideologiia sovetskikh khippi"; Iulia Troll', "Pis'mo moskovskogo khippi," *Novoe russkoe slovo* (N.Y.), 13 May 1987; *Novoe russkoe slovo*, 23 July 1987; "Rok: Muzyka? Subkul'tura?" p. 48; Presman, "Eshche raz o khippi," pp. 113–14. No published source mentions the punk samizdat journal *Budushchego net*, the first issue of which is dated August 1988 (copy in the author's possession).

22. I found one example of the graffito in both 1984 and 1988. Tim Pogachar saw the same graffito in the Moscow University library, downtown campus, in 1983; he saw a librarian wearing a pin with the same insignia. I thank him for that information. Nikolai Khramov in September 1988 confirmed that this was a feminist pacifist symbol.

23. *Soviet Nationality Survey*, v. 1, no. 6, June 1984, p. 3.

24. R. Rassol'nikov, "Tekh zhe shei, da pozhizhe . . . ," *Novoe russkoe slovo* (N.Y.), 6 Aug. 1981.

25. See the picture in *Time*, 9 Aug. 1982.

26. On this type of grave marker, see Felix Oinas, *Essays on Russian Folklore and Mythology*, Columbus, Oh., 1985, pp. 77–86.

27. For Soviet press comment, see for example "My khodim v maske," and I. Rudenko, "Pochemu," *Komsomol'skaia pravda*, 24 Oct. 1985; Aleksandr Drobotov, "Eta vstrecha perestriakhnula vsiu moiu zhizn'," *Komsomol'skaia pravda*, 8 Jan. 1986. See also Bohdan Nahaylo, "The Protests in Pushkin Square," *Encounter*, Mar. 1983, p. 63; *Glasnost'*, 1987 no. 8; *Vesti iz SSSR*, no. 15, 15 Aug. 1988; Bill Keller, "Russia's Divisive War: Home from Afghanistan," *New York Times Magazine*, 14 Feb. 1988; Eduard Topol', "Poteriannoe pokolenie," *Novoe russkoe slovo* (N.Y.), 26 Aug. 1988.

28. The accounts of this demonstration, as of the fascists, conflict in many details. I have relied heavily on the testimony of Soviet informants, most of whom provided second- (rather than third- or fourth-) hand information, and who could be examined systematically. All of the published accounts are based on secondhand evidence at best. The best published source on the 1982 demonstration is *Vesti iz SSSR*, no. 8, 30 Apr. 1982; no. 11, 15 June 1982; no. 18, 30 Sept. 1982. See also "Fashizm v SSSR. Spontannyi protest ili inspirirovannoe dvizhenie?" *Strana i mir*, no. 1–2, 1984, pp. 51–55; "Organizatsiia iunykh neofashistov," *Strana i mir*, 1985 no. 5, p. 18; *New York Times*, 29 Apr. 1982; *Christian Science Monitor*, 27 Apr. 1982; Andrew Nagorski, *Reluctant Farewell*, New York, 1985, p. 190; Alla Sariban, "O iunykh sovetskikh fashistakh," *Russkaia mysl'* (Paris), 23 Sept. 1982; M. P., "Fashizm v SSSR," *Novoe russkoe slovo*, 6 Aug. 1982. D. Pospielovskii, "Iunye fashisty v SSSR—podlinnoe dvizhenie

ili provokatsiia," *Russkaia mysl'* (Paris), 26 Aug. 1982, considers the incident to have been a police provocation.

29. The account from Hospital No. 24 is in *Vesti iz SSSR*, no. 18, 30 Sept. 1982.

30. *Vesti iz SSSR*, no. 8, 30 Apr. 1982; no. 18, 30 Sept. 1982; no. 19, 15 Oct. 1982.

31. The information on the 1983 and 1984 celebrations, and fascist dress, comes from Soviet informants. The dress code is also mentioned in *Vesti iz SSSR*, no. 9, 15 May 1985.

32. *Vesti iz SSSR*, no. 4, 29 Feb. 1984.

33. The characterization of the situation in the early 1980s is based on personal observation and discussion with Soviet informants. For a summary of the articles in *Leningradskaia pravda*, see Valerii Konovalov, "Desecration of Cemeteries in the USSR," *Radio Liberty Research*, 12 June 1987; Valerii Konovalov, "Neo-Nazis in the USSR: A Menace to Society or 'Mindless Childish Games'?" *Radio Liberty Research*, 29 Oct. 1987; V. Vital'ev, "Fiurery s Fontanki," *Krokodil*, no. 18, June 1988, pp. 3, 6–7. For other information on the Leningrad fascists, see *Vesti iz SSSR*, no. 11–12, 30 June 1987; no. 21, 15 Nov. 1987; *Glasnost'*, 1987 no. 8.

34. Vera Tolz, "The USSR This Week," *Radio Liberty Research*, 15 July 1988.

35. Tolz, "The USSR This Week." The information on other beliefs comes from extensive discussion with Soviet informants.

36. For the text, see Alexander Yanov, *The Russian New Right: Right-Wing Ideologies in the Contemporary USSR*, Berkeley, 1978, pp. 170–72.

37. For a useful introduction to right-wing nationalism, see Yanov, *Russian New Right*, pp. 11–13, 113–27, and passim; John Dunlop, *The Faces of Contemporary Russian Nationalism*, Princeton, 1983, pp. 41–42, 143–54, 218–26, 262–63, 267–68, and passim. Both Yanov and Dunlop have written extensively on the subject; Yanov is hostile, Dunlop sympathetic. A good introduction to the views of *Pamiat'* and to their reception: "Vnimanie: opasnost'," *Kontinent*, 1986 no. 50, pp. 211–27; V. P., "Zashchita russkoi kul'tury ili bor'ba s 'zhido-masonami'?" *Russkaia mysl'*, 15 May 1987; Vladimir Kozlovskii, "Vozvrashchenie v Moskvu," *Novoe russkoe slovo*, 6 Jan. 1988, 7 Jan. 1988, 8 Jan. 1988, 9 Jan. 1988, 10 Jan. 1988, 12 Jan. 1988, and 13 Jan. 1988.

38. *Vesti iz SSSR*, no. 7, 15 Apr. 1983.

39. Information from Nikolai Khramov, who received it from members of the Pskov counterculture.

40. On the *Liubery* and bodybuilding: *Sovetskii sport*, 11 and 13 Oct. 1977, 14 Dec. 1977; Natalya Paroyatnikova, "Flexing Their

Muscles," *Moscow News*, no. 23, 14–21 June 1987; Leonid
Kozlovskii, "Tol'ko moda?" *Rodnik* (Minsk), 1988 no. 8, p.
44; *New
York Times*, 7 May 1988; Keller, "Russia's Restless Youth"; Vera Tolz,
"Controversy in Soviet Press over Unofficial Youth Groups," *Radio
Liberty Research*, 11 Mar. 1987; *The Times* (London), 23 Mar. 1987;
Glasnost', nos. 21–23, March–May 1989. On karate: Sergei Voronitsyn,
"Unofficial Karate Gets the Chop," *Radio Liberty Research*, 18 Jan.
1982; *A Chronicle of Current Events. Numbers 37, 38, and 39*,
London, 1978, p. 222; D. Ivanov, "V dobryi put', karate!," *Sovetskii
sport*, 16 Nov. 1978; K. Preobrazhenskii, "Karate—ne tol'ko sport,"
Komsomol'skaia pravda, 15 Feb. 1979; V. Kupriianov, "Karate:
problemy i ikh reshenie," *Sovetskii sport*, 28 Sept. 1979; D. Ivanov,
"Ostorozhno—karateedy!," *Sovetskii sport*, 29 Apr. 1981; A.
Drozdov and K. Preobrazhenskii, "Karate: legendy i real'nost',"
Komsomol'skaia pravda, 1 Dec. 1981; "Fenomen karate: vzgliad
iznutri," *Novoe vremia*, no. 20, 12 May 1989.

41. Interview with Iurii Shchekochikhin, October 1988.

42. "A nas boiatsia . . . ," *Komsomol'skaia pravda*, 14 Dec. 1986.

43. *The Times* (London), 23 Mar. 1987.

44. Shchekochikhin, "Na perekrestke"; Iurii Shchekochikhin, "O
'liuberakh' i ne tol'ko o nikh," *Literaturnaia gazeta*, no. 10, 4 Mar.
1987; Aron Katsenelinboigen, "Paradoks Gorbacheva," *Vremia i my*,
v. 99, 1987, p. 114; *Novoe russkoe slovo*, 13 May and 14 June 1987;
Boris Kagarlitsky, "The Intelligentsia and the Changes," *New Left
Review*, no. 164, July-August 1987, p. 22; Tolz, "Controversy in
Soviet Press"; Ksenia Mialo, "Kazanskii fenomen," *Novoe vremia*,
no. 33, 12 Aug. 1988; "Rok: Muzyka? Subkul'tura?" pp. 30–32; and
talks with Soviet informants.

Graffiti and Cultural Critique: An Appreciation of The Master and Margarita

> . . . She chanted the phrases that she
> especially liked.
> (Mikhail Bulgakov, *The Master and Margarita*)

The largest, most interesting, and most influential collection of graffiti in Moscow—in all of the Soviet Union, for that matter—has taken over the dimly lit stairwell of entry 6, No. 10 Bolshaia Sadovaia Street. The building stands next to the Military-Political Academy on the ring of boulevards around the center of Moscow. The writer Mikhail Bulgakov lived in apartment 50 in entry 6 in the early 1920s, and the graffiti celebrate him and his masterpiece, *The Master and Margarita*. Much of the action in that novel takes place in an apartment 50, located like Bulgakov's own on the fifth floor of entry 6. In the novel Bulgakov altered the street address to Sadovaia 302-bis (302B), but that did not deceive the graffiti writers.[1]

In the summer of 1984, when the collection had already disrupted their lives but before it had become legendary, residents of the stairwell could still recall that the first graffiti had appeared in the middle of 1983.[2] They had at first found the inscriptions curious but, because neatly executed, not particularly objectionable, and for the first half year or so the Bulgakov graffiti sheltered in stairwell 6 unobtrusively. Children used the courtyard walls to call each other names, to

warn "keep out, evil hag" (*ne khodit'—zlaia babka*), to write out a short grammar school Russian-English dictionary with spelling mistakes in both languages, and to produce a set of drawings and smudged phrases under the heading *RESTORAN KAVBOI* ("Cowboy Restaurant," with cowboy misspelled in Russian). Adolescents who controlled the walls of a passageway to a side courtyard contributed some heavy metal graffiti and announced *GOLUBOI MIRAZH* (Blue Mirage) in Russian, and in English: FANS BLUE MIRAGE. Blue Mirage, an amateur rock band of no renown at all, practiced in the basement. There was not a single graffito in the courtyard that directed attention to Bulgakov or stairwell 6.

That changed in the early spring of 1984. A graffito in the archway from street to courtyard proclaimed *SLAVA BULGAKOVU!!!* ("Hail Bulgakov!"), an arrow with the injunction *SIUDA* ("This way") pointed toward the interior, another arrow directed passers-by specifically to apartment 50; an inscription *302-BIS* renumbered the building, just as Bulgakov had. The directions pointed the way to entry 6, also marked with an arrow; inside at the bottom of the stairs another large block arrow directed visitors *TUDA* ("That way"). From the second floor landing to apartment 50 on the fifth and top floor, the graffiti on the walls, ceilings, and even stairs had grown so rank and tangled that, as the residents saw it, they had turned the entry into a squalid eyesore. By then the graffiti were causing serious physical inconvenience as well, because in the evenings adolescents and young adults, following the directions in the courtyard, flocked to the stairwell to admire and contribute to the collection. Residents occasionally summoned the police to clear the stairs, but that did not deter Bulgakov's young fans from gathering again.

The 800 to 1,000 graffiti in the stairwell in the summer of 1984 included large and small drawings of characters and scenes from *The Master and Margarita*, tributes to Bulgakov in the form of poems and exclamations—*BULGAKOV GENII!!* ("Bulgakov's a Genius!")—and numerous quotations from the novel. Most of the tributes were anonymous; others were signed with the names of characters from the novel. The Russian Pacifist Army (*Russkaia patsifistskaia armiia*) left an admiring inscription; someone, probably a resident of the

stairwell, crossed that out and wrote *POZOR* ("Shame"), a sign of opposition not to Bulgakov but to the pacifists. Another group, styling itself the Russian Army of Pacifists and Society of Moscow Hippies, inscribed a lengthy encomium to Bulgakov's genius. That graffito in turn sprouted another, expressing the approval and solidarity of the punk rock band *Musoroprovod* (Garbage Chute). And over the next few years the encomia continued to multiply. At the very least, the number, variety, and authorship of the graffiti provided unusual testimony to the popularity of Bulgakov and his masterwork.

The graffiti were also unusual as graffiti, and in a number of respects. They were, for one thing, written entirely in Russian. The adolescent, even the children's, graffiti on display in the courtyard as of the winter of 1983–1984 adhered to convention and incorporated English words and symbols. The Bulgakov graffiti did not exhibit, either, any of the codes, symbols, or repetitive formulae that graffiti produced by adolescent groups always incorporated. The collection in some ways resembled the accumulations of graffiti at counterculture hangouts; a few counterculture groups contributed inscriptions, and stairwell 6 soon developed into a stop—not a regular *tusovka*, but an attraction—in the counterculture network. Yet the graffiti were almost entirely about Bulgakov, not about the counterculture or its constituents. By 1985 or so, the graffiti in the Grebenshchikov stairwell in Leningrad provided a close parallel to the Bulgakov collection; that was a connection that the graffiti writers themselves eventually made, and it was important. But what distinguished the Bulgakov graffiti from all other collections, the Grebenshchikov included, was their public impact. They not only drew people to the stairwell, they exerted pressure on civic authorities.

GRAFFITI CREATE A MUSEUM

Publication of an expurgated version of *The Master and Margarita* in two issues of the literary journal *Moskva* in 1965

and 1966 rescued Bulgakov from near oblivion. He was at the time barely remembered as a playwright, and at that chiefly as the author of *The Days of the Turbins*, a play about the Bolsheviks' opponents during the Russian civil war that Stalin had particularly liked. Bulgakov had labored on the novel throughout the 1930s, a decade during which his work could not be published and that he survived—he died of natural causes in 1940—only because Stalin took a personal interest in him. The first complete edition, also the first in book form in the Soviet Union, did not appear until 1973. But even with great gaps and censored lines the 1965–1966 version created a sensation and turned Bulgakov into a posthumous celebrity. Not only was the novel of exceptional literary quality, it treated themes that lay well beyond the pale of Soviet literature at the time. And because the tale the novel told anticipated the fate of Bulgakov and his work, author and novel assumed the proportions of archetypes.

The Master and Margarita tells three separate stories, one of which gives the novel its name. The nameless Master, assisted by his devoted lover Margarita, writes a novel about Pontius Pilate and the crucifixion of Jesus. When he submits the manuscript for publication, he is told that the religious subject matter is utterly inappropriate for Soviet literature. When a newspaper editor nevertheless publishes an excerpt, the novel becomes the center of a denunciatory campaign, of the sort that really did occur in the 1930s. The Master sinks into disabling, fearful depression, in a fit of despair burns all of the manuscript copies of his novel, is denounced by a journalist with whom he had been friendly but who craves his apartment, and ends up in a psychiatric ward, which is where he believes he belongs.

Four chapters from the Pilate novella are also included, and their respectful treatment of a religious subject was just as unusual in the 1960s as in Bulgakov's day. Bulgakov presents in the confrontation between Pilate and Jesus a reimagined Gospel story. Bulgakov's Jesus cringes when in pain, makes no claim to divinity, recruits no disciples, and laments that Matthew the Levite who follows him around and copies down everything he says keeps getting the words wrong. Jesus explicitly denies some of the details of the Gospel account of

his activity in Jerusalem, an account that Bulgakov treats as charges from an indictment. But Jesus does in a naive way always speak the truth, asserts that all men are good, and has superhuman powers of discernment; he brings tranquility to Pilate as they converse. Pilate understands that Jesus is not guilty of the lèse-majesté of which he is accused, but orders Jesus executed to protect his own career. Pilate then has the informer Judas killed, dreams that Jesus has not been executed after all, and yearns to renew his interrupted conversation. The Pilate chapters can be taken as a heterodox affirmation of Christianity, which is how many of Bulgakov's Soviet admirers and Western critics read them.

No less extraordinary in a Soviet novel is the story of Satan's descent on Bulgakov's own Moscow. Satan, under the name of Woland, arrives as a professor of black magic. He and his retinue—the chief personages in which are the tricksters Behemoth (who usually appears as a giant cat) and Koroviev (sometimes known as Fagot), and Azazello, the bearer of sudden death—discover that the revolution has wrought no change for the better in Muscovites. They expose and punish venality and corruption, especially in the literary and theatrical worlds, and in the process bedevil the police and everyone else who looks for a rational explanation of their supernatural deeds. They provide the comic and satirical element in the novel, but they are presented in realistic detail as creatures who can literally frighten people to death. It is chiefly through them that Bulgakov comments on some of the mysterious and frightening features of Soviet society during the 1930s.

These three different strands of the novel differ in tone, mood, and manner of writing, but Bulgakov weaves them together into a single story. Woland narrates, as an eye-witness, the first chapter of the Pilate novel to the atheist and disbelieving literary critic Berlioz and the poet Ivan Bezdomny. The poet dreams the second Pilate chapter after meeting the Master in an insane asylum. Margarita agrees to preside over the satanic ball that Woland hosts, and thereby wins Woland's assistance in restoring sanity, tranquility, and manuscript to the Master. As Woland and troupe prepare to quit Moscow, Matthew the Levite appears as an emissary of the Lord to

request that Satan arrange a peaceful refuge for the Master. And at the end of Bulgakov's novel Pilate and Jesus continue the conversation they had begun in the Master's novel. The interplay of the three stories, the elusive parallels between Bulgakov's narrative and the Gospel and Faust tales, the novel's utterly anomalous appearance in Soviet literature, and the power of the writing make *The Master and Margarita* both a masterpiece that attracts the critics and a popular novel with an immense Soviet audience.

In theatrical adaptation, *The Master and Margarita* entered as well the lists of civic literature. After three years of effort, the director of the Taganka Theater, Yuri Liubimov, managed in 1977 to win approval for the production. Despite criticism in *Pravda*, it remained in the Taganka's repertoire. Because *Pravda*'s complaint that the play raised questions about the fate of literature in the Soviet Union and mocked Soviet society was accurate, it was a resounding success.[3] Of all Moscow theater tickets, those for *The Master and Margarita* were the most difficult to obtain. When the play finally closed in May 1984, a howling mob of World War II veterans—who have the right to obtain tickets on demand—besieged the box office. Many Muscovite veterans could not manage to get hold of tickets during the entire seven years that the play was in repertory.

Perhaps the timing was only a coincidence, but the events surrounding the closing of the play may have played a part in the sudden increase in the number of graffiti at No. 10 Bolshaia Sadovaia in early 1984. They certainly left their mark on the collection. While in England directing a play in the fall of 1983, Liubimov complained publicly about political interference with his work in Moscow, and he then refused to return home on schedule. In February and March 1984 rumors swirled through Moscow that the next, and then the next, performance of *The Master and Margarita* would be the last. In March Liubimov was officially removed as director of the Taganka. Later, Anatoly Efros was named in his place, and Liubimov was stripped of Soviet citizenship.[4] Graffiti writers responded by writing (all of these inscriptions were in Russian in the original) BRAVO LIUBIMOV! DOWN WITH EFROS!!! (TAGANKA *FANATY*). That attracted an approving AGREED.

Other graffiti urged DON'T GO TO THE TAGANKA. The anger at Efros was understandable, but at least partially misdirected; as of 1983, he enjoyed a reputation for theatrical daring and innovation second only to Liubimov's, and had once lost a theater for modernizing the staging of Russian classics.[5] Indignation found its proper target in a graffito aimed at the then minister of culture: DOWN WITH DEMICHEV! LONG LIVE ARTISTIC FREEDOM!

Whatever the role of the upheaval at the Taganka, Bulgakov's admirers very early sought to convert the spontaneous pilgrimage to the stairwell into an organized social event. The earliest of the inscribed proposals for scheduled congregation read:

I PROPOSE THAT ALL WHO LOVE, ADMIRE AND ESTEEM THE WORK OF M. A. BULGAKOV GATHER HERE AT LEAST TWICE A YEAR (I'M SERIOUS). THE FIRST TIME MIGHT BE THE FIRST SATURDAY OF THE YEAR (7/I-84). COME SOBER BUT CHEERFUL (I'M NOT JOKING) AT 6 P.M.

Other dates were added subsequently—February 4, April 1, and May 14 were legible as of June 1984—and the summons attracted large approving comments, such as WE WILL!!! and GOOD IDEA! Judging from the annoyed reports of the residents of entry 6, the response far exceeded the modesty of the original proposal. Another invitation read HEY, YOU, THOSE WHO LOVE M. BULGAKOV! ON THE NIGHT OF MAY 1 THERE WILL BE A SABBATH FOR ALL WITCHES! COME! I IMPLORE YOU! IT WILL BE FUN. Yet another graffito invited everyone to gather nearby, at the Patriarch's Ponds, the scene of Woland's first appearance in Moscow. But a graffito below that related sadly: I WAS THERE. WHERE WAS EVERYONE ELSE?

Having established effective proprietorship over the stairwell and its walls, the Bulgakov enthusiasts advanced a claim to apartment 50 as well. In the first half of 1984, a number of graffiti demanded that the apartment be turned into a Bulgakov museum. In the novel, Woland and his entourage settle into apartment 50, and one of the graffiti calling for a museum alluded to that fact: MAKE APARTMENT NO. 50 A

MUSEUM DEVOTED TO WOLAND AND OTHER UNCLEAN POWERS! In April of 1984, the bemused occupants of apartment 50, draftsmen for a design bureau, yielded to the pleas and opened their office to the public. They even provided a notebook in which visitors could inscribe appreciative comments. And they allowed pilgrims to tack drawings, poems, and other tributes on the walls, so that the apartment reproduced in a more restrained way the celebration on the stairwell walls. That was the only Bulgakov museum in all of Moscow, and also at the time the only Soviet museum created on popular demand—if the stairwell were included, also the only museum that was the work of the visitors' own hands. The willingness of the sober, middle-aged draftsmen and women working in apartment 50 to cooperate with the mostly youthful visitors who barged in on them was just one more evidence of Bulgakov's special status with the Soviet reading public.

That did not sway the building manager—who certainly spoke for the permanent residents of stairwell 6—or city officials, or even the design firm that employed the draftsmen, all of whom worked to obliterate the unsightly graffiti and unseemly popular initiative. During 1984 the building manager regularly changed the security code at the doorway, but visitors broke the combinations and wrote them around the entrance for all to see. The day after an article appeared in the newspaper *Izvestiia* in January 1985 reporting on the graffiti and suggesting that perhaps a real museum might be opened in apartment 50, the building manager painted the stairwell. The design bureau told the draftsmen not to admit any more visitors, to get rid of the Bulgakoviana that had accumulated in the apartment, and to move to other premises. Officials in the Moscow city government said that the fifth floor was a bad place for a museum—there was no elevator— and that the building was going to be assigned to the military-political academy next door. Other newspaper and television reports on the graffiti and the enthusiasm for Bulgakov, even the support of the quite orthodox Moscow writers' union, failed to sway city officials. And the building manager continued to paint over the stairwell walls every six months or so, into the middle of 1986. But that merely provided a fresh

canvas for graffiti at about the point when the old had been used up.[6]

Despite their best efforts, housing and city officials could not control the stairwell, and they lost the struggle to sustain the image of the graffiti as a public nuisance just as decisively. By 1986, a legend had grown according to which Bulgakov's admirers had been inscribing tributes to him in the stairwell for decades.[7] The graffiti had become an institution with an imaginary but nonetheless validating lineage. They were no longer thought of as graffiti, but rather as a cultural landmark representing legitimate opinion.

It may have been the realization toward the end of 1986 that everyone now thought of the graffiti as a Moscow fixture that persuaded the petty officials who had a voice in the disposition of the stairwell to give up their attempts to reclaim it from the graffiti writers. Apartment 50 was abandoned, and a counter-culture commune dedicated to turning it into a museum moved in. No further attempts were made to clean the stairwell walls; when every possible space had been written— and rewritten—over, visitors began to leave their messages and quotations on scraps of paper glued to the wall. Several thousand graffiti accumulated on the walls alone, and spilled out into the courtyard. The official tour that bused visitors around Moscow's "Bulgakov Spots" began to stop at Bolshaia Sadovaia 10. A steady stream of adults and children flowed through the stairwell. And finally in the spring of 1988 the city agreed to the establishment of an official Bulgakov museum in the apartment, and an embryonic staff began to track down furnishings that dated from Bulgakov's day. The museum staff cleaned away the paper glued to the stairwell walls, but planned to leave the graffiti on the plaster in place as a popular tribute to Bulgakov.[8]

The Bulgakov fans who four years earlier had broached the idea of creating a museum had triumphed completely, due in no small part to the impact of the graffiti themselves. The graffiti not only expressed opinion, they organized it. Some of the graffiti called explicitly for gatherings of Bulgakov's fans, others made equally explicit demands for the opening of a museum in apartment 50, but these appeals would have had only a modest impact if they had not been part of a growing,

and evolving, collection of graffiti. The collection, not individual graffiti, focused attention on the stairwell and apartment and attracted devotees, the merely curious, and then some members of the official cultural establishment. The snowball growth of the collection of Bulgakov graffiti was not unique, even in the Soviet Union; written public messages attract additional statements if they strike the right nerve, as (to mention only two examples) the John Lennon Wall in Prague and the Democracy Wall in Peking also demonstrate. What was unique in the case of the Bulgakov collection was its efficacy: the cumulation of messages and the refusal of the messengers to desist finally had an impact on official cultural institutions and on cultural policy. That had much to do with the years in which the Bulgakov collection grew; by 1986 Gorbachev's policies were beginning to have an impact, particularly in the cultural sphere. But Bulgakov's enormous, and enormously broad, appeal also played a part. It is not every writer who appeals to both the members of a punk rock band and middle-aged draftswomen.

THE SOURCES OF BULGAKOV'S POPULARITY: EXPLICATION DES GRAFFITI

The graffiti not only highlight Bulgakov's popularity, they also help to explain it.[9] The reasons for the astonishing resonance that *The Master and Margarita* enjoys in almost all segments of Soviet society are not, it should be clear, self-evident. The complexity of the novel's structure offers readers many different points of engagement, and any one of them, or any combination, might be what excites the popular imagination. Some do read the novel as an essentially religious work, all the more precious because—as the Master discovered—Soviet literature has for decades excluded almost all writing that exhibits a religious sensibility. Others read the novel as a subtle, and therefore particularly powerful, anti-Stalinist fable. Readers indifferent to religion and politics find the antics of Woland's assistants entertainingly comic. Any superior

work of literature can be read in a number of different ways. Uniquely in the case of *The Master and Margarita*, thousands of readers have since 1983 provided written testimony about what draws them to the novel. Admittedly, the graffiti are not an obviously representative source on reader opinion. Nevertheless, the consistency of views represented in the graffiti over the entire history of the collection gives us some grounds for believing that the ideas the graffiti writers express are shared by those who do not write their favorite lines in stairwell 6.

The most numerous graffiti in the stairwell throughout have been quotations from the novel. These and the drawings of scenes and characters dominate the stairwell visually, and they are what visitors come to admire and read. And they have consistently, in all of the collection's incarnations, focused on Woland and his suite. Most of the several dozen drawings in mid-1984 were of Behemoth (as an enormous cat, the most popular subject of all), Koroviev (a tall figure with thin mustache and pince-nez—one lens cracked, the other

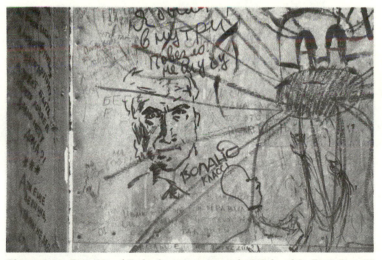

Photo 5.1 Portrait of Bulgakov, captioned "Woland Is First-Rate!" surrounded by numerous quotations from *The Master and Margarita*. The mysterious figure on the right is a composite of at least three different drawings. (Bulgakov Stairwell, Moscow, 1988)

missing—jockey cap, and plain jacket), and Azazello (short, broad-shouldered, wall-eyed, brick-red hair, protruding fang). They have been the most frequently drawn characters since then, too. And theirs have been the lines most frequently inscribed on the walls. Together with their master Woland, they accounted for all but two or three quotations from the text during the first phase of the collection—which consisted of between 800 and 1,000 separate graffiti—and for almost as large a proportion since.

Many of the quotations the graffiti writers favored in 1984 are famous, and convey an obvious political message: MANUSCRIPTS DON'T BURN; WITHOUT PAPERS YOU DON'T EXIST (more literally, "no papers, no person"); and NEVER TALK TO STRANGERS, the title of the novel's first chapter. At least three different hands had written in at least three different places a brief exchange between Koroviev and Azazello:

> WHAT ARE THOSE FOOTSTEPS ON THE STAIRS?
> THEY'RE COMING TO ARREST US.
> MY, MY.

In the novel, that exchange precedes the arrival of the police, who have tracked the source of the deviltry besetting Moscow to apartment 50. Behemoth then confronts the police alone, and his reproach to Azazello, who remains invisible and continues eating, also found a place on the wall: YOU HAVE ABANDONED POOR BEHEMOTH, SELLING HIM OUT FOR A GLASS OF COGNAC—VERY GOOD COGNAC, TO BE SURE.

These lines carry a straightforward political message about the pervasiveness of police, informers, and surveillance in Soviet society, but they do not have to be read that way. Indeed, it is difficult to be sure what context and what meaning should be assigned to them. The line about the police coming to make arrests sounds ominous when we assume that it is a comment on Soviet society, but it loses much of its sinister ring when visualized in its place just above the very steps the police in the novel mounted—the graffito and the steps together become a multidimensional illustration of a scene from the

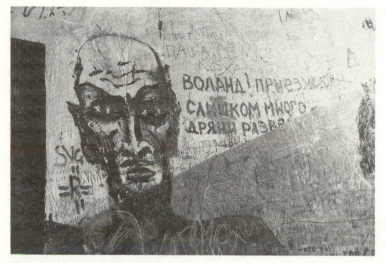

Photo 5.2 "Woland, Come Back, Too Much Crap Has Piled Up." (Bulgakov Stairwell, Moscow, 1988)

novel, and one in which the police are confounded. The line may have owed its popularity among the graffiti writers to the fact that in 1984 real police repeatedly climbed those very steps, not to arrest but to disperse Bulgakov's fans; as commentary on that circumstance, the quotation may be distinctly ironic, as it is in its plain reading in the novel. Other lines—about the glass of cognac, for instance—are devoid of political implications in the novel, and may have been remembered, and inscribed, simply as choice turns of phrase. Every graffito can be read in several different contexts: the full scene from the novel, the isolated one-line statement on the wall, the graffiti collection as a whole (MANUSCRIPTS DON'T BURN can be read as a triumphant commentary on the collection). We cannot ignore the political meanings that attached to the graffiti in 1984, and that have been evident since as well, and we ought not to imagine that the writers did not understand how their graffiti could be interpreted. But certainly they savored the language and the images as much as the political message. If they had wanted only to make a political point, they could have done so directly, without speaking in quotations.

In any event, in 1984 and later the great majority of the quotations in stairwell 6 had a humorous and epigrammatic quality that did not depend at all upon a political charge. Woland's observation that A BRICK DOESN'T FALL ON YOUR HEAD OF ITSELF (a corruption of Bulgakov's text) is in the novel a slyly theological statement, but one may suppose that the writer, who illustrated his graffito with a picture of a brick falling on an unsuspecting head, cherished the image more than the philosophy. Behemoth and Koroviev frequently and enthusiastically exclaim WE ARE ENCHANTED! Those who in 1984 inscribed those words in large letters in several different places in the stairwell no doubt found their old-fashioned ring pleasing, and used the phrase to express their own enchantment with the graffiti collection, and with Bulgakov. A chess game between Woland and Behemoth furnished three different inscriptions in two different hands: KILL THE STUBBORN CREATURE (Azazello's remark when Behemoth plays the fool); [the knight] GALLOPED OFF SOMEWHERE AND SOME SORT OF FROG HAS TAKEN ITS PLACE (Behemoth); and NEVER, MESSIRE! THE CAT HOWLED, AND INSTANTLY CRAWLED OUT FROM UNDER THE BED WITH THE KNIGHT IN HIS PAW. A lovingly illustrated excerpt from the novel provided one of the most striking of all the graffiti in 1984:

> BEHEMOTH MOVED INTO A SHAFT OF MOONLIGHT
> FALLING FROM THE WINDOW
> DO I REALLY RESEMBLE A HALLUCINATION?
> SILENCE, BEHEMOTH!
> ALRIGHT, I'LL BE A SILENT HALLUCINATION

Two writers effectively employed lines spoken by Azazello to denounce the Taganka's new director, Efros: EFROS, YOU WERE TOLD NOT TO LIE OVER THE PHONE (Azazello); and, without crediting Azazello, IF HE'S A DIRECTOR, I'M A BISHOP.

That small sampling of inscriptions reflects the variety and spirit of the graffiti in stairwell 6 in 1984, and it conveys the very narrow reading of *The Master and Margarita* that the graffiti presented. The writers quoted Behemoth, Azazello,

Koroviev, and Woland, not Jesus and Pilate, not even the Master and Margarita. The demonic foursome have many of the pithiest lines, and the Pilate chapters are more lyrical, and so less epigrammatic, than those devoted to the antics of Woland's assistants. Nevertheless, the long exchanges between Jesus and Pilate are rich in potential epigrams. Jesus' characterization of Judas—"a very good man and eager to learn. He expressed the greatest interest in my thoughts and was quite cordial"—offers material for several pointed graffiti. Jesus' rejoinder when Pilate observes that his life hangs by a thread, "Don't you agree that only the one who suspended the thread can cut it," is not so pithy a theological statement as Woland's comment on falling bricks, but it too could easily be turned into an illustrated graffito. Yet in their first year of activity, the graffiti writers almost completely ignored the Pilate novella, and all of the religious and philosophical themes that can be drawn from it. The one legible exception in the collection as of mid-1984—THE PROCURATOR IS ADDRESSED AS HEGEMON. STAND EASY. DO YOU UNDERSTAND, OR DO I HAVE TO HIT YOU AGAIN? I UNDERSTAND, DON'T BEAT ME, an exchange between the legionnaire Krysoboi and Jesus—seems if anything a faintly political statement. The writers ignored not only the Pilate novella, but the chapters devoted to the life of the Master and Margarita as the Pilate novella was being written and denounced, the Master's stay in the psychiatric hospital, Ivan Bezdomnyi, and much else besides, though quotable lines and images abound.

In its mid-1986 incarnation, the collection presented a somewhat broader range of images and themes, but its overall character had not changed. A few clearly religious sentiments had found a place on the walls, and one of the most prominent drawings was of a finely detailed and tinted head of Christ, captioned *INRI/IISUS NAZAREUS REX IUDEUM*. A few graffiti mentioned (but seem not to have quoted) Margarita, a few others referred to the Master and the peace he sought. But the words and drawings of the four chief characters of 1984—and of Behemoth especially—continued to overwhelm all the other graffiti both numerically and visually. Probably it was the graffiti writers' preoccupation with the demonic quartet

that accounted for the fact that the most frequently drawn and quoted new character of 1986 was not the Master, or Margarita, or Jesus, but Stepa Likhodeev, a minor figure whose only function in the novel is to be victimized by Woland's assistants.[10]

That phase of the collection was painted over—the building manager intervened one last time—but the thousands of graffiti that accumulated in stairwell 6 between late 1986 and late 1988 introduced no changes at all. Visitors drew a dozen or

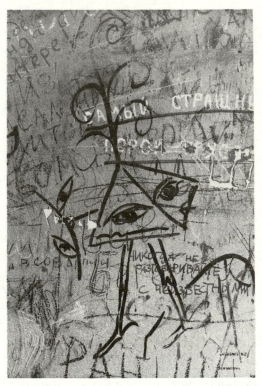

Photo 5.3 The central figure does not refer to *The Master and Margarita*, and is possibly a counterculture insignia. It has been superimposed over what was once a drawing of Behemoth and over a number of quotations from the novel, the most prominent of which are "The worst sin is cowardice" and "Never talk to strangers." (Bulgakov Stairwell, Moscow, 1988)

so pictures of Margarita and the Master (or of Bulgakov, the intent is not always clear). There were two elaborate drawings of Pilate's palace, one captioned with the last words in the novel: FIFTH PROCURATOR OF JUDEA, THE HORSEMAN PONTIUS PILATE. A number of Bulgakov's fans contributed one version or another of THE GREATEST SIN IS COWARDICE, three different variations on which appear in the novel. Someone also wrote, probably with more irony than when Jesus, under interrogation, delivered the remark to Pilate, SPEAKING THE TRUTH IS EASY AND PLEASANT.[11] A number of visitors inscribed crosses, and one wrote at least twice: HOLY RUS, PRESERVE THE ORTHODOX FAITH. That is not a line from *The Master and Margarita*, but it can reasonably be taken as a comment inspired by the novel. And it is just possible that I WON'T ARGUE WITH YOU, OLD SOPHIST, a retort from Matthew the Levite when he conveys to Woland the request that arrangements be made for the Master, was meant to be a reference to the religious element in the novel.

Invocations of Behemoth alone overwhelm these references to the Master and to the Pilate novella, and he and the other demonic personages continue to define the character of the collection as a whole (GREETINGS FROM THE DEMONS is how one graffito puts it). Many of the favorite lines from the first phase of the collection—about the footsteps on the stairway, fireproof manuscripts, and the danger of speaking to strangers, for instance—appear in the latest as well. Among the hundreds of new lines (often slightly misremembered from the novel) are Behemoth's remark to the police when they arrive in apartment 50, I'M NOT BOTHERING ANYONE, I'M FIXING MY PRIMUS AND WAITING FOR YOU (accompanied by an illustration); and Koroviev's announcement during a performance of black magic, WE'LL OPEN A WOMEN'S SHOP, women taking advantage subsequently suffering the indignity of their clothes disappearing. Stepa Likhodeev still figures on the walls, and the graffiti also recall the building manager of Sadovaia 302-bis, another victim of Woland's assistants: REPENT, IVANICH, YOU'LL GET A REDUCED TERM, his wife's plea when the police discover foreign currency that Koroviev planted on him; SURRENDER

YOUR FOREIGN CURRENCY. SO, IT APPEARS YOU DON'T HAVE ANY, from the building manager's subsequent nightmare; and INTERMISSION, SCUM! from the same dream. Woland's remarks as he contemplates the audience his suite is entertaining with black magic provides the longest and largest graffito legible in the fall of 1988:

> WELL, THEY'RE PEOPLE JUST LIKE EVERYONE ELSE. THEY LOVE MONEY, BUT THAT'S ALWAYS BEEN THE CASE . . . MANKIND LOVES MONEY NO MATTER WHAT IT'S MADE OF, LEATHER, OR PAPER, OR BRONZE, OR GOLD. OF COURSE, THEY'RE THOUGHTLESS . . . WELL, SO WHAT . . . AND SOMETIMES COMPASSION STIRS THEIR HEARTS . . . THEY'RE ORDINARY PEOPLE . . . ON THE WHOLE, THEY REMIND ME OF THEIR PREDECESSORS . . . IT'S JUST THAT THE HOUSING PROBLEM HAS RUINED THEM. PUT THE HEAD ON.

The last is a command to Behemoth to put back the head that he has torn off the master of ceremonies.

Woland and company dominate the popular conception of the novel, or at least that is what the graffiti imply. Over a five-year period, thousands of inscriptions in stairwell 6 quoted, alluded to, or depicted Woland, Behemoth, Koroviev, and Azazello, while relatively few (a hundred or so?) referred to the other principal characters. Perhaps—just perhaps—the graffiti at Bolshaia Sadovaia 10 reflect only one of several popular readings; perhaps there are large numbers of readers whose interest in *The Master and Margarita* lies chiefly with Jesus and Pilate, or with the Master's tribulations. If so, they have forgone the opportunity to leave much of a mark on the collection, which has remained substantially unchanged in its several incarnations between 1983 and 1988.

The persistence of the original themes despite the periodic destruction of the collection supports an inference that the graffiti express a view of the novel shared by graffiti writers and nonwriters alike. The potential for a change of emphasis is extraordinarily large when the collection must be repeatedly re-created. One might have expected, for example, that during any of the periods during which graffiti accumulated prior to late 1986 the interests of the writers would have changed

slightly, at the very least as they responded to or commented on graffiti already in place; that the interests represented by the last graffiti in one phase would have provided the point of departure for the next stage; and that the cumulative change of emphasis after three or four shifts of interest would have been considerable. Yet the graffiti writers' preoccupation with Woland's troupe held constant and kept the collection focused firmly on those characters. If that did not represent the dominant popular reading of the novel, one would expect far more variety than is evident among the graffiti, more change in the collection over time, or both.

Of course, it was interest in Woland, Behemoth, and the others that attracted graffiti writers, and then graffiti readers, to apartment 50 at Bolshaia Sadovaia 10 in the first place. Bulgakov did not write *The Master and Margarita* in apartment 50, in fact he lived there only briefly. The nature of the setting, in other words, contributed to the character of the inscriptions. But even if Woland has been the main attraction, Bulgakov's graffiti-writing admirers might have shown by some sign that they found other sections of the novel interesting, or at least that they had read the rest of the novel. During the first year of the collection's existence, there was no such sign in the stairwell. The scattering of graffiti on the nondemonic characters that had appeared by the middle of 1986 and that persisted into 1988 is surely the exception that proves the rule: those who feel, just for example, that Jesus is the most important figure in the novel do not think it inappropriate to contribute to the collection. Relatively few such contributions have been in evidence, however. Alternatively, writers with nondemonic interests might leave messages at other of Bulgakov's Moscow addresses. But they have not. To the graffiti writers, and the many nonwriters whose views they represent, the novel is about Woland and his assistants.

The graffiti tell us that those characters have a firm grip on the popular imagination and also—if less clearly—why that is so. The fact that Behemoth and friends have crowded out all other characters narrows the range of possible explanations. In Woland, for instance, Bulgakov offers a character with obvious theological resonance, and some of Woland's lines inscribed in

the stairwell hint at theology. For instance, both in 1984 and 1988 graffiti quoted the novel's misleading epigraph:

> WHO ARE YOU THEN?
> I AM PART OF THAT POWER
> THAT FOREVER WILLS EVIL
> AND FOREVER ACCOMPLISHES GOOD.

But none of the graffiti associated with Woland's assistants has ever betrayed any theological or philosophical preoccupations. And in fact we would not expect graffiti writers who have by and large ignored the Pilate novella to place a religious construction on the words and deeds of Woland, Behemoth, and the rest. Readers much more likely respond to them as comic characters, who say and do funny things and are at the same time appealingly earthy. But earthy and comic are adjectives that can be applied, even in combination, to characters in a few other Soviet novels, none of which have stirred anything like the popular reaction to *The Master and Margarita*. Moreover, Azazello, deliverer of death—as of mid-1984 the most frequently drawn and quoted character after Behemoth, and still popular in 1988—is more sinister than comic.

The reading of the novel that emerges most clearly from the graffiti is of a carnivalesque assault on dogma and authority, of Woland, Koroviev, Behemoth, and Azazello turning the natural and social order of things upside down. They trick those who wield and enforce authority, and lay the pompous and privileged low. The defeat of the police who invade apartment 50 (anticipated by footsteps on the stairs, called to mind by Behemoth's announcement that he has been waiting for them), the bedevilment of the unfortunate theater manager Likhodeev and the building manager of Sadovaia 302-bis, the redirection of Azazello's threats toward the real-life theater director Anatolii Efros—these are images that delight Bulgakov's public and that the graffiti frequently recall.

And it is not just single instances but the general rule that the graffiti call to mind. The novel begins with the overthrow of the rationalist and materialist dogma that the editor Berlioz defends, as Berlioz is decapitated by a streetcar. In 1986, a fine

picture of the head beside a rail had a place in the stairwell. The threat that Woland's assistants pose is represented in miniature by the primus that Behemoth carries around, and readers understand that. Several of the drawings of Behemoth in mid-1984 and mid-1986 showed him with primus in hand; one of the most imposing drawings in mid-1986 was of Behemoth with primus lit, ready to set fire to Moscow's dens of privilege. Behemoth is the most beloved—most frequently quoted, most often drawn—character. His very existence affronts the novel's rationalists and materialists, and he systematically overthrows all rules, as in the chess game with Woland that so interested the graffiti writers in 1984. Any individual graffito may have multiple meanings, but when a very large group all contain comic subversive references, then it is reasonable to conclude that they reflect a carnivalesque reading of the novel. The persistence with which this reading has been repeated in successive incarnations of the graffiti at Bolshaia Sadovaia 10 suggests that it is widely shared.

Life itself, as Soviet writers might once have said, primes Soviet readers to understand *The Master and Margarita* as a carnivalesque novel. Soviet citizens confront dogma and authority at every turn; the dogma is of the most wearying and stuffy sort, the petty authorities provokingly self-important. Readers can vicariously let off steam as Behemoth and friends turn Moscow upside down, humiliate stuffed shirts, punish the many petty gatekeepers who dole out scarce theater tickets and scarce housing, and torment the police with events that cannot be rationally explained. Some of the graffiti in 1986 and 1988 spoke directly of the readers' desire for Woland and company to repeat their exploits: CAT COME BACK!; WE'RE WAITING FOR YOU, WOLAND; WOLAND, COME BACK, TOO MUCH CRAP HAS PILED UP (this as caption to a great black scowling portrait of Woland). KOROVIEV IS THE SOUL OF *PERESTROIKA* implies that what the Soviet public wants most from Gorbachev's reforms is the dethronement of the petty officials whom Koroviev tormented. In Behemoth, Koroviev, and Azazello, Bulgakov provided secondary characters whose actions so perfectly fit the imaginative needs of the Soviet public that the popular reading

of the novel has transformed them into the novel's central figures. That same reading has reduced Woland-Satan to a force for civic justice.

The carnival that readers have made out of *The Master and Margarita* is subversive of the Soviet order, but part of its appeal must be that it offers emotional release without requiring either an emotional or intellectual commitment actually to replace the system that presses readers down, or even to accept (or imagine accepting) responsibility for their behavior when the rules are suspended. When carnival is over, Woland and the others leave town, and Moscow returns to normal. And despite the hubbub—the satanic ball, the public hysteria, the purging fires that Behemoth sets—no permanent damage has been done. That is the way of carnival, and of a carnivalesque reading of the novel, to revel in a world in which one can with impunity violate all of the rules and humiliate the authorities, without having to create or imagine an alternative. Readers criticize Soviet society vicariously and symbolically rather than articulate their discontents. Bulgakov provides them a carnivalesque rather than a political challenge to the social order. That suits perfectly a society that, when the Bulgakov graffiti first appeared, was in many respects pre-political.

To read *The Master and Margarita* as carnival is to ignore a great deal of the novel, but carnival is in it, and that happens to be the facet that has captured the public imagination. Behemoth and friends provide the words and images that people remember to the exclusion of almost everything else. Since 1983, thousands of readers have provided written testimony to that effect. They have also, in a small way, acted out their reading of the novel. Woland, Behemoth, Koroviev, and Azazello have once again taken up residence in apartment 50. Invitations to a witches' sabbath have been extended, sounds of merriment echo in the stairwell, and residents have again summoned the police to rescue them from the mysterious deviltry. The police of the 1980s were no more able to exorcise the demons that mocked Moscow's social and cultural mores than were the police in the novel.

THE LANGUAGES OF POPULAR CULTURE
AND CULTURAL OPPOSITION

To repeat a point made at the beginning of this chapter that now needs further elaboration: the graffiti dedicated to Bulgakov differ from other large and small concentrations of graffiti in Moscow in their almost exclusive use of Russian, and in the absence of any group symbols or codes. That is, no trace of an organization of Bulgakov fans appears among the graffiti, in the way that heavy metal, punk, pacifist, and fan gang graffiti all betray the presence of at least rudimentary organizations. Of course there is system to the writing of the Bulgakov graffiti, in place and theme, but the writers do not think of themselves as part of an organization, nor do they inscribe tributes to Bulgakov or quotations from *The Master and Margarita* in pursuit of some organizational mission. And when these unorganized admirers of Bulgakov write their graffiti, they write in Russian. There is probably a connection between those two facts.

The contrast between the Bulgakov graffiti and the run of Moscow graffiti is evident within stairwell 6 itself. While there is no organization of Bulgakov fans, members of graffiti-producing counterculture groups contribute to the collection. The popular reading of *The Master and Margarita*, as a carnivalesque assault on authority, fits counterculture attitudes so well that the connection is natural. A counter-culture presence was evident early in the collection's history— the "Russian Pacifist Army" and the "Russian Army of Pacifists" contributed graffiti prior to mid-1984, for instance— but it became more prominent with time. The number of identifiably counterculture inscriptions increased, and they eventually employed counterculture symbols; there was not a single pacifist logo in stairwell 6 in the middle of 1984, while by late 1988 there were several score. The visual evidence confirms published and unpublished testimony on the use of the stairwell, and of the attic above the stairwell, as an irregular *tusovka* by counterculture groups, *metallisty* as well as pacifists.[12]

Many of the counterculture graffiti in stairwell 6 have nothing specifically to do with Bulgakov, others claim an

association. Russian-language punk ("Anarchy is the mother of order") and beatnik ("Beatniks still live!" with a yin-yang symbol) statements merely register those groups' presence; the English-language graffiti BEATLES ONLY and ALL YOU NEED IS LOVE are standard pacifist exclamations even unaccompanied by pacifist logos. The most interesting of the narrowly counterculture inscriptions in the stairwell in 1988 was a pacifist logo inscribed TEACH PEACE and *FORPI-SOVAIA TUSOVKA* ("for peace *tusovka*"), one more example of the counterculture's creative transformation of English into Russian. Counterculture statements linked to the Bulgakov theme in 1988 included a Russian Orthodox six-pointed cross—of which there were a few dozen in the stairwell, and which unquestionably referred to the religious message in *The Master and Margarita*—coupled with JOHN LENNON, and a pacifist logo captioned LONG LIVE VOLAND. In addition to METAL-*ROK BUDET ZHIT' VECHNO* ("Metal rock will live forever"), there were many inverted crosses with 6-6-6 at the bottom three points; the sign of the Antichrist that some *metallisty* favored blended easily with the surrounding celebration of Woland. One of these anticrosses with the number of the beast established an explicit association with the novel through the caption *PRIMUS* ("primus").

Except for the relatively few English and near-English counterculture messages, since the beginning the graffiti in stairwell 6 have been written exclusively in Russian. In mid-1984, the only English words in the entire 800–1,000-item collection were PUNK GROUP, added in parentheses to identify the rock band *Musoroprovod* (Garbage Chute), and a stray FORTRAN. Among the thousands of graffiti in September 1988, only SATAN and NO POLICE could be considered English-language, Russian-authored, noncounter-culture (or not necessarily counterculture) comments on *The Master and Margarita*. There was not a single FAN in the stairwell in 1984 or 1988, despite that word's wide currency in graffiti of all kinds all over Moscow, and its seeming appropriateness to the setting. *FANATY*, the Russian-language progenitor of FAN, did appear once each year: *FANATY TAGANKI* ("Taganka *fanaty*") in 1984, *FANATY AZAZELLO* ("Azazello *fanaty*") in 1988.

Bulgakov's admirers might have adapted not just English, but the entire graffiti argot to their purposes: V-for-victory, stars, crown, and English superlatives to exalt Bulgakov, Russian derogatory slang to excoriate Efros and Demichev in 1984 and others who thwarted the opening of an official museum later. That argot was long established when the Bulgakov graffiti first appeared in stairwell 6; indeed, it was at that very time in occasional use in the courtyard of No. 10 Bolshaia Sadovaia. Nevertheless, Bulgakov's admirers have consistently eschewed use of the established graffiti idiom when writing about Bulgakov, and their graffiti are so numerous that the absence of words and symbols of foreign origin cannot be a chance occurrence. The linguistic frontier between graffiti about Bulgakov and graffiti about almost everything else could scarcely be more clearly demarked.

Language must stand for culture, at least in part: Bulgakov is a figure from Russian culture, enthusiasm for *The Master and Margarita* has exclusively native roots, so Russian is the appropriate language in which to express that enthusiasm. Rock music has over the years been thoroughly assimilated into Soviet society, but its origins and totems are foreign. Pacifists and punks are also well-rooted Soviet phenomena, but they take their representational cues from the West. Of course, the *fanaty* who created the graffiti argot are Soviet in both origin and totem. Although the gangs are aware of analogous soccer hooliganism in Western Europe, they do not trace their lineage from the West as pacifists and punks do. Gang graffiti nevertheless incorporate foreign words and symbols, because they draw upon the culture to which Soviet adolescents attach importance. Western popular culture and English, the principal language of that culture, have acquired prestige among Soviet young people, who live in a world saturated with Western symbols and artifacts. Their graffiti express that reality. By contrast, the Bulgakov graffiti derive from an enclave of Russian culture unaffected by the latest Western trends. When they write graffiti, one may suppose, Bulgakov's devotees instinctively ignore the example set by almost all other graffiti writers and express themselves in their native tongue. Or to put that another way, the Bulgakov graffiti, on the one hand, and gang and counterculture graffiti,

on the other, have cultural referents so dissimilar that they cannot be written in the same language.

The logic and economy of that explanation—graffiti written in different languages derive from different fields of popular culture—would be compelling were the Bulgakov graffiti truly unique in cleaving to the Russian language. But the Bulgakov collection is not quite singular, it is only very rare: the inscriptions devoted to Boris Grebenshchikov and the rock group Aquarium in Grebenshchikov's stairwell in Leningrad are also written in standard Russian, and the appearance of a few English-language graffiti there provoked a rebuke from another graffiti writer. In both cases, too, the tributes and quotations shun symbols deriving from the fan gangs' graffiti argot. And in Grebenshchikov's as in Bulgakov's stairwell there are graffiti that register the counterculture's presence and link the affirmation of a counterculture group or attitude with tributes to St. Bob. In short, Grebenshchikov and Bulgakov are comparable objects of adulation, and the graffiti dedicated to them are similar in language and composition.

By 1988 some of the graffiti writers themselves had posited a connection between Bulgakov and Grebenshchikov. In that year—no such association was evident in 1984—a graffito at No. 10 Bolshaia Sadovaia in Moscow suggested (in Russian, of course): IF BULGAKOV HADN'T BEEN KILLED BY STALIN, HE WOULD LISTEN ONLY TO AQUARIUM. Quotations from Grebenshchikov songs dotted the stairwell (all in Russian, and credited in each case to B.G.):

WE ARE DANCING REMARKABLE DANCES, TURNING SILVER
 INTO BRASS

YOU ARE A WINDOW ONTO A MARVELOUS WORLD
BUT WHO IS THE WORLD, AND WHO THE WINDOW?

AND WHEN ALEKSANDR SERGEICH WENT INTO THE HOUSE
WITH MOUTH SMASHED, THEY CRUCIFIED HIM, CONFUSING
HIM WITH CHRIST, AND REALIZED THEIR MISTAKE ONLY
THE NEXT DAY

HIGH TIME TO START A SAILING FLEET

There were also a few A-and-halo Aquarium logos, and alongside one of them the plaint: PLEASE DON'T WRITE, THIS IS BIS, NOT BORYA'S STAIRWELL. All that was lacking was a comparable scattering of graffiti dedicated to Bulgakov mixed in with the Grebenshchikov collection in Leningrad, and an assertion that "Grebenshchikov reads only Bulgakov."

In language, colocation, and explicit claim, the graffiti link Grebenshchikov and Bulgakov, but that cannot be due to their cultural proximity. Unlike Bulgakov, Grebenshchikov works in a medium recently sprung from the West, which still takes the West as its standard of reference. Grebenshchikov's many admirers do consider him to be the most Russian, and not coincidentally most literary and lyrical, of the Soviet Union's rock composer-performers. Without any doubt, he brings the Russian tradition of sung verse to rock music. Perhaps Grebenshchikov's perceived Russianness explains in some small part the linguistic properties of the graffiti devoted to him. But it is no criticism of Grebenshchikov to observe that, exceptional as he may be in his own metier, he is not comparable to Bulgakov either in literary stature or in style. His lyrics are dense and contemplative, not sharp and witty; they are thoughtfully oppositional, not carnivalesque. Because of their indirection they do hold multiple meanings, but that hardly creates the bond asserted by the graffiti in the Bulgakov stairwell.

Bulgakov and Grebenshchikov are unlike each other, but they are also unlike everyone else; each is in his own way and own art exceptional. The graffiti in the stairwells alone tell us that both produce unusually strong responses in their audiences. Devotees write graffiti to express their admiration, and they use Russian to produce what is in fact a variety of literary appreciation. The quotations must be in Russian, and extended tributes in English would be impractical even if desired. It is, after all, perfectly natural for Russians to write appreciative graffiti in their native language. Bulgakov's and Grebenshchikov's Russianness is relevant only in that it is presumably a part of what makes them exceptionally appealing to a Russian audience. In short, the language of the graffiti is not necessarily, or not only, a by-product of the particular cultural referents embedded in them.

The Russianness of the Bulgakov and Grebenshchikov graffiti is nevertheless culturally significant. Of all the figures in modern Russian culture to whom Russians might have dedicated graffiti, only Bulgakov and Grebenshchikov have triggered that kind of popular response. At least within the world of Soviet graffiti, the use of Russian is a sign of cultural validation precisely because it is so rare. No other writer, no other performer, has so stirred adolescent graffiti writers. Since popularity of that sort is rare, it is not surprising that the audiences overlap, and that admirers of one are attracted to the striking words and images of the other. In the flatlands, every hill is a landmark.

It is significant, too, that the Soviet counterculture has adopted them both. Counterculture graffiti appear in the two stairwells, Bulgakov and Grebenshchikov are invoked and quoted in graffiti at some of the counterculture's own principal *tusovki*, Grebenshchikov's songs circulate in typescript within the counterculture network. Their popularity is by no means confined to the counterculture, but the fact that the counterculture has singled them out points to the cultural and social subversion at the heart of their appeal. Different as they are, Grebenshchikov and Bulgakov stand outside official culture and have been adopted as constituents of a counterculture that has emerged as an alternative to the officially approved pablum.

The Russian-language graffiti devoted to Grebenshchikov and Bulgakov are thus a form of cultural criticism. In inscribing their enthusiastic tributes, the graffiti writers single those two out, and by implication oppose them to the rest of Soviet culture. In establishing links among Grebenshchikov, Bulgakov, and the counterculture, the graffiti confirm that the oppositional interpretation is indeed an important source of their popularity.

The much more numerous graffiti written in the gang argot, or in plain and fractured English, also function as cultural criticism. Groups employ English in their graffiti because that language corresponds to the values or images they wish to project. Pacifists, punks, and *metallisty* write English-language slogans and copy Western symbols—even Western lettering—because that associates them with Western,

prestige-conferring exemplars. English by itself conveys the prestige associated with Western popular culture. These graffiti demonstrate just how deeply Western popular culture and English as the language of that culture have become embedded in Soviet society, and the positive value that attaches to them.

By the same token, they announce the rejection of officially approved Soviet culture: use of English is an implicit rejection of Russian and of everything associated with Russian, which is to say the world of familiar cultural, social, and political landmarks. Indeed, to the many who cannot read them the only message English-language graffiti convey is "not-Russian, incomprehensible, alien." Comprehensible or not, English has long been associated with an imported, officially disapproved popular culture, so that in a Soviet setting the very language has acquired oppositional associations. The cultural messages encoded in Russian and English were partly responsible for the long failure of Russian-language rock music to take hold. According to Artemii Troitskii, the leading Soviet rock critic: "The Nomads, the first Leningrad group to begin singing in Russian, were often booed off the stage and earned no respect. The Russian language was considered somehow an attribute of conformity, the symbol of some 'hostile,' non-rock system of values."[13] Rock music communicated nonconformity—this is attested to as well by its importance to the counterculture—and the native language of rock conveyed opposition to convention.

Hence the importance of English to the graffiti-producing groups. They do not generally produce extensive commentary like that in the Bulgakov and Grebenshchikov stairwells. They use graffiti to declare themselves, to communicate basic attitudes, and to mark territory. They produce organizational logos or stereotyped messages—the pacifist invocation of peace, love, and Beatles, the *metallist* inventory of bands. English abbreviations and English-language slogans communicate the groups' hostility to mainstream Soviet culture. They could (and, when necessary, do) spell out their messages in Russian, but for pacifists, punks, and *metallisty*, representing themselves in Russian is as inconceivable as Russian-language rock music was in the late 1960s. The graffiti argot of the fan gangs makes use of the same oppositional association

of English, which is why the counterculture groups find it so natural to draw on the argot in their own writing.

Thus the linguistic boundary between the Russian-language graffiti devoted to Bulgakov and Grebenshchikov, and the graffiti outside the stairwells that make extensive use of English, is important but upon examination actually underscores the critique of Soviet culture embodied in all the public graffiti that have appeared since the late 1970s. Overlapping differences in the function and cultural referents yield differences in language. There is a yawning divide between the enormous arena of Soviet popular culture that is a provincial variant of Western popular culture and Bulgakov's *The Master and Margarita*. Graffiti that refer to those two cultural worlds must in some manner reflect that difference. It is almost equally appropriate that the graffiti devoted to Grebenshchikov be in Russian, while the graffiti of the *metallisty* and pacifists are by and large in English. Yet graffiti in both languages reject official culture: the Grebenshchikov and Bulgakov collections by singling them out for special treatment and by associating them with carnivalesque opposition and counterculture, the graffiti in English and argot by employing Western totems and disdaining Russian, or treating it at best as the language of dishonor. English-language graffiti condemn Soviet culture generically; the Russian-language collections represent an effort to construct an alternative.

NOTES

1. On Bulgakov's residence here, and its relationship to the novel, see V. Levshin, "Sadovaia 302-bis," *Teatr*, 1971 no. 11, pp. 110–20. Levshin suggests that Bulgakov also altered, intentionally, the location of the apartment within the building; if so, that would be a typical if minor bit of Bulgakov mystification.

2. Aleksandr Tan, "Moskva v romane M. Bulgakova," *Dekorativnoe iskusstvo SSSR*, 1987 no. 2, p. 28, claims to have found the stairwell chock-full of graffiti in early 1983. That date is either misprinted or misremembered, because different residents questioned

separately said they noticed no graffiti until the middle of 1983. The later legend that admirers had been inscribing tributes to Bulgakov in the stairwell for decades was reported as fact by Thom Shanker, "Midnight Mecca in Moscow," *Chicago Tribune*, 11 Jan. 1987.

3. Aleksandr Gershkovich, *Teatr na Taganke*, Benson, Vt., 1986, pp. 31–38; N. Potapov, " 'Seans chernoi magii' na Taganke," *Pravda*, 29 May 1977. For Western reviews, see *Washington Post*, 8 Apr. 1977, and *Newsweek*, 13 June 1977. For the script, Iurii Liubimov, *Stsenicheskaia adaptatsiia "Mastera i Margarity" M. A. Bulgakova*, London, 1985.

4. Gershkovich, *Teatr na Taganke*, pp. 192–97.

5. For one bitter attack on Efros (a Jew) for corrupting Russian national treasures, see Mikhail Lobanov, "Prosveshchennoe meshchantstvo," *Molodaia gvardiia*, 1968 no. 4, pp. 300–301. Something of Efros's travails is revealed in Anatolii Efros, "O blagorodstve," *Ogonek*, 1987 no. 32, pp. 22–24. A sympathetic portrait of Efros is provided by Vladimir Solov'ev, "Istoriia odnoi skvernosti," *Vremia i my*, 1987 no. 95, pp. 122–35. Liubimov, on the other hand, bitterly denounced Efros: Iurii Liubimov (interview), "Praviteli i teatr," *Vremia i my*, 1987 no. 98, pp. 165–69. For a less vitriolic account, see Gershkovich, *Teatr na Taganke*, pp. 197–200.

6. Vl. Arsen'ev and Iu. Grin'ko, " 'Nekhoroshaia kvartira.' (Sadovaia, 302-bis, No. 50)," *Izvestiia*, no. 13, 13 Jan. 1985; Vl. Arsen'ev and Iu. Grink'ko, " 'Ne stuchai, ne zvonit'!" (Sadovaia 302-bis, No. 50)," *Izvestiia*, no. 39, 8 Feb. 1985; Vl. Arsen'ev and Iu. Grin'ko, " 'Muzeefitsirovanie netselesoobrazno'? Eshche raz o sud'be bulgakovskoi kvartiry," *Izvestiia*, 7 Jan. 1987. I am indebted to Michelle Marrese and to Professor Adele Barker of the University of Arizona for information on the state of the graffiti and their treatment in 1985 and 1986. Iu. A. Bakhchiev, who was organizing a museum in the apartment in 1988, stated in October of that year that the walls of the stairwell had last been painted over in 1986. The graffiti that Professor Barker found there in the summer of 1986 were gone in October 1988. Some of the same graffiti that she observed could be seen in pictures published in Aleksandr Tan, "Moskva v romane M. Bulgakova," *Dekorativnoe iskusstvo SSSR*, 1987 no. 2, p. 28; and *Der Spiegel*, 30 Mar. 1987, pp. 204, 207.

7. Reported as fact rather than as legend by Thom Shanker, "Midnight Mecca in Moscow."

8. I owe much of this information to Iu. A. Bakhchiev, October 1988 interview. The rest comes from personal observation and from information supplied by visitors to the stairwell in 1987 and 1988.

9. I have also dealt with this in "A Popular Reading of Bulgakov:

Explication des Graffiti," Slavic Review, v. 47, no. 2, Fall 1988, pp. 502–11. That article covers the graffiti only up to 1986.

10. I draw here on information and pictures provided by Professor Adele Barker. Tan, "Moskva v romane M. Bulgakova," p. 28, lists the characters who appear on the walls in the same period, in descending order of frequency, as Behemoth, Margarita on her broomstick, Koroviev, Pontius Pilate, Hella, and, more rarely, Woland, Azazello, and Jesus. It is just remotely conceivable that Tan's assessment is accurate, but more likely not. He also claims that the only inscription that was not a quotation from the novel was the frequently reiterated "Long Live Bulgakov"; that has never been the case. Tan also misdated the beginning of the collection. His article is accompanied by a few pictures of the graffiti of 1986, including a drawing of Margarita on a broomstick. One suspects he confused memorable visual impression with frequency.

11. In "A Popular Reading of Bulgakov," I singled out both "Speaking the truth is easy and pleasant" and "The greatest sin is cowardice" as lines that ought to appear on the walls if the graffiti writers were reading the novel as more than the adventures of Behemoth and friends. Now that these lines have appeared, I can add that they do not change the overall impression that the graffiti leave.

12. September 1988 interview with a countercultural pacifist who spoke of once- or twice-monthly gatherings of Bulgakov's pacifist admirers in the attic. See also Bill Keller, "Russia's Restless Youth," *New York Times Magazine,* 26 July 1987, pp. 14–15, for a picture of *metallisty* in this stairwell, captioned *"Metallisti,* not unlike such groups in the United States, in a house they have plastered with graffiti." That caption credits the *metallisty* with a much larger contribution than they have actually made; Keller cannot have understood what the graffiti in the stairwell were actually about.

13. Artemy Troitsky, *Back in the USSR: The True Story of Rock in Russia,* Boston and London, 1987, p. 35.

CHAPTER 6

Graffiti and the
Soviet Urban Subculture

ADOLESCENT GRAFFITI WRITERS

In June 1984, Iurii Shchekochikhin, a Soviet newspaper correspondent specializing in juvenile delinquency and other youth problems, published an article about the *fanaty* in *Literaturnaia gazeta* (*Literary Gazette*), the most prestigious weekly in the Soviet Union. There was more to the phenomenon of soccer hooliganism than rowdy fans causing public disturbances, he observed. In fact, soccer was not really involved at all. And the *fanaty* were only the first of a new class of adolescent groups, others with different symbols and identifying characteristics had followed. Teenagers had always formed into groups united by courtyards, or classrooms, or sports, or other interests, Shchekochikhin noted, but these new groups were different: they determined their members' dress, behavior, even values. They held themselves apart from the world adults controlled, but they also sought to impose themselves on society. Shchekochikhin suggested that these adolescent groups merited attention, and that perhaps their creative energy could be channeled in a more useful direction. At the end of the article, he announced that adolescents who wanted to talk about their groups and what they were searching for could call him any Thursday between 3:00 and 6:00 p.m.[1]

Many adolescents responded. They phoned, visited the offices of *Literaturnaia gazeta*, or sent letters about themselves and their organizations. Over the next several years Shchekochikhin published excerpts—some fragmentary,

some quite extensive—from the transcripts of the phone conversations and meetings. Partial transcripts are no substitute for the originals, but Shchekochikhin's articles did provide some scope for *fanaty*, *metallisty*, hippies, punks, fascists, *rokery*, and others to speak for themselves.

Here is 16-year-old Igor, a TsKA *fanat* from a Moscow suburb:

> Not long ago we had a brawl with Torpedo *fanaty*. They were stronger, but they paid for it. . . . I've been in fights with guys from different groups. With some pacifists just a while back. They formed an alliance with the Torpedo gang against us. They were suburban pacifists, I know them. [What kind?] Suburban . . . And I've fought with punks . . . [Is it worth fighting?] The thing is, I'm not a leader. That is, I'm a leader, but not high up. The top leaders begin the fights, we just support them. [He complains about the adults who criticize *fanaty*.] They're not so hot themselves. For instance, at one subway station we climbed into the car like always, shouting "Moscow Army." And a woman working there said "I'd line fans like those up against a wall." [But it's very unpleasant.] Who cares! It's all because they won't let us shout at the stadium, understand? [Nonsense.] But we want to be together!

Igor later dropped in at the newspaper office to talk, and Shchekochikhin relates: "He amazes us because he reads a lot. His favorite writer is Mikhail Bulgakov. And he amazes us even more by being amazed that we have read Bulgakov, too."[2]

Aleksei, 18 years old, began as a Dinamo *fanat* when he was 15, then joined the punks, and finally took up with the skateboard set. His account starts with the fan gangs:

> I really buried myself in it. [Did you go on trips?] Once. To Minsk. What drove me away was that I was always getting picked up by the police for no reason at all. [How long were you a *fanat*?] A year. I heard about the punks very late, they'd been around for some time, I just didn't pay any attention. I was completely absorbed with *fanatizm*. You know, they used to gather at Pushkin Square, and there was an incident . . .

Aleksei recounts a story that went the rounds in Moscow, that the *fashisty* had hanged two Spartak *fanaty* by their scarves.

We all agreed, all the *fanaty*, to gather at Pushkin Square—it was Hitler's birthday, we knew they'd celebrate it. We came to beat them up. I only saw two Nazis there, we attacked them, but the police surrounded everyone. [They had swastikas?] See, the crowd rushed them, the police stepped in, I couldn't see. I remember one of them—he was dressed completely in black, with dark glasses and a swastika on the side.

[Punks were there?] Yes, of course. [Did they come to beat up the Nazis, too?] I didn't know then whether there were punks there or not. But I can say that the punks always hated the Nazis. . . . I didn't abandon *fanatizm* right then, but I began to pay less attention to it. I was having trouble at school and at home, the police called me in. Anyway, they were coming at me from all sides. That is, I had to find some other atmosphere to get away from everyone who was ganging up on me.

[So you began to go to Pushkin Square every evening, like going to work?] Yes, but not like going to work. It attracted me somehow. It was a completely different situation. No hooliganism at all. Some people think: Pushkin's everything. [And who are the punks?] Punks—in short, D students. [I thought that was the *fanaty*.] *Fanaty* are trade schoolers. What were we like? Spent a lot of time at Pushkin, no time to study, we began to fall behind at school. [How did you show you were a punk?] I liked it when we attracted attention. We went around painted up. [I've never seen anyone painted in Moscow.] Of course. As soon as we saw the police, we'd take cover. That's why I left, because in our society you can't do punk. [How else?] You see, a kind of free behavior. Bright clothes, tasteless. That is, to draw attention somehow. To say—see, I'm unusual. A special hairstyle. Shaved temples. Hair standing out straight. There were some guys who dyed their hair violet, or green. I can tell you, there was nothing illegal about it.

[What were relations between punks and *fanaty* like?] Both punks and *fanaty* gathered at Pushkin. They didn't disturb each other. [And with pacifist groups?] Negative. Decisively negative. You know why I don't like the pacifists? Peace, friendship and all that's fine, but they're fighting against all weapons, and they should fight only against NATO. That's their mistake. Naturally, I have friends among the pacifists, too. And there weren't any fights. Punks simply didn't like pacifists. . . . [Why did you quit the punks?] I told you, there were problems with the police. If you're a punk . . . I won't say anything bad. I simply understood that there's no point in being a punk, you'll only have trouble. Better to be normal.

Aleksei went on to explain that another reason for quitting the punks after better than a year was that toughs beat them up. He then took up skateboarding, which he called "a very progressive diversion" because it improves coordination and balance. Asked if he considered skateboarders akin to *fanaty* and punks he said no, the latter two have a kind of belief, while skateboarding is only a pastime. But he was still persecuted, as he relates in this incident from one May 9, the holiday in honor of the end of World War II in Europe.

> Our crowd had gathered at Nogin Square. We skated around the square, and then after the fireworks we see a mob of great Boers heading our way. Luckily, I didn't have my board with me. They asked, "Are you skatists?" The right way to say it is skateboardists. Well, of course we played the fool. "Who're they? What's that?" Look out, they said, you'll get it from us too. We learned later they were from [Liubertsy]. They're always coming to pick a fight.[3]

Finally, Sergei—who as a 17-year-old punk in 1984 came to Shchekochikhin's office wearing a very narrow black tie, a musical emblem on his left knee, 15 safety pins scattered on jeans, shirt and sweater, and a small bell fastened to the side of his jeans just above the knee—told Shchekochikhin he found himself moving toward the punks after the eighth grade.

> I didn't know myself what I wanted then, but I wanted to be someone. The only thing that was "me" was wearing knee-breeches, a black shirt, and a black tie, this one, and he touched the end of his tie. I shaved my temples, pressured some friends to do the same, and we went around so everyone would see us. Public attention didn't bother us. Just the opposite. But that was when I was 15. And now, today? Showing ourselves is the principle of our gang. We want people to look at us, to notice us. It's a real kick to walk the street and see from people's faces that they're disturbed. You pass someone really solid, and he looks at you arrogantly, and you feel that the way you look has offended him—Sergei emphasized that. Does that make you feel good? Yes it does, it warms my heart.[4]

The same Sergei, at another meeting two years later, had forsaken his bell and safety pins for the long-haired hippie

look (most punks were not, after all, so patriotically inclined as Aleksei).

> I didn't switch to the hairy ones [*volosatye*] just to switch. I let my hair grow, began to hang out with them, and understood that these guys were much closer to my heart, although I'm not thrilled that among them, the hairy ones, many aren't very bright, and that the interests of many of them are limited to the musical sphere.[5]

Igor, Aleksei, Sergei, and adolescents like them constitute Moscow's graffiti-writing population. They may have contributed to the recognizable graffiti genres in every one of their identities—*fanat*, Bulgakov fan, punk, hippie, even skateboardist. As adolescents they try out and discard social identities in rapid succession, brag about (and certainly exaggerate) the fights they have been in, take easy offense at adult reproval, and have an exaggerated sense of the importance of whatever their latest enthusiasm may be. Moreover, the groups to which they belong are unstable and bear no fixed relationships to one another. Igor the *fanat* beats up punks, Aleksei the *fanat* easily switches allegience to the punks and dislikes pacifists, Sergei the punk matures into a hippie with (we may safely assume) pacifist inclinations. And who but an adolescent would imagine that taking on a punk identity would provide relief from the harassment he experienced as a *fanat*, or would seek to provoke the public by donning punk garb and at the same time complain indignantly that the police paid too much attention?

Over and over, in their talks with Shchekochikhin and in their natural habitat, they circle around two antithetical themes: we are victims, we just want to be left alone, we're not bothering anyone; we want to assert ourselves, we have the right to take our place in society. These contradictory attitudes are scarcely unique to Soviet youth. Octavio Paz observed eloquently of the zoot-suited pachuco youth gangs of the American Southwest in the period around World War II:

> [The pachuco] knows that it is dangerous to stand out and that his behavior irritates society, but nevertheless he seeks out and attracts persecution and scandal. It is the only way he can establish a more vital relationship with the society he is antagonizing. As a

victim, he can occupy a place in the world that previously had ignored him; as a delinquent, he can become one of its wicked heroes.[6]

And the same could be said of the punks and rockers of England and Western Europe. This seems a peculiarly adolescent pattern of behavior.

Paz and commentators on British punks seldom point out that their subjects, who are presumed to be making profound statements about the social world, are adolescents beset with identity problems whether or not they follow the pachuco example. Yet the Moscow graffiti writers' adolescence makes it hard to take what they say and do completely seriously. It is equally difficult to take their transitory social identities—the groups they join—seriously. They will certainly grow out of them, or out of several of them, in the space of a year or two. Like Rashid Seifullin, the original leader of the Spartak *fanaty*, they may even become schoolteachers. Leonid Radzikhovskii, one of the first scholars to give serious attention to the Soviet youth groups, has aptly noted that membership is characteristically a stage in the life cycle. When young men and women begin to assume adult responsibilities, they shed their punk, *fanat*, and *metallist* skins.[7]

Adolescents such as these produce the public graffiti that have been the principal subject of this book, so the conclusions we draw must be circumspect. Many of the graffiti will still be on the walls after their authors have outgrown the groups the graffiti celebrate. Graffiti freeze what may be a momentary assertion of an identity taken on to shock adults into a fixture of the cityscape. Or at least that is the case when the medium is spray paint, and no one takes the trouble to repaint the walls. The graffiti in a Soviet middle-class neighborhood tell us what groups middle-class teens have been affiliated with at one time or another, not how serious their commitment or enduring their interest.

Yet Iurii Shchekochikhin was right: these adolescent groups are significant if only because they are new. No matter how unstable and transitory membership may be, they did not exist prior to the middle of the 1970s. Of course there were exceptions: the counterculture *sistema* has been around in one

form or another since the early 1970s, the motorcycle-riding *rokery* since the 1960s, and the style-conscious *stiliagi* of the 1950s might be considered a distant forerunner. But these were small groups that by and large existed outside the public eye. Since the emergence of the *fanaty* in the late 1970s, the social identities available to Soviet adolescents have proliferated extravagantly. And as Shchekochikhin implied, a central element in all of these new identities is an assertive challenge to the public at large; they demand public attention. Even if the adolescents involved quickly move on to other interests, they are playing out roles that did not exist before, and doing so on a public stage. The graffiti register, at a minimum, the emergence of new adolescent roles that were not available to the Sergeis and Alekseis of the early 1970s.

Variations are being played out everywhere in urban Russia. I have introduced graffiti from Leningrad at almost every stage in the narrative, because they support and amplify conclusions drawn from Moscow graffiti. Whatever the graffiti may reveal about Soviet society, the message is roughly the same in both cities. But there are some differences. Neither in 1984 nor in 1988 were the graffiti of the *fanaty* as numerous in Leningrad as in Moscow, nor were they so obviously gang related: very few of the logos of the local Zenit club bore any freight of graffiti invective, or any benedictions other than an unadorned FAN'S (Figure 6.1a). The obvious explanation is that Leningrad has only a single major league soccer team, and hence lacks the rivalries that provided the stimulus and pretext for the formation of genuine gangs in Moscow.

On the other hand, there are more counterculture graffiti in Leningrad, probably because Leningrad is a major focus in the national counterculture circuit. The city is an easy journey from the summer meets in the Baltic, and many of the messages on the walls at Leningrad *tusovki* have to do with travel arrangements and plans for rendezvous in other cities.[8] The Leningrad rock club, Boris Grebenshchikov (who has a particularly strong following among young Soviet hippies), and the cafe known by its *tusovka* name as the Saigon, where rock musicians hang out, are famous throughout the Soviet *sistema*, and indeed not only within the counterculture system; the only stop in Moscow that can compare is the

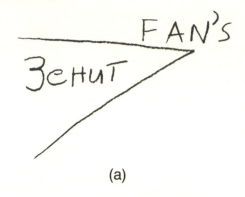

(a)

(b)

Figure 6.1

Bulgakov stairwell. And there was in Leningrad as of the end of 1988 a *tusovka* in a late eighteenth-century edifice with a massive, spiraling central rotunda (giving the building its counterculture name, the Rotunda), four stories high and densely covered with counterculture graffiti comparable in volume to the Bulgakov graffiti. Many of them expounded at length upon the counterculture philosophy and were therefore in Russian, as were homages to Bulgakov and Grebenshchikov; pacifist and hippie slogans, and graffiti devoted to the Beatles and to heavy metal music, were as everywhere else in English.[9]

Minsk, too, was chock-full of graffiti in both 1984 and 1988. A 1984 graffito in Leningrad proclaimed (in English) MINSK HARD ROCK CITY, and there was truth in that advertisement, since the most numerous of all graffiti in Minsk in that year were of the heavy metal variety. Heavy metal graffiti remained

dominant in 1988: the HMR logo was everywhere, and there were the characteristic lists of heavy metal band names (but with fewer of the KISS and AC/DC graffiti than in Moscow and Leningrad, proportionately more of METALLICA, VENOM, and ACCEPT). The most frequently named Soviet bands were the local heavy metal groups METAL BOYS and METAL WOLF. But Minsk also had a significant subset of graffiti devoted to NEW WAVE rock music, and new wave enthusiasts had devised NW ligatures analogous to the HMR logo (Figure 6.1b). There was also a scattering of pacifist (and associated Beatles) and punk graffiti, while the local *fanaty* inscribed an occasional tribute to the Dinamo-Minsk soccer franchise. The graffiti accurately reflected the strength of the various adolescent groups in the city.[10]

Minsk is the capital of the Soviet republic of Belorussia, a city with over a million inhabitants, not far from Poland and with many international contacts, so it is not surprising that its adolescents should be fully attuned to the fluctuations of the youth culture in Moscow and Leningrad. Smolensk, on the other hand, is a smaller city of 300,000, a quiet provincial backwater. Yet the most prolific producers of graffiti there in 1988 were punks, whose anarchist A-in-circle and locally devised punk logo (see Figure 4.6c, in Chapter 4) were on walls all over the shopping streets and residential courtyards in the historic center. Smolensk punks also frequently employed an inverted hammer and sickle in their graffiti declarations, and sometimes a combination of stars and hammer and sickle that resembled the emblem of the Association of Soviet Socialist Anarchists (Figure 4.8c); one of these graffiti had the appealing caption *SVOBODA VYSSHE SOLNTSA* ("Freedom is higher than the sun"). And in contrast to punks in Moscow and Leningrad, those in Smolensk not only wrote PUNK ROCK on the walls, they also inscribed the names of some punk rock groups, such as CLASH and SEX PISTOLS. *Metallisty* of course contributed a great many HMR logos and lists of heavy metal band names, and there were a few pacifist symbols as well (one Christian pacifist emblem was joined to the punk and anarchist logos). Smolensk teenagers questioned more or less at random reported that these graffiti and the groups producing them had appeared in the city around 1985. A few

graffiti celebrated the local minor league soccer team, Iskra, but Smolensk *fanaty* grouped themselves around the country's two most popular major league clubs, Spartak of Moscow and Dinamo-Kiev, and produced a faint likeness of the fan gang graffiti on display in Moscow.

Graffiti do vary from city to city, and in interesting and unpredictable ways, but they are produced by the same groups everywhere. At least that is true of cities that are Russian or, like Minsk, predominantly Russian.[11] Graffiti in Minsk and Smolensk also observe the same linguistic conventions as in Moscow and Leningrad. *Fanaty* in Smolensk use stars, crowns, V-for-victory ideograms, and FANS to exhalt their team and gang, Russian to denigrate. Smolensk, in fact, produced two interesting variations on the standard negative epithets for Dinamo (Dinamo-Kiev is sponsored by the Ukrainian Ministry of Interior): one fan of Spartak wrote *MESTO DLIA D-K* ("place for D[inamo]-K[iev]") on a garbage bin, turning the usual slang expression for police into a visual pun; another turned the Dinamo D into *spiD, SPID* being the Soviet acronym for AIDS. Graffiti writers in both Smolensk and Minsk use the *fanat* crown in conjunction with heavy metal and other graffiti. And they feel the same compulsion to use English for slogans or praise. But their command of English (in Smolensk especially) is appreciably less secure than in the capital. Typical slogans in Smolensk in 1988 were ROCK-N-ROLL *BUDET ZHIT* ("rock-n-roll will live") and *MY LIUBIM TIAZHELYI* METALL ("We love heavy metall") next to a raised hand inscribed YES. The authors of those graffiti at least recognized their limitations; their example ought to have been heeded by the author of a Smolensk graffito proclaiming ANARCHY MY LIVE. And in both Smolensk and Minsk, Russian letters slipped into graffiti that were supposed to be in English (Figures 6.2a, from Minsk, and 6.2b, from Smolensk).

The new adolescent roles represented on the walls of Moscow exist throughout urban Russia. Representation—public display—is a central feature of all of them. *Fanaty* wear team colors, *metallisty* don leather and metal, punks adorn themselves with safety pins and dyed hair. Shchekochikhin was the first to draw attention to this phenomenon, but others have noted and characterized the same change. Leonid

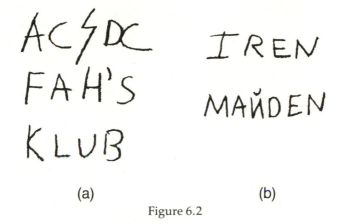

(a) (b)

Figure 6.2

Zhukovitskii, for instance, likens their appearance to the advent of carnival: the new groups have become a colorful and energetic presence against the drab urban background.[12] Graffiti writers may be only adolescents, their behavior may reveal, as Octavio Paz said of the pachucos, "an obstinate, almost fanatical will-to-be" that "affirms nothing specific except their determination not to be like those around them," but that determination has produced a variety of adolescent unknown to Soviet society before the mid-1970s.[13] At the very least, these new Soviet teenagers changed the look of Soviet society.

THE SUBCULTURAL FUNCTIONS OF SOVIET GRAFFITI

The adolescent roles that the graffiti advertise constitute a youth subculture, and it is precisely in their subcultural attributes—the public assertiveness and carnivalesque display that Shchekochikhin and Zhukovitskii noticed—that the groups involved differ from the groups that Soviet adolescents formed in the past. The history of the subculture in most respects is coterminus with the history of Soviet public graffiti,

because graffiti have played a crucial role in generating, defining, and sustaining the subculture. And we can read in the graffiti many of the subculture's social and cultural attributes. As argot, the graffiti express a cultural program and distance the subculture from adult society.

Subculture is an elusive and elastic concept, which I have used until this point only in the very narrow sense that Maurer gave it: a criminal culture, parasitical upon the main body of society, and marked by the use of an argot. But of course there are many other, more inclusive usages of the concept. The main body of society is itself a congeries of subgroups, sometimes called subcultures, each with its own patterns of behavior and belief, traditions, codes, and special vocabulary, from midwestern farmers to New England fishermen, from race car drivers to college professors. Not to mention the many ethnic variations upon class and geography. The concept is so diffuse that it has even been suggested that it might have been better had sociologists never gotten into the habit of using it.[14]

In what follows I use the term somewhat more expansively than Maurer, but not much: a subculture is recognized by ordinary men and women to be alien in its behavior and values, while the subcultural group recognizes or defines itself as in opposition to the rest of society. That covers Maurer's professional criminals, but it also includes the defiantly different but noncriminal punks and hippies of the Soviet Union and other countries. Even a noncriminal subculture is probably parasitical as Maurer would have it (in that punks, hippies, and others cannot survive without money from legitimate society), and is certainly linguistically specialized. A subculture consists more of roles than of the individuals who pass through them (which is no different than the multiplicity of roles that make up the rest of society). And a subculture interacts intensively with legitimate society, either criminally or in the manner of Paz's pachucos.

The graffiti of course illuminate the subculture's linguistic specialization. The most striking feature of Soviet graffiti is their use of English, but that is not an exclusively subcultural characteristic. English actually serves as an umbilical cord linking the subculture to the parent society of which it is an offshoot. By the time the *fanaty* invented public graffiti,

English had been contributing to Soviet slang for decades and stood for the prestige of all things Western, especially in the realm of popular culture and fashion. Graffiti writers merely tapped values that had already taken root; the use of English as the language of honor in everyday graffiti demonstrates for all to see just how powerful the values associated with English are. Since these values were, in the Soviet context, inherently subterranean—they could not be officially acknowledged, even though many officials shared them—it is not surprising that they should be incorporated into the subculture. The Soviet youth subculture, like all subcultures, appropriated elements of its society of origin.

The language of the graffiti discloses more than the intrusion of Western popular culture into Soviet society. Graffiti writers distinguish between Western and native popular culture, and language delimits the two domains. Graffiti with Western referents—heavy metal rock music, the Beatles, punks, the antinuclear movement—employ English; graffiti referring to Russian popular culture are written chiefly in Russian. Graffiti writers display a strong sense of the cultural appropriateness of language. Because either language may be used, they must choose, and the choice is neither arbitrary nor incidental. The authors pick the language of the graffiti deliberately, and intend their choice to have meaning.

Since they can choose both the language and the subject of their inscriptions, the infrequency with which adolescent graffiti writers refer to native popular culture must be taken as a judgment: very little domestic popular culture meets their emotional needs. Not that the graffiti are an infallible guide. The absence of graffiti devoted to Vladimir Vysotskii, the most popular of the Soviet guitar poets of the 1960s and 1970s, whose death in 1980 was marked by a massive outpouring of grief and adulation, and whose cult remains so strong that it supports a minor second economy industry of Vysotskii memorabilia, is especially striking, because his popularity does reach down to the adolescent population.[15] Perhaps the explanation is that adolescents cannot make Vysotskii their own. He was a member of their parents' generation, and their parents played his tapes. Grebenshchikov, in contrast, belongs to them. Nevertheless, whatever other native popular

culture icons we may want to place alongside Bulgakov and Grebenshchikov, the shelf will look bare next to the massed ranks of Western idols and images to which Soviet graffiti refer.

The very sharp linguistic distinction between the two popular culture domains is misleading in at least one respect: Western popular culture and its forms are quickly assimilated into Soviet popular culture. With time, the distinction between native and Soviet blurs. As Soviet cultural liberals point out in defending rock music against the fulminations of conservatives and nationalists, if everything imported from the West in the last three centuries were to be excised, Russia would hardly have any culture left. As an assimilationist case in point, native rock music now claims a small share of the wall. There is even a hint of pride in native origins in those inscriptions that use the hammer and sickle emblem to denote "Soviet metal" (see Figure 3.4a, in Chapter 3). And, of course, graffiti identify Boris Grebenshchikov and Aquarium as thoroughly Russian. In a small way, the graffiti illustrate the gradual domestication of popular culture imports.

But the countervailing tendency is far stronger: to confer honor, the graffiti represent native popular culture as though it were Western. For instance, most of the symbols and annotation accompanying the names of Soviet rock bands deliberately assimilate them to the class of Western bands. In like manner, all of the countercultural and subcultural groups that go under Western names are distinctly Soviet in behavior and organization, but they produce graffiti that emphasize their association with the West. They prefer a Western to a Soviet image, even though they are themselves thoroughly Soviet, even though—Aleksei the ex-*fanat* and ex-punk is a good example—they may be conventionally patriotic. That is no longer just a judgment on the relative merits of competing popular cultures, it is an explicit repudiation of Soviet culture.

The Soviet regime bears much of the responsibility for this cultural anti-Sovietism, because for decades it made the origins of popular culture an issue. Rock music and the rest of Western popular culture were officially bad because Western, while bland Soviet popular culture was officially good because Soviet. It was the most natural thing in the world for generations of Soviet adolescents to turn the equation around:

popular culture that was bland and dull must be Soviet; if it was tantalizing and exciting, it must be Western. Western culture was good, Soviet bad—a judgment reflected in the language and symbols of all but a few special collections of graffiti, and built into the very grammar of the fan gangs' graffiti argot.

And yet even the graffiti that invoke the West most directly remain Soviet. We can read the defeat of the Soviet regime's efforts to control culture in the English the graffiti writers use, but even that language is Soviet rather than British or American. The effort to imitate has involved, unwittingly, cultural creativity, from the misattribution of a Soviet gang meaning to the English word FAN to the fabrication of the English-language HMR and NW ligatures. The PACIFIC that sometimes accompanies pacifist graffiti may have originated, like FANS', as a language error, but in NEW PACIFIC, LENINGRAD PACIFIC CLUB, and LP it functions as a regular lexical unit in an evolving language that we can call Soviet graffiti English. Even the listing of heavy metal bands is a creative use of language, a composition specific to Soviet society. And of course graffiti English in combination with Russian slang produced the unique graffiti argot of the fan gangs.

The graffiti are thoroughly Soviet, but esoterically so. Because the argot and the graffiti English are the outcome of specialized linguistic evolution, they must be studied and practiced like any unfamiliar language. Fedia, a precocious 10-year-old fan of heavy metal music from a family of intellectuals, provides an atypical but nevertheless instructive example of the learning process. A friend from school gave him a list of the names of heavy metal rock groups, and during the summer of 1988 Fedia practiced writing those and a few other band names in a special notebook. The master list that Fedia compiled included 26 rock groups, 10 of which were either misspelled or included stray Russian letters. Fedia paid particular attention to the heavy metal lettering (as in Figure 3.1c). He also practiced other items from the graffiti lexicon, including FAN'S, HMR, and METALL (he was convinced that the apostrophe and the extra L were proper English), and he worked on drawing the crowns and stars that are a necessary

adornment in any elaborate composition. It had not yet occurred to Fedia actually to write his list on a wall; these exercises were, for him, still in the nature of formal schooling. He was too young to be involved in the social rituals of the *metallisty*, or to have occasion to put his learning to public use.

Unlike the assiduous Fedia, most adolescent graffiti writers probably master the language and its rules in a more informal way, by hanging out at the *tusovki* where their interests draw them. There they learn not only the special vocabulary of their particular group—the names of the heavy metal bands, for instance—but also the vocabulary of the other groups with whom they share a hangout or who have their stand nearby. Even if no *fanaty* are present, they learn the use of the symbols and terms from the graffiti argot, and the grammatical rules governing the use of English and Russian, because the vocabulary and grammar of the argot have spread to all graffiti-producing groups. The aspiring *fanat, metallist*, punk, or pacifist will learn the one graffiti language and its subordinate dialects by associating, and only by associating, with the adolescent community within which the language and dialects are used.

The writers of graffiti thus form both a linguistic and a social community. They are a linguistic community because they share a language the knowledge of which is highly restricted. Most Russians, even most Russians who have studied English, cannot understand the graffiti around them, because the words and symbols have special meanings and are chosen according to the principles of an unfamiliar grammar. The ability of graffiti writers to compose statements meaningful to each other joins them together, while setting them apart from other Russians. This linguistic community is at the same time a social community, because the special language cannot be learned except by association with the groups that produce it. *Fanaty, metallisty*, pacifists, punks, *fashisty*, and *Liubery* write in a common graffiti language because they have picked it up from each other: they must be joined together by personal associations, no matter how tenuous.

It is not necessary, in fact it may be something of an oddity, that graffiti-producing groups form a social and linguistic community. As noted at the conclusion to Chapter 4, in the

United States graffiti are highly differentiated linguistically, and the linguistic divide follows social and cultural fault lines. The ghetto writers of gang graffiti and the college students who write about animal rights or Greenpeace find each other's inscriptions incomprehensible. The social distance between *Liubery* or working-class *fanaty* and the hippies of central Moscow may not be quite so great as the abyss dividing the Devil's Disciples on Chicago's West Side from the upper-middle-class students at Northwestern University, but it is not inconsequential. In Soviet society, youngsters from different social classes do not ordinarily mix and have little sense of identity with each other. Suburban working-class teens regularly beat up central Moscow teens, and graffiti do reveal some of the class hostility. On a priori grounds, one would expect that graffiti produced by groups that have emerged in different social settings would demonstrate that the writers formed neither a linguistic nor a social community. Yet there can be no doubt that in Moscow they do.

The social space that the graffiti writers jointly occupy is not anywhere within Soviet society, but at the margins. Apart from the production of graffiti, what these groups have in common is an urge to impose themselves on the public, to play a role on the public stage. The impulse toward public performance is what makes them all graffiti producers, but also marginalizes them. Because they insist on demonstrating their independence and nonconformity, there is by definition and in daily practice no room for them within the thicket of official institutions. When the Komsomol, which is charged with approving and supervising adolescents' group activities, from time to time overcomes its institutionalized hostility to genuine expressions of adolescent initiative and makes tentative overtures to these groups, it is rebuffed. Official institutions push the graffiti-writing groups to the margins of society, but the groups' confrontational stance would put them there in any case.

Because official institutions cannot accommodate them, they must appropriate space for themselves. The space they inhabit is often literally as well as metaphorically marginal: abandoned basements where *Liubery* and break dancers hold their workouts, back courtyards taken over for *tusovki*. But

they also gain a purchase at cafes and public squares and display themselves on public thoroughfares. Occupying similar habitats at the margins of Soviet urban society, and exhibiting a common habit of display, they naturally share space at *tusovki* and at public parading grounds. This is self-evidently true of punks, pacifists, hippies, *metallisty*, and other minor groups that circle around the counterculture system. But *fanaty* and *Liubery*, too, know where the counter-culture *tusovki* are, raid them or hang out nearby, and thus join in the community that understands and shares the graffiti language. The intermingling of graffiti reflects the human interaction. The graffiti also document antagonisms, but then linguistic and social communities need not be harmonious. The bands of *fanaty*, which have become socially more homogeneous over the years, war among themselves even as they write the same graffiti argot.

The linguistic and social community that uses the argot and graffiti English constitutes the Soviet urban youth subculture. The subcultural groups are bound together by a shared language that is nourished by their social interaction, and they have all deliberately set themselves apart from official society. The history of the graffiti, and of the groups that produce them, is in fact a history of the Soviet urban subculture. The *fanaty* launched the subculture, which was at first undifferentiated. As a linguistic and social community they transcended the socioeconomic divisions of Soviet urban society and included social groups (the children of central Moscow's middle elite) that later adopted a different subcultural role. The subculture underwent rapid differentiation in the early 1980s; the *fanaty* became only one, eventually a working-class, group among many. Some of the new groups (punks, *metallisty*) became fixtures in the subculture, others came and went. As a whole, the subculture—like the normative culture —offered a set of social roles that individuals could try out and discard until they found the one in which they felt most comfortable.

Although many of the subcultural groups are uniquely Soviet, the subculture as a whole does resemble the British youth subculture, that succession of groups from teddy boys through mods and rockers, punks, and others that has

preoccupied British social commentators since the 1950s. In reality, of course, this has come over time to be a pan-Western European subculture.[16] Like the British groups, the Soviet subculture communicates chiefly through symbols: each group has its own special dress code and peculiar mode of behavior; groups define themselves in relationship both to normative society and to each other; the dress and behavior constitute a challenge to the dominant verities and values of society. It is that challenge more than any specific actions that Soviet authorities—adults in general—find most upsetting. We can say of the Soviet subculture what Dick Hebdige has said of its British forerunner, "The emergence of such groups has signalled in a spectacular fashion the breakdown of consensus."[17] The Soviet social consensus may have been superficial and artificially enforced, but it did hold public sway until the late 1970s, and its disappearance deeply unsettled Soviet adult society.

Unfortunately, so little serious attention has been paid to the Soviet subcultural groups that aside from the few generalities and sparse details given earlier, little more can be said confidently about them. Close analysis of the graffiti provides important clues about subcultural attitudes, structures, and development, but cannot take the place of careful ethnographic and sociological observation of rituals, dress, beliefs, demographic characteristics, and career patterns. On the other hand, once we appreciate that the public graffiti are connected to a subculture, we can better understand their social and cultural functions.

The difficulty of the graffiti language for ordinary Russians is a measure of the gulf between normative culture and subculture, and a (surely unconscious) subcultural mechanism for maintaining that distance. I have already quoted David Maurer on the relationship between language and subculture: "Subcultures and specialized linguistic phenomena seem to arise spontaneously and simultaneously; language seems to lie at the heart of their cultural genesis."[18] Maurer had in mind the subculture of professional criminals and confidence men, but his observation applies perfectly to the emergence of the *fanaty* and their graffiti argot. It fits equally well the large and variegated youth subculture of which the *fanaty* were only the

opening installment. Set apart from the rest of urban society by choice and by the incapacity of official institutions to accommodate them, subcultural groups naturally develop their own codes and symbols. Because they wish to impose themselves on society they write graffiti. But because the graffiti express subcultural preoccupations—rock music, Western totems, and other symbols—they are highly meaningful within the subculture but opaque to everyone else. Which is to say that the graffiti constitute an argot that, like all argots, is the language of a socially marginal group.

Like all argots, too, the graffiti express a cultural critique. All serious commentators on argot point to the special emotional characteristics of the language, the ironic connotations of the vocabulary that make argot impossible to translate into anything but another argot or slang (thus, a too easy example, *menty* translates into English "pigs" but not into any standard Russian word for police). The ironic distance of the language corresponds to the antagonism between the subculture and the society to which it is opposed.[19] In the case of the argotizing groups to which linguists have heretofore directed their attention, the antagonism is that of the criminal toward victim and police, or between peddler and the victim of sharp practice.

In the case of the Soviet youth subculture, graffiti argot and graffiti English are an ironic, untranslatable expression of cultural antagonism. The emblematic use of English expresses linguistically the subculture's rejection of official Soviet culture. Of course there are exceptional cases, such as the *Liubery*, who claim to be defending Soviet culture against contamination by Westernisms, but in employing the Latin *L* in their logo they acknowledge the subcultural judgment that Western emblems confer value. And the special connotation that English has in the graffiti cannot be translated into standard Russian: FAN does not mean the same thing as its nominal Russian equivalent, *bolel'shchik*; PUNK ARMY and MAKE LOVE NOT WAR would not have the same meaning if written in Russian. The use of English in a Russian linguistic environment amounts to an explicit rejection of the Russian. The English in the graffiti expresses the subculture's rejection of official cultural values in the same way that the hippies'

long hair symbolizes a rejection of close-cropped society, or that any of the other stylistic conceits of the subcultural groups express opposition to the normative culture.

Graffiti and youth subculture go together in Soviet society. Graffiti argot and its subsidiary graffiti English help to mark the subculture off from the rest of society, and express the subculture's critique of the Soviet adult world. They have played a key role in subcultural generation, most notably for the *fanaty* but also for *metallisty* and in a lesser way some of the other groups. The Bulgakov and Grebenshchikov graffiti are outliers, neither produced by nor producing special subcultural groups, and disdaining English; but these graffiti, too, play a role in the subculture. At the other end of the graffiti-subculture continuum, some groups (most notably the hippie counterculture) for a time existed without benefit of graffiti. Those qualifications aside, since the emergence of the *fanaty* in the late 1970s, graffiti have played a crucial role in the generation of subcultural groups, and have communicated the inherently subcultural attitude of cultural opposition. The graffiti English of the counterculture and subculture in the 1980s has conveyed that opposition more overtly, but the same attitude was built into the grammar of the fan gang argot in the late 1970s. That is why argot spread to the counterculture groups, and it is the principal warrant for identifying the fan gangs as the progenitors of the Soviet youth subculture.

SUBCULTURE AND SOCIAL HISTORY: PRELIMINARY OBSERVATIONS IN LIEU OF A CONCLUSION

The habit of writing public graffiti eventually spread beyond the youth subculture. On the one hand, individual elements of the graffiti argot—particularly the nonverbal symbols—by dint of use became familiar to a broader public and turned into a visual slang, just as argot has always become slang. The graffito shown in Figure 6.3a, from Leningrad in 1984, is a good example. On the other hand, genuinely political graffiti

finally appeared in considerable numbers as part of the political awakening under Gorbachev. Here, too, the subculture led the way: in 1988 most political graffiti either included counterculture labels (as in Figure 6.3b, which translates as "Give us food," a comment on the rampant shortages then in evidence even in Moscow) or appeared at or near counterculture *tusovki*. In the fall of 1988 political graffiti most often dealt with Boris Yeltsin, popular party boss of Moscow until November 1987, when he resigned that post and was removed from the Communist party Politburo. *DAI SLOVO ELTSINU* ("Let Yeltsin speak") and *SVOBODA SLOVA ELTSINU* ("Freedom of speech for Yeltsin") were among the most common political graffiti. The same and many other slogans were on the buttons that private entrepreneurs were hawking; the counterculture can be given credit only for pioneering the use of graffiti for political purposes, not for taking political expression public. During the election campaign in early 1989, political graffiti blossomed far beyond their modest counterculture beginnings.

However they may evolve in the future, subcultural graffiti will always hold an honored place in the history of Soviet graffiti. The subculture's standing in social history is another matter. This has been a study of graffiti and of what they reveal about Soviet society, not—except inferentially and as necessary to make sense of the graffiti—a study of Soviet urban society itself. Graffiti tell us a great deal about the groups that produce them, but not much about how those groups and the subculture they collectively represent came to be. Yet it is clear enough that three overlapping processes were at work. First, large groups in Soviet society became decoupled from official norms and official institutions. Second, major social changes created niches within which the subculture—the new social roles of which the subculture consists—could exist. Third, for a significant portion of the urban population, approved and disapproved values were reversed. Since the third trend has already been sketched out, we will look briefly at the first two.

Of the fact of decoupling there is no longer any doubt, nor there any question that this was a cumulative change, increasing with every generation since the 1950s. There is even quantitative evidence, in the form of results from the Soviet

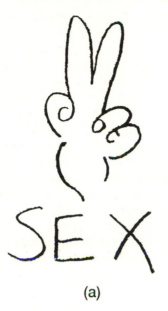

(a)

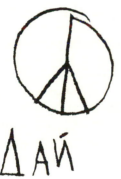

ДАЙ ПОЕСТЬ

(b)

Figure 6.3

Interview Project, a survey of emigrants who left the Soviet Union during the 1970s. Against the background of a considerable overall degree of satisfaction with life in the Soviet Union prior to the emigrants' decision to leave, the Soviet Interview Project established that the younger and better educated the respondents, the less satisfied they were with the quality of life in the Soviet Union, the less they accepted Soviet normative values, and the more likely they were to engage in activities that by Soviet standards were politically deviant. This was, interestingly, just the reverse of the findings of the Harvard Project, which surveyed post-WWII émigrés: then, older Soviet citizens had been more likely to object to the Soviet system, the younger more likely to accept it (with a couple of major exceptions, to be sure).[20]

The surveys do not establish precisely how Soviet institutions lost their command over Soviet citizens, but a plausible explanation is that as millions of Soviet citizens had the opportunity to visit Eastern Europe (more than a million a year as tourists by 1973), and other millions learned about Eastern and Western Europe and the United States at second- or thirdhand, often through the products of Western popular culture, the conviction gradually gained hold that the Soviet Union lagged behind the developed West and East and was doomed never to catch up. Failure of the Soviet system to raise the standard of living as rapidly as expectations mounted bred pessimism about the long-term performance of the system and cynicism about its current operations. Older generations remembered truly hard times compared to which the present continued to look good, but the younger generations did not have that cushion against despair. Of course, conditions other than disappointed material expectations must have borne some of the responsibility for official institutions' gradual loss of command over Soviet hearts and minds. The plain inability of the regime to manage the increasingly complex society produced by economic and social growth was one. Political and economic decisions and indecisions facilitating the spread of knowledge about the outside world were another. Taken all together, these had the effect of producing a widespread conviction that Soviet society would never ever achieve a Western standard of

living, seriously fraying the bonds between regime and younger citizens.[21]

Just as clear as the waning of regime credibility have been the consequences of ongoing socioeconomic change. We usually associate the great burst of industrial and urban growth with Stalin, but the urban share of the population rose from 39 percent in 1950 to 49 percent in 1960, to 56 percent in 1970, to 63 percent in 1980. In other words, the post-Stalin decades have seen rapid urban growth (while many American cities were beginning to contract, so that assumptions about Soviet cities based on the contemporary American situation scarcely applied). Well into the 1950s, migration from the villages continued to account for 60 percent of urban growth, while growth from births in the cities accounted for not much more than 20 percent of the total. Only in the decade of the 1960s did the flood of rural migrants begin to slow (to 56 percent of urban growth), while natural growth rose to 40 percent, and then to 44 percent in the 1970s. Growth continued, but urban natives were no longer being swamped by peasants. There was comparable growth in education. The number of Soviet citizens who had graduated from an institution of higher education rose from 3.8 million in 1959 to 8.3 million in 1970 to 14.8 million in 1979. In the same years, the number with completed secondary (but no higher) education rose from 17.8 million to 36.8 million to 68.6 million. As Moshe Lewin argues, urbanization, industrial and scientific development, improved education, improved communications, expansion of the arts, and other developments "changed the nation's overall social, professional, and cultural profile, and the social structure underwent a significant qualitative transformation."[22] Above all, he notes, urban growth created "microworlds and microsocieties," or in other words social complexity and heterogeneity, which constituted—I add in this context—a suitable medium for the emergence of a youth subculture.[23]

It is possible to guess at some of the finer alterations in social patterns that contributed to the brew. Better than a 35 percent increase in leisure time between the 1950s and 1970s, concurrent with the introduction of the five-day workweek, made possible major changes in leisure behavior.[24] Something,

certainly, also changed in the conditions of Soviet urban adolescence. Declining family size combined with the norm of two earners to produce more only children with unsupervised time on their hands. Rising incomes put more money in teenagers' pockets. Although there has been no study of the matter, by the middle of the 1980s an allowance of 20 rubles per week (with household income of around 450 rubles per month) for 16-year-old males seemed not to be uncommon; Soviet teens buy many of their meals at cheap canteens, but they still have the resources that many of the activities of the youth groups require. Changes in the physical infrastructure (slabs of low-rise and stands of high-rise apartments, greater distances between population and city centers, more movie theaters and cafes, to name only three) may have increased both the demand for and supply of places for teenagers to hang out, as well as alterations in the patterns of their leisure congregation. In a complex urban world, a multitude of social, economic, and demographic changes must have combined to produce the *fanaty* and the many groups that came after them.

The Soviet Union underwent dynamic transformation in the decades preceding Gorbachev. This point is worth expanding upon somewhat, because of misconceptions about Soviet society that have long held sway in the West, and that Gorbachev's reform rhetoric has reenforced. The Soviet standard of living rose under Brezhnev as under Khrushchev, even though Soviet citizens' expectations rose so much faster than the reality that by the 1970s they were inclined to deny that there was much improvement and by the early 1980s were convinced that living standards were declining.[25] The variety of goods, art, and performances available to consumers of popular and high culture expanded steadily, with the fastest-growing segment (at least in popular culture) consisting of foreign imports. The "second economy"—that is, the black market, or the Soviet private economy—responded creatively to changing popular tastes. The development of the underground rock music industry bears witness to that. There was a parallel increase in the number of privately produced and privately imported literary works and intellectual essays— samizdat and tamizdat—circulating among consumers of high culture. In fact, there was a complex network of art exhibits,

plays, poetry readings, and other unofficial but nevertheless frequent and widespread cultural performances. The upheaval in the world of approved culture since Gorbachev's advent to power in 1985 could not have occurred had there not been for some time a vibrant underground culture waiting to go public. The instantaneous revitalization of Soviet culture under Gorbachev has involved little more than the legitimation of what had existed before but had been officially invisible.

Soviet society and culture changed; official institutions did not. They became increasingly calcified at the very time when change was going on all around, and so they became progressively more irrelevant. The ineffectiveness of the apparatus for central planning and management at generating growth and technological development, and the corruption of officials who connived at or tolerated and profited from the growing second economy, epitomized stagnation so far as Gorbachev and the reformers were concerned. But if central planning institutions could not manage the complex official economy, unplanned and unregulated economic growth nevertheless continued; official corruption was the tax that underground entrepreneurs paid. Official cultural institutions lost their ability to influence the tastes of and cultural goods available to Soviet consumers. The Komsomol lost all the influence it had once had over Soviet young people. By the early 1980s all Soviet institutions were in a bad way, but by then they were a poor guide to the actual state of Soviet society. Of course, the dysfunctional performance of the official apparatus distorted and obstructed social development, and social ills—rising infant mortality and declining adult male life expectancy most notably—accumulated apace with the social heterogeneity. Nor was all of the unofficial social change that occurred benign. But Soviet society was anything but stagnant.

The gross changes in Soviet society are obvious enough, and they certainly created good conditions for the appearance of the youth subculture. Moreover, the contrast between official pomposity and manifest ineffectuality and corruption on the one hand and the dynamic unofficial world on the other might have been crafted deliberately to promote a subcultural

critique of official institutions and values. Since official institutions could not manage even the major business of Soviet society, it is not surprising that they could not cope with that challenge, or prevent the proliferation of subcultural groups, or even keep the walls clean.

A number of particular developments point to the 1970s as the decade during which many of the social trends converged in a way that would produce a youth subculture. This was the second decade in a row in which 40 percent or more of the urban growth came from urban births—and was thus the first decade in which probably 50 percent or more of urban adolescents had spent their entire lives in cities (probably about twice the proportion in the 1960s). The 1970s was also the decade in which a serious crisis in educational aspirations struck. While 57 percent of regular daytime secondary school graduates could go on to a daytime institution of higher education in 1960–63, by 1975 the corresponding figure was only 22 percent. In other words, the proportion of secondary school graduates going on to daytime higher education—the traditional route to social advancement—had been cut far below half. Higher education in night school and by correspondence remained possible, but there is no question that for a very large proportion of the adolescent population in the 1970s the future seemed to hold only dead-end jobs. Furthermore, a sharply declining proportion of those who did make it into higher education in the second half of the 1970s actually went on to take a job corresponding to their training: the Soviet Interview Project found that while a steady 70–75 percent of their respondents who had completed higher education between 1946 and 1975 had first jobs appropriate to their educational specialties, that was true of only 50 percent of those who completed higher education between 1976 and 1980.[26] However this sudden change might be explained, it does point to a breakdown in the formerly rather orderly progress through the educational system and into the world of work.

Thus, on top of the disengagement from the official Soviet world and the general changes associated with urbanization and economic growth, on top of the changes in the structure of leisure, the character of adolescence, and the physical

parameters within which adolescents lived, the 1970s saw the first genuinely urban generation of adolescents who could hold their own numerically—as well as socially and culturally —against the migrants from the village. Yet this was a generation particularly likely to despair over its educational and social prospects, and even its most fortunate members were prone to fall off the conveyor belt leading from school to appropriate job. No wonder this was the generation in which an urban youth subculture emerged. Its graffiti were the outward sign of the profound interior changes that had occurred in Soviet society.

NOTES

1. Iurii Shchekochikhin, "Predislovie k razgovoru," *Literaturnaia gazeta*, 6 June 1984.

2. Iurii Shchekochikhin, "Po kom zvonit kolokol'chik?" *Sotsiologicheskie issledovaniia*, 1987 no. 1, pp. 84–85.

3. Iurii Shchekochikhin, *Allo, my vas slyshim. Iz khroniki nashego vremeni*, Moscow, 1987, pp. 194–98. In the last passage, Shchekochikhin's text reads "from a suburb." Almost certainly Aleksei said "Liubertsy," and Shchekochikhin turned it into a generic suburb in order to avoid fueling passions (something he has warned against in his reports on the *Liubery*).

4. Shchekochikhin, "Po kom zvonit kolokil'chik?" p. 92. This segment originally appeared in *Literaturnaia gazeta* in 1984.

5. Iurii Shchekochikhin, "Na perekrestke," *Literaturnaia gazeta*, 22 Oct. 1986.

6. Octavio Paz, *The Labyrinth of Solitude: Life and Thought in Mexico*, translated by Lysander Kemp, New York, 1961, p. 16. My attention was directed to this essay by Joan W. Moore et al., *Homeboys: Gangs, Drugs, and Prison in the Barrios of Los Angeles*, Philadelphia, 1978, p. 37.

7. L. N. Radzikhovskii, "Problemy psikhologicheskogo rassmotreniia neformal'nykh molodezhnykh ob 'edinenii," in *Psykhologicheskie problemy izucheniia neformal'nykh molodezhnykh organizatsii*, Moscow, 1988, pp. 17–23.

8. The importance of Leningrad as a counterculture destination emerged from conversations at Moscow *tusovki* in September and

October 1988. Two young hippies from Moscow provided a map of 26 coded and named Leningrad *tusovki*, which they had compiled to sell to other hippies who needed orientation in Leningrad.

9. I visited this *tusovka* in October 1988. A. P. Fain reports that it was painted over and sealed in late 1988, and gives some of the texts that appeared on the walls as illustrations of the hippie philosophy; A. P. Fain, "Liudi 'sistemy.' (Mirooshchushchenie sovetskikh khippi)," *Sotsiologicheskie issledovaniia*, 1989 no. 1, p. 91.

10. This judgment is based on an October 1988 interview with Sergei Klubov of Minsk, a one-time and still occasional participant in the *sistema*.

11. Graffiti in Riga are produced by many of the same groups as graffiti in Moscow and Leningrad, but there are in addition many graffiti in Latvian, and the ethnic and nationality issues that are so important in local life obviously create a different graffiti universe than exists in the Soviet heartland. I am indebted to Susan Costanzo for pictures of and notes on the graffiti in Riga in summer of 1988. Minsk is nominally a Belorussian city, but in both 1984 and 1988 the graffiti were almost entirely in Russian (when not in English), and betrayed no ethnic consciousness. Graffiti in Kiev in 1984 were not very numerous, but despite the large Ukrainian population did not differ significantly from graffiti in Moscow.

12. Leonid Zhukovskii, "Problema kontakta," *Iunost'*, 1988 no. 8, pp. 2–7.

13. Paz, *Labyrinth of Solitude*, p. 14.

14. A useful collection of essays on the concept is David O. Arnold, ed., *Subcultures*, Berkeley, 1970. For a critique, see M. Clark, "On the Concept of Subculture," *British Journal of Sociology*, v. 25, no. 4, Dec. 1974, pp. 428–41. For yet another use, see Dick Hebdige, *Subculture: The Meaning of Style*, New York and London, 1979.

15. The literature on Vysotskii is by now vast. A good introduction to him and to the phenomenon of guitar poetry is Gerald Smith, *Songs to Seven Strings: Russian Guitar Poetry and Soviet "Mass Song,"* Bloomington, Ind. 1984.

16. There is an extensive literature on the British and American youth subcultures. See, for example, Stuart Hall and Tony Jefferson, eds., *Resistance through Rituals: Youth Subculture in Post-War Britain*, London, 1976; Hebdige, *Subculture*; and Mike Brake, *Comparative Youth Subculture*, London, 1985. On one variety of continental youth subculture, see Almuth Bruder-Bezzel and Klaus Jurgen Bruder, *Jugend. Psychologie einer Kultur*, Munich, 1984.

17. Hebdige, *Subculture*, p. 17.

18. David W. Maurer, *Language of the Underworld*, collected and edited by Allan W. Futrell and Charles B. Wordell, Lexington, Ky., 1981, p. 264.

19. See the sources in Chapter 2, note 25.

20. James R. Millar and Elizabeth Clayton, "Quality of Life: Subjective Measures of Relative Satisfaction," in James R. Millar, ed., *Politics, Work, and Daily Life in the USSR: A Survey of Former Soviet Citizens*, New York, 1987, pp. 31–57; Donna Bahry, "Politics, Generations, and Change in the USSR," *ibid.*, pp. 61–99; Brian D. Silver, "Political Beliefs of the Soviet Citizen: Sources of Support for Regime Norms," *ibid.*, pp. 100–41; James R. Millar and Peter Donhowe, "Life, Work, and Politics in Soviet Cities—First Findings of the Soviet Interview Project," *Problems of Communism*, Jan.-Feb. 1987, pp. 46–55.

21. John Bushnell, "The 'New Soviet Man' Turns Pessimist," in Stephen Cohen et al., eds., *The Soviet Union Since Stalin*, Bloomington, Ind., 1980, pp. 179–99. Some of the articles in the volume edited by Millar (see note 20) hint at a similar explanation.

22. Moshe Lewin, *The Gorbachev Phenomenon: A Historical Interpretation*, Berkeley, 1988, p. 46. The statistics come from Peter H. Juviler, "The Urban Family and the Soviet State: Emerging Contours of a Demographic Policy," in Henry Morton and Robert Stuart, eds., *The Contemporary Soviet City*, Armonk, N.Y., 1984, p. 87; Robert C. Stuart, "The Sources of Soviet Urban Growth," *ibid.*, p. 30; and *The USSR in Figures for 1986*, Moscow, 1987, p. 36.

23. Lewin, *Gorbachev Phenomenon*, pp. 63–71 and passim. See also L. A. Gordon and E. V. Klopov, *Chto eto bylo? Razmyshleniia o predposylkakh i itogakh togo, chto sluchilos' s nami v 30-40-e gody*, Moscow, 1989, pp. 280–304.

24. In John Bushnell, "Urban Leisure Culture in Post-Stalin Russia: Stability as a Social Problem?" in Terry L. Thompson and Richard Sheldon, eds., *Soviet Society and Culture: Essays in Honor of Vera S. Dunham*, Boulder, 1988, pp. 58–86, I argue that traditional leisure activities expanded to fill much of the new leisure time, even while there was also an expansion of nontraditional leisure. None of the time-budget surveys on which those conclusions rest dated from after the mid-1970s.

25. See Bushnell, "The 'New Soviet Man' Turns Pessimist," pp. 179–99, and Gordon and Klopov, *Chto eto bylo?* pp. 287–88.

26. Gail Warshofsky Lapidus, "Social Trends," in Robert F. Byrnes, ed., *After Brezhnev: Sources of Soviet Conduct in the 1980's*, Bloomington, In., 1983, pp. 203–10; William Zimmerman, "Mobilized Participation and the Nature of the Soviet Dictatorship," in James R. Millar, ed., *Politics, Work, and Daily Life in the USSR: A Survey of Former Soviet Citizens*, New York, 1987, pp. 347–49.

A Postscript
on Art and Life

Many readers must have noticed early in this study the startling similarities between the adolescent graffiti writers of modern Soviet society and the adolescent cutthroats of Anthony Burgess's dystopian novel *A Clockwork Orange*, published in 1962. In a prescient overreaction to the teddy boys of the late 1950s, Burgess imagined an England terrorized by violent, amoral, sartorially expressive teenagers. The novel exemplified the moral panic that confrontation with a subculture often sets off, but it also correctly projected the youth subculture as a permanent fixture of the British urban world and captured some of the subculture's attitudes and accents. From the perspective of the Soviet youth subculture, the most suggestive feature of the novel is the subcultural argot that Burgess invented for his vicious delinquents: it consists largely of transformed Russian, "glazz" (*glaza*) for "eye," "gooly" (*guliat'*) for "walk," "neezhnies" (*nizhnie*) for "underwear," "droog" (*drug*) for "friend," and so on. Burgess grasped the importance of language in subculture, but got the relationships between English and Russian, Western and Soviet societies, exactly backward. Nothing like this "nadsat" (teen) slang ever came into use in England, but members of the Soviet counterculture system do lard their speech with transformed anglicisms. And the graffiti of the entire subculture is based on the use of English.

Burgess put Russian words into his teenagers' mouths to underscore their alienation from the society they terrified. Their language created a barrier between them and the adult world. Adults could not understand what their teenage children said, for one thing. But in Burgess's treatment, the subcultural argot also expressed the attitude of hostile superiority that subcultures and their argots always exhibit toward respectable (or adult) society. The language of Burgess's

imagined subculture performed precisely the same functions as the argot and English of real Soviet subcultural graffiti.

Burgess did not offer much of an explanation for the Russian roots of the argot his teddy boys spoke, but what he did say is interesting in its very inadequacy. "Propaganda. Sublimal penetration," is the offhand remark of an expert credited with understanding nadsat speech. That was appropriate to the Cold War era in which Burgess wrote, and in a novel that itself turns on the idea that supraliminal conditioning can alter behavior. Of course, it was preposterous to suppose that propaganda masters could have foisted on British society as rich and creative a language as nadsat argot. But since the 1960s Soviet commentators baffled and enraged by the penetration of Western popular culture into their society have said almost the same thing, and in almost those words. The West, Soviet culture monitors have said, has been using rock music and mass consumer culture to corrupt Soviet teenagers and undermine Soviet values. Although Burgess may not have intended that one remark to carry such an interpretive burden—he may in this particular have shared the limitations of his characters—art did anticipate the reality of the uncomprehending official explanation of the Soviet subculture.

Attributing the challenge posed by the subculture to the machinations of the ideological enemy did make sense at one or two removes, however. A subculture defies and therefore subverts dominant cultural and social values. The challenge to conventions that are not recognized as mere convention is what most shocks and angers the subculture's enemies. Pinning the blame on an external foe is a defensive reaction that writes off the subculture's challenge as alien and therefore irrelevant. Soviet spokesmen have not been the only guardians of a dominant culture to resort to that defense.

Burgess himself certainly recoiled from the youth subculture that he saw emerging. But he did understand that a contest of values was under way, and his delineation of a dystopian Britain suggests that he imagined the spontaneously violent subculture he drew to be a response to a drably uniform and overregulated dominant society from which spontaneity had been eliminated. For Burgess, the culprit was socialism, the necessary drabness of which was a prominent tenet of one

style of anticommunism at the time he wrote *A Clockwork Orange*. Members of the Soviet subculture would agree that socialism as they know it is drab and restrictive, but then subcultures everywhere make the same charge against dominant society. In any case, the link that Burgess drew between subculture and the densely institutionalized urban world was perceptive, and it fits the Soviet case perfectly.

In *A Clockwork Orange*, the shocking alienness of the subculture's speech mirrors the frantic but random assaults of youth on their elders. In the world that Burgess created, physical violence matches linguistic violence. The same cannot be said of the real world of the Soviet subculture. The *fanaty* and *Liubery* have indulged in gang fights with some regularity, as have the *metallisty* occasionally, but there is no Soviet parallel to the frenetic violence that Burgess described; the groups for which English is the most important—hippies, for instance—are the least violent. Burgess's association of linguistic and physical violence may be a literary device, or perhaps a reflection of the writer's hypersensitivity to deviant language. But it may be too soon to draw a final conclusion. The Soviet youth subculture is still young and developing. In the past, many argotizing groups have routinely indulged in violence; use of an argot is (we must keep in mind) a sign of fundamental antagonism toward the surrounding society. There is, after all, an association between linguistic and social deviance, and between social deviance and violence.

There are at least some signs that the Soviet youth sub-culture is moving closer toward Burgess's model. The Soviet press in 1988 and 1989 carried a number of alarmed reports and investigative articles on rapidly rising gang violence and mushrooming deaths in gang fights. Most attention focused on Kazan, where gang-related deaths rose from four in 1985, and three each in 1986 and 1987 (although one report counted eight gang murders in 1987), to five in a single month in early 1988. Adolescents in Kazan have organized on the order of 100 territorial gangs; they form gang alliances, and they pre-arrange the time and place of their gang fights. Fights usually last for only a minute or two and break up before the police arrive; but if brief, they involve deadly use of knives, pipes, and chains. In their intense fury they resemble the sudden

razor-and-chain rushes Burgess depicted. True, Soviet commentators do not describe the gangs and violence in Kazan or other cities as an outgrowth of the youth subculture. They incline instead (as police often do) toward an economic explanation, insisting that the gangs run extortion rings, that millions of rubles are involved, and that the strings are being pulled by professional criminals.

But a few details, mentioned only by chance, suggest that the rising gang violence is an inherently subcultural phenomenon. First, the gangs in Kazan at one point declared a truce among themselves so that they could clear the city of punks and others viewed as defilers of Soviet culture. In other words, the Kazan gangs (and gangs in other cities are reported to have the same attitude) define themselves at least in part in opposition to counterculture groups. In that way they resemble the *Liubery* in Moscow, who are part of the subculture whether they know it or not. Second, the gangs have graffiti emblems, which they post as territorial markers. Unfortunately, the only characteristic of the Kazan graffiti reported in the Soviet press is the use of the crown that originated with the *fanaty* and has been picked up by every other graffiti-producing group. It is likely that graffiti played the same role in structuring the Kazan gangs as they did for Moscow's fan gangs, and it is possible that, like the graffiti of the *Liubery* and *fanaty*, Kazan's gang graffiti employ English as the language of honor. There is some indication, at least, that the Kazan gangs evolved from local *fanaty*, which would locate them in the subculture.[1]

Burgess anticipated, inversely, the key role that the language of the ideological and cultural enemy plays in the Soviet subculture; he at least suggested the way in which subculture would be misdiagnosed as an ideological threat implanted from outside; he understood (even while being distinctly unsympathetic to it) that youth subculture posed a cultural challenge to the dominant society; and the link he established between extreme linguistic deviance and extreme violence may yet prove to have been predictive. What he missed entirely was the role of popular culture in providing the reference points for youth subculture in all of its manifestations, linguistic included. The only explanation he could give

of the development of nadsat speech was subliminal indoctrination, because he did not provide a cultural landscape that could support a Russian-influenced argot.

English has become the prime language of Soviet subcultural graffiti because it rests on a popular culture that Soviet adolescents—and many of their elders—find attractive. The underground rock and roll industry above all, but also the movies (and, in the last few years, videos), fashions, and an enormous variety of Western consumer goods that enter Soviet society, have sustained an image of the West as an affluent, energetic, and colorful world the opposite of Soviet society in every respect. That image is what lends English, the principal language of Western popular culture as Soviet teens know it, the special prestige that it enjoys. Had English not acquired that cultural connotation, it could not be used by the subculture to mock Soviet society. If Burgess had invented Soviet popular culture goods that British teens of the late 1950s might have found attractive, his nadsat speech would have had credible roots in British urban society. His inability to imagine Soviet cultural goods of that sort illustrates why Russian has never entered the lexicon of Western subcultures.

NOTE

1. *Novoe russkoe slovo* (N.Y.), 3 Apr. 1988 (an account from the Soviet weekly *Nedelia*); Dmitrii Likhanov, " 'Drianye' mal'chishki," *Ogonek*, no. 29, July 1988; *Moskovskie novosti*, no. 31, 31 July 1988; Kseniia Mialo, "Kazanskii fenomen," *Novoe vremia*, no. 33, 12 Aug. 1988, and no. 34, 19 Aug. 1988; Iurii Shchekochikhin, "Ekstremal'naia model'," *Literaturnaia gazeta*, 12 Oct. 1988; Dmitrii Radyshevskii, "My prishli sami. Podrostkovaia prestupnost' v Moskve," *Moskovskie novosti*, no. 24, 11 June 1989.

Bibliography

This bibliography includes all books and most journal articles cited, as well as a few sources on medieval Russian graffiti that do not appear in the notes. Some short and relatively unimportant articles in popular journals, and most newspaper articles, are not listed separately. Complete references can be found in the notes.

NEWSPAPERS AND OTHER PERIODICALS

Chicago Tribune
Christian Science Monitor
Ekspress Khronika
Glasnost' (also in English, *Glasnost*)
India Today
Izvestiia
Komsomol'skaia pravda
Komsomol'skoe znamia (Kiev)
Kommunist
Latvian Information Bulletin
Literaturnaia gazeta
Moskovskie novosti (also in English, *Moscow News*)
Nedelia
New York Times
Newsweek
Novoe russkoe slovo (New York)
Ogonek
On Gogol Boulevard: Networking Bulletin for Activists East and West
People
Posev (Frankfurt)
Pravda
Rodnik (Minsk)
Rovesnik
Russkaia mysl' (Paris)
Smena
Sovetskaia kul'tura

Sovetskaia Rossiia
Sovetskii sport
Soviet Nationality Survey
Spiegel
Time
Times (London)
Trud
Vesti iz SSSR (Munich) (also in English, USSR News Briefs)
Washington Post

BOOKS AND ARTICLES

Aksyonov, Vassily, *The Island of Crimea*, translated by Michael Heim, New York, 1983.

Alekseev, L. V., "Tri priaslitsa s nadpisiami iz Belorussii," *Kratkie soobshcheniia Instituta istorii material'noi kul'tury*, 1955 no. 57, pp. 129–32.

Alexeyeva, Ludmilla, *Soviet Dissent: Contemporary Movements for National, Religious, and Human Rights*, Middletown, Conn., 1985.

Allchurch, David, "Diversions and Distractions: Beyond the Leisure Principle," *Soviet Survey*, no. 26, Oct.-Dec. 1958, pp. 48–55.

Andreeva, L. A., "O nekotorykh obstoiatel'stvakh, soposobstvuiu-shchikh polovym prestupleniiam nesovershenoletnykh, i merakh ikh preduprezhdeniia," *Voprosy bor'by s prestupnostiu*, 1969 no. 10, pp. 108–13.

Arnold, David O., ed., *Subcultures*, Berkeley, 1970.

Artamonov, "Raskopki Sarkela-Beloi Vezhi v 1950 g.," *Voprosy istorii*, 1951 no. 4, pp. 146–51.

Artsikhovskii, A. V., "Novgorodskaia ekspeditsiia," *Kratkie soobshcheniia Instituta istorii material'noi kul'tury*, 1949 no. 27, pp. 113–22.

Artsikhovskii, A. V., "Novye otkrytiia v Novgorode," *Voprosy istorii*, 1951 no. 12, pp. 77–87.

Artsikhovskii, A. V., "Raskopki v Novgorode v 1948 g.," *Kratkie soobshcheniia Instituta istorii material'noi kul'tury*, 1950 no. 33, pp. 3–16.

Avdusin, D. A. and M. N. Tikhomirov, "Drevneishiaia russkaia nadpis'," *Vestnik AN SSSR*, 1950 no. 4, pp. 71–79.

Bahry, Donna, "Politics, Generations, and Change in the USSR," in James R. Millar, ed., *Politics, Work, and Daily Life in the USSR: A Survey of Former Soviet Citizens*, New York, 1987, pp. 61–99.

Baudoin de Courtenay, J. I., *Izbrannye trudy*, v. 2, Moscow, 1963.

Beletskii, V. D., "Raboty Pskovskoi ekspeditsii," *Arkheologicheskie otkrytiia 1972 goda*, Moscow, 1973, p. 8.

Benson, Michael, "Rock in Russia Today," *Rolling Stone*, 26 Mar. 1987.

Borisova, E. G., "Sovremennyi molodezhnyi zhargon," *Russkaia rech'*, 1980 no. 5, pp. 51–54.

Brake, Mike, *Comparative Youth Subculture*, London, 1985.

Brandenburg, N. E., *Staraia Ladoga*, St. Petersburg, 1896.

Bright, Terry, "The Soviet Crusade Against Pop," *Popular Music*, v. 5, 1985, pp. 123–48.

Bruder-Bezzel, Almuth and Klaus Jurgen Bruder, *Jugend. Psychologie einer Kultur*, Munich, 1984.

Bushnell, John, "The 'New Soviet Man' Turns Pessimist," in Stephen Cohen et al., eds., *The Soviet Union Since Stalin*, Bloomington, Ind., 1980, pp. 179–99.

Bushnell, John, "A Popular Reading of Bulgakov: *Explication des Graffiti*," *Slavic Review*, v. 47, no. 2, Fall 1988, pp. 502–11.

Bushnell, John, "Urban Leisure Culture in Post-Stalin Russia: Stability as a Social Problem?" in Terry L. Thompson and Richard Sheldon, eds., *Soviet Society and Culture: Essays in Honor of Vera S. Dunham*, Boulder, 1988, pp. 58–86.

Buslaev, Fedor, *Russkaia khrestomatiia. Pamiatniki drevnei russkoi literatury i narodnoi slovesnosti*, Moscow, 1904.

Cambridge Encyclopedia of Russia and the Soviet Union, New York, 1982.

Carlson, William, "Russian Rock Scales the Iron Curtain," *Rolling Stone*, 9 Sept. 1976.

A Chronicle of Current Events. Issues no. 19 and 20, London, 1971.

A Chronicle of Current Events. Numbers 37, 38, and 39, London, 1978.

A Chronicle of Current Events. Numbers 40, 41, 42, London, 1979.

A Chronicle of Current Events. Numbers 43, 44, 45, London, 1979.

A Chronicle of Current Events. Number 51, London, 1979.

Clark, M., "On the Concept of Subculture," *British Journal of Sociology*, v. 25, no. 4, Dec. 1974, pp. 428–41.

Cohen, Barney, "R and R in the USSR," *Saturday Review*, 23 June 1980.

Danchenko, V. A., "Kontrkul'tura: karat' ili milovat'?" *Sotsiologicheskie issledovaniia*, 1988 no. 2, pp. 140–42.

Darkevich, B. P., "Issledovaniia Staroriazanskoi ekspeditsii," *Arkheologicheskie otkrytiia 1979 goda*, Moscow, 1980, pp. 52–53.

Dauzat, Albert, *Les argots*, Paris, 1929.

del'Agata, D. (Dell'Agat, Giuseppe), "Stari kiriliski nadpisi v katedralata 'San Martino' v grad Lukka," *Slavianskie kul'tury i Balkany*, v. 1, Sofiia, 1978, pp. 62–64.

Dell'Agat, Giuseppe, "Antiche Inscrizioni Cirilliche nel Duomo di Lucca," *Ricerche Slavistiche*, v. 20–21, 1973–1974, pp. 5–14.

Dimov, Aleksandr, "Blues, Jeans, and All That Jazz," *National Review*, 31 Aug. 1979, pp. 1106–7.

Dolgova, A. I., "Problemy profilaktiki kriminogennykh grupp," *Voprosy bor'by s prestupnostiu*, 1980 no. 32, pp. 16–30.

Doronin, An., "O roke—bez prikras," *Molodaia gvardiia*, 1987 no. 12, pp. 213–28.

Doronin, Anatolii and Arkadii Lisenkov, "Chto proku ot 'roka,' " *Molodaia gvardiia*, 1986 no. 5, pp. 214–30.

Drevnie rossiiskie stikhotvoreniia sobrannye Kirsheiu Danilovym, Moscow, 1977.

Dunlop, John, *The Faces of Contemporary Russian Nationalism*, Princeton, 1983.

Dunning, Eric, Patrick Murphy, and John Williams, "Spectator Violence at Football Matches: Toward a Sociological Exploration," *British Journal of Sociology*, v. 57, no. 2, 1986, pp. 221–44.

Efros, Anatolii, "O blagorodstve," *Ogonek*, 1987 no. 32, pp. 22–24.

Fain, A. P., "Liudi 'sistemy' (mirooshchushchenie sovetskikh khippi)," *Sotsiologicheskie issledovaniia*, 1989 no. 1, pp. 85–92.

Fain, A. P., "Spetsifika neformal'nykh podrostkovykh ob"edinenii v krupnykh gorodakh," *Psikhologicheskie problemy izucheniia neformal'nykh molodezhnykh ob"edinenii*, Moscow, 1988, pp. 23–43.

"Fashizm v SSSR. Spontanyi protest ili inspirirovannoe dvizhenie?" *Strana i mir* (Munich), no. 1–2, 1984, pp. 51–55.

Feigin, Leo, ed., *Russian Jazz: New Identity*, London, 1985.

Feldman, Linda, "Laid-Back in the U.S.S.R.," *Philadelphia Inquirer*, 24 Dec. 1987.

Fowler, Roger, *Literature as Social Discourse: The Practice of Linguistic Criticism*, Bloomington, Ind., 1981.

Gallagher, Jim, "Russia's Young Rebels," *Chicago Tribune Magazine*, 21 May 1982.

Gambino, Thomas, *NYET: An American Rock Musician Encounters the Soviet Union*, Englewood Cliffs, N.J., 1976.

Geoponika. Geoponicorum sive de re rustica, Lipsiae, 1781.

Gershkovich, Aleksandr, *Teatr na Taganke*, Benson, Vt., 1986.

Gitlin, Todd, *The Sixties: Years of Hope, Days of Rage*, New York, 1987.

Golubeva, L. A., "Nadpis' na korchage iz Beloozera," *Sovetskaia arkheologiia*, 1960 no. 3, pp. 321–23.

Gordon, L. A. and E. V. Klopov, *Chto eto bylo? Razmyshleniia o predposylkakh i itogakh togo, chto sluchilos' s nami v 30-40-e gody*, Moscow, 1989.

Goshev, Ivan, *Starob''lgarski glagolicheski i kirilski nadpisi ot IX i X v.*, Sofiia, 1961.

Graps, Gunnar, "Muzyka dlia obshcheniia," *Avrora*, 1984 no. 3, pp. 139–41.

Grigorian, Grigor, "Armianskie nadpisi Kievskogo sobora sviatoi Sofii," *Vestnik obshchestvennykh nauk AN Armianskoi SSR*, 1979 no. 4, pp. 85–93.

Guiraud, Pierre, *L'argot*, 2nd edition, Paris, 1958.

Gupalo, K. N., G. Iu. Ivakin, and M. A. Sagaidak, "Issledovaniia tserkvi Uspeniia Pirogoshchi," *Arkheologicheskie otkrytiia 1977 goda*, Moscow, 1978, pp. 317–18.

Hall, Stuart and Tony Jefferson, eds., *Resistance through Rituals: Youth Subculture in Post-War Britain*, London, 1976.

Halliday, M. A. K., *Language as Social Semiotic: The Social Interpretation of Language and Meaning*, Baltimore, 1978.

Hebdige, Dick, *Subculture: The Meaning of Style*, New York and London, 1979.

Hindus, Maurice, *The Kremlin's Human Dilemma*, Garden City, N.Y., 1967.

Horbatsch, Olexa, "Einige slavische Pilgerinschriften in der Hagia Sophia-Kathedrale in Konstantinopel," *Die Welt der Slaven*, v. 22, no. 1, 1977, pp. 86–88.

Horowitz, Ruth, *Honor and the American Dream: Culture and Identity in a Chicano Community*, New Brunswick, N.J., 1983.

Ianin, V. L., *Ia poslal tebe berestu . . .* , 2nd edition, Moscow, 1975.

Ianin, V. L. et al., "Novgorodskaia ekspeditsiia," *Arkheologicheskie otkrytiia 1985 goda*, Moscow, 1985, pp. 46–48.

Igoshev, K. I., *Pravonarusheniia i otvetsvennost' nesovershennoletnego*, Sverdlovsk, 1973.

Ilves, Toomas, "Punks, Drugs, and Violence," *Radio Free Europe Research*, Baltic Area, 27 Jan. 1986.

Ilves, Toomas, "Youth Trends: Breakdancing In, Heavy Metal in Trouble," *Radio Free Europe Research*, Baltic Area, 29 Aug. 1986.

Ioannisian, O. M. et al., "Raskopki v Nikol'skom monastyre v Staroi Ladoge," *Arkheologicheskie otkrytiia 1978 goda*, Moscow, 1979, pp. 11–12.

Iudin, N. I., *Pravda o peterburgskikh 'sviatynikh,'* Leningrad, 1962.

Iumashev, Valentin, "Zarisovka v stile breik," *Iunost'*, 1986 no. 12, pp. 101–4.

Juviler, Peter H., "The Urban Family and the Soviet State: Emerging Contours of a Demographic Policy," in Henry W. Morton and Robert C. Stuart, eds., *The Contemporary Soviet City*, Armonk, N.Y., 1984, pp. 84–112.

Kagarlitsky, Boris, "The Intelligentsia and the Changes," *New Left Review*, no. 164, July-Aug. 1987, pp. 5–26.

Kaiser, Daniel, *The Growth of the Law in Medieval Russia*, Princeton, 1980.

Kamanin, I., *Zverinetskie peshchery v Kieve*, Kiev, 1914.

Karger, M. K., "Razvaliny Zarubskogo monastyria i letopisnyi gorod Zarub," *Sovetskaia arkheologiia*, v. 13, 1950, pp. 33–62.

Kataev, S. L., "Muzykal'nye vkusy molodezhi," *Sotsiologicheskie issledovaniia*, 1986 no. 1, pp. 105–8.

Kataev, S. L., "Soderzhanie i intonatsiia molodezhnoi pesni," *Sotsiologicheskie issledovaniia*, 1987 no. 1, pp. 77–80.

Katsenelinboigen, Aron, "Paradoks Gorbacheva," *Vremia i my*, v. 99, 1987.

Keiser, R. Lincoln, *The Vice Lords: Warriors of the Street*, New York, 1969.

Keller, Bill, "Russia's Divisive War: Home from Afghanistan," *New York Times Magazine*, 14 Feb. 1988.

Keller, Bill, "Russia's Restless Youth," *New York Times Magazine*, 26 July 1987.

Kharlamov, V. A., "Raboty Arkhitekturno-arkheologicheskogo otriada," *Arkheologicheskie otkrytiia 1985 goda*, Moscow, 1987, pp. 425–26.

Khramov, Nikolai, "Is It Easy to Be Truthful? Reflections in a Movie Theater," *Across Frontiers*, v. 4, no. 1, Winter 1988.

Kirpichnikov, A. N., and E. A. Riabinin, "Issledovaniia srednevekovogo Porkhova i ego okrugi," *Arkheologicheskie otkrytiia 1974 goda*, Moscow, 1975, pp. 19–20.

Kolchin, B. A., *Novgorodskie drevnosti. Dereviannye izdeliia*, Moscow, 1968.

Konovalov, Valerii, "Desecration of Cemeteries in the USSR," *Radio Liberty Research*, 12 June 1987.

Konovalov, Valerii, "Neo-Nazis in the USSR: A Menace to Society or 'Mindless Childish Games'?" *Radio Liberty Research*, 29 Oct. 1987.

Korovin, A. K., "Raskopki Tamanskogo gorodishcha," *Arkheologicheskie otkrytiia 1972 goda*, Moscow, 1973, pp. 294–95.

Kozlovskii, V., *Argo russkoi gomoseksual'noi subkul'tury. Materialy k izucheniiu*, Benson, Vt., 1986.

Kulikov, V., "Besprizornye 'fanaty,' " *Komsomol'skaia pravda*, 5 Oct. 1986.

Kuniaev, Stanislav, "Chto tebe poiut? Polemicheskie zametki o modnom v kul'ture," *Nash sovremennik*, 1984 no. 7, pp. 171–82.

Labutina, I. K., "Raskopki v Pskove," *Arkheologicheskie otkrytiia 1974 goda*, Moscow, 1975, pp. 21–22.

La Feria, Ruth, "Soviet Chic," *New York Times Magazine*, 31 July 1988.

Lapidus, Gail Warshofsky, "Social Trends," in Robert F. Byrnes, ed., *After Brezhnev: Sources of Soviet Conduct in the 1980's*, Bloomington, Ind., 1983, pp. 186–249.

Larin, B. A., *Istoriia russkogo iazyka i obshchee iazykoznanie*, Moscow, 1972.

Lee, Andrea, *Russian Journal*, New York, 1981.

Lehman, Karl, *Samothrace*, v. 2 part 2, *The Inscriptions on Ceramics and Minor Objects*, New York, 1960.

Lemkhin, Mikhail, "Kto zhe oni, kumiry?" *Vremia i my* (N.Y.), 1987 no. 95, pp. 136–49.

Leonidov, Pavel, *Vladimir Vysotskii i drugie*, New York, 1983.

Leskov, S., "Fal'shivye strasti," *Komsomol'skaia pravda*, 11 June 1982.

Levshin, V., "Sadovaia 302-bis," *Teatr*, 1971 no. 11, pp. 110–20.

Lewin, Moshe, *The Gorbachev Phenomenon: A Historical Interpretation*, Berkeley, 1988.

Likhachev, D. S., "Argoticheskie slova professional'noi rechi," in *Razvitie grammatiki i leksiki sovremennogo russkogo iazyka*, Moscow, 1969, pp. 311–59 (written in 1938).

Likhachev, D. S., "Cherty pervobytnogo primitivizma vorovskoi rechi," *Iazyk i myshlenie*, v. 3–4, 1935, pp. 48–100.

Likhachev, N., "Vladimirskie epigraficheskaia zapis' XIV veka," *Izvestiia Otdeleniia russkogo iazyka i slovesnosti Akademii nauk*, series 2, v. 6, book 3, St. Petersburg, 1901, pp. 290–96.

Likhanov, Dmitrii, " 'Drianye' mal'chishki," *Ogonek*, no. 29, July 1988.

Liubimov, Iurii, "Praviteli i teatr," *Vremia i my*, 1987 no. 98, pp. 165–79.

Liubimov, Iurii, *Stsenicheskaia adaptatsiia "Mastera i Margarity"* M. A. Bulgakova, London, 1985.

Lobanov, Mikhail, "Prosveshchennoe meshchanstvo," *Molodaia gvardiia*, 1968 no. 4, pp. 294–306.

Malevskaia, M. V., "Arkhitekturno-arkheologicheskie issledovaniia v Lutskom zamke," *Arkheologicheskie otkrytiia 1984 goda*, Moscow, 1986, pp. 267–68.

Mal'm, V. A., "Shifernye priaslina i ikh ispol'zovanie," *Istoriia kul'tury Vostochnoi Evropy po arkheologicheskim dannym*, Moscow, 1971, pp. 197–206.

Marcus, Naomi, "Glasnost's First Gold Record," *Mother Jones*, Oct. 1988.

Marsh, Peter, "Life and Careers on the Soccer Terraces," in Roger Ingham, ed., *Football Hooliganism: The Wider Context*, London, 1961, pp. 61–81.

Marsh, Peter, Elizabeth Roser, and Rom Harre, *The Rules of Disorder*, London, 1978.

Martynov, Leonid, ("Stikhi"), *Iunost'*, 1966 no. 1, p. 49.

Materialy samizdata.

Maurer, David W., *Language of the Underworld*, collected and edited by Allan W. Futrell and Charles B. Wordell, Lexington, Ky., 1981.

Mazurova, A. I., "Slovar' slenga, rasprostranennogo v srede neformal'nykh molodezhnykh ob"edinenii," *Psikhologicheskie problemy izucheniia neformal'nykh molodezhnykh ob"edinenii*, Moscow, 1988, pp. 148–57.

Medvedev, A. F., "Drevnerusskie pisala X-XV vv. (po dannym arkheologicheskikh raskopok)," *Sovetskaia arkheologiia*, 1960 no. 2, pp. 63–88.

Medvedev, A. F., "Raskopki v Staroi Russe," *Arkheologicheskie otkrytiia 1972 goda*, Moscow, 1973, pp. 25–26.

Medvedkova, Olga, "The Moscow Trust Group: An Uncontrolled Grass-Roots Movement in the Soviet Union," Mershon Center, *Quarterly Report*, v. 12, no. 4, Spring 1988.

Medyntseva, A. A., "Drevnerusskie nadpisi iz tserkvi Fedora Stratilat v Novgorode," *Slaviane i Rus'*, Moscow, 1968, pp. 440–50.

Medyntseva, A. A., *Drevnerusskie nadpisi Novgordskogo Sofiiskogo sobora. XI-XIV veka*, Moscow, 1978.

Medyntseva, A. A., "Epigraficheskie nakhodki iz Staroi Riazani," *Drevnosti slavian i Rusi*, Moscow, 1988, pp. 247–56.

Medyntseva, A. A., "Gramotnost' zhenshchin na Rusi X-XIII vv. po dannym epigrafiki," in B. A. Rybakov, ed., *Slovo o polku Igoreve i ego vremia*, Moscow, 1985, pp. 218–40.

Meinert, N. P., "Po vole roka," *Sotsiologicheskie issledovaniia*, 1987 no. 4, pp. 88–93.

Mialo, Ksenia, "Kazanskii fenomen," *Novoe vremia*, no. 33, 12 Aug. 1988, and no. 34, 19 Aug. 1988.

Millar, James R. and Elizabeth Clayton, "Quality of Life: Subjective Measures of Relative Satisfaction," in James R. Millar, ed., *Politics, Work, and Daily Life in the USSR: A Survey of Former Soviet Citizens*, New York, 1987, pp. 31–57.

Millar, James R., and Peter Donhowe, "Life, Work, and Politics in Soviet Cities: First Findings of the Soviet Interview Project," *Problems of Communism*, Jan.-Feb. 1987, pp. 46–55.

Moiseev, Igor, "Ot menueta do tvista," *Semia i shkola*, 1968 no. 1, pp. 36–38.

Mongait, A. L., "Raskopki v Staroi Riazani," *Ogonek*, 1950 no. 9, p. 28.

Monohan, Barbara, *A Dictionary of Russian Gesture*, Ann Arbor, Mich., 1983.

Moore, Joan et al., *Homeboys: Gangs, Drugs, and Prison in the Barrios of Los Angeles*, Philadelphia, 1978.

Morris, Desmond et al., *Gestures: Their Origins and Distribution*, New York, 1979.

Nagorski, Andrew, *Reluctant Farewell*, New York, 1985.

Nahaylo, Bohdan, "The Protests in Pushkin Square," *Encounter*, Mar. 1983.

Novye slova i znacheniia. Slovar'-spravochnik po materialam pressy i literatury 60-kh godov, Moscow, 1973.

Ocherki po arkheologii Belorussii, v. 2, Minsk, 1972.

Oinas, Felix, *Essays on Russian Folklore and Mythology*, Columbus, Ohio, 1985.

Okulov, Andrei, "Nastroeniia molodezhnoi oppozitsii," *Posev*, 1981 no. 1.

"Organizatsiia iunykh neofashistov," *Strana i mir*, 1985 no. 5, p. 18.

Orlov, A. S., *Bibliografiia russkikh nadpisei XI-XV vv.*, 2nd edition, Moscow, 1952.

Ostroumov, S. S., "Nekotory voprosy izucheniia pravonarushenii sredi nesovershennoletnikh," *Izuchenie i preduprezhdenie pravonarushenii sredi nesovershennoletnykh*, Moscow, 1970, pp. 16–61.

Partridge, Eric, *Here, There and Everywhere: Essays upon Language*, London, 1950.

Pascal, Pierre, *The Religion of the Russian People*, translated by Rowan Williams, Crestwood, New York, 1976.

Paz, Octavio, *The Labyrinth of Solitude: Life and Thought in Mexico*, New York, 1961.

Pereverzev, " 'Arsenal' Alekseia Kozlova," *Iunost'*, 1976 no. 6, pp. 102–3.

Perkins, Useni Eugene, *Explosion of Chicago's Black Street Gangs*, Chicago, 1987.

Polonskii, I. S., "Nekotorye sotsial'no-psikhologicheskie faktory organizatorskoi deiatel'nosti v stikhiinykh gruppakh podrostkov," *Uchenye zapiski Kurskogo pedagogicheskogo instituta*, v. 70, no. 1, 1970, pp. 48–62.

Presman, A. M., "Eshche raz o khippi," *Sotsiologicheskie issledovaniia*, 1988 no. 4, pp. 113–14.

Prokhorov, V. S., "O gruppovoi prestupnosti nesovershennoletnikh," *Vestnik Leningradskogo universiteta* (Seriia ekonomika-filosofiia-pravo), v. 2, no. 11, 1967, pp. 117–24.

Raba bozhiia Blazhennaia Kseniia, Shanghai, 1948, reprinted London, Canada, 1986.

Radzikhovskii, L. N., "Problemy psikhologicheskogo rassmotreniia neformal'nykh moldezhnykh ob"edinenii," *Psykohologicheskie problemy izucheniia neformal'nykh molodezhnykh organizatsii*, Moscow, 1988, pp. 17–23.

Ramet, Pedro and Sergei Zamascikov, "The Soviet Rock Scene," Kennan Institution for Advanced Russian Studies, Occasional Paper no. 223, 1987.

Robinson, Logan, *An American in Leningrad*, New York, 1982.

"Rok: Muzyka? Subkul'tura? Stil' zhizni? (Obsuzhdenie za 'kruglym stolom' redaktsii)," *Sotsiologicheskie issledovaniia*, 1987 no. 1, pp. 29–51.

Rokotov, Sim, "Govori!" *Iunost'*, 1987 no. 6, pp. 83–85.

"Rok-razgovor," *Iunost'*, 1983 no. 5, pp. 86–92.

Rothchild, Sylvia, *A Special Legacy: An Oral History of Soviet Jewish Emigres in the United States*, New York, 1985.

Rozin, M. V., "Psikhologiia moskovskikh khippi," *Psikhologicheskie problemy izucheniia neformal'nykh molodezhnykh ob"edinenii*, Moscow, 1988, pp. 44–69.

Rubenstein, Joshua, *Soviet Dissidents: Their Struggle for Human Rights*, revised edition, Boston, 1985.

Russkii iazyk. Entsiklopediia, Moscow, 1979.

Rybakov, B. A., *Drevniaia Rus'. Skazaniia. Byliny. Letopisi,* Moscow, 1963.

Rybakov, B. A., "Imenni napisi XII st. v Kiivs'komu Sofiis'komu sobori," *Arkheologiia,* v. 1, Kiev, 1947, pp. 53–64.

Rybakov, B. A., "Raskopki v Liubeche v 1957 godu," *Kratkie soobshcheniia Instituta istorii material'noi kul'tury,* 1960 no. 79, pp. 27–34.

Rybakov, B. A., *Remeslo drevnei Rusi,* Moscow-Leningrad, 1948.

Rybakov, B. A., "Russkaia epigrafika X-XIV vv. (Sostoianie, vozmozhnosti, zadachi)," originally published in 1963, reprinted in B. A. Rybakov, ed., *Iz istorii kul'tury Drevnei Rusi. Issledovaniia i zametki,* Moscow, 1984, pp. 34–58.

Rybakov, B. A., *Russkie datirovannye nadpisi XI-XIV vekov,* Moscow, 1964.

Rybakov, B. A., "Smolenskaia nadpis' XIII v. o 'vragakh igumenakh,' " *Sovetskaia arkheologiia,* 1964 no. 2, pp. 179–87.

Rybakov, B. A., "Zapis' o smerti Iaroslava Mudrogo," *Sovetskaia arkheologiia,* 1959 no. 4, pp. 245–49.

Sarkitov, N. D., "Ot 'khard-roka' k 'khevi-metallu': effekt oglupleniia," *Sotsiologicheskie issledovaniia,* 1987 no. 4, pp. 93–94.

Shchapov, Ia. N., ed., *Drevnerusskie kniazheskie ustavy XI-XV vv.,* Moscow, 1976.

Shchapov, Ia. N., "Kirik Novgorodets o berestianykh gramotakh," *Sovetskaia arkheologiia,* 1963 no. 2, pp. 251–53.

Shchapov, Ia. N., *Kniazheskie ustavy i tserkov' v Drevnei Rusi,* Moscow 1972.

Shchekochikhin, Iurii, *Allo, my vas slyshim. Iz khroniki nashego vremeni,* Moscow, 1987.

Shchekochikhin, "Ekstremal'naia model'," *Literaturnaia gazeta,* 12 Oct. 1988.

Shchekochikhin, Iurii, "Na perekrestke," *Literaturnaia gazeta,* 22 Oct. 1986.

Shchekochikhin, Iurii, "Po kom zvonit kolokol'chik?" *Sotsiologicheskie issledovaniia,* 1987 no. 1, pp. 81–96.

Shchekochikhin, Iurii, "Predislovie k razgovoru," *Literaturnaia gazeta,* 6 June 1984.

Shchepkin, V. N., "Novgorodskie nadpisi Graffiti," *Drevnosti,* v. 19, no. 3, 1902, pp. 26–46.

Shkol'nikov, Leonid, *Rasskazy o tantsakh,* Moscow, 1966.

Shkol'nikov, Leonid, "Vsegda li tanets sluzhit krasote?" *Molodoi kommunist,* 1968 no. 11, pp. 117–21.

Shtykhov, G. V., "Okhrannye raskopki v Belorussii," *Arkheologicheskie otkrytiia 1981 goda*, Moscow, 1983, p. 366.

Shtykhov, G. V., "Raskopki v Vitebske i ego okrestnostiakh," *Arkheologicheskie otkrytiia 1972 goda*, Moscow, 1973, pp. 370–72.

Silaev, A., "Zapiski palomnika," *Posev*, 1986 no. 1, p. 43.

Silver, Brian, "Political Beliefs of the Soviet Citizen: Sources of Support for Regime Norms," in James R. Millar, ed., *Politics, Work, and Daily Life in the USSR: A Survey of Former Soviet Citizens*, New York, 1987, pp. 100–41.

Sizov, E. S., "Graffiti v usypal'nitse Ivana Groznogo," *Arkheograficheskii ezhegodnik za 1968 god*, Moscow, 1970, pp. 119–26.

Sloane, David, "Grandfathers and Children: The Rock Music Phenomenon in the Soviet Union," *Semiotext(e)*, forthcoming.

Smith, Gerald, *Songs to Seven Strings: Russian Guitar Poetry and Soviet "Mass Song,"* Bloomington, Ind., 1984.

Smith, Hedrick, *The Russians*, New York, 1976.

Solov'ev, Vladimir, "Istoriia odnoi skvernosti," *Vremia i my*, 1987 no. 95, pp. 122–35.

Spegal'skii, Iu. P., *Pskov. Khudozhestvennye pamiatniki*, 2nd edition, Leningrad, 1972.

Sreznevskii, I., "Peshchera Ivana Greshnogo i Feofila," *Izvestiia Imperatorskogo arkheologicheskogo obshchestva*, v. 2, part 1, St. Petersburg, 1861, columns 1–7.

Starr, S. Fredrick, *Red and Hot: The Fate of Jazz in the Soviet Union 1917–1980*, New York, 1983, pp. 292–315.

Starr, S. Fredrick, "The Rock Inundation," *Wilson Quarterly*, v. 7, no. 4, Autumn 1983, pp. 58–67.

Straten, V. V., "Argo i argotizmy," *Izvestiia komissii po russkomu iazyku*, v. 1, Moscow-Leningrad, 1931, pp. 111–47.

Stuart, Robert C., "The Sources of Soviet Urban Growth," in Henry W. Morton and Robert C. Stuart, eds., *The Contemporary Soviet City*, Armonk, N.Y., 1984, pp. 25–41.

Sundiev, I. Iu., "Neformal'nye molodezhnye ob"edineniia: opyt ekspozitsii," *Sotsiologicheskie issledovaniia*, 1987 no. 5, pp. 56–62.

Tan, Aleksandr, "Moskva v romane M. Bulgakova," *Dekorativnoe iskusstvo SSSR*, 1987 no. 2, pp. 22–29.

Taylor, Ian, "On the Sports Violence Question: Soccer Hooliganism Revisited," in Jennifer Hargreaves, ed., *Sport, Culture and Ideology*, London-Boston, 1982, pp. 152–96.

Tempest, Richard, "Youth Soviet Style," *Problems of Communism*, May-June 1984, pp. 60–64.

Thomas, Keith, *Religion and the Decline of Magic*, New York, 1971, pp. 25–50.

Timroth, Wilhelm von, *Russian and Soviet Taboo Varieties of the Russian Language*, revised and enlarged edition, translated by Nortrud Gupta, Munich, 1986.

Tolochko, P. P., *Drevnii Kiev*, 1976.

Tolz, Vera, "Controversy in Soviet Press over Unofficial Youth Groups," *Radio Liberty Research*, 11 Mar. 1987.

Troitsky, Artemy, *Back in the USSR: The True Story of Rock in Russia*, Boston and London, 1987.

The USSR in Figures for 1986, Moscow, 1987.

Vital'ev, V., "Fiurery s Fontanki," *Krokodil*, no. 18, June 1988.

"Vnimanie: Opasnost'," *Kontinent*, no. 50, 1986, pp. 211–27.

Volkov, Solomon, "Rok-muzyka v Sovetskom Soiuze. Sem tezisov k probleme," *SSSR. Vnutrennie protivorechiia*, v. 5, New York, 1982, pp. 44–50.

Voronin, N. N., "Graffiti 2 fevralia 1238 g.," *Slaviane i Rus'*, Moscow, 1968, pp. 401–5.

Voronin, N. N., "Oboronitel'nye sooruzheniia Vladimira XII v.," *Materialy i issledovaniia po arkheologii SSSR*, 1949 no. 11, pp. 203–39.

Voronin, N. N., "Smolenskie graffiti," *Sovetskaia arkheologiia*, 1964 no. 2, pp. 171–78.

Voronin, N. N., *Zodchestvo Severo-Vostochnoi Rusi XII-XV vv.*, v. 1, Moscow, 1961.

Voronitsyn, Sergei, "Unofficial Karate Gets the Chop," *Radio Liberty Research*, 18 Jan. 1982.

Vysotskii, S. A., *Drevnerusskie nadpisi Sofii Kievskoi*, v. 1, *XI-XIV vv.*, Kiev, 1966.

Vysotskii, S. A., *Kievskie graffiti XI-XVII vekov*, Kiev, 1985.

Vysotskii, S. A., *Srednevekovye nadpisi Sofii Kievskoi*, Kiev, 1976.

Wagg, Stephen, *The Football World: A Contemporary Social History*, Brighton, 1984, pp. 194–219.

Ware, Timothy, *The Orthodox Church*, 1980.

Wilson, N. G., *Scholars of Byzantium*, Baltimore, 1983.

Yanov, Alexander, *The Russian New Right: Right-Wing Ideologies in the Contemporary USSR*, Berkeley, 1978.

Yurchenko, Vadim, "Festival Shows Strength of Russian Rock," *Billboard*, 22 Jan. 1972.

Zeldes, Ilya, "Juvenile Delinquency in the USSR: A Criminological

Survey," *International Journal of Comparative and Applied Criminal Justice*, v. 4, no. 1, Spring 1980, pp. 15–28.

Zhilina, N. V., "Tverskaia berestianaia gramota No. 1," *Sovetskaia arkheologiia*, 1987 no. 1, pp. 203–16.

Zhirmunskii, V., *Natsional'nyi iazyk i sotsial'nye dialekty*, Leningrad, 1936.

Zhitinskii, Aleksandr, "Zapiski rok-diletanta," *Avrora*, 1982 no. 2, pp. 128–40; 1982 no. 9, pp. 123–26; 1983 no. 3, pp. 123–38; 1984 no. 3, pp. 128–39; 1985 no. 10, pp. 127–38.

Zhukovskii, Leonid, "Problema kontakta," *Iunost'*, 1988 no. 8, pp. 2–7.

Zimmerman, William, "Mobilized Participation and the Nature of the Soviet Dictatorship," in James R. Millar, ed., *Politics, Work, and Daily Life in the USSR: A Survey of Former Soviet Citizens*, New York, 1987, pp. 332–53.

Zulman, G. B. et al., "Formirovanie muzykal'noi kul'tury molodezhi," *Sotsiologicheskie issledovaniia*, 1983 no. 4, pp. 120–23.

About the Author

JOHN BUSHNELL is associate professor of history at Northwestern University and a former translator for Progress Publishers in Moscow. He is the author of *Mutiny amid Repression: Russian Soldiers in the Revolution of 1905-1906* (1985), as well as numerous articles on Russian and Soviet history.

Index